No
Space
Hidden

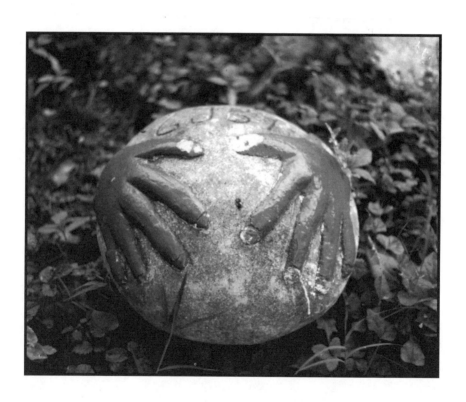

No Space Hidden

The Spirit of African American Yard Work

Grey Gundaker / Judith McWillie

THE UNIVERSITY OF TENNESSEE PRESS / KNOXVILLE

Frontispiece: Property marker by Dilmus Hall. Athens, Georgia, 1975.
Photograph by Judith McWillie.

This book is printed on acid-free paper.

Library of Congress Cataloging-in-Publication Data

Gundaker, Grey.
 No space hidden: the spirit of African American yard work /
Grey Gundaker and Judith McWillie.— 1st ed.
 p. cm.
Includes bibliographical references and index.

ISBN 1-57233-356-1 (pbk.: alk. paper)

1. African Americans—Social life and customs.
2. Landscape—Symbolic aspects—United States.
3. Landscape—Social aspects—United States.
4. African American aesthetics.
 I. McWillie, Judith.
II. Title.

E185.86.G76 2004
306.4'7'08996073—dc22 2004010751

Time, for me, works like a door. You have to go through time in order to be in it. It seems like one big cycle from within, like a spring. You start at the inner most part of the spring and you move outward as you grow. And, as you grow, this materialistic body, which is flesh, takes its place and acts; then it falls back to the beginning to recreate itself. Time is standing still if one is not moving in it; and, if one is moving in it, time moves so fast that we cannot keep up with it. We can speed through time and then we can be in time and not move at all. Man could stay still and time won't even matter. But if man is moving in time and trying to keep up with time itself, then he'll somehow or another be like time, out-run himself. Because there is no distance, there is no limit, no space hidden.

—Lonnie Holley, 1987

Contents

A Word about Sources xiv

Acknowledgments xv

Contents

Illustrations

Plates

Figures

A Word about Sources

The main themes and arguments in this book developed as both of us documented yards and talked with their makers over the years. In order to sketch the historical bases of yard work, however, we have also turned to memoirs and folklore accounts written in the nineteenth and early twentieth centuries by authors who hold stereotyping and exoticizing views. Despite the problems of bias and faulty dialect transcription they pose, however, these accounts offer descriptions of material signs, healing, and other repositories of cultural knowledge that exist nowhere else. We sometimes quote at length so that readers can form their own critical evaluations of the author's voice along with the information the source contains.

Acknowledgments

Judith McWillie

From the 1960s until the middle 1990s, yards that included the elaborate and colorful display of everyday objects were plentiful in African American neighborhoods in Memphis, Tennessee, where I grew up. So, as an art student at Memphis State University (now the University of Memphis) in 1969, I started to make photographs of these neighborhoods and collect narratives and folktales from friends in the north Mississippi Delta. After moving to Georgia in 1974, the scope of this project expanded to include vernacular artists and yards in Georgia, Alabama, Mississippi, Louisiana, North and South Carolina, Virginia, Pennsylvania, Delaware, Massachusetts, Rhode Island, and New York. By the time Robert Farris Thompson introduced Grey Gundaker and me to each other in 1985, I had assembled a loose collection of slides and prints tentatively organized according to recurring imagery in African American cemeteries, yards, and visual art. Thompson's publications and Grey's research expertise and methodology made it possible to situate the images in this collection within a transatlantic context at a time when "folk/outsider" art was becoming a popular commodity. Because of their associations with "folk/outsider" art, yard works, in particular, were commonly perceived to be local anomalies rather than contemporary manifestations of longstanding cultural integrities.

For opening my eyes to these integrities, I am deeply indebted to the artists and practitioners I have known, especially Zebedee "Z. B." Armstrong, E. M. Bailey, Hawkins Bolden, Eddie Bowens, Eva Mae Bowens, Clarence Burse, Henry Luke Faust, Mary Lou Furcron, Florence Gibson, Ralph Griffin, Dilmus Hall, Bishop Washington Harris and Pastor Marvin White of the Saint Paul Spiritual Temple in Memphis, Bessie Harvey, Lonnie Holley, the Reverend George Kornegay, Wess and Sue Willie Lathern, Bennie and Elizabeth Lusane, Victor Melancon, Robert "Boot Roots" Montgomery, John B. "J. B." Murray, Mary Tillman Smith, Annie Sturghill, Robert Watson, and Eddie Williamson. As friends and, in several instances, neighbors, they embodied the idea that lives lived mindfully resonate far beyond local frames of reference.

While visiting the Metropolitan Museum of Art in 1983, I purchased a copy of Robert Farris Thompson's *Flash of the Spirit: African and African American Art and Philosophy* and, a few weeks later, the catalogue for the National Gallery of Art's 1981 exhibition *The Four Moments of the Sun: Kongo Art in Two Worlds,* curated by Thompson and Joseph Cornet. Thompson and I first met a year later when he lectured at the University of Georgia's Lamar Dodd School of Art, where I am a member of the studio faculty in painting. His vast knowledge and spiritual depth, as well as his generous encouragement of my work, made it possible for me to pursue a life that would have been considerably different had our paths not crossed. No amount of thanks could possibly be adequate.

In 1984 Robert Anderson, former vice president for research of the University of Georgia,

made it possible for me to purchase some of the first affordable home video equipment and, subsequently, to revisit practitioners and interview them more thoroughly and also to document their neighborhoods and their relationships with family and friends. This work was supported by travel grants and release time from the Lamar Dodd School of Art.

Between 1985 and 1987, I was a guest curator for the William Arnett Collection in Atlanta and came into contact with a number of southern artists previously unknown. At about the same time, Lynda Hartigan of the Smithsonian American Art Museum (now affiliated with the Peabody Essex Museum in Salem, Massachusetts) and Liza Kirwin of the Archives of American Art introduced me to relevant artists in the northeastern and middle western United States. Lynda arranged an interview in Washington, D.C., with Mrs. Otelia Whitehead, who knew the deceased artist James Hampton (see portfolio VI), whose *Throne of the Third Heaven of the Nations Millennium General Assembly* is a master icon of African American vernacular art profoundly related to yard work. William Ferris, Charles Regan Wilson, and Ann Abadie recommended valuable readings in African American studies, anthropology, and southern studies while I was a Ford Foundation Faculty Fellow at the Center for the Study of Southern Culture of the University of Mississippi in 1986–87.

My awareness of the urban Afro Atlantic world was considerably enhanced by John Mason of the Yoruba Theological Archministry of Brooklyn, New York. John was a catalogue essayist for *Another Face of the Diamond: Pathways Through the Black Atlantic South,* a 1989 exhibition at INTAR Latin American Gallery in New York, for which I served as curator. Inverna Lockpez, as gallery director and coeditor of the catalogue, was a paragon

of tact and professionalism while hosting one of the first exhibitions of African American vernacular art in Manhattan. At the time Inverna commented that the objects on exhibit reminded her of works she had seen in her native Cuba. Albert J. Raboteau contributed immeasurably to that project with his lecture at its opening, and in subsequent years he became a valuable correspondent and advisor. Dan Dawson, who in the mid-1980s was with the Caribbean Cultural Center in New York, was a most generous advisor and pointed the way to Harry Middleton Hyatt's extraordinary work as an independent scholar.

Time spent and projects completed in New York would have been impossible without the hospitality and good cheer of artist friends Nadine Valenti Beauchamp, her late husband, Robert Beauchamp, and Jean Busuttil Zaleski, as well as Chuck and Jan Hinman, who offered lodging, sustenance, and moral support on frequent visits there.

Grey Gundaker, patient collaborator and friend, has been both steadfast and liberal in her giving and sharing over the past nineteen years in marathon telephone conversations, road trips, and our critiques of one another's work.

Before any of these associations, Lilla Dewitt, Chaney Gentry, and Ramelle Young gave me the privilege of sharing a small part of their lives and assisted at the birth of this work, as did loyal friends from the North Mississippi Delta: Bard Selden, Eugene Woods, and Ashley Harris. I am deeply grateful to them and to my father, James McWillie, and sister, Betty, as well as to my late mother, Elizabeth, for their patience and faith throughout the years. My parents, James and Elizabeth, also shared friendships with some of the Memphis practitioners who came into our lives through this research (Bishop Washington Harris, Pastor Marvin White, Eddie Williamson) and helped me to

stay in touch with them after I moved to Georgia. I must also thank and pay tribute to my undergraduate art teachers at the University of Memphis, William Christenberry and Steve Langdon, for emphasizing the untapped visual legacy of the American South, where art was somehow, at the same time, nowhere and everywhere, and also to Joni Mabe, Judy Long, and Jill Read for devoting so much of their energy and time to this same discovery and for sharing their resources with me. They dispelled stereotypes of regional inferiority and instilled confidence that "art," when conceived as an inclusive rather than an exclusive term, can be a potent instrument of spiritual liberation.

Grey Gundaker

Without the guidance of these consultants and practitioners, this project would have been impossible: Edward Houston, Leon Hardin, Bennie Lusane, Marie Taylor, Ruby Gilmore, Victor Melancon, Johnson Smith, Mary Ethel Smith, Gyp Packnett, Marie Taylor, Estelle Hamler, Olivia Humphrey, Willie Deloatch, Jackie Jones, Sam Hogue, Robert "Boot Roots" Montgomery, Henry Craig, Bishop Washington Harris, Sister Shirley Dailey, and, from an earlier time, Edna Dorsey Jones, Flossie Bailey, and Ulysses S. Jones. An early conversation with Alan Goodheart prompted me to pay more attention to landscape design. Dan Rose shared his humor and expertise at a crucial moment in the beginning of this project and a field adventure or two later on. Gladys-Marie Fry has shared her home and knowledge generously. I warmly thank Mei Mei Sanford for introducing me to her friend LaVerne Spurlock, who contributed her valuable insights; for joining me in meeting the very generous Delores Smith of the Seventh Church of God; and for giving me so much to look forward to.

Special thanks also go to the women and men who donated their time and recollections to the Federal Writers' Project interviews during the 1930s. The resulting material has been used extensively to write histories of slavery. Ironically, this has also had the consequence of marginalizing these elders from the twentieth century and the important events to which they also contributed. Most of the Federal Writers' Project interviews were conducted a scant twelve or thirteen years before Judith and I were born, in places where we and our parents grew up, places that changed little before the 1970s. Thus, the interviews are not just relevant; they are an invaluable legacy of the great-grandparents and grandparents of the current generations of yard makers.

Over the years this project has received support from my mother, Martha Jones Gundaker, who has provided a vast amount of information as well as emotional and financial sustenance; from the Yale University chapter of Sigma Xi, the Scientific Research Society, and the Williams Fund of the Yale Department of Anthropology, for fieldwork in the summers of 1987 and 1988; and from the estate of Nell D. Turner, for field research from 1989 to 1992. Donald J. Cosentino's encouragement when I submitted a paper on African American yards to *African Arts* in 1989 during the dark days of graduate school was much appreciated. A fellowship in landscape studies in 1992–93 at the Dumbarton Oaks Research Library and Collection in Washington, D.C., offered a chance to compare the histories of European and American landscape traditions, and subsequent opportunities to present material in roundtables and symposia have occasioned many helpful criticisms. I thank the Dumbarton Oaks staff and fellows: Joachim Wolschke-Buhlman, Annie Thatcher, Michel Conan, the late Heidi Fogel, Tim Davis, Eric de Jong, Ann Helmreich, and,

especially, Dirk Krausmuller, who has joined my travels and provided vital encouragement for the past decade. From 1993 through 1995, a postdoctoral fellowship at the Commonwealth Center for the Study of American Culture, directed by Chandos Michael Brown, provided time to edit a collection of papers on African American landscapes that lay groundwork for parts of the present volume; thanks also go to my fellow fellows Patrick Hagopian, Sharon Ghamari-Tabrisi, and George Henderson. I was fortunate to spend the 1997–98 academic year at the Center for the Study of American Religion at Princeton University, where I wrote, searched for documentation, and benefited from the comments and scholarship of Albert Raboteau, Robert Wuthnow, Anita Kline, Cynthia Eller, Ann Taves, Brad Verter, and other members of the Religion in American Culture Workshop. A summer research grant from the College of William & Mary in 1999 made possible additional fieldwork; thanks go to Provost Gillian Cell. A Fulbright lecturing and research fellowship to the University of Haifa, Israel, for the 2000–2001 school year at the invitation of Mechal Sobel, enabled me to write the first draft of chapters 1 through 6. I appreciate the use of the university's excellent library and the comments, encouragement, and hospitality of Mechal Sobel, Svi Sobel, and Maya Talmon-Chvacier, as well as conversations in Israel with Fu-Kiau Kia Bunseki, perhaps the world's greatest expert on the philosophy implicit in these yards. Participation in the African Americans and the Bible project has opened many new perspectives; I extend thanks to Vincent Wimbush, the project's director, Velma Love, John Jackson, and many others. Earl P. Scott and George Henderson of the University of Minnesota's Department of Geography provided a forum for discussion of chapter 2. Many ideas and distractions came from colleagues in the American Studies Program and Department of Anthropology at the College of William & Mary: Jean Brown, David Aday, Chandos Michael Brown, Bob Gross, Kimberley Phillips, Arthur Knight, Rich Lowry, Maureen Fitzgerald, Leisa Meyer, Lynn Weiss, Alan Wallach, Ywone Edwards-Ingram, Mary Voigt, Bill Fisher, Brad Weiss, and Michael Blakey. Carrie Albinger, with help from Hüsnü Kavisbudak, kept the homefront functioning for the final two years of writing. Many, many thanks to long-haul supporters Susan Sgorbati, Gladys Myers, and Esther Lutto.

My outlook on the world has been shaped (perhaps not enough) by four extraordinary teachers. At Teachers College, Columbia University, in the early 1980s and on to the present, Paul Byers and Ray McDermott showed me how to be an anthropologist in and of life close to home. John F. Szwed and Robert Farris Thompson have been knowledgeable and generous beyond all imagining during my studies at Yale University and thereafter; I will never be able to thank them enough. My debt to them is clear throughout this book, and my contributions to it rest squarely on the shoulders of their encyclopedic research.

Grey Gundaker and Judith McWillie

Finally, we both thank the University of Georgia Center for Humanities and Arts, under the direction of Betty Jean Craige, for providing funds for color reproduction through its Book Subvention Program; Judith Wilson, Allen Roberts, John F. Szwed, and Faye V. Harrison, who read the proposal for this book and shared their comments; Erica Doss and two anonymous readers, who commented on the whole manuscript; and our editors, Joyce Harrison, Scot Danforth, Gene Adair, and Stan Ivester, who have seen it through to publication.

Estelle Hamler, Olivia Humphrey, and Sam Hogue

Chattanooga, Tennessee

1987–1997

Estelle Hamler's Yard

To drive east through Chattanooga's Alton Park neighborhood early on a spring morning before the leaves are full is to risk blindness from the sun streaming over the ridge ahead. Add amplifying flashes of light from a lilac bush in one of the yards, and it is best to pull over.[1]

At the curb beside a vacant lot, looking across the street, everything has been made white or bright: the painted trunks of the crepe myrtles, the assortment of furniture and utensils concentrated in the center of the space, the rock borders, the lilac and iris blossoms, and the fence made from the iron headboards and footboards of beds partly enclosing the flower bed and chairs (fig. I.2). Brightest of all are the spotlight bulbs wired to the lilac bush. Because of the mirrored surface at the back of each bulb, they beam stronger from reflected sunlight than they ever did from an electric current.

A gray gravel driveway divides the side yard from the main area in front of the house. The bungalow design of the house is similar to that of the rest of the houses on the street. However, in the seventy-odd years since the houses were built, each has developed its own character. Estelle Hamler's house has a high

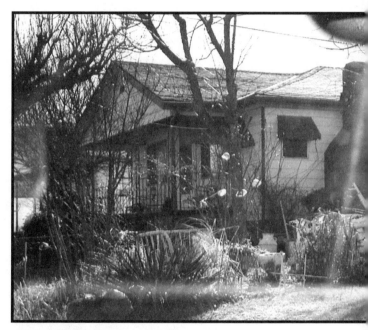

Top right: Fig. I.1

View of Estelle Hamler's yard from street. Chattanooga, Tennessee, 1992. Photograph by Grey Gundaker.

Right: Fig. I.2

"My old junk . . . These are antiques and things that people used a long tine ago in past generations. I put them all together over there from my mother's time and the time before that."
—Estelle Hamler, 1992. Photograph by Grey Gundaker.

front porch with brick pillars, approached by steps between staggered levels of brick capped with concrete slabs. On these, on both sides, Mrs. Hamler has placed large chunks of melted, crystalline glass that refract speckles of light across the steps on sunny days.

A fence of thin wire encloses the main yard. More ornamental than protective, it has open mesh that permits passersby to enjoy the burgeoning, almost muscular plant life within. In summer the foliage is tropical, fed with a solution Mrs. Hamler calls her plants' "tonic," made from water, Miracle Gro, and a few secret ingredients. Each plant occupies its own carefully tended space. Mrs. Hamler comments that plants are like people, especially children. She says that they "deserve to be raised right" and "when other people see you doing that, they'll think about it." Nodding at the elementary school playground across the street, she adds, "Maybe they'll do it too."

Mrs. Hamler clearly sees her yard as communicating valuable information. Her plants are role models, and the red-painted tires along the eastern boundary show that "we're rolling; folks in this house are rolling." Toy trucks that belonged to her son head up a tree trunk: "He's moved on up." Mrs. Hamler has suspended a guitar from a branch: "The wind plays it."

Mr. and Mrs. Hamler are now in their seventies. Both are retired, he from a textile plant, she from home-care nursing. Mr. Hamler has become quite infirm but still serves his Baptist church, where he is an elder and his wife is a church mother. When the weather is warm they spend part of each day on the front porch conversing with visitors, old and young. Every few years someone from the local news media rediscovers their yard, especially in iris season. The resulting pictures in the paper or on TV draw a week's worth of heavy traffic to the quiet street as admirers gaze their fill.

Olivia Humphrey's Yard

In the St. Elmo neighborhood, a mile from Estelle Hamler's, Olivia Humphrey moves favored objects in and out of her "arrangements." Over time, she carries these groupings from one side of the yard to another.

The yard is made to change. During the 1980s two swing-set frames draped with garden hose, resembling large gateways, filled most of it. Chairs, dishes, and bottles, oblong coffin-shaped boxes (with white, child-sized shoes lining their tops), and a covered barbeque grill paralleled the street. A few years later, the swing frames reappeared in the side yard, the larger one about halfway down the depth of the lot, the smaller one centered above a tree

Fig. I.3
Objects set aside to honor past generations.
Olivia Humphrey's yard, Chattanooga, Tennessee, 1990.
Photograph by Grey Gundaker.

stump. Beneath the frame Mrs. Humphrey had arranged a large metal bowl made from the wheel rim of a truck and filled it with white china cups and plates, glass jars, and water. From the top of the frame she suspended a black iron cooking pot that had belonged to her mother (fig. I.3).

Around the outside of the metal bowl, she placed inverted white vases and pots, topped with the same small white shoes that used to rest on the barbecue lid. She explains that to keep up the arrangement, she periodically blackened the pot and sprinkled white lime powder around it in a circle "to keep bad things out." Lime also makes a wide white stripe around the perimeter of the property, defending it against insects and rodents. At the corner she cultivates an enormous yellow chrysanthemum almost as tall as she is. When she sees the camera pointing toward her, she says, "Take a picture of me working. I'm a preacher's wife. I'm always working." This certainly seems to be true because, in addition to time spent in the yard, she makes time to visit the housebound and infirm, to ferry invalids to the doctor, and to care for her grandchildren, nieces, nephews, and young neighbors after school.

In front of the house, Mrs. Humphrey has designed a newer area (fig. I.4) whose crisper,

Fig. I.4
Formal garden in Olivia Humphrey's yard. Chattanooga, Tennessee, 1990.
Photograph by Grey Gundaker.

Fig. I.5
Front entrance to
Olivia Humphrey's house,
1992. Photograph by
Grey Gundaker.

brighter whiteness and formality contrast dramatically with the more varicolored, old, and asymmetrical objects on the other side of the drive. An ornate white cement birdbath in the form of a child pouring water into a shell sets the tone, along with a new lawn chair. White gravel marks the area off from the grass in the rest of the front yard and the older gray gravel of the driveway. Behind a wire fence dividing backyard from front, a line of tricycles and bicycles range along the south wall of the house—another "rolling" house.

Mrs. Humphrey enjoys collecting. In the backyard she arranges trunks of toys to entertain visiting children. Inside she arranges family photos, dolls, and china on shelving and on the walls of the living room. A hallway leads to a huge collection of hats in all shapes and sizes. Her front window displays animals and toys looking out toward the street from narrow shelves. Chrome and aluminum coffee pots, small appliances, and lamps line the balcony-like front porch railings (fig. I.5).

The light bulb over the front door glows night and day: the Humphrey household lets its "little light shine." For a while a pair of Pastor Humphrey's work boots stood on a little table beside the steps to the front door. Mrs. Humphrey made no comment about this, but an acquaintance from Trinidad offered an instructive observation: "If somebody did that where I'm from, especially a preacher or somebody like that, they'd be saying, 'See, I walk the walk; I wear the shoe.' In other words, 'I've been there, I'll understand—you can come talk to me.' So when somebody puts shoes by the door they show they can teach people."[2]

Sam Hogue's Yard

At first Sam Hogue is invisible among the lush leaves of one of a pair of pollarded maples in his front yard. Then a leg appears

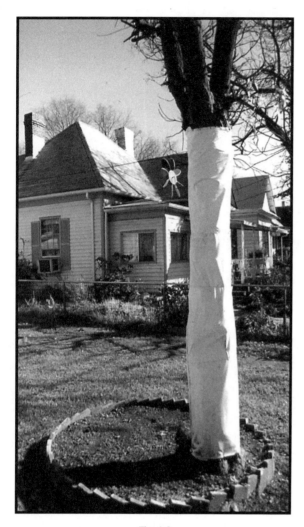

Fig. I.6
Tree wrapped with white plastic in Sam Hogue's yard.
Chattanooga, Tennessee, 1989. Photograph by Grey Gundaker.

stand like sentinels on either side of the walkway to the Hogue home, which is covered in green indoor-outdoor carpeting and edged with bricks set into the ground at a slant.

The trunks of the trees wear white plastic wrappings reminiscent of the old custom of whitewashing tree trunks (fig. I.6). However, the wrappings shine brighter and stay cleaner than whitewash because Mr. Hogue scrubs them often. As he explained, they serve the same purpose as the lime in whitewash: they keep insects from nesting in the bark. "I planted them when I moved here forty years ago," he says. "I do for them and they do for me. We keep each other going."

Mr. Hogue kept going for a few more years after speaking those words, but not, apparently, without effort. He worked on his house and yard as he had worked throughout his career as a factory foreman, diligently and without missing a single day on the job, year in, year out. He was a tall, imposing man with elegant manners. A broad sweep of his arm invited guests to take a chair in the living room, where the high,

Fig. I.7
Sam Hogue. Chattanooga, Tennessee, 1990.
Photograph by Grey Gundaker.

at the top of an oddly angled aluminum ladder leaning against the tree, followed by an arm holding a pruning saw. The ground around the tree is littered with branches. Cutting back the trees is an annual event and not the time to try to carry on a conversation. "I try to talk to you while I'm doing this," he says, "and the Lord may decide to try to teach me how to fly, and I don't want to learn that lesson right now. Come back tomorrow." The two trees

mirrored mantelpiece framed tiers of family photographs interspersed with cut-out pictures of hybrid tea roses: "That's my son. He died seven years ago. My wife. She's been gone four years. My little girl, she passed last spring. God took them all." The photographs showed not just images of people posed forever in the past but also an imagined future that Mr. Hogue had worked towards as a husband and father. When his family predeceased him, with not even one grandchild left behind to keep the family going, his newest labor, although he

Right, Fig.I.8
"Egyptian Snake," painted plaster ornament by Sam Hogue attached to a tree in his yard. Chattanooga, Tennessee, 1990. Photograph by Grey Gundaker.

Fig. I.9
Backyard memorial for deceased wife in Sam Hogue's yard. Chattanooga, Tennessee, 1990. Photograph by Grey Gundaker.

never said so outright, became finding reasons to keep on living.

He made whirligigs and sun catchers from bicycle wheels and pop bottles (see portfolio II, fig. 11). He grew roses. He cast plaster statuary such as an "Egyptian" snake that he painted silver, red, and black, and attached to a tree (fig. I.8). He meticulously colored each minute rose blossom with red and green enamel and did the same with the bud and leaf motifs cast into

the black metal filigree that edged his front porch: "That was fun. My wife would never let me do that." To commemorate her life, he moved all the garden ornaments that had previously been spread around the yard into a single circular enclosure around a fruit tree in the backyard, arranged them concentrically, and painted them white (fig. I.9). "Sure," he said, "there are women around who want to move on in here but I don't want anybody after her."

Chapter 1

Resources and Contexts

All the way down through the Bible it says, "These signs shall follow you." And some people can read signs so well until they can see beyond, and look at people and see things about them.

—Bessie Jones, 1983

Many kinds of work go on in yards, some commonplace, some startling, some aimed at survival, some at pleasure, and some, occasionally, at retribution. Practitioners themselves speak variously of "doing something I enjoy," "knowing how to do things right," "decorating," "caretaking," and "showing God's love."[1] We wish for their voices to be heard and for readers to work out their own associations and responses to what these individuals communicate both visually and verbally. Therefore, this book alternates between conventional chapters that focus on the philosophical and historical contexts of African American yard work and portfolios that contain narratives, photographs, and personal remembrances of some of the practitioners we have known. Our research for this book consisted of interviews and documentation of approximately two hundred yards over the past twenty years, and it especially depends on long-term relationships with approximately thirty practitioners, many of whom find places in these pages.

We chose to begin with descriptions of the yards of Estelle Hamler, Olivia Humphrey, and Sam Hogue because these are the kinds of places one might casually encounter anywhere in the United States where African Americans have built and sustained communities. These individuals contribute to an open network of ideas, achievements, and material signs whose generative power comes from the ways in which they knit things and places together, acting according to their knowledge of land, plants, the cosmos, and the responsibilities of human beings to each other. Although this network has a long history of considerable cultural distinction, it does not have nor need a singular unifying name. Over the years researchers have discussed "yard art," "vernacular landscape design," "folk art environments," "dressed yards," "yard shows," "spirit gardens," and "material prayer."[2] All of these terms offer frames of reference that can help us to organize and interpret what we see. However, they can also reify some aspects of the subject at the expense of others, masking the spontaneity and complexity of the processes that link yards such as Estelle Hamler's, Olivia

Humphrey's, and Sam Hogue's to others more spatially and temporally removed from them. So we proceed cautiously, hoping to present information in ways that encourage readers to explore further on their own.

Our historical research focuses primarily on the mid-nineteenth through the mid-twentieth centuries, a period that roughly coincides with the lifetimes of the grandparents and parents of present-day practitioners. We use the term "yard" as a shorthand description of the spaces central to our subject, and "work" for the many activities that shape these spaces. The practitioners we have interviewed—mainly in the southeastern United States, but also in the Northeast and the anglophone Caribbean— use these terms often and charge them with a range of simultaneous meanings. Rather than being merely referential, polysemous words such as "yard" and "work" also have performative and interactive dimensions. They can refer straightforwardly to places and physical labor, but because many testimonies are couched in terms of Christian faith and community well-being, they can also imply spiritual invocation, artistic creation, healing, and protection. What matters, regardless of its scale, is that yard work often involves more than adornment: it is a means of mapping relations among matter, spirit, and human action onto the material world.

Yard workers draw on European, African, and American Indian resources and contribute to a lexicon of material signs that have recurred with striking consistency in the sites we have studied. For this book we chose to focus on yards whose makers address broad goals: service to God, justice on earth, and community improvement, in addition to decoration and gardening. The impulse to make the world better is pervasive among these individuals. Even ordinary activities such as cutting grass and planting flowers work toward moral instruction and community building that, at first, might not seem to fall within the purview of yard work at all. Yet we came to see that this curing-commemorating-teaching-protecting-celebrating-and-beautifying network has a remarkable coherence in which art, healing, cosmology, and politics openly converge. This book is therefore both a record of our learning process and a tribute to people whose lives and ideas deserve to be more widely recognized.

Some of the sites we discuss have been previously approached as idiosyncratic folk/outsider environments detached from culture; others, as repositories of dying traditions that preservationists wish to record before it is too late.[3] We contend that while these sites are intensely personal accomplishments, they are not isolated from one another or from culture, nor are they reducible to the traditional resources used to make them. Rather, recurring themes and material signs link works that may not call much attention to themselves to those that do. What demands more recognition is that these works are, above all, directives for living that also aim a forceful critique at whoever has eyes to see.

As a form of moral instruction, yard work shares material and philosophical components with communicative and therapeutic sites around the world.[4] Thus yard makers draw on a residential landscape in the United States that includes allusions to the aristocratic vistas, formal gardens, and statuary of European estates, with their implication of power vested in land ownership, and to an ancestral past linked to the culture of ancient Greece and to local spirits of place such as trolls and gnomes. They also

draw on the great diversity and regional specificity of African cultures, where similar practices regarding healing, protection, and activation of materials recur from Senegambia to southern Africa, changing and adapting to new circumstances there as well as in the Americas. Some of these very widespread practices in yard work include color coding, such as associating white and silver with spiritual powers,[5] red and blue (depending on the region) with protective energy and sight respectively, and black or dark blue with deep knowledge; separating land into wild and cultivated zones (chap. 3); balance and omni-directional mastery, having the personal security and maturity to command movement in all directions (chap. 6);[6] use of medicines, herbs, gris-gris (the Senegambian term),[7] and powders (chaps. 2, 4); stationing social and spiritual buffers and filters at entrances to communities, residences, and the body (chap. 4); using recursive patterns that display a spectrum of states from order to disorder;[8] and honoring the ancestors as still-active members of the community (chap. 6). For example, on both sides of the Atlantic, relatives are remembered through materials arranged to instantiate praise names or the qualities they communicate. Thus, the big bowl and pot belonging to her mother that Mrs. Humphrey (portfolio I) arranged in her yard parallels an Akan dirge, "Grandmother, the big cooking pot that entertains strangers,"[9] just as it accords with the African American custom (mainly before 1970) of placing a large water pitcher on the grave of an important church mother to show, as Johnson Smith put it, that "she pours out love" to other people.[10]

Because most African American yard workers in the United States have West and Central African ancestors, as well as European and American Indian ones, and since they have maintained ideas and practices from these traditions in their families, the study of their work requires a global perspective. This became feasible only after Robert Farris Thompson's publications began appearing in the late 1960s. In *The Four Moments of the Sun: Kongo Art in Two Worlds* (1981), Thompson focused specifically on the influence of Kongo belief and material culture on African American cemetery decoration and traditional healing in the American South.

On both sides of the Atlantic, modes of access, training, and knowledge employ what Thompson has called "admonition through signs," using substances and natural phenomena to instruct people about how to behave. Thompson has also identified principles that organize yard shows toward these purposes, including *enclosure, motion, figuration,* and *enthronement,* all themes that recur throughout this book.[11] For him, as well as for the practitioners we have interviewed, yard work, like art, is, or can be at its best, a spiritual medium, rather than merely a form of "expression" or accommodation for its own sake. Thompson's discussion of the Kentucky yard worker Henry Dorsey and the visionary artist James Hampton (see Thompson's coda in the book *Flash of the Spirit*) was therefore a watershed. It clearly established that the network of meaning and practice that encompasses religion, healing, conjure, and aspects of yard work in North America draws from resources that may be geographically distant but nevertheless culturally cognate in their approach to the relationship of visible materials to invisible powers.[12] Certainly other cultural resources from Africa are active in North America, but Thompson's work on Kongo remains the most extensive

and detailed to date and its importance is underscored by the demographics of the slave trade: at least a quarter of the Africans transported to North America came from West Central Africa.[13]

More specifically, Thompson has described what he aptly calls "objects that pun on verbs," citing the dynamics of the Kongo nkisi complex.[14] Often mistaken for statuary alone, the network of objects, medicinal substances, and modes of activation attending minkisi comprise one of the major transatlantic currents that interweaves with Christianity in North America and generates the material signs that structure yard work both visually and philosophically. The nkisi complex provides a working paradigm for approaching the organizational dynamics of yard work even though American practitioners' actions and motives often vary considerably from their African forebears.[15] Thompson's words quoted at the beginning of chapter 2 convey a sense of this purposeful energy and list, in a matter-of-fact way, many of the objects most frequently used and reused in American yards—light bulbs, hubcaps, old chairs and tires, various transmitters of flash, containers of energy, pedestals of power and generosity—blending (sometimes invisibly) into the ordinary background of everyday life from which they come and to which they give special meaning.

We are not interested in transatlantic parallels and resources as ends in themselves or as singular items of historical interest ("Africanisms"). We view the practices involved in yard work as quintessentially American in their ethnic and temporal diversity. However, we also recognize that African contributions are among the most overlooked in accounts of American history and character. Rather than the design or

technique of specific handmade items, it is the potency of act and sign in accounts of West and Central African religious practice that most vividly corresponds to yard work. Thus, interpreting yards, like making them, is an active process that in many respects parallels Charles Piot's summary of the ritual cycle of Kabre of northern Togo:

> It is . . . largely through the visual and the nonverbal, through actions of display and mimesis—the display and jettisoning of broken pots, the plugging and unplugging of holes, the cutting of chickens, the movement in and out of homesteads, the filling of calabashes, the tying of tufts of grass, the insertion of yams into ritual mounds and sorghum into metaphorical granaries—that Kabre coax their spirits and magically affect the world in which they live. In doing so, they employ a symbolic code that "speaks" not so much through words as through objects and actions.[16]

This is precisely what we argue that certain yard workers are doing: finding in materials and actions the ingredients of a metalanguage not reducible to speech or writing with which to comment on the human condition and take responsibility for directing its course.

In addition to the resources Africans brought with them to North America, the contributions of African American Christianity give yard workers an extraordinarily rich heritage to build upon.[17] Most of the individuals we interviewed for this book are evangelical Protestants, members of Baptist, Methodist, and Pentecostal denominations in approximately that order according to their numbers. Their religious commitment profoundly affects the nature of their practice. More than a few of them have been given

titles such as "Mother," "Reverend," "Professor," and "Preacher" by their neighbors in recognition of their superior knowledge and communication skills even when they do not serve in these roles officially.

Especially important for yards are varied forms of engagement with the Bible that include reading and quoting, but also using the physical book itself as an instrument of healing and a material sign.[18] While studying the Bible approaches the book historically as God's Word, studying *on* the Bible also means taking to heart biblical messages and making concrete applications of biblically couched concepts and philosophy. In this way the imagery and moral force of the Bible inform the mundane events, crises, and celebrations of everyday life. This comes through clearly

in the inscribed panels that Mary Tillman Smith (1904–1995) painted and attached to her outbuildings and fence in Hazlehurst Mississippi (fig. 1.1). The panels read:

MY NAME IS SOMEONE THE LORD FOR ME. HE NO

I LOVE THE NAME OF THE LORD

I LOVE GOD, PEOPLES. THE LORD NO ME

THE LORD MY HART

I AM FOR GOOD NONE FOR BAID

HEAR I AM DON'T YOU SEE ME

A nineteenth-century description from Barbados could apply equally well to Mrs. Smith and many other African American yard workers: "[T]he Scriptures never failed him. They tinged his every-day conversation; they were essential in his fierce denunciations of his wrongs; he used them freely and

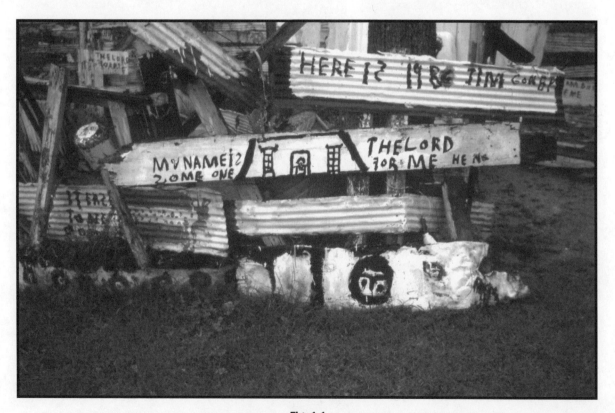

Fig. 1.1

Hand-lettered signs in Mary Tillman Smith's yard. Hazlehurst, Mississippi, 1986. Photograph by Judith McWillie.

aptly for illustration; and he pointed his wit and assisted his satire with them."[19]

The Bible explains happenings and can be explained by them. It also offers myriad ways to make sense of adversity and knit personal concerns into the structures of a grander design. Biblical imagery and phrasing "translates" easily into material form: "walk the walk," "hair like lamb's wool," "feet like polished brass," "feet of clay," "tower of Babel," "carry the cross to wear the crown," "Jacob's ladder," and so forth.

Perhaps the best known allusion to the biblical equivalent of "a yard" was referenced by a formerly enslaved man who crossed the river from Kentucky to live in Ohio: "Colored preachers use to come to the plantation and they would read the Bible to us. I remember one special passage preachers read an' I never understood it til I cross the river at Buffington Island. It was, 'But they shall sit every man under his own vine and fig tree; and none shall make them afraid; for the mouth of the Lord of Hosts hath spoken it.' Micah 4:4. Den I knows it is de fulfillment of that promise; I would soon be under my own vine and fig tree and have no fear of being sold to a mean marse."[20]

The famous African American preacher John Jasper (1820–1900) of Richmond, Virginia, preached a funeral sermon visualizing the homes and yards of those he would see in Heaven: ". . . an' David . . . I'd like to see his house; an Paul, de mighty scholar . . . I want to see his mansion, an all of 'em. Den I would cut roun' to de back streets an look for de little home whar my Savior set my mother up to housekeepin' when she got thar. I spec to know de house by de roses in de yard and de vine on de porch."[21] In a very real sense an African American homeowner's yard is his or her Promised Land.

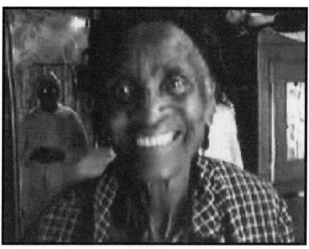

Fig. 1..2
Mary Tillman Smith. Hazelhurst, Mississippi, 1986.
Video still by Judith McWillie.

Yet, while some of the practitioners we have interviewed use items in their yards that are associated with biblical references or African precedents, they do not treat them as relics frozen in time. Change and innovation are fundamental to the ethos of yard work. In a yard on the eastern shore of Virginia, for example, a chair made of white plastic replaced an old one made of wood but retained the same position in a constellation of other objects that included a tree, a wheel, an antique chain, red reflectors, and a closed container. These, too, will eventually be replaced by more contemporary counterparts, yet as long as the basic configuration of wheel-tree-antique-seat-container remains, the chair retains its identity as an implied throne, a special kind of seat, looking out upon a busy highway and proclaiming to passersby a place in Heaven for all who can see and believe.

When asked to interpret the same set of objects in a yard over time, many practitioners

improvise new meanings for different occasions, tailoring their instruction to specific visitors. As Pastor Marvin White of the Saint Paul Spiritual Temple in Memphis, Tennessee, explained, "Some things can only be understood through the eyes of faith."[22] The material signs in the lexicon that makes up portfolio II have proven to be more than adequate to this task since they address larger cosmological contingencies as well as interfaces between home ground and the world at large. Because the objects involved are familiar but provocatively absent from their usual contexts, they introduce "double sight" into the banal world of "trash" and consumer culture. This type of generative ambiguity not only contributes to the longevity and efficacy of these signs, it gives visitors a hint of what it must have been like for African Americans to live in a social milieu that denied them voice and authority, making disguised material signs a matter of survival.

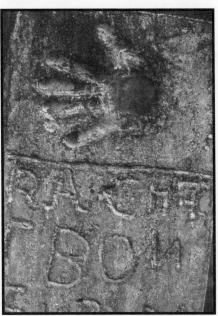

Fig. 1.3

Monument to Rachel Bowens (mirror in hand print) by Cyrus Bowens, c. 1932. Sunbury, Georgia, 1984. Photograph by Judith McWillie.

In the days of segregation and Jim Crow, the material signs that were eventually imported into yards were most often found in African American cemeteries. Perhaps the most celebrated example was the cemetery of the Sunbury Missionary Baptist Church in the Georgia tidewater region between Savannah and Brunswick. In a section of the cemetery reserved for the Bowens family, a mirror flashed from the palm of an impressed hand-print on an upright concrete slab (fig. 1.3).

An automobile headlight capped another marker with shells scattered at its base. Ivan Tompkins's photographs from the 1930s reveal the same monuments when they were new, along with another marked by a porcelain commode. A metal pipe resembling a tree served as an armature for bottles attached to extended limbs. These works, including three large-scale wooden figures that were reportedly stolen sometime in the 1950s, were created by Cyrus "Bub-One" Bowens, a deacon of the church. In 1987, at the age of ninety-eight, Eddie Bowens, Cyrus's nephew, recalled how his uncle worked on the family grave enclosure and stationed a hand-lettered wooden sign at the entrance, listing the names of both ancestors and progeny. He made the hand-print marker for his wife, Rachel, who was not yet deceased, and others for the rest of the family, including his father, Alec. Later, Bowens's children would mark his own grave by placing a dolphin skull on a cross and painting it silver.[23] In the late 1980s, when the cemetery was renovated, the surviving remnants of these monuments were transferred to a local history museum. The lost wooden sculptures, photographed by Malcolm and Muriel Bell in 1939 and by Orrin Sage Wightman for his book *Early Days of Coastal Georgia,* were made from found wood selected for its resemblances to birds and serpents (figs. 1.5, 1.6, 1.7). When shown a copy

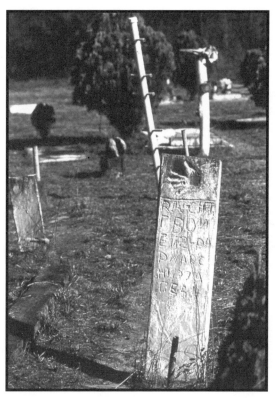

Above: Fig. 1.4
Foreground: Rachel Bowens's monument—
handmade by Cyrus Bowens, c. 1935—in the
Sunbury Missionary Baptist Church cemetery.
Background: Cross with dolphin skull marking
Cyrus Bowens's grave. Sunbury, Georgia, 1984.
Photograph by Judith McWillie.

Top right: Fig. 1.5
Monument in Bowens family grave
enclosure. Sunbury Missionary Baptist Church,
Sunbury, Georgia, c. 1935.
Photograph by Orrin Sage Wightman,
courtesy of the Georgia Historical Society,
Savannah, Georgia.

Right: Fig. 1.6
Bowens family graves, with monuments by
Cyrus Bowens. Sunbury Missionary Baptist
Church, Sunbury, Georgia, c. 1935.
Photograph by Orrin Sage Wightman,
courtesy of the Georgia Historical Society,
Savannah, Georgia.

Top left: Fig. 1.7

Bowens family monuments, made by Cyrus Bowens from found wood in about 1935. Sunbury Missionary Baptist Church, Sunbury, Georgia, 1939. Photograph by Malcolm and Muriel Bell..

Above: Fig. 1.8

Eddie Bowens. Sunbury, Georgia, 1984. Photograph by Judith McWillie.

Left: Fig. 1.9

Portrait of Cyrus Bowens, c. 1940. Courtesy of his daughter, Eva Mae Bowens, Sunbury, Georgia. Photographer unknown.

Fig. 1.10
"King of Africa" by Bessie Harvey: wood, beads, and paint. Alcoa, Tennessee, 1988. Photograph by Judith McWillie.

of the Bell photograph in 1987, Eddie Bowens remembered:

> This is absolutely a tree that was bended in the time of the big freeze. All them came out of the woods and he hued them out. . . . And he put these rods all around [metal pipes in the ground]. They used to go out on the beach at Catherine's Island. They was out at an old wrecked ship. That was where he

got that rod. He put that rod in the cemetery to dress it. He liked to make an image of different things and put them in the cemetery. People would come by and they loved to see.[24]

The porcelain commode, the mirrors, shells, and rods, the anthropomorphic wood, all had their origins in what Eddie Bowens, described as "the old way that's not in the Bible."[25] In 1987, Eva Mae Bowens, remembered how her father "did all them things":

> The little man he had with a pipe in his mouth—he made all of them. Some of them before I was born. He always said, "You don't be a preacher till God send you to preach." He got up to go to preach at Riceboro Crossroads and at the Praise House and right up to Sunbury. He was preaching, you know, "God is up there. God is a big-eyed God. He sits in one place but he can see all over the world." Sometimes the people would start laughing, but one of his nieces would get up and say, "One of these days he's gonna preach your funeral!"[26]

In recent decades, the delicate balance between transatlantic modes of address that include "admonition through signs" and biblically informed exegeses and witness has, at times, proved challenging for some practitioners. Bessie Harvey (1929–1994), of Alcoa, Tennessee, a renowned sculptor, recalled how her childhood discovery of roots and trees that resembled faces startled some of her associates, even as her mother encouraged her to continue to work with them:

> Some think it's evil. People accused me of voodoo. They say you're "sorcery" or "witchcraft," or you work evil powers. I don't know why they believe this to be.

Fig. 1.11
Home of Henry Luke Faust.
Athens, Georgia, 2002.
Photograph by Judith
McWillie.

I think that's backwards. I think the world's been taught backwards. My mother said, "Keep that thing because one of these days you're gonna find out what goes with it." And I really believe she knew what was to follow. All through life I have thought that the trees was praising God. I talk to the trees. All the roots are little people. . . . I'm giving all praise and thanks unto God. I'm able, through God, to see the faces and bring them out where the world can see them. That should say something! We've all got to be together to bring out Him—to make it the Whole. They call it "art," but what is "art"? That's a big question and I'd really like to hear it answered, "Our father who 'art' in Heaven." Where the world got the name for "art," I can't say. But, yesterday touched me in today and made me well.[27]

Gladys Faust also struggled with a habit that her husband, Henry Luke, had of using cast-off objects and secondhand lattice fenc-ing to decorate the yard of their small shot-gun house in Athens, Georgia (fig. 1.11). So did Sue Willie Lathern when her husband, Wess, built a large scale assemblage in their back yard in Oakman, Alabama (see portfolio III and plate 8). Their ambivalence is under-standable since the paradigmatic cemetery decorations that spawned yard work are, as Eddie Bowens remarked, part of "the old way that's not in the Bible." But in most cases we have found that family or neighbors' objections to conspicuous yard displays are primarily aesthetic or else associated with questionable uses of time and energy.

Bessie Harvey's reference to voodoo, however, exposes genuine sensitivities and resistances to the dimensions of yard work that some consider unchristian. An extreme example of this involves the Saint Paul Spiritual Temple community of Memphis, Tennessee. The temple's founder, Bishop Washington "Doc" Harris, renounced his worldly pursuits during the 1950s and purchased several acres of rural wetlands

south of the city. He built a compound for his family and established the temple as a church and a center of traditional medicine. For over forty years, under Bishop Harris's direction, the temple community also created monuments, tableaus, and wooden assemblages for display in the buildings on their property and in their yard. Designed as instruments of teaching, "The Degrees of God,"[28] as Bishop Harris called them, were off-limits to unexpected visitors.

In the early 1960s, attracted by the brightly colored wooden structures near the compound's perimeter, local newspaper reporters appropriated the temple as an urban legend and named it "Voodoo Village." Bishop Harris tried, without success, to persuade them to focus on the temple's actual purpose. In 1961 he told a staff writer for the *Memphis Press Scimitar,* "We have an eternal organization here. A church. Our temple is the most beautiful place in the world. All these things have a meaning. They are symbols of God."[29] In a short feature article, the reporter described what he observed and heard during his visit:

> A canvas awning was pulled back, and he [Bishop Harris] motioned into the temple. The floor, walls, and ceiling were covered with colorful pieces of satin. The little building was filled with other symbols and dolls, illuminated by tiny electric lights.
>
> "It took me four years to make this. Sometimes I would go in in the morning and not come out until the next. How did I do it? By the power of God."[30]

As the legend of "Voodoo Village" spread across the city and beyond, Bishop Harris and his family endured frequent harassment from thrill-seeking teenagers, hostile religious

zealots, and Halloween pranksters. This account from the *Memphis Commercial Appeal* describes one incident in 1965:

> A sheriff's deputy arrested three youths early yesterday after a cursing and shooting incident near "Voodoo Village" in southwest Shelby County. The deputy was on still-watch . . . when the youths drove up and started cursing. A gun was fired and the youths attempted to flee before the deputy stopped them and placed them under arrest. The name "Voodoo Village" has been given to the area because of figures and symbols in the yard of Wash Harris. . . . He calls his home St. Paul's Spiritual Temple.[31]

Nineteen years later, in 1984, little had changed. Another reporter from the *Commercial Appeal* condescendingly described the temple as viewed from an adjacent road:

> At first glance, much of it looks like the exaggerated objects in a children's playground—a candle eight feet tall, a set of wheels connected by a crosscut saw, a giant figure with outstretched arms, fans, spindles, spinners, all in rainbow colors—but the mood is serious rather than whimsical. . . .
>
> There's one gizmo with a propeller big enough to take off and another that looks like a Thunderbird with a pair of horns. There are painted stumps and towering crosses. There are things that make your head real [sic] to look at them.
>
> "I'm the only one who understands it," he [Bishop Harris] said. "God told the black man and the Indian some things he didn't tell nobody else. The only way you're ever going to find out what all this means is to get like me."[32]

The temple fared no better in the alternative press where, for the first time, Bishop Harris is described as an "artist." Steven Russell of the *Memphis Flyer* wrote that he found the temple "both startling and striking, resembling a sprawling playground constructed by a near-sighted artist on hallucinogens."[33] He continued:

> The artist in this case, however, is Wash Harris, a reclusive man who has claimed in the past to be part African-American and part Indian. Reportedly in his early 80's now, Harris has grown tired of the curiosity his commune inspires and has ceased speaking with those who are merely intrigued. I had been told that it's nearly impossible to talk with him, and that, in fact, gaining entrance to Voodoo Village would be highly improbable.
>
> As we cruised by the first time, entering seemed unlikely. The entire site is surrounded by a metal fence and the main driveway is blocked by a heavy iron gate. When we returned just minutes later, however, the gate was flung wide open. I parked the car, facing the main road (having been warned not to get trapped in the dead-end street), and we quietly slipped inside the compound, wondering how many eyes might be watching. We marveled at the rough craftsmanship and artistic intricacy of the displays, which looked like products of a whittling disciple of Salvador Dali.[34]

In 2003, one Memphis citizen devoted two pages of his personal Web site to the so-called Voodoo Village and reminisced about an intrusion in 1968:

> Voodoo Village was nothing more than a few houses on a dead-end street in remote southwest Memphis. Before we pulled in, Charlie asked me to drive so he could take some pictures. I drove past a couple of small houses with what appeared to be some really interesting lawn art. I don't know how many photographs Charlie took as we drove past because I was eager to get turned around. I turned the car around in a cul-de-sac at the end of the road and headed back the way we had come. Off to the left, from the houses we'd just past [*sic*], a couple of young men appeared to be coming out to the street to meet us. As I drew even with the houses, one man had come into the street and was gesturing for us to stop. Which would have been the normal thing to do with someone standing in the middle of the street. But somehow I never considered stopping. Not for a second. In fact, I put it to the floor. And never swerved. The fellow got out of the way and I must have been doing 50 by the time we pulled back onto the highway.[35]

When we met Bishop Harris in 1986, he emphatically refused to refer to his works as "art," preferring the terms "craftwork" or "The Degrees of God," borrowed from Freemasonry.[36] Promoters and collectors from the "folk" and "outsider art" constituencies had attempted to persuade him to let them photograph the temple and buy some of his work. Rejecting their advances, he reinforced his longstanding ban on photography, citing the temple community's desire to shelter the meaning and interpretation of their work as well as its aesthetic integrity. He told us that, by photographing or displaying elements of the temple out of context, "you can make it mean anything you want it to mean. It is not for that. This is God's work. This is a holy place."[37]

Bishop Harris stood his ground until his death in 1995 at the age of eighty-nine. Subsequently, Marvin White, the husband of his granddaughter, assumed pastoral responsibilities while also working for the local public utility company and studying for his degree in electrical engineering at the University of Memphis at night. Pastor White helped Bishop Harris complete the last of his works, lending his own distinct sensibility to the monuments and tableaus of the 1980s. In a letter to Judith McWillie in 1988, he cited continued disruptions from unwanted publicity: "[T]hat which is irreplaceable continues to be plagued by the very real threat of sudden disaster."[38] In September 2003, he directly confronted the *Commercial Appeal* in a published letter to the editor:

Fig. 1.12
Marvin White. Memphis, Tennessee, 2003. Photograph by Judith McWillie.

> Doc Harris did not build a compound named "Voodoo Village." He built Saint Paul Spiritual Temple, a Christian church. Voodoo Village is a disrespectful, false characterization spread by this newspaper. Although many people who believe they are victims of voodoo seek help from us, our ministry is strictly one of healing. The structures outside the Temple support our ministry. They are physical expressions of our faith. They protect our unapologetic love and reverence for Jesus Christ.[39]

It remains to be seen whether Pastor White's letter will have a substantive effect on the media's representations of the temple community. The Saint Paul Spiritual Temple has no precedent or context in the minds of those who view it as a tourist attraction or as "outsider art." Several members of the third generation of the Harris family who grew up there have now left for college and the temple community's resources are beginning to wane. Pastor White's decision to "go public" with his letter to the editor and with the statement below, given to us in December 2003, represents a new initiative in the lives of the temple community as they struggle to weather the shocks of time and change:

When is art not art?
In seeing a cross dripping red, I am reminded of the blood Christ shed.
Seeing another allover white, I recall my Lord's sinless life.
I see another like a candy cane: stop, think, then understand; sweeter than honey in the Honeycomb is Christ the living word.
I am shaken as I turn around and see two caskets raised above the ground.
One is there, I gather, to gather the eagles around the carcass of the slain.
And the other, I see, is the Savior being lifted up from the earth.
He said, "I'll draw all men unto me."

As minister of Saint Paul Spiritual Temple for more than 25 years, I still marvel at the exquisite simplicity and beauty of the church that Doc built. But despite its spiritually uplifting purpose,

for more than 40 years, our Christian church and community has endured the vulgar and false label, voodoo village. Thousands of people yearly are attracted to our place of worship. Many, if not most however, come to poke fun or to do far worse. Young, old, black and white alike seem to abandon their civility and take delight in hurling insults and hard objects at the Temple and its people. In light of the pleadings of our late founder, Bishop Wash 'Doc' Harris, it is difficult for me to understand how such extremisms for or against our church can exist, let alone persist for more than four decades. Yet, presently, some website operators, radio disc jockeys, and newspaper writers continue to defame us as voodoo village.

Some art collectors, though, take a different approach. In the art world, our sacred place of worship is some kind of folk art which, some say, should be opened to the public. The dollar amount that a few art promoters predict that the Temple would receive by "going public" is astounding. Nonetheless, the artist's secular desire for the spiritual work is as distasteful as the disdain others have for it. For the sake of argument, let us say that the spiritual work of God created at Saint Paul Temple is "folk art." If so, what art in recorded history has invoked such intense reaction, either for or against, so as to motivate literally thousands of people each year to risk peril in the dark of night for a speedy five second drive by glimpse of the "art," as they do at Saint Paul's Spiritual Temple?

If we argue that voodoo is the attraction—regardless if one has a passion for it or against it—Beale Street merchants publicly offer voodoo trinkets and books of spells. Yet there are no clandestine visits to their establishments in the dark of night. There are no blaring automobile horns, no beer bottles thrown and no pistols or shotguns being fired at any of them as it is the case almost nightly at Saint Paul Temple. One would think that if voodoo was the motivation for such uncivilized behavior, dealers of voodoo paraphernalia would have more bullet holes in their doors than we who cleave unto none but Christ.

It has been said that our church is a secret society. No, we are not. We are simply Christians. However, our church ministry, as other ministries, requires that a reasonable measure of privacy be maintained. We minister to both the ordinary and the extraordinary spiritual needs of the general public. Anyone, regardless of race or religion may seek an appointment to speak with the church minister: single mothers not apt to handle business, young men seeking direction or confirmation, couples on the brink of divorce. We also minister to some individuals who insist that they are ill despite being diagnosed as healthy by qualified physicians. Many of these individuals or their families believe deeply and wholeheartedly that they are victims of voodoo or witchcraft. All these and others seek and find understanding, strength and healing at Saint Paul Temple.

Some say the spiritual works have secret meanings. All of the works have meaning. Most have clearly obvious meanings. Others have meanings that require thought to reveal. Still others exist on a higher plane where it is

impossible for man to discern their meaning except it be revealed to him by the Holy Spirit. Ordinarily, no earthly being can articulately describe these works of the Spirit.

The essence of spirituality is that spirit defies the physical senses. Theoretically, that which is totally spirit has no physical description. Many of the spiritual works at Saint Paul Temple have an indescribable physical description that sublimes into a spiritual identity. Make no mistake however, the physical structures themselves, which are made mainly of wood and paint, quickly decay and are not to be adored; they are mere vessels used to attract attention. The physical structure can be compared to a preacher who is not to be idolized while the spiritual message represented by the works is similar to preaching. It is another silliness of God[40] that communicates visually rather than audibly. Both are avenues for the Holy Spirit.

Others say that we are unfriendly. It is not unfriendliness; we simply do not try to push our convictions onto others nor do we aggressively solicit membership. In fact, we, the caretakers of the temple, will only consider unsolicited petitions for membership from adults who feel led by God to this specific work of the Spirit. But, it is true that onlookers and sightseers are discouraged and there are no public tours. Furthermore, it is contrary to church policy to photograph any part of Saint Paul Temple; as photographs capture imperfections created by time and weather, which, without corrective commentary, inaccurately reflect the spiritual message. For this reason, consistent with this present effort, we will offer a series of sketches[41] [see plates 17, 18, 19] of some of the Temple spiritual works for limited public viewing.

The opening ode is an attempt to convey the visual affect of a quick glance of the Temple grounds. Via this medium [word and print], however, much is lost in the translation of these scriptures: Psalm 119:103 and the dual scriptures Matthew 24:28 and St. John 12:32.[42]

Pastor White's statement draws clear distinctions between "spiritual" and "secular" contexts, with the Saint Paul Spiritual Temple belonging to the former and art to the latter. The temple community's complex and many-faceted works require a degree of immersion unavailable in museums and art galleries. In the meantime, in less complex circumstances, Bessie Harvey and other individuals who intentionally made objects that could be transported into galleries and museums discovered that Western concepts of "art" somewhat mitigated the pressures felt from family and skeptics. Significantly, however, presenting their work as art did not change their commitment to its performative dimensions—to what they saw as their responsibility to teach and honor God. Harvey, Dilmus Hall (see portfolio IV), and Lonnie Holley (see portfolio III) were known to give significant amounts of their earnings from art exhibitions to neighbors in need. Harvey believed that exporting her works into galleries and museums afforded her a new opportunity to extend her spiritual witness:

I'm from a family of ten kids. My daddy died before I was old enough to even remember. God saw me through that; then he saw me through bringing my own. How can a woman my age, the

mother of eleven children, twenty-eight grandchildren, and two great-grandchildren, do the most to bring them up on welfare, and sit here and still be sane? But God said, "You sowed a good seed, now you can reap a harvest." God said if we wanted wisdom and knowledge of him to ask him for it. That's where my wisdom comes from. God showed me. He said, "Bessie, you're mine and you haven't got a thing to worry about. Let me show you my power. Pick up that stick. Meditate on me and play with that stick." Look at what he done with it. I didn't do it. But you know what? If I want you to love me, I've got to love myself. I feel like I'm full of the love of Christ, and I'm fit for everybody to love.[43]

Fig. 1.13
Bessie Harvey. Alcoa, Tennessee, 1988.
Photograph by Judith McWillie.

We rarely discuss "art" as an instrument of accommodation for profit even though several of our informants have made the same contextual leap as Bessie Harvey. The aim of this book is to draw attention to precisely what much contemporary art discourse is unable to do, that is, to address concerns that have motivated much of the art African Americans in and out of the South have made for their homes and communities: how to live a just, productive, and loving life in a safe, healthful place, using talent, skill, and insight to further this goal. While catalogues for art exhibitions occasionally publish artists' narratives, too few emphasize the liturgy of yard work, its performative and invocatory dimensions which, like the modes of activation attending minkisi, are of its essence.

In the following chapters we examine practices and materials, the ways that yards have been configured at specific times and places by particular individuals, and the philosophical perspectives that inform their work. Themes that emerge include using material signs to diagnose and communicate (chap. 2); making and protecting home ground, and moving between zones of wilderness and cultivation (chaps. 3 and 4); transforming ordinary yards into safe places of witness for God's presence (chap. 5); and commemorating ancestors, celebrating the successes of lives well lived, and instantiating bits of Heaven on earth (chap. 6).

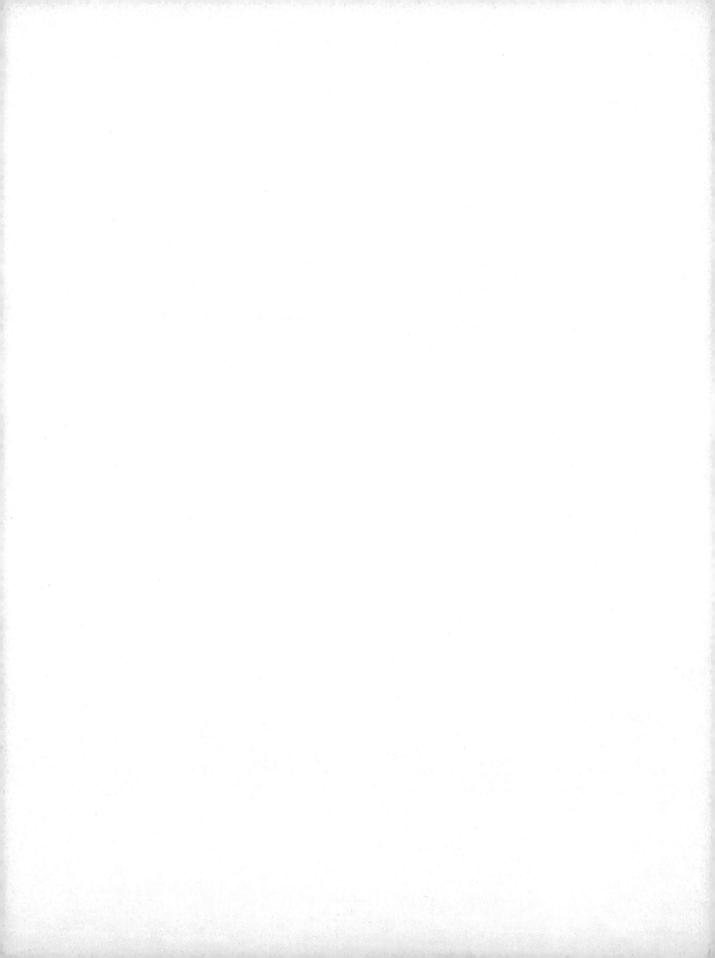

PORTFOLIO II

A Proposed Lexicon

Traditional Signs in African American Cemeteries, Homes, and Churches

ortfolio II is a visual reference for discussions throughout the book.[1] It proposes a lexicon of material signs frequently and consistently used in African American expressive culture and art. Many of these signs first appeared in cemeteries and were later translated into domestic settings. In the United States, practitioners sometimes refer to them as "the old way."[2] The process of recognizing and interpreting these signs runs the risk of undermining their purpose unless their performative and interactive dimensions are also recognized. Therefore, we encourage readers to discover and visit sites on their own, to stop and talk with yard workers, and to watch how their spaces develop over time.

The Diamond Star

he diamond shape, often described by practitioners as a "star," doubles as both the all-seeing, protective Eye of God and an emblem of commitment to advancing wisdom —a map of the soul as it progresses through the cycles of time (figs. II.1, II.2, II.3, II.4, II.5, II.6, II.7).

Top left: Fig. II.1
Inscribed diamond shape on the gravestone of Rev. Hesikiah Allen. Sunbury Missionary Baptist Church cemetery, Sunbury, Georgia, 1984. Photograph by Judith McWillie.

Above: Fig. II.2
Diamond shape on grave marker. Hodges, South Carolina, 1989. Photograph by Judith McWillie.

Left: Fig. II.3
Grave marker with diamond shape and star. Chattanooga, Tennessee, 1985. Photograph by Judith McWillie.

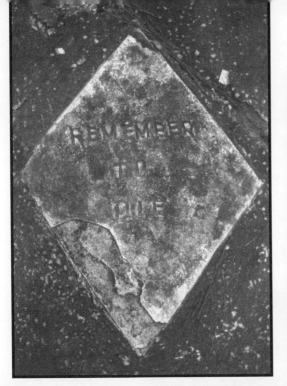

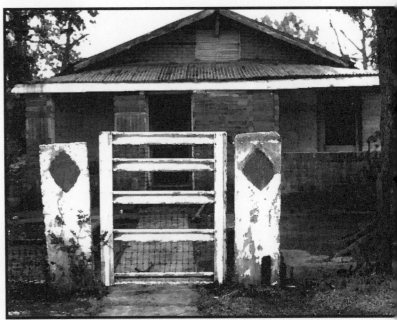

Above: Fig. II.4
Threshold with diamond shapes.
Baton Rouge, Louisiana, 1988.
Photograph by Andy Nasisse.

Top left: Fig. II.5
Paving stone in driveway with
inscription: "Remember to Die."
E. M. Bailey's residence,
Atlanta, Georgia, 1986.
Photograph by Judith McWillie.

Left: Fig. II.6
Exterior of Dilmus Hall's residence.
Athens, Georgia, 1984.
Photograph by Judith McWillie.

Bottom left: Fig. II.7
Diamond shapes painted on
living room ceiling in Dilmus Hall's
residence. Athens, Georgia, c. 1968.
Photograph by Judith McWillie, 1985

Flashing and Reflective Surfaces

Brilliantly reflective surfaces are invocations of divinity—of glory, the light of Heaven on earth (figs. II.8, II.9; plates 5, 7, 10, 16). They also remind us that the material world masks higher powers that come to light only intermittently. By displaying mirrors, chrome objects, safety reflectors, and silver-painted surfaces, yard workers honor ancestors whose brilliant lives continue to shine in present memory exhorting those left behind to consciously strive for rightness with God, community, and self.[3] Mirrors also protect by deflecting negativity and unwanted energy back onto the sender.[4]

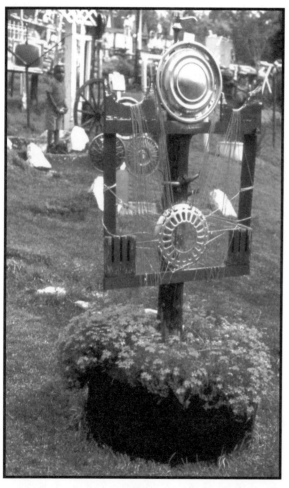

Fig.II.8
Monument with hubcaps. Rev. George Kornegay, Brent, Alabama, 1992. Photograph by Judith McWillie.

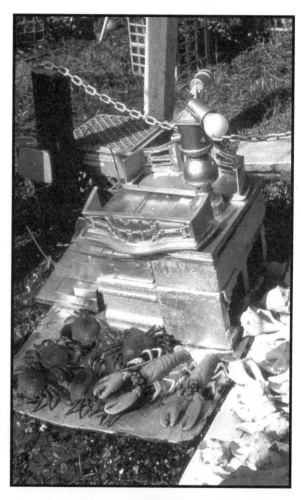

Fig.II.9
Silver-painted objects in Florence Gibson's yard. Savannah, Georgia, 2003. Photograph by Judith McWillie.

God's Wheels

Circular motion, manifested in rotating fan blades, automobile wheel rims, clock faces, whitewashed tires, and other round or spherical objects, recalls the rising and setting of the sun—the cyclical dimensions of time in nature—and the continuities underlying change (figs. II.10, II.11, II.12; plates 1, 4). As signs of progress and accomplishment, wheels are also a reminder of the defeat of complacency through progressive action.[5]

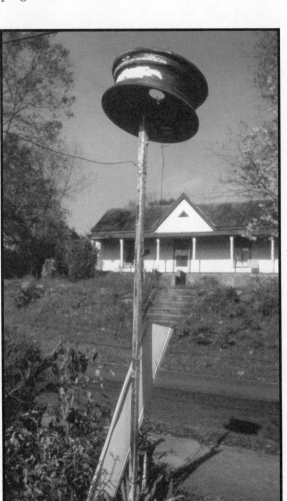

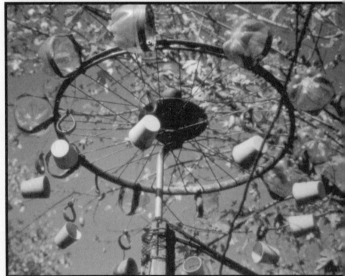

Left: Fig.II.10

Automobile wheel casing on pole. Athens, Georgia, 1984. Photograph by Judith McWillie.

Above: Fig.II.11

Wheel with cups, reflectors, and bottle parts. Sam Hogue, Chattanooga, Tennessee, 1990. Photograph by Grey Gundaker.

Top: Fig.II.12

Wheel in Charlie Greer's yard. Kings Mountain, North Carolina, 1985. Photograph by Judith McWillie.

Cisterns, Pipes and Other Hollow Conduits

The Central African custom of driving hollow rods into the ground near graves was eventually introduced into cemeteries and yards in the United States[6] (figs. II.13, II.14, II.15; plate 1). In addition to serving as conductors of messages to the dead, pipes also carry water, the preeminent signifier of Spirit.

Left: Fig.II.13

Detail of grave enclosure with pipe fittings and personal effects. Grave of Mother Ella Riley, Holly Hill, South Carolina. Photograph by Judith McWillie, 1994.

Above: Fig.II.14

Pipe markers in cemetery. Sunbury Missionary Baptist Church, Sunbury, Georgia, 1984. Photograph by Judith McWillie.

Below: Fig.II.15

Pipe markers in yard. Darien, Georgia, 1984. Photograph by Judith McWillie.

Watchers

Dog, lamb, and lion figurines, mannequins, stuffed animals, and anthropomorphic groupings of objects, when conspicuously positioned at entrances and thresholds, represent messengers of judgment and authority, reminding those who approach that, upon entering the yard, one should behave as if all of the world is watching (figs. II.16, II.17, II.18, II.19, II.20; plates 6 and 13).[7]

Top row, left: Fig.II.16

Statue of the Virgin Mary with dove's head at entrance to driveway in Bennie Lusane's yard. Royston, Georgia, 1990.

Top row, right: Fig.II.17

Roger Finney's yard. Macon, Georgia, 1985.

Bottom row, left: Fig.II.18

Figure at entrance to yard in central Georgia, 1989.

Bottom row, center: Fig.II.19

Statue of Moses at entrance to porch of Charlie Jackson's residence. Memphis, Tennessee, 1994.

Bottom row, right: Fig.II.20

E. M. Bailey's sculptures installed in his yard. Atlanta, Georgia, 1986.

All photographs by Judith McWillie.

Fences and Objects Wrapped and Tied

Tying and wrapping are traditional ways of enclosing charms and sealing intentions. Tied and wrapped fences are reminders that the yard has assimilated the protective powers of the signs within (figs. II.21, II.22, II.23, II.24; plate 2).

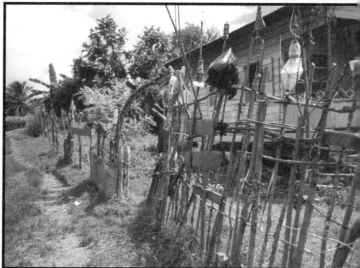

Upper left: Fig.II.21

Henry Jackson's backyard fence and gate. Memphis, Tennessee, 1990. Photograph by Judith McWillie.

Top: Fig.II.22

Detail of Clarence Burse's fence. Memphis, Tennessee, 1983. Photograph by Judith McWillie.

Left: Fig.II.23

Detail of Ruby Gilmore's fence. Hattiesburg, Mississippi, 1989. Photograph by Judith McWillie.

Above: Fig.II.24

Fence in Gros Islet, St. Lucia, West Indies, 1987. Photograph courtesy of Paula Temple Robbins.

Thrones and Chairs
Set Apart

Stools, thrones, and specially constructed seats are associated with visionary experience and spiritual sight. In traditional yards they lend an air of formality to the spaces they occupy and appear in groupings separate from ordinary lawn furniture (figs. II.25, II.26, II.27; plate 3). They remind visitors of unseen watchers, especially when they are memorials to the persons who used them (earthly counterparts of the seats prepared for them in Heaven). Others are dedicated to Christ's return in the last days.

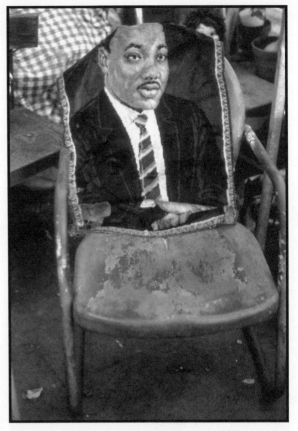

Left: Fig.II.25
Special seat in Bennie Lusane's yard, 1992.
Photograph by Judith McWillie.

Lower left: Fig.II.26
Special seat in Robert "Lightnin'" Watson's yard.
Palmers Crossing, Mississippi, 1991.
Photograph by Judith McWillie.

Above: Fig.II.27
Chair with Martin Luther King tapestry in
Clarence Burse's yard. Memphis, Tennessee, 1984.
Photograph by Judith McWillie.

Experienced Objects

Objects belonging to deceased or absent friends and family and those with strong autobiographical connotations such as tools and cooking utensils are grouped in specially designated zones within the yard, extending the older practice of placing them on graves (figs. II.28, II.29, II.30).[8] They are considered to be "experienced," rather than "used" (obsolete) and are thus more spiritually potent than new ones.

Whitewashed Rocks and Trees

Whitewashed rocks and trees mark sanctified ground and are reminders of the responsibility of composing oneself and attending to the things that are left in one's care (figs. II.31, II.32, II.33; plate 11). Some yard workers carry boulders from their birthplaces each time they move to a new home, painting them white and setting them along the boundaries of the property or at its corners.[9]

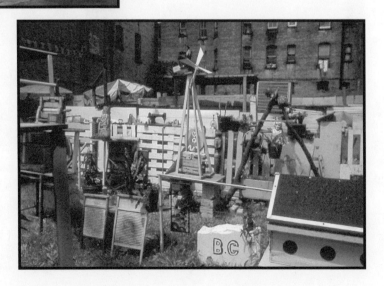

Above: Fig.II.31

Entrance to Annie Sturghill's yard. Athens, Georgia, 1988. Photograph by Judith McWillie.

Upper right: Fig.II.32

Whitewashed tree, post, and rocks in Charlie Greer's yard. Kings Mountain, North Carolina, 1985. Photograph by Judith McWillie.

Right: Fig.II.33

Whitewashed rock with inscription: "B.C." Harlem, New York City, 1987. Photograph by Judith McWillie.

Broken and Inverted Vessels

Originally an aspect of cemetery decoration, inverted vessels allude to death as "the other side" of earthly life, where things are again made whole.[10] When broken, they encourage the spirits of the deceased to move into their new role as ancestors, not to hold back and remain preoccupied with their former lives. In yards they are usually placed alongside other material signs of burial, making a place for relatives and friends who have passed on (figs. II.34, II.35, II.36).

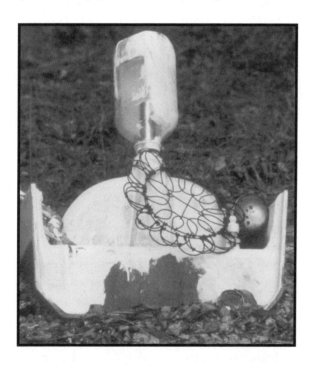

Above: Fig.II.34
Inverted basin with bottle in Elijah Davenport's yard.
Clarke County, Georgia, 1985. Photograph by Judith McWillie.

Upper right: Fig.II.35
Broken clock on grave. Sapelo Island, Georgia, 1985.
Photograph by Judith McWillie.

Right: Fig.II.36
Crushed oil lamp on grave. Sapelo Island, Georgia, 1985.
Photograph by Judith McWillie.

Spiritual Script

Some Central African rituals make use of non-discursive writing as a medium of prophecy and revelation (figs. II.37, II.38, II.39, II.40). In the United States, visionary artists such as James Hampton and John B. "J. B." Murray wrote in spiritual scripts that they believed were revealed by Jesus and the Holy Spirit. In other instances in the Americas and the Caribbean, "spirit writing" is used to sign and seal domestic spaces and communicate blessings from God.

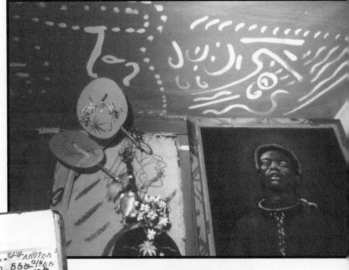

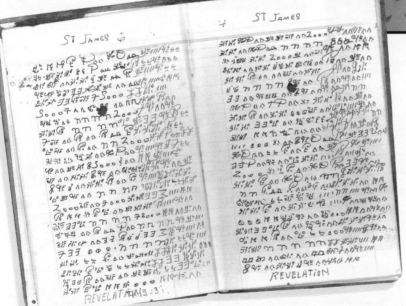

Upper left: Fig.II.37

J. B. Murray's script: "It's the language of the Holy Spirit direct from God." Glascock County, Georgia, 1985. Photograph by Judith McWillie.

Left: Fig.II.38

Pages from James Hampton's notebook "St. James: The Book of the 7 Dispensation." Collection of the Smithsonian American Art Museum, Washington, D.C.

Above: Fig.II.39

Spiritual script on ceiling. Lonnie Holley's residence, Birmingham, Alabama, 1986.

Top: Fig.II.40

Spiritual script marking boundary. Victor Melancon's yard, Hammond, Louisiana, 1988. Photograph by Judith McWillie.

Water

With its transparency, reflectivity, ability to flow into and fill any shape, as well as its life-sustaining properties, water constitutes a threshold between the everyday world and the world of spiritual power (figs. II.41, II.42, II.43; plate 7).[11]

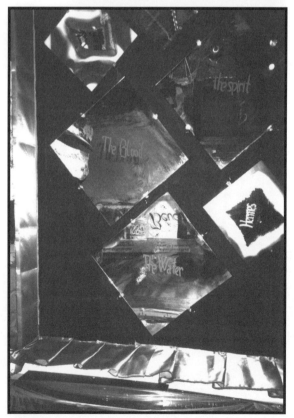

Upper left: Fig.II.41

Water used by John B. "J. B." Murray to interpret his spiritual script. Glascock County, Georgia, 1986. Photograph by Judith McWillie.

Above: Fig.II.42

J. B. Murray praying "through the water." Glascock County, Georgia., 1986. Photograph by Judith McWillie.

Left: Fig.II.43

"The Spirit, the Blood, the Water": mirror tiles hand-lettered in red on ceiling of the Seventh Church of Christ in Freeport, New York, 2002. Photograph by Grey Gundaker.

Twisting Roots and Trees

As the forces of nature act on roots and trees, some become suggestive of animals or humans; others are especially dynamic in their shape. They mirror the visible living world in their branches and the invisible spirit world in the their roots and invoke the spirituality of the woods and the challenges of the wilderness. Yard workers often collect and prominently display these formations (figs. II.44, II.45, II.46). Some paint them to bring out their anthropomorphic qualities or to call attention to the power expressed in their form.

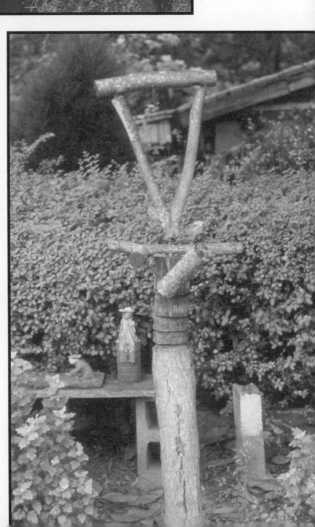

Above: Fig.II.44

Inverted root in Edward Houston's yard. Center Star, Alabama, 1991. Photograph by Grey Gundaker.

Upper right: Fig.II.45

Sculpture by Ralph Griffin. Gerard, Georgia, 1987. Photograph by Judith McWillie.

Right: Fig.II.46

Wood construction at entrance to Dilmus Hall's yard. Athens, Georgia, 1976. Photograph by Judith McWillie.

Chapter 2

Material Signs and Sight

"Meaning" is a way of commanding the actions of
oneself and others.
> —Wyatt MacGaffey, 1986

Here are some verbs . . . to command the spirit on both sides of the Atlantic. Be contained: within the tomb, within a vessel on the porch, within gleaming glass vessels impaled on a tree or . . . a whitewashed rock boundary, within a line of quartz pebbles. Be blessed or driven back, according to your character, by figuration. Be healed—or stung—by lightning-related cacti or witch-resistant plants. . . . Be healed of loss by association with an immortal tree. . . . Be attracted, to the spiritual flash of mirrors or of beetle wings or of kaolin, in Kongo, and of mirrors, tinfoil, light bulbs, silver balls, and chrome hubcaps in America; be warned or exalted by their spirit-repelling and spirit-attracting flash. Be enthroned in glory. . . . Complete your circle, travel your life protected by a perforated disk . . . say the same thing with a dime on a string, . . . stud land and yard with automobile tires, white-washed and serrated, like a sun streaming rays. . . .
> —Robert Farris Thompson, 1993

Diagnostic and Communicative Signs

In African America many kinds of signs have been used to diagnose, communicate with, and act upon the environment. This process reveals a great deal of information about a person's inner and outer states, the physical and psychic climate of the community, and the condition of the materials themselves. This is evident in the roles materials play in the signs and aphorisms folklorists collect. For example, a woodpecker pecking on the wooden siding of the house, instead of a tree, is said to warn of the approaching death of a close relative for the person who hears it.[1] A lamp that goes out suddenly, for no apparent reason, signals the same thing.[2] In other instances, something missing, made poorly, or used incorrectly points to a deeper malaise. And, occasionally, even the act of collecting signs has offered an occasion for pointed commentary on social ills. Writing in

the 1930s of research in Adams County, Illinois, Harry Middleton Hyatt reported this exchange:

> An old Negro said to the white person who supplied the following information:
> Did you know that you never see a jay bird on Friday?" I said, "Why?" He said, "The jay birds all go to hell on Friday and tell the devil all the meanness you [white] people do to us [Negroes] all through the week."[3]

Also put in her place was Marictta Minnigerode Andrews, a slaveholder's daughter who, in *Memoirs of a Poor Relation,* recalled growing up on a plantation in the last years of slavery in Virginia. She described her attempts to bake a cake and the painful lesson she learned from an African American cook:

> Once I attempted to make a sponge-cake under [Fannie, the cook's] critical eye. The result was very serious for the cake was a failure and she shook her . . . head over it. . . . [and] murmured, "It takes a pure heart to mek a spownge-cake." The failure was humiliating but the cause of the failure was devastating. Yet it would always crop up and do harm—waste good material—disappoint reasonable hopes—injure other people, this thing of not having a pure heart. And how could people help it if they did not have a pure heart? And old Fannie . . . the proof was there—she could make sponge cake.[4]

This story vividly relates how signs in the material world can be used for moral instruction. It also encapsulates a theory of living as familiar to New York advertising executives, African healers, Byzantine abbots, and Zen gardeners as it is to many African Americans who work their yards.[5] According to this the-ory, materials affect their surroundings for good or ill, particularly when they have been activated through choice, placement, and combination with other selected substances.[6]

African Americans have a long history of using objects to "signify," and "Old Fannie" was one of a long line who communicated pointed messages and directed proverbs toward needful recipients through the medium of material signs.[7] Baking a cake can be a practical act of food preparation or a form of divination built into the very fabric of everyday life.[8] Despite her condescending tone, in the author's recollection this childhood episode made an impression on her that lasted well into old age. She was forced to think about how to achieve a purer heart along with a lighter cake, and she was also judged want-ing and placed in a distinctly inferior position by a family "servant," as white Virginians preferred to call those they enslaved.

Demonstration is the key to the principle of "admonition through signs," the dynamic that connects diverse instances of yard work over time and space. The growth of a tree planted on a grave can signify whether or not the soul of the deceased has gone to Heaven and the same holds true for trees planted as memorials in yards.[9] The death of a memorial tree in a yard also signals social failure, whether on the part of those responsible for the maintenance of the tree, or the deceased who failed to have family and friends willing to care for it. The same principle applies to growing plants in yards. The robust plants in the Hamler yard show their own health as well as how to *be* healthy (fig. 2.1).

In Andrews's story, the failed sponge cake prompted a claim that "Old Fannie" articulated verbally, but material signs also lend themselves to communications that would be unwise, even dangerous, to put into

Fig 2.1
Robust plants in Estelle Hamler's yard. Chattanooga,
Tennessee, 1992. Photograph by Grey Gundaker.

words. The recollections of Mary Belle Dempsey, formerly enslaved in Kentucky, include a good example:

> We had our churches, too. Sometimes the white folks would try to cause trouble when the [N]egroes were holding their meetings, then at night the men of the church would place chunks and matches on the white folks gate post. In the morning the white folks would find them and know that it was a warning if they didn't quit causing trouble their buildings would be burned.[10]

Obviously, signs such as these command attention and action. The chunks of tinder

and matches make a composite sign: wood is the substance; matches are the means of activating it. Wood and matches are *metonyms* for buildings and the fire that can destroy them.[11] They serve as warnings for the white households in the area where the black population is ready to defend itself. Furthermore, the message was installed at a threshold, which is one of the most common locations for material signs because thresholds are "crossroads" areas that mediate entry and egress and divide the yard from the world outside.[12] While some signs at thresholds are hidden or partly hidden, the chunks and matches were raised on a gatepost where they could not be overlooked. However, as a Yoruba saying states, "Half a speech to the wise is sufficient," and this, as Henry John Drewal and John Pemberton III have noted, "reminds us that allusions alone convey meaning to knowledgeable persons."[13] Failure to heed signs like these promises dire consequences not only to property but also to health, family, community standing, and relationships with higher powers.

Even when white repression was at its strongest, African Americans used the threat of fire and the setting of actual fires to signal the action they were prepared to take to protect their homes and families. For example, the elderly woman in figure 2.2 posed in a rocking chair for a photograph included in a nostalgic volume of plantation sketches. The author of the sketches, Essie Collins Matthews, a slaveholder's daughter and the wife of an Episcopal priest in South Carolina, presented her subjects as loving mammies, despite the coldness of their expressions as they faced her camera.[14] However, the woman in figure 2.2 defies Matthews's description. She once tried to burn down the slaveholder's house and lived

Fig. 2.2
"Aunt Jonas." Represented by Essie Collins Matthews in
*Aunt Phebe, Uncle Tom, and Others: Character Sketches
Among Old Slaves of the South, Fifty Years After*
(Columbus, Ohio: Champlin Press, 1915).

[S]he intoned her prayer and rocked from side to side as she plead for help. Then she stood up. Tears ran down her cheeks. "Do gi' me a sign fo' know wha' fo' do. Please, Suh! Do, Massa Jedus! Gi' me a sign! All my chillens' gone an lef' me heah.' Her bony arms were raised high and her knotted fingers held [a] cold pipe. . . . With a start she became conscious that ashes from her pipe were trickling through her fingers and falling on the floor. She stopped and looked at them. *Ashes! Cold ashes!* She had asked for a sign and the sign had come! It was *ashes!* Plain as the dawn that streaked the East! There was no doubt of it! She lifted her arms and with tears streaming, said softly: "Yessuh, Massa Jedus. I understand you, suh."[15]

The message Maum Hannah understood from the ashes and the red sky, and subsequently acted upon in the story, was that Jesus had told her that she should burn down the new house next door to protect her own. Phrases such as "burn, baby, burn" and "the fire next time" carried the same promise of retributive action forward into the civil rights era.

Activated Materials

These accounts also show that material signs imply a number of different kinds of agency and knowledge. The tinder and matches on the gate post leave no doubt that human beings put them there and would follow through on the implied threat if necessary. In the cake story, the young maker handled the materials while a person with superior knowledge interpreted them. "Old Fannie's" interpretation implied a power

into old age to tell about it. Her mere existence must have been a signal of survival to other African Americans and a reminder to the plantocracy that the romanticization of "slavery-time" glosses over fears that were sometimes wholly justified.

Julia Peterkin, another white southerner and a planter's daughter whose novels contain carefully observed details, tells a story set in the early twentieth century of Maum Hannah, an elderly woman threatened with eviction by whites who had bought the land on which her house stood and who had built a new house for themselves next door:

Fig. 2.3
Reflector and face.
Collegeville, Tennessee, 1989.
Photograph by Grey Gundaker.

immanent in humans and materials, as well as a moral order that encompasses them both. Maum Hannah approached the material world as a transmitter of divine guidance. In yards today, red reflectors beam warnings such as "stop and think" and "watch out" from gateposts, boundary markers, and watcher figures (fig. 2.3).

Other accounts suggest more direct forms of supernatural agency through hoodoo and conjure, medicine, or religious practice, depending on the context. The 1849 narrative of Henry Bibb, who escaped from slavery and settled in the North, contains a frequently quoted passage about secret doctors on the plantations: "[S]ome of them pretend to understand the art, and say that they can prevent their masters from exercising their will over their slaves. Such are often applied to by others. . . . [T]hey prepare certain kinds of powders, to sprinkle about their masters' dwellings. This is all done for the purpose of defending themselves in some peaceable manner, although I am satisfied there is no virtue in it at all."[16]

Although Bibb plainly doubted the power of conjure and the skills of the secret doctors,

his choice of words, "in some peaceable manner," is telling, given the fact that at least some of the powders that conjurers used contained potent poisons. At the time Bibb was writing, the slaveholders worried far more about weapons and violent revolt than about powders on the ground; the powders were insider knowledge, a discreet mode of resistance that allowed people to protect themselves without inviting slaveholder retribution. It was also one of the few means available to ward off thieves and jealousy within the community, usually as part of a larger medical and ethical complex that treated social as well as physical ailments.[17] Acts of healing extended to the planter's house as well. Samuel Sutton, born under slavery in 1854, told an interviewer in 1937 that people on his plantation did not believe in hoodoo much, but he did recall that "we use to sprinkle salt in a thin line 'round Mars Ballinger's house, clear round, to ward off quarrellin' an arguin'."[18]

Past uses of material signs are apparent in the archaeological record. In the 1980s archaeologists began uncovering material associated with conjure, including bones,

Fig. 2.4
Tree with pill bottles attached.
Bennie Lusane's yard,
Royston, Georgia, 1991.
Photograph by Grey Gundaker.

pins, bits of quartz, mirrors, and shells buried during the eighteenth century under the floor of a house in Annapolis, Maryland, and have subsequently found similar material placed under the floor of a house occupied by African Americans during the mid-nineteenth century in Texas.[19] This material may have been placed to defend living spaces against physical and psychic intrusion. Historian Alice Eley Jones interpreted a twisted wood staff and a cowry shell discovered in the wall of a house built by enslaved laborers at Stagville Plantation near Durham, North Carolina, as conjure equipment placed to protect the property.[20] The wall of a cabin in Georgia photographed during the Great Depression has a bottle inserted between wooden boards under the window.[21]

In the United States and Caribbean, bottles filled with nails, liquids, animal remains, and other substances were placed in yards, fields, trees, and produce gardens. These bottles were the most visible components of dressing or setting fields, but other items might also be buried as a form of booby trap for intruders or to encourage the growth of individual plants.[22] "Come Back," "Go Away," "Squint," and other powders designed for application to yard walkways and doorways continue to be sold in magic and religious supply stores in medium to large cities across the country, on the internet, and through mail-order companies that run classified advertisements in the *Star* and other supermarket tabloids.[23] In the late 1980s Bennie Lusane hung pill bottles in a shrub in his yard in Georgia, combining a visual thank-you for his recovery from a heart attack with a reiteration of the message that powerful medicine comes in bottles (fig. 2.4).[24]

Powders of various kinds also figure in everyday yard work, most commonly salt and lime. These help to kill snails and insects. They also mark areas and boundaries. The widespread use of lime, powdered insecticide, and fertilizer by black and white gardeners somewhat masks their long association

with more esoteric activities, but "salting" someone's house can be synonymous with putting a spell on it. In late-nineteenth-century Philadelphia, a clean glass bottle was one of the items that a man took to a conjurer after he discovered that the four corners of his house had been salted.[25]

While some materials worked to protect the land, its occupants, and its crops, materials for conjure, luck, and protection were drawn from the land, animals, and plants as well. A local-color passage in a novel of black life in Louisiana during the Depression mentions a powerful amulet containing "a pebble which had been taken from the Indian mound on the far side of the plantation. It had been soaked for forty days in rattlesnake oil and wrapped in human hair. . . . It seemed almost alive . . . capable of dispelling all evil."[26] Here again the components include material to be activated, the pebble, and material that activates and directs it, the rattlesnake oil and the hair. Considered metaphorically and metonymically, these materials leave little doubt that the amulet was designed to invoke, feed, and *tie* an Indian spirit. ("Tie" is a common term in African American usage for putting a spell on some person or spirit so that they obey the orders of the person who cast the spell or for whom it was cast by a conjurer.[27] In the United States it also implies a very special relationship, as in the hymn words, "I'm all tied up, wrapped up in Jesus.")

At least one trajectory of the history of the term points toward Kongo, and pulls together several related concepts and material complexes. As R. E. Dennett observed in 1903: "KANGA is another word for FUNZI, both meaning the guinea fowl. The word kanga means to tie, to fry [e.g. a mode of cooking that seals in juice and flavor]—KANJI = he

who ties. A man who is tied up or made a prisoner becomes according to native law one of the family of the man who ties. So KANGA as a power may mean conjunction or assimilation."[28]

The pebble embodied the spirit of an Indian buried in the mound; the rattlesnake oil infused the pebble/spirit with energy to strike enemies with the speed and venom of the snake; and the hair focused the powers of the dead on humans, probably one particular human, because the hair in protective charms often came from the head of the person who wanted protection. Considering the different places the material in the amulet came from, it also encapsulates a miniature landscape of graveyard, woods, and personal space.

The importance of Indian imagery in African American expressive culture is well known, as in the case of the famous Mardi Gras Indians of New Orleans. Widespread intermarriage gave a sense of cultural and political identification that established Native Americans as an ancestral group for people of African descent. Visible references to this ancestry not only demonstrate roots on the American continent but also a claim prior to that of Europeans to own land there. The Reverend George Kornegay, uses the colors black, red, and white in his yard assemblages to stand for his African, Indian, and European ancestors. He also made a teepee of wood and mounted it on top of a chapel he built on his property, doubling teepee and steeple (fig. 2.5).

In conjure and religious practice, Indian imagery aligns the user with autochthonous people and their special connection to the powers of place. This carries over into contemporary products like perfumed candles, house-blessing sprays, incense, and car air fresheners printed with the picture of a chief

Fig. 2.5
Teepee on roof of home chapel,
Rev. George Kornegay.
Brent, Alabama, 1992.
Photograph by Judith McWillie.

in a feathered war bonnet. These products can be bought in most American supermarkets and mainly serve as domestic cosmetics. As material signs they also imply that the protective power of the Indian spirit extends as least as far as the aroma of the perfume. The Indian candles can serve as offerings and focusing devices for prayers and on altars alongside other color-coded candles dedicated to Roman Catholic saints and the Seven African Powers. Any of this material counts as conjure when one person uses it to try to hurt another or to counterattack another's attempt to cause harm. However, such products can be considered benign when used to perform the functions—perfuming and washing—that are overtly stated on their packaging. While they might still seem somewhat "superstitious," they do not have the underhanded connotations of conjure when employed to clean and protect one's own home.

In any case, "conjure" versus "protection" is a matter of viewpoint. A few of the many rites involving houses and yards that the premier recorder of hoodoo technique, Harry Middleton Hyatt, collected include the following: To keep police officers away, bury a dozen eggs under the nearest path and mix one quart of cod liver oil with the soil under another path to the house.[29] To win a lawsuit, place nine new leaves of a double pansy plant from your yard into your shoe along with the names of the Twelve Disciples.[30] To attract roomers, mix powdered horse hoof, incense, and sugar and sprinkle it in the room you want to rent out.[31] To cause someone to vacate a house within five days, bury the person's name, a piece of bluestone, and rock salt in a hole at the north corner of the house.[32] To hoodoo someone, causing ill health and bad luck, plant vermilion camellias at the side of their house.[33] To kill someone, distill milk from figs, mix it with other ingredients, and cause a snake to hide a package of the mixture under the doorstep of the victim.[34] To tie a person to you, take up their foot track, wrap it with lime in black silk and hang it over the door or bury it under the house step.[35] To make a man who

is staying out late come running home, bury a crawfish leg stuffed with filings from inside a cow horn under the house.[36] To "scatter the mind" of someone, blow their hair into the outdoor air along with the "hair" (pinfeathers) of a live mockingbird.[37] Vines, especially grapevines will also tangle a person's mind.[38] And (in our revision of Hyatt without dialect transcription): "If you want to be lucky and draw the influence of people, or into your business, you would sharpen you a piece of fence about six inches long. And you would trim it smooth on each side with a knife and sharpen the end of it Then you can write with ink on it: Make R, make a cross mark [an *x*]; Z, another cross mark; S; A; another cross mark; D. R. And you drive that stick right down in front of your door where no one will see it, turn it out from the house, to draw the influence of who may come by and they come in."[39] Also, urine is good for killing a hoodoo "germ": "Just say, for instance, if you thought somebody had put something at your gate to harm you, you could throw it at the gate and that will kill that."[40]

Many practices that encourage spiritual healing, good luck, and protection throughout the African diaspora use feeding, anointing, offerings, and libations to activate materials. In the Yoruba-oriented Orisha religions, sacred stones receive sacrificial offerings of blood that reciprocally keep them active as repositories of the Orisha.[41] Thunder stones said to appear after storms were also sought after in the Americas, including the southern United States.[42] Mojos, hands, and roots, the power objects of hoodoo, receive different kinds of liquor and cologne depending on their purposes.[43] Some Christians also regard the bread and wine consumed during Holy Communion as active, transfigured substances. And there are indications that in the past, if not today, certain black Christians have also reversed the order of consumption, so that the object of worship is fed, not the worshiper. One elder told an interviewer that when things were going badly, he knew it was time to "feed the Lord" but gave no details.[44]

Since feeding the spirits is widespread in West and Central African and African diaspora religions but not so common in American Protestantism, feeding Jesus certainly seems to indicate a more African than European orientation to materials. But the bread and wine of Christianity (or, for that matter, the "magic" powers of commodities such as cars and soaps to make consumers beautiful, rich, and successful) also demonstrate that there is nothing inherently "African" or "premodern" about regarding objects as agents.[45] People around the world associate power with faraway places and peoples, just as they do the reverse with ancestral peoples and spirits associated with places close to home.

Many of these themes come together in the words of LaVerne Spurlock, a spiritual healer and priestess of the Yoruba orisha Obatala, who grew up in Mississippi and Virginia before apprenticing with a senior healer in Washington, D.C. She explained that the numerous items arranged in the waiting room of her Long Island office— figures of Indians, Africans, and Asians; mobiles; wall hangings; plants; containers; and altar assemblages—were of two kinds, passive matter and active spirit. "Things are thoughts," she said. "In this room they are props. I use them to make points clear to people who would otherwise have trouble understanding, but they are not active in themselves." One of two exceptions, however,

Fig. 2.6
Johnson Smith. Lumberton, Mississippi, 1988.
Photograph by Grey Gundaker.

is the doll-like figure of an elderly African American woman with a head tie, wire-rimmed glasses, and a long calico dress seated in a replica rocking chair. She represents a special protector from the healer's youth. About two feet tall, the seated figure holds a full-sized hand mirror in her lap with the glass facing outward toward anyone who approaches her. "People are drawn to her because she is the only thing in this room—except one other—that is active," Spurlock explained. "She has things from the real lady with her so she is alive. People are so drawn to her that I put this mirror to keep her from getting so much, to protect her from all that. She saved my life when she was alive so I respect her and don't work her spirit."[46] (Spurlock would not identify the second exception; presumably, it is something hidden, enclosed, or otherwise out of sight.)

Overall, whether pursued through the product offerings of retailers such as Schwab's drugstore in Memphis and Latin botanicas,

or through the work of healers such as LaVerne Spurlock, the search for efficacious ways of protecting one's home, yard, and body seems to foster an ecumenical and multicultural outlook that has persisted for generations. Consider this description of Big Angy, a woman of African, Indian, and French ancestry from nineteenth-century Missouri: "Her faith . . . being of as many hues as Joseph's coat was evinced by her keeping her medicine-pipe and eagle-bone whistle along with her missal and 'Key to Heaven'; by carrying a rabbit's-foot and rosary in the same bosom and the fetish known as a 'luck ball' under her right arm."[47]

Fig. 2.7
Glass insulator, fez, telephone, and Mardi Gras beads in tree.
Johnson Smith's yard, Lumberton, Mississippi, 1988.
Photograph by Grey Gundaker.

This diverse array of material signs and activated substances foreshadows the equally inclusive approach to materials in African American yard work. For example, a bush by the gate to Johnson Smith's backyard in Lumberton, Mississippi, contained the red fez he wore as a thirty-third-degree Mason, a telephone—later exchanged with a police radio—that showed he was in communication with unseen powers, and beads from Mardi Gras in New Orleans (fig. 2.7). "You know people go down there to get stuff [powder, charms called 'hands'] and this shows I've been there," he explained.[48]

Active Material

Whether intended as protection, good luck, social comment, or visual play, material signs sometimes involve separable and movable parts that combine and recombine rather like syllables in a larger word or phrase. Anthropologist Dan Rose calls this "detachment," a transatlantic sensibility that permits objects and parts of the body to move separately and be personified, as if acting of their own volition. During his fieldwork in an African American neighborhood in south Philadelphia, Rose compared conversations that involved separable body parts with a scene in *The Palm Wine Drinkard,* a work by the Nigerian novelist Amos Tutuola, in which the body of a forest spirit progressively disassembles until nothing is left but a moving, talking skull.[49] Apparently this sensibility has remained relatively constant. Eliza Hasty's description of a gawky youth on the South Carolina plantation where she grew up serves as an example: "Oh yes! It was Fred, a *all 'round de creation boy,* do anything and everything. He was a sort a *shirt-tail boy* dat pestered me wid *goo-goo eyes.* . . . Dat boy both *box-ankle* and *knock-kneed.* When you hear him comin' from de horse lot to de house, *his legs talk to one another, jus' lak sayin': 'You let me pass dis time, I let you pass nex' time.'* I let you know I had no time for dat ape!"[50] In the same collection, Millie Barber remarked, "My tongue too short to tell you all dat I knows."[51] One of Newbell Niles Puckett's informants recalled, "A group was going across the fields at noonday when they suddenly saw a *whole house* coming after them. It passed so close that it knocked their hats off and neither house nor hats were ever seen again."[52]

Not only can the knees, tongue, and house act on their own, but parts of one thing can also detach and become part of another. An account by a white southerner of "how we lived on the old plantation" recalls the epithet "skillet-headed."[53] Zora Neale Hurston has described the southern—and, one might add, African American—penchant for creative insults that characterized the victim as an agglomeration of mismatched parts.[54] Her phrases "shovel-footed," "butt-sprung," and "puzzle-gutted" echo Eliza Hasty's. These phrases not only translate easily into material form, but they also derive in the first place from vivid images and familiarity with everyday objects, a familiarity that, not surprisingly, can play as easily with objects themselves as with words—for example, the "bust" Annie Sturghill made with a paint can, bricks, a slab of wood for shoulders, and a table-tennis paddle head (fig. 2.8) and Bennie Lusane's handlebar bull head (fig. 2.9).

The same type of detachment and reshuffling permits the part-for-whole dynamics of amulets, hands, and other power objects. The term "hand" is a case in

Right: Fig. 2.8

Figure in Annie Sturghill's yard: paint can, bricks, wood, and table tennis paddle. Athens, Georgia, 1988. Photograph by Judith McWillie.

Far right: Fig. 2.9

"Bull's head" by Bennie Lusane, 1998. Photograph by Judith McWillie.

point, and on occasion "give me a helping hand" can mean just that, complementing Bo Diddley's sung question, "Who do you love?" and its auditory pair, "Hoodoo you, love." What matters is the intention, whether the site of use is the yard or the human body (which are often analogous in any case), whether the materials are ordinary or exotic, and whether or not they have other interpretations. The following summary, written about the Mende of Sierra Leone by anthropologist Kenneth Little, fits practices in the United States as well:

> An essential part of the technique of "working medicine" is that the objects should be deliberately set aside: one is tempted to say "consecrated," for the purpose in view. Once the medicine man in charge of the work has done this, the objects themselves are impregnated with power and become effective media for transmission. As such, their potency

varies with their previous and present associations and with the medical prestige of the persons compounding them. In other words they may be likened metaphorically to electric batteries.[55]

Electric batteries make good analogues for materials that have been activated to relay various powers. But because material signs communicate, often what counts is that they *could* be activated, not that they actually have been. Whereas conjure materials and protective amulets intended for real work are usually kept out of sight, the same material in plain view is probably intended to serve as a reminder that someone who has been threatened will mobilize higher powers if necessary.

Certain yard work is of this sort; it aims to make people stop and think before they act. This is usually the aim when practitioners of yard work use materials that may suggest conjure to some of the people who pass the

yard, especially those tempted to trespass. For example, in addition to the Fez and phone we mentioned earlier, Johnson Smith hung bottles and shoes from trees, sprinkled salt and lime on the ground, and made other visual allusions to put potential trespassers on notice. When asked, "Mr. Smith do you think this stuff will really keep people out?" he answered, "No, but it tells them who they are dealing with." (If they failed to get the message through material signs visible from outside his fence, his large pit bull dog was ready to deal with them.) Philip Winsome, an Afro-Trinidadian expert in herbal gardening now living in Philadelphia, described a similar approach. When questioned about yard-protecting practices in his hometown of Maruga, which has a reputation as an Obeah center, he told a story about his sister: "Someone stole the clothes off her clothesline. She hung some stuff [objects associated with Obeah such as bones, leaves, and small bags] on the line and left the house for a few hours. When she came back, the clothes were back on the line. My sister doesn't believe in any of that stuff, but she knew it would get her clothes back because other people do; or at least they were afraid she knew something they didn't. That's how it works: nobody says they believe it, but few are willing to take a chance."[56]

To our knowledge, none of the people either of us has interviewed has ever used conjure or attempted to harm anyone. Quite the opposite. Most are respected family members; some are community leaders. Practitioners of yard work tend to be generous people, extremely positive in their outlook and exemplary in their forgiveness of others, even when deeply wronged. For many, yard work is part of their generosity, a labor of love for everyone to see and enjoy. However, the same materials in the yard that attract an artist like Bessie Harvey (see chap. 1) can cause other people concern.

Although human agency combines things, activates them to become something different from what they were originally, and reads messages into the process, human beings cannot fully control the tree, the plant, or the ingredients of a sponge cake, divination kit, or yard. Material of all kinds remains part of creation, the vast cosmological design that humans can comprehend only partially, if that. A few people we know have acquired reputations as practitioners of hoodoo when members of the community decided that the yard has crossed over into antisocial territory. Victor Melancon of Hammond, Louisiana, was one such person. After he lost his job as a line foreman when a General Motors plant closed down, he began to accumulate castoffs and arrange them in his yard in order to stay busy. He established a route through the residential neighborhoods and woods around his house in Louisiana and walked it regularly, picking up papers and litter, which he burned in his backyard. When he found larger objects that interested him—a chandelier, machine parts, furniture, toys—he searched his large collection of books for information about them and arranged them accordingly. He also arranged some items autobiographically and thematically. For example, he told of having a vivid dream about an old ship, *The Bounty*, which sank to the bottom of the ocean. He set aside a corner of the backyard to commemorate it, piling layers of objects like those people on the ship might have used into a bulky frame of wooden ribs and planks, with the chandelier on top and a furled sail made of a plastic tarpaulin lashed to a mast.

Although Mr. Melancon kept his house painted and his grass trimmed, the aesthetics of the yard did not conform to the birdbaths, bathtub grottoes, and Christian statuary in this neighborhood. Some of the compositions he made conveyed mixed messages, whether he meant for them to or not. For example, the wooden form in figure 2.10 resembles a cross, and the object hanging from it could be taken for a skull. Together, the result looks strikingly like the symbol of Gede, the Iwa (spirit) in charge of the dead and the cemetery in Haitian Vodou.[57] The area around the wooden form supports the visual reading "cross + skull," calling to mind traditional African American graveyards that also contain pipes, vessels, shiny materials, and whiteness.

We recognized these graveyard references. We also thought the wooden form was a cross. But when questioned about it, Mr. Melancon seemed surprised. He explained that while, yes, the pipes and bottles did look like things you see in cemeteries, he did not view the wooden form as a cross at all. He said that it represented an anchor and that the white Styrofoam ball represented what it was in fact used for—a float attached to a fish net. He said that he put the composition together as a memorial to the uncle, a professional fisherman, who brought him up. Then he walked over to two overlapped slabs of wood lying on the ground, with an aluminum sauce pan attached at the point where they intersected. "This is the cross I made. You know the True Cross of Jesus? This is like that. Very old wood. Wood from that day and time."

Yard work goes forward in continual tension between tradition and experimentation, social convention and the unexpected twists that make life interesting and work

Fig. 2.10.
"Anchor" construction in Victor Melancon's yard. Hammond, Louisiana, 1989. Photograph by Grey Gundaker.

worthwhile. Usually, the yard maker's overall reputation for sociability is decisive. A yard that is too big in proportion to those around it can seem antisocial, even if the house and grounds are well kept. Consider this description from Charles E. Thomas's book *Jelly Roll: A Black Neighborhood in a Southern Mill Town:*

> The Jackson house is painted a vivid pink and stands alone on a spacious lot facing the main highway. . . . Although it is no more than 200 feet from the row houses on Thomas Street, it is widely viewed as isolated, unnaturally positioned

("like white folks' houses"), and far too big for a widow. In short, the house has become a symbol of what has become regarded around town as Miss Odelia's uniqueness and anti-social behavior. . . . Miss Odelia . . . is piously devoted to the work ethic. Everything around her house shows a thoughtful hand, from the precise rows of asparagus and potatoes in her ample garden, to the neat what-not shelves in her living room that display her own handicraft. Her home is a visual reinforcement of her . . . words . . . "I was raised to work, I live to work, and all my life I have lived in that joy, and never suffered from want of anything."[58]

This widow had everything she needed but was too self-sufficient to be truly sociable. An atypical lifestyle underlies the labeling of somebody as a possible conjurer or messer with things best left alone. Trash itself can be an instrument of conjure. As Harry Middleton Hyatt observed, "I have described my finding on a public dump the tin-can-covered house of Doctor Dog Face. . . . But *dilapidated house, isolation, queer looks,* while occasionally true, —these are part of hoodoo mythology."[59]

Suspicions also can arise about the intentions of a practitioner when there is no clear reason for things being where they are. Places that look cluttered invite suspicion not just about conjure but about a person's intentions toward others. As a general rule, like the sponge cake and the memorial tree, objects in a yard are diagnostic. Keeping too many castoffs and recycled objects not only causes talk because people regard them as unsightly, but as material signs they can signify something wrong with the household and give pests places to hide. When the

purpose of an object in a yard is unclear, when it fails to serve some obvious, practical function, and fails to meet expectations about decoration, the implication remains that it has some purpose. But what? Given the open-ended possibilities of material signs, everything has multiple potentials for significance. Anything that seems random or out of place introduces an element of the un-predictability of "wild" land into a "cultivated" area, a distinction we discuss in the next chapter. As a result, some of the most moving and artistically innovative yards sometimes prove unpopular with the maker's family and neighbors. This may be an inevitable byproduct of experimentation: an improvised tune blows away on the breeze, but an improvised yard stays put day after day, a visual irritant or a visual feast, depending on one's point of view.

The content of a yard is especially suspect when, like Mr. Melancon's, it includes things associated with death and places that have the random appearance of old-time burial mounds. Graveyard (goofer) dust was a staple of conjure. Materials such as the pebble from the Indian burial mound and graveyard dust gain their potency from the view that the grave is a threshold between material and immaterial worlds where powers from one side cross over into the other. Some of the practices that testify to this view include arranging the last-used articles of the deceased on the grave to anchor the spirit's energies there, instead of at the deceased's former home; placing articles such as lamps and vases on the grave; and planting trees on the grave, themselves "threshold" forms—transitions linking earth and sky. Pipes, broken china, inverted vessels, and mirror-like surfaces can imply that the maker of the yard has activated materials to tie and direct

spiritual power in dangerous ways or will do so if called upon—for example, using objects in the yard to advertise a practice as a conjurer, spiritual healer, or "two-headed" doctor, and perhaps to behave in an unchristian manner.

Seeing Double

As with anointing oils and other substances, the potentials of materials associated with death and burial have positive and negative sides, depending on one's point of view. What may seem to arouse the dead to harm others may offer a modicum of security from the point of view of a beleaguered homeowner. Or, the material may have been assembled with a benign and respectful purpose in mind, as with Mr. Melancon's tribute to his uncle. Above all, material associated with older generations signals that present-day residents have connections to the past: roots.

Conjure and hoodoo may be marginal compared to acceptable forms of healing and religious practice; however, sometimes the physical materials and actions involved are identical. This is true of objects associated with burial as well as candles and house-blessing soaps. Similarly, some churches dispense oils that act beneficially when used to cleanse, anoint, and protect the home and the body, purposes consistent with church-going values. But the same oils can also be "turned" when used by one person to harm another. This is also true of herbs. Thus it often is not clear from the materials alone how practitioners and their communities would classify their use. Nor, even knowing

the context, would they necessarily agree. This ambiguity reflects American and African American diversity. But it also fits notions of power as double faced—neither good nor bad in absolute terms, but only in relation to one's own position and the intentions of the practitioner.[60] Phrases such as "two-headed doctor," work with "both hands," "double sighted," and "four-eyed" attest to the ambivalence of power.[61]

Gemini is the astrological sign and light blue is the color associated with special powers of sight.[62] While the terms "two-headed" and "four-eyed" recur throughout African American history and in virtually all parts of the African diaspora (although the link with astrology is fairly recent), such terms are also vulnerable to misunderstanding. For example, an African American spiritual counselor told us about her disturbing ability to know when accidents had occurred, explaining that she could sense the presence of fresh blood even when she couldn't see it. She pointed to the base of her rib cage: "It's like something flashes in there and I just know, even though I can't see the accident. Like when Mrs. P cut herself down at the other building. I was on my way before anybody called us up here. It worries me. I don't know if it's from God or not." She went on to explain that on a recent visit to New Orleans, she considered consulting a "three-headed woman" about her problem. "This woman was born with something on her face. But I don't think it's still there. I decided not to go. I was trying to tell [a friend] about it but we were talking at cross purposes. She thought I was talking about going to a side show. She thought a three-headed woman was a carnival freak."[63]

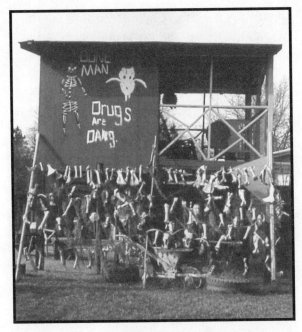

Fig. 2.11

Rack of bones, made by Oskar Gilchrist. Nichols, South Carolina, 1989. Photograph by Judith McWillie.

The idea that some people can see and work on both visible and invisible planes of existence is not limited to conjure and rootwork. Its permutations mirror the openness of materials in yard work that make it possible to cue specific associations, while also leaving room for multiple and diverging interpretations. Nevertheless, there is considerable patterning in the choice and use of these materials in yards. Thus, it makes sense that complementary signs often say "the same things" with different materials in two or more ways— a printed "Keep Out" sign beside the figure of a watchdog, a warning against drugs near an arrangement of bones (fig. 2.11).

This not only ensures effective communication with different audiences but gives a partial translation that helps to direct interpretation. Even widely shared values such as honoring forebears and God can be represented in countless ways, mixing up-to-date technology and icons of popular culture with older forms (note the Darth Vader head in fig. 2.12).

Fig. 2.12

Darth Vader figure and warning sign. Ruby Gilmore's yard, Hattiesburg, Mississippi. Photograph by Grey Gundaker, 1988.

What Wyatt MacGaffey discerned among the BaKongo seems equally true in African American yard work: "The highest and most general powers (i.e., those most obviously of public and collective significance) are represented by relatively abstract forms: wind, water, weather, and whiteness, and the most specific and particularistic powers by arrangements of organic materials."[64] Yet, significantly, the profusion of materials seems to sustain perennial themes rather than diffuse them—wind, water, weather, whiteness remain resources for material signs. Surely, their persistence comes from their integral relationships with land and cosmology.

Zones of Wildness, Cultivation, and Ruin

Wess and Sue Willie Lathern
Oakman, Alabama

O ur interviews with Wess and Sue Willie Lathern began shortly after an article appeared in the *Birmingham News* on Christmas Day 1990 with the headline "Discards Become His Art: Oakman's 'Sanford' Fills Yard; Wife Draws the Line."[1] The headline hinted at the fact that, in the community of Oakman, Alabama, Wess Lathern's yard art was less controversial than in his own household. Sue Willie Lathern was persistently skeptical about her husband's "habit," especially with the comparison to Sanford and Son, a popular television sitcom about a shrewd junk dealer from south-central Los Angeles. But these rebuffs were no match for Wess Lathern's formidable will and energy. He divided his time between a sensitively maintained front yard and an ever-expanding object display in the back that emerged from behind the house and extended into the far end of the driveway. Sue Willie Lathern's regulation of her husband's work was so tenacious that it had a collaborative effect on the aesthetics of their yard.

At the front entrance (fig. III.2), a post flanking a paved and gated walkway supported a sheet-metal square with a lawn mower blade bolted on top in the form of an x. On the opposite side of the walkway, a rotating bicycle wheel was mounted on another pole at the same height. The protective xs and os, so often painted on windows and porches in African American neighborhoods were here formalized—polished and set on posts at eye level. The impression of symmetry was heightened by the custom-built stone staircase ascending to the porch and by the carefully pruned and trimmed trees and bushes in the yard. Mrs.

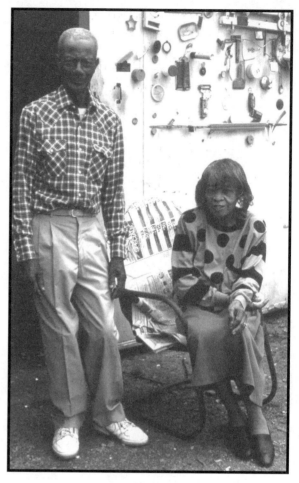

Fig. III.1
Wess and Sue Willie Lathern. Oakman, Alabama, 1991.
Photograph by Judith McWillie.

Lathern tended her roses there while her husband experimented with topiary, training the top of a boxwood near the driveway into an open-centered arc. The arc provided a transition between the formal gardens in front of the house and what Mrs. Lathern called "the old junk place" in the back. In introducing "the old junk place," Wess Lathern commented, "It gives me great pleasure to do it. I'm just decorating. I never saw another yard like this." He "took up the habit" in the 1960s; then, after his retirement from working in the Walker County coal

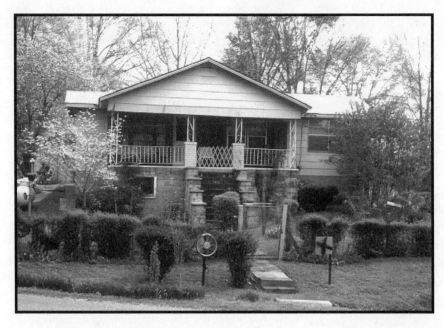

Fig. III.2
Front yard of Latherns' residence.
Oakman, Alabama, 1991.
Photograph by Judith McWillie.

mines in 1974, his hobby became an obsession. Sue Willie Lathern told the Birmingham News that her husband would "spend a whole morning moving one tiny object from one side of the display to another."[2]

"The first thing I put out there was a swing," Wess Lathern remembered. "After that I started putting up different things, then a stove, a washing machine, the old coal heater, and the first lawn mower I owned."[3]

"And I used to sew with that sewing machine." said Mrs. Lathern. "It was my mother's. Anything he see in the kitchen, if I don't want it, he puts it out there, like that Tide box." She pointed to the detergent box with its logo of fluorescent orange concentric circles. Soon friends were adding to the items that Lathern chose with gifts of their own. But, he insisted, "I don't collect nothing that doesn't go in here."

In the planting of the grounds as well as in the construction of the "old junk place," circles were the most prominent image. Wess Lathern repeated them in barrel rings, hose loops, tires, jar lids, hubcaps, fan blades, lamp-shade skeletons, buckets and jugs, armatures from discarded wreaths supplied by the local cemetery, plastic cups, silver flood lamps, baskets, and hula hoops—all accentuated with hundreds of colored safety reflectors.

Mrs. Lathern's rule that the construction be confined to the backyard forced her husband to compose in the spaces between individual sculptures. While he began with relatively large items such as a stove and a washing machine, he had to use smaller objects to solve the problem of containment. This introduced variations in scale and a sense of miniaturization within the work as a whole, resulting in a microcosm/macrocosm effect. Lathern set the armatures for his sculptures out in rows so that he could get among them and work. Visitors, too, could go "inside" and see how each receding row stood slightly higher than the next, the farthest one peaking in the center with a mailbox on a pole topped by a blue light bulb. The most prominent feature of the bottles, their color, was used to spectacular advantage, but whereas the traditional bottle tree would have had its form

determined by the natural growth of branches,[4] Lathern added pipe fittings, bicycle handlebars, and other bifurcated elements with aesthetics in mind.

Over the years the visual field became so dense that, by 1990, the cumulative effect was of a self-contained, aesthetically effusive, free-for-all that neighborhood children had begun to call "The Fair" (see plate 8). Wess Lathern preferred this description to "Sanford and Son" and "the old junk place," although he decided not to assign a title of his own.

Lathern's conscious attention to aesthetics and his welcoming approach to sightseers made it easy for the *Birmingham News* to call his work "art," a distinction rooted not so much in cultural signifiers as in the ingenuity and spectacle of the place. The idea that art involves this kind of individuation may itself be culturally determined, but it is useful in contrasting the attention focused on "The Fair" with the relative neglect of the prominently displayed and beautifully maintained front yard, with its x and o threshold posts by the street. Sue Willie Lathern considered the posts more acceptable than "The Fair." A distinction in kind was being made. The low-key boundary posts, with their subdued color, held traditional signs, however stylized, while the links between "The Fair" and the community at large were less clearly established. It called attention to itself in more direct ways. Thus, Mrs. Lathern felt compelled to draw another kind of boundary, introducing an element of performance into the dynamics of the yard. She once asked her husband to dismantle a complex grouping that had branched away from the main ensemble and crawled up a tree next to the driveway.

The objects Lathern put on the doors of his garage were another significant deviation from the norm. He painted the doors bright cerulean blue (see plate 8) and composed the objects according to their silhouettes, so that the finished work resembled tablets of hieroglyphics. Each object was carefully chosen for its graphic qualities rather than for its history: spoons, bottle caps, cosmetic mirrors, flash lights, paint brushes, locks, and Maxwell House coffee can lids—the ones with the star on top.

Across the driveway, in a relatively isolated patch of ground, a few small constructions stood alone. One had many of the same elements that made "The Fair" stylistically distinct. A metallic reflector with a floodlight in it was mounted in the center of an armature made of bent aluminum tubing. A serrated blue blade from an electric hedge trimmer bisected the bottom of the reflector. Silverized light bulbs of several sizes and varieties were attached. A bright green soda pop bottle and several tubes of stacked plastic cups splayed out from the center. The sculpture seemed animated, evoking a rambling spider with one large eye (fig. III.3).

Within the main body of "The Fair," other sculptures were just as self-contained, but since they were blended into the whole, they went mostly unnoticed. One was a six-foot tower near the back door of the house (fig. III.4). On a visit in 1992 Mr. Lathern insisted on wearing his coal miner's helmet and standing next to it while holding up a plastic doll, also in coal miner's regalia, with "West" written on its shirt. He and the sculpture were about the same height. Its base was a black tire with slashes of white paint on the tread. This particular sculpture had a front and a back, while his more autonomous works were composed in the round. Lathern had a virtuoso's understanding of visual transparency. Large plastic hoops in graduated sizes were wired to the column, giving it symmetry and

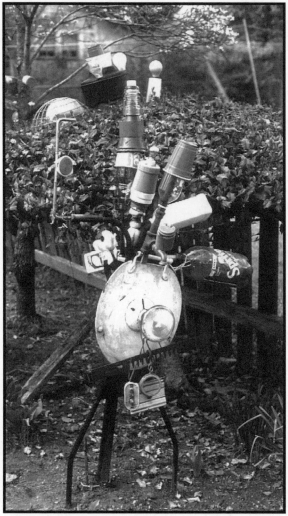

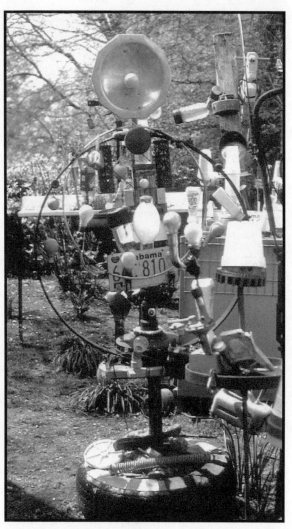

Fig. III.3
Construction in Wess Lathern's yard. Oakman, Alabama, 1991. Photograph by Judith McWillie.

Fig. III.4
Construction with hula hoop, tire, license plate, light bulbs, and bottles in Wess Lathern's yard. Oakman, Alabama, 1991. Photograph by Judith McWillie.

closure. A pear-shaped mercury vapor bulb was positioned within the center of the hoop at the height where the heart would be in a human figure. The requisite reflector-with-light-bulb was again on top. As Lathern stood beside the sculpture in his coal miner's helmet, smiling widely without explaining anything, it suddenly became obvious that it could be his self-portrait.

Another sculpture even more directly linked to Lathern's integrative skills stood next to the fence by the driveway. It was a stacked arrangement of ceramic pots, concrete pipes, bricks, and cinder blocks (fig. III.5). These were dressed with an electric steam iron and a lamp supporting an inverted colorless bottle. An isolated blue light bulb rose out of the top of the base parallel to the bottle. A piece

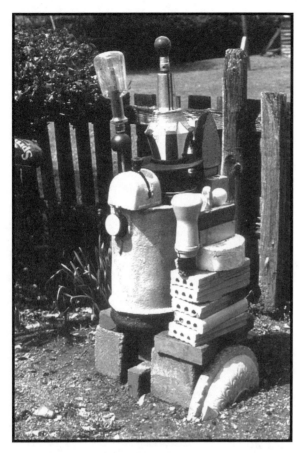

Fig. III.5
Construction in Wess Lathern's yard. Oakman, Alabama, 1991. Photograph by Judith McWillie.

at INTAR Gallery in New York. When questioned about his thoughts on being called an "artist," he reiterated his earlier statement: "It gives me great pleasure to do it. I'm just decorating. I never saw another yard like this. I try to make them beautified. I replace things sometime." When the exhibition's curator told him that "some people would give thousands of dollars for things like these," Sue Willie Lathern perked up and replied, "And they'd get it too. I don't say much, but I *will* come in then."

After the exhibition, Lathern added many new elements to his yard and garage doors. "Star" coffee jar lids now cropped up everywhere. There were scores of new bottles and silver fan blades. Hubcaps were newly wired to the towers within "The Fair." A clock face and a woman's handbag appeared under the eaves of the garage. A dead car radio became a face when Lathern put a set of false teeth on it. An open umbrella was now suspended over the "self-portrait," but hard winter weather had stripped its fabric except for a few strands hanging between the staves like a spider's web.

The physical resemblance between a light bulb's forward-facing base and the human eye was doubly reinforced when Lathern wired a large Styrofoam ball to the umbrella and painted a black circle on it. The construction in the tree that Sue Willie Lathern had made her husband dismantle was back and twice as large. The space between the main body of the work and the "grave" sculpture by the fence was now completely filled.

"The Fair" had only one overt reference to the Latherns' Christianity, a small cross, about two feet high, with a clear transparent bottle upside down on top (see plate 9). Twin metal plates were mounted on the arms, each showing a set of serial numbers and the word "MUTE" in block printed letters and "silencer" in a smaller type face. A red plastic flower

of ornate circular molding was sunken into the ground at the base with only the top half showing. There were no pockets of space to see through and no whimsical digressions. The iron stood like a gothic arch above the semicircle of the base. A peg next to the iron supported an inverted blue household cleanser jar in the shape of an hourglass. In this one-of-a-kind statement, Lathern condensed the elements of traditional grave decoration and clarified a vocabulary that was otherwise diffused throughout the site.

In 1991, Lathern was invited to participate in the exhibition "The Migrations of Meaning"

was wired to one of the arms. "I belong to the church that God set up," Lathern said. His wife agreed: "See, anytime you in Christ Jesus, you are holy and living God's commandment. Some people call it 'holy' 'cause it's the church, but the building doesn't mean anything."

Although the Latherns mentioned no explicit connection between the yard and their religious faith, Mrs. Lathern's regulation of what she saw as her husband's tendency towards excess had both aesthetic and moral implications. Wess Lathern repeatedly made it clear that he relied on his wife's judgment. "We've been married fifty years," she explained, "That's a long time for any woman to stay with a man, isn't it? . . . I first confessed religion when I was a kid and I've been living it. The elderly people would tell me, 'Cry mercy and He will change things.' I was seeking my soul's salvation until it looked like the trees was saying 'mercy.' My mother would send me out early and she would come at night and I'd already be on the moaning bench. That's 'moaning,' like sinners be moaning, not 'morning,' like 'in the morning.' The moaning bench." Then Wess Lathern began to discuss his own conversion experience:

> I was born again in nineteen hundred and twenty-five in August on a Thursday. It's a feeling like he told Nicodemus about the wind. You can't see it but it's a feeling. The way the wind blows is the way the Spirit is. You know not whence it come from or where it goes. So it is with the Spirit. It put love in your heart. Before I got born again, I was in the world. I chipped out a little bit after I got born again too. I tried that. But you can't do that. I'm not saying I didn't go wrong, but what I mean is I didn't accept it. I got up in the church one day over there and I promised the Lord I'd stay with him till I die. That was

the first one. And the second one was when I said I'd stay with her till I die. And I said, "Lord help me keep that with her." Two rights gonna agree; two wrongs won't agree. . . . When God done fixed you up, you don't want no part of the world.

After the exhibition in New York, Wess and Sue Willie Lathern's work traveled to a community arts festival in Tuscaloosa before being reintroduced into the yard a few months later. Mrs. Lathern remained a little ambivalent about the attention "The Fair" was getting, but she found a new means of addressing her husband's "habit" while, at the same time, reminding him that God's mysteries go hand in hand with the intrepidness of skill. She planted tulips around the outer rim of "The Fair," their brilliant red temporarily outshining the colors of the plastic cups and bottles so abundant in the rest of the yard. "You come by again sometime and see the azaleas too, when they're out," she said.

Eddie Williamson (1922–1990)
Memphis, Tennessee

The intersection of the Southern Railroad and Highland Avenue in the Normaltown neighborhood of Memphis, Tennessee, is a busy urban crossroads that divides the campus of the University of Memphis from the mostly African American Orange Mound neighborhood to the west. From the late 1960s until shortly before his death in 1990, Eddie Williamson lived as a "squatter" on a narrow grass right-of-way flanking the railroad tracks. There he worked on a vast assemblege that art students named "Parking Lot Eddie's Bottle Garden" (fig. III.7). Williamson functioned with

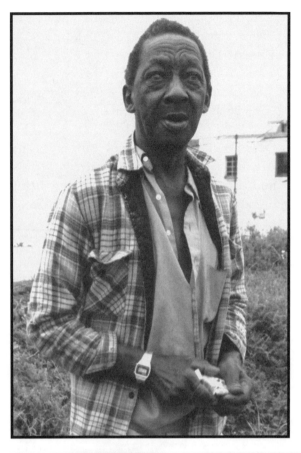

no supplies other than the detritus of the surrounding neighborhood, although he had once studied photography at the Art Institute of Chicago on the GI Bill.

The focus of Williamson's life, as well as his contributions to the neighborhood, revolved around this 150-by-25-foot work. Assembled from discarded bottles, sprouting stalks and seedlings, carpet and fabric remnants, mattresses and bedsprings, oil lamps, shopping carts, chrome hubcaps, and other found objects, the Bottle Garden was a cultivated oasis whose design honored the horizontal sweep of the railroad tracks and recalled the patchwork

Left: Fig. III.6

Eddie Williamson. Memphis, Tennessee, 1984.
Photograph by Judith McWillie.

Below: Fig. III.7

"Parking Lot Eddie's Bottle Garden," looking east.
Eddie Williamson. Memphis, Tennessee, 1984.
Photograph by Judith McWillie.

grids of rural subsistence gardens. Its parameters were marked by glass bottles set in troughs next to the street curb (fig. III.8). Other bottles were planted in rows, creating discrete zones within the site. While transporting found objects, Williamson often filled discarded jars and buckets with cuttings from plants that had somehow managed to break through the neighborhood's veneer of concrete and asphalt. Within a two-block radius of the central installation, he cultivated patches of exposed earth, pulling weeds from the crumbling edges of parking lots where they intersected the bases of buildings, exposing enough raw ground to plant zucchini and watermelon. These he later harvested and distributed free of charge to patrons of an adjacent strip mall. He sometimes camped in a pyramid-shaped shelter in the center of the display; later he moved to a used car parked next to a meat market.

The neighborhood's merchants and restaurateurs championed Williamson, but a few transient motorists complained of the "junk yard" adjoining the railroad tracks. Houston Brown, owner of the Southern Meat Market across the street, marshaled support from a local television station and hired a lawyer to represent his friend in court battles with the city health department. "As long as it was at least twenty-five feet from the center of the tracks, the railroad allowed it," said Brown, who added:

> The city health department got onto him, but all three cases against him were dismissed. This was back in the 1970s when, unlike today, it was illegal to live on the street. At one point they tried to prove him mentally incompetent, so Channel 13 got a psychiatrist who declared him sane. Another time, when he

Fig. III.8

Bottles bordering street held in place by carpet remnants. Eddie Williamson. Memphis, Tennessee, 1984. Photograph by Judith McWillie.

> was living in the car, they said he had to store his belongings at least eighteen inches above the ground. That was when we got the shopping carts in order to be in compliance with that law. Eddie refused Social Security and his service pension, not wanting to take any money from the government. He earned what money he had from cleaning up the alleys and parking lots. It's the way he wanted to live and he deserves credit for doing what he wanted to do. He was just different, and he was going to do what he wanted to do regardless.

Four years before his death at the age of sixty-eight, Williamson permitted the city to bulldoze the site since ill health prevented him from further maintaining it. He continued to live in the car next to Brown's meat market, planting seedlings in Styrofoam cups and placing them at the bases of telephone poles.

Eddie Williamson Narrative

Memphis, Tennessee, 1986

I have lived in this part of town, oh, roughly twenty-five years, I'd say. See, when you live in a 'home house' where you always dwell, it supports your memory, but when you get out something like a wild bird, well, I meet so many people.

Oh, I was looking for work. I lived about a mile west of here, and it's in walking distance if you don't have bus fare. So I had walked around here looking for yards to cut, yards to clean, domestic work. And at the same time, if I could find something in commerce, why, I would have preferred it because the residents are informal in their payments [for yard work] and you don't make as much as a rule. And I got stuck, and so one day I passed by here and the cook came out and told me that the boss, he wanted to see me, so he started paying me, I think I was making five dollars a day. All I did was just hang around, take out the garbage, take out the boxes, and [I had] all I wanted to eat and drink. I thought it was real nice. And it was in the fall of the year, winter was coming, and I had no place to go, and I just kept it, and I just stayed here.

You see, I live by the railroad track over here. I live in an area that is closed after six for the most part, and those commercial ventures have a lot of boxes and I work with the meat market for disposing of their boxes to keep from having a twenty-five-dollar pick-up every day. That's the Health Department's policy. And the boxes that I stack up, the men that pick them up, they sell them as pri-

vate contractors, and the businesses don't have to worry about having boxes scattered around over the entire area, because the trucks, they won't pick up boxes like that. So that's the box story. I'm just trying to make a living and help others as well.

[The bottle garden], that's like a constructive occupation, when you don't have nothing to do, and you don't want to go crazy, and you don't have no money. You know, if there's something you can do to improve the things around you and yourself, why, you do that. I mean, I don't eat out of a garden or nothing like that. I was trying to get enough of them [bottles] to circle the places I was trying to hold onto. I never did, though. I eat out of the store, or even a restaurant, or even the butcher shop and don't have to spend as much. That's just how it is. And the dual purpose: this grows up [*pointing at vines growing on the ground over cleared earth*]. One year I had this whole wall lined with zucchini squash. They have great big foliage, big old green squash. I gave them to everybody in the neighborhood. They make salads with them. I didn't even know. I went to the hardware store and saw the zucchini seeds. And the grass used to peep up, and I'd have to scrape it up because the grass pulls up this asphalt. So I just planted some gourds, had a whole lot of them one year.

I used to go to the grocery store. I try to have gardens wherever I stayed to make it look like I wasn't a hobo or something. I got rotten fruit from over there, cause they were clean people. If a peach or an apple had a speck on it they threw it away. See, there, peaches [peach trees]. There are two right together. There are seven or eight of them. See, it's like I said:

I thought if I had to stay here, I might as well do something constructive. There's an apple growing out of an old stump. Sometimes I didn't even have time to plant them. I'd just throw them on the ground; then when I got a chance, I take a shovel and cover them up, and they'd come up the next year. But it sure takes a lot of worry. Of course I knew what I wanted first. But you wouldn't think of renting a room and going around and planting fruit trees on the property because you wouldn't get permission to. Yes, [I planted] all those fruit trees except for maybe one bush. They're all peach, nectarine, and apple. Every one. From seeds.

Between fifty and a hundred [birds] come over here, and they be eating all day long. I get stuff from the Chinese restaurant and anywhere else that I find food at. Any place they have assets at, I get it. I even bring twenty, thirty pounds of chicken eliminations, chicken, turkey, duck. And they like corn. And those shreds they make salads of. . . . Some of the birds are black all over with yellow eyes and yellow legs. A cardinal came over. But mostly it's sparrows and starlings.

The railroad never did ask me to move, and [I put] the bottles around it. I was staying. Since I was staying—I guess I had been there a couple of years then—I had established a sort of feeling, like home, see, so I put the bottles around it. I grew a garden around it like now, planted melons and stuff. I'd give melons to people who come by and across the track I planted peach trees and they were bearing. And that shows a nice aura about somebody you'd call a vagabond or tramp. . . . I tried to make it as much like

I wanted to live here as possible, even though I didn't think I would like it.

The railroad got lots of complaints from different people so finally they sent a health inspector down here because I was so closely associated with them. So finally Mr. Brown [Houston Brown, owner of the neighborhood meat market], he got tired of it [the harassment]. See, I was over there in the corner. He works very hard. . . . See, he came up from about the same background as I did. Somehow or other he got into the grocery business.

You mean [you want to know about] that improvised house? That improvised shack? [See fig. III.9.] Well, it was in the winter when I got put out of the parking lot over there by the butcher shop. They just told me to take my stuff and put it over there on the railroad track. And the only thing that I could find, 'cause you know it was night and I had to go to bed that night and get some rest, and you know you can't bathe and shave like you do at home, so I got four used store shopping baskets and just put them together and put, uh, threw some big cloths or quilts something over the rugs over the top. I usually kept junk like that around. Then if it rained I wouldn't have to move so fast. I had to take note of the terrain, where it sloped, where to put it. I found out later I couldn't get too close to the railroad but I wouldn't have got that close no way.

But I didn't want to get too close to the street neither, cause the trains weren't as frequent as automobiles, and a lot of times a wreak can happen and it spreads. As days passed, I stretched it so that if it rained I would have someplace to lie down. And then along came a lot of

Fig. III.9
Improvised shelter by Eddie Williamson. Memphis, Tennessee, 1984. Photograph by Judith McWillie.

fraternity people. They just came over there and tore my place up. Came a whistle about nine o'clock and somebody called, 'Hey, how about coming out and having a beer?' I didn't want beer, I said, 'I'm OK, everything's fine.' I didn't even go out. It was hard to get in and out, harder to get in and out of than this car [where he lived at the time of the interview]. This car is tight. They started throwing rocks at it, hitting on the side of it like they was going past. Then they jumped on the top of it and broke the pallets and things that I had the roof made out of and then fled across the tracks. So I went and called the police, and they told me to let them know if they came back. I think they were in a pickup truck. They were all loaded on the back and I think they

were six or eight or ten guys on there. And that's what they did. And it kind of scared me too, because didn't anybody hardly ever bother you like that. Everybody around here knew me, and they wouldn't [do that] so it was youngsters and they, it looked to me like a made-up tale or a premeditated plot because they were students in college, and they were old enough to plan something like that.

Then there is a distaste for integrated living in this area. They had to work on that. I mean Negroes, the races; they had to work that out. But they did a lot of bad stuff in here, then they went on back out to Memphis State.

I was in the army, but I wasn't in long because I didn't agree with the contract. After World War II all discharged veterans had an opportunity to go to school at government expense, and your time was determined by how long you served. My six months or five-and-a-half

months gave me nine months on scholarship. I roomed with a relative, an aunt. I couldn't go to school down here, and I didn't have the money anyway. So after I come out of the army I went back up there, you see, I could go to school because I had nine months' tenure of a scholarship so I used it. You see, in your first year you do your introductory courses where you set your goals, you set your form, you register what you want to do. I wanted to do something where I could make a living and at the same time sort of like what I was doing so I wanted to be a teacher. They give you a variety: designing, painting, sketching, oh uh music, camera art, and everything. You have to participate in everything possible. There was a difference between camera art and what they call the 'fine arts.' The camera wasn't considered too much a part of the fine arts. It was a distinctive commercial venture. It was just like a sign painter or a commercial artist who sold, who painted window signs or things of that sort. But things must have been changing . . . because we were advised to use cameras as much as possible. It gave a commercial slant that a painter or a sculptor or a real art student wouldn't think that way. . . . Of course, it's a private institution: the Art Institute [of Chicago] and Goodman Memorial Theatre. They're set one behind the other, but I never took acting, you know theatrics. No it was a real nice place. I enjoyed it. They had two big lions sitting out front on Michigan Avenue, and of course, it's right in the heart of town. It's not in the middle, eyeball and center, but it's on Lake Michigan. Writing, literature, they are associated in the fine arts. And the life of an artist or a writer in the fine arts—these artists—they're too poor! They have to live off of too little! And they can't relax and be civilized human beings and exercise enough intelligence to take care of themselves and be secure, so I would have preferred doing it commercially. But I like to read and things like that. But when it comes to writers—there are too many poor writers. And it takes them so long! It's just like being a painter. You've got to be chosen by the environment that you paint in unless you finance yourself. And very few students are able to finance themselves, or even their parents. And if they do, they don't want to. The rich ones who could, they don't want to. The study of art gives you such an accentuation on individuality that you're likely to—you wouldn't be able to give the public an accurate description of what you're talking about as a personality. You would always just show yourself. Take art you've probably studied, Vincent Van Gogh and people like that. What did he do? Cut his ear off? All that kind of crap? One-eyed, one-eared, living, trying to paint common people over in Holland or wherever his home was?

Your functioning of your senses depends on a lot of mental work and rationality along with it. You have to sense, reason, and decide for a given period of time, and ain't many people can do any of it at no time. For example, take a sight-seeing tour to a place you've never been, and you find that your senses are fully occupied if you are interested in what you are doing and want to know, and when you get back, you're so tired you feel like you've been plowing a mule or something, and you got to lay down and rest.

Fig. III.10
Eddie Williamson's site after destruction, with new seed cultures in Styrofoam cups. Memphis, Tennessee, 1986. Photograph by Judith McWillie.

This is where a couple of dump trucks and tractors, they just picked all that stuff up in about an hour. They must have started about six o'clock because I was up at seven or seven-thirty. When I looked out here there was nothing. . . . I saw a couple of white trucks, and they had put it on the trucks. They must have made more than one trip. They had one of those blades like what the city uses on the streets, and they must have scraped it up in the shovel and put it on the

dump trucks. I had been given warning. It wasn't a very lengthy warning. I was told the day before they did it. I was told 'if I wanted anything off there,' because the city'd send somebody out in a day or so, and they were going to pick it up, so they did.[5]

Lonnie Holley (b. 1950)
Harpersville, Alabama

Lonnie Holley spent most of his youth in foster homes until he was fourteen, when his grandmother adopted him and taught him to pick through dumps and landfills for items to sell at flea markets. He cites her intervention as a turning point in his life; yet he endured years of economic stress and spiritual uncertainty before finding his way. A gifted poet as well as an artist, he educated himself in African religions and philosophy by reading popular texts. In his youth he explored Islam and Christianity as well as African American spiritual religion.

His first art work was a tombstone for his sister's two children, who had been killed in a house fire. At the time he was living in a caretaker's house in an African American cemetery, later moving to a one-acre tract of land adjacent to the Birmingham, Alabama, airport, where he received a continuous stream of curiosity seekers and art collectors primarily from the "folk" and "outsider art" constituency.

In 1987, when we began interviewing him, his compound by the airport had become a monumental site-specific work constructed from cast-off objects intermingled with raw sandstone, a byproduct of the local steel industry, which he carved into dynamic sculp-

Fig. III.11
Lonnie Holley. Birmingham, Alabama, 1987.
Photograph by Judith McWillie.

Lonnie Holley Narratives
Birmingham, Alabama, 1987

The Spirit have gave it to me like this: a sun shine for each time period, to show the difference in them. . . . It seems like one big cycle from within, like a spring. You start at the innermost part of the spring and you move outward as you grow. And as you grow, this materialistic body, which is flesh, takes its place, acts, then it falls back to the beginning to recreate itself. Man was supposed to know all about all the things that had been created on earth from one time period all the way to another. God has blessed us, man and woman (she's the continuation of mankind). The children turn into the world itself. Man thinks there is not enough space to maintain life. Life has its own limit of growth, also; one would not have gotten in the way of another. But God has His way of plucking one part of growth up, like you pull up an old corn stalk, shaking the soil off and putting it down where it can fertilize the ground for a new grain of corn. So I'm sure that everything that has happened—all the ancestors that have had to pass away in order for the earth to be as it is—they was playing a part, like I'm playing a part in life today, just living and creating. Then I'll fade away and kind of fertilize the soil around my children. Then they'll live, and they'll get children and they'll die to fertilize the soil around theirs.

I'm cultivating the roots of a new seed from an old source. To deal with me as an artist, and see all of my art as art and not just as garbage or junk, is to see that I went to the depths of where no one

tures reminiscent of Meso-American and Egyptian art. The cumulative effect of the massive volume of works in the yard was of an endogenous universe where nature and technology perforated and tunneled into each other almost seamlessly. Recurring themes included the eternal mother as the origin of life, the organization of knowledge through ancestral continuity, and the reciprocal exchange of matter and spirit. By 1991 he had begun to support his wife and five children with the sales of his work.

Fig. III.12
Lonnie Holley's residence.
Birmingham, Alabama, 1987.
Photograph by Judith McWillie.

Fig. III.13
Detail of Lonnie Holley's yard with sandstone sculptures.
Birmingham, Alabama, 1987. Photograph by Judith McWillie.

else even would go to speak for life. God said, "I made enough in your yard that I could show my people how to change," and I have to work it all right back out of me so I can come back and handle another one. And that's what keeps me from going insane; and I think that's the way it is with every artist.

Birmingham, Alabama, 1991

I pay tribute with my mind and with my labor to the Spirit—something which is grander than time. I think about the seriousness of art. I also want to speak about the spiritual part of art. I have to look at it this way, that I'm serving time. All those bodies that has passed through time (leaving them nameless, they are there), I must keep their respect or else fear that I will lose all that I have gained.

I think respect for the elders makes community. Once that respect is lost, there is no longer a community because if we lose respect for that from which

Fig. III.14
Detail of Lonnie Holley's yard. Birmingham, Alabama, 1991.
Photograph by Judith McWillie.

we came, we are somehow or another on the journey to losing our grip with reality. And art allows us to keep that grip. If I had not started looking back to appreciate, I would have went on disappreciating and destroyed not only myself but the whole world around me. We don't need artists destroying themselves. The Spirit that inhabited the great ones of the past, do you think that it would not inhabit you?

The mind is like the body. It have to put on clothes. When we find the master force of life—love being the nurturer, the pacifier—I can see the mind that lays a law, and have to think a law, and walk a law through life. Everybody is fearful that the world will come to the point of being destroyed. It's not; it's the mind that will come to a point of stopping to think in the order that it is in and think in a new order.

That's the whole point of the spirituality of it. I'm looking at that baby who was five thousand years in the wombs of time and saying, "It's all right, your space is secure—we made sure."

Hurt comes to an artist. It stays with his thoughts because if you're the kind of artist that is able to think and never cut off your thoughts and you is the type of artist that reduces things to their lowest terms, you just don't take things and say, "It's OK; it's OK that the grass is growing; it's OK to step on it, and it doesn't matter." If you have the type of knowledge that you know when you step on that grass

Fig. III.15
Sculpture by Lonnie Holley in yard.
Birmingham, Alabama, 1991.
Photograph by Judith McWillie.

you are putting pressure on the root and the soil around it and also mashing the moisture from it—knowing that you are causing something to happen—that's what makes the difference. We're talking about a divineness here; we're talking about a divine level. I hope that this will allow others to see all that need to be done and how much we have to do it with. Once upon a time, to come into life cost man nothing. How have we allowed the values that we have proclaimed to be in the way of a continuation of life? These words are said for time and times to come.[6]

Kinds of Land and
What Happens There

There is nothing quite so alluring in Virginia as a forest in a
thickly settled neighborhood.

—Lydia Wood Baldwin, 1884

When the whites moved away they left their dead behind. . . .
Believing in the high nitrogen content of dead white people,
some of the farmers had knocked down the gravemarkers,
plowed up the plots, and planted soybeans or peanuts where
the cemeteries used to be.

—Hal Bennett, 1966

Spatial Divides

In their content and use of space, Estelle
Hamler's, Olivia Humphrey's, and Sam
Hogue's yards in portfolio I each have
a distinctive style and personal approach,
but clearly they also have much in common.
They are located within the same city within
a mile of each other, but in addition to
recurring materials and imagery, the common
ground they share includes similarities in the
ways the spaces have been organized. Each
yard comprises a main area and a secondary
area differentiated from it. The secondary
area lies on the "other side" of a driveway,
and its content contrasts noticeably with
the rest of the yard. Like the line "Who do
/ hoodoo you love?" that calls for doubled

hearing, the spatial organization of these
yards, and many others (like the Lathern's'),
calls for vision attuned, both seriously and
playfully, to more than one "reality." The
Hamler, Humphrey, and Hogue yards not
only have more decorative touches and
lusher plant life compared with their
neighbors, but they also set up a contrast
between two distinct kinds of spatial zones,
albeit in somewhat different ways.

In the Hamler yard, a fence encloses the
main area, which is relatively formal with
symmetry, straight lines, clear surfaces, and
individuated plants dominating the design.
The colors red and green recur, from the trim
of the porch and vibrant leaves of the philo-
dendrons to the hibiscus flowers, the painted
tires along the east edge of the yard, and even
the bird feeder. On the other side of the drive,

the closest things to fencing are several bed headboards set at angles with open spaces between them. Here, the plants are not separate individuals; rather, they run into each other and around the various found objects in the area. On this side of the drive, the dominant color is white, enhanced by flashing silver and glass, and in Mrs. Hamler's own word, the contents are "antique" and belonged to past generations of her family. It is impossible to mow the grass in this area into a lawn. Its heights and densities vary, although Mrs. Hamler controls it enough to keep it from choking out her irises and candy tuft.

In the Humphrey yard, color is also the axis of contrast. But bright white furniture, ornaments, and gravel dominate the main, more formal area of the front yard, while across the driveway a mix of subdued colors and rougher surface textures of earth, wood, and rusting metal creates a backdrop for a memorial made of a large bowl of water, worn white shoes, and white vessels toned down by use. Mr. Hogue's front yard echoes Mrs. Hamler's in its varied colors, manicured surfaces, symmetry, and grid-like structure. However, the set-apart, white-painted memorial area of the yard is relatively small and seems to float in the grass of the backyard like an island. It consists of a series of three concentric rings moving out from a white dogwood in the center. The first contains statues of angels, birds, and animals; the second, a ring of ten-inch flower pots inserted in the soil with rims raised above it; and the third, a metal fence. All of these materials, including the seasonal flowers, are repainted and replanted annually. But like Victor Melancon's memorial to his uncle, it is these set-apart areas, with their use of cast-off objects collected into unusual

assemblages and their references to the other world and the dead that differ most from other yards in the neighborhood. If a yard causes unfavorable comments, it is nearly always in reference to these areas.

Across the River

Although Hamler, Humphrey, and Hogue had heard about each other through mutual friends, service organizations, and church contacts, they did not see their yards as linked in any way. What Mrs. Humphrey and Mrs. Hamler had most in common was an interest in neighborhood improvement, an active role in their respective churches, and a fondness for antiques. Mrs. Humphrey had met Mr. Hogue and knew he liked to garden and make whirligigs, but she did not consider this unusual. Each voiced similar attitudes about the commemorative zones in their yards, emphasizing that what people do to commemorate loved ones is "their business," that, while commemorations are visible to others, this visibility is integral to giving honor and respect, although it is unnecessary, even rude, to discuss them. When asked specifically about the similarities between their yards, replies were benevolently nonspecific. "She sure has pretty flowers," it was said of Mrs. Hamler. "His wife was a wonderful lady" was an observation about the late Mrs. Hogue. All were willing to allow their yards to be documented, discussed, and written about as if they were singers or poets whose work was worth recording on its own merits. They saw their work as a means of letting future generations know about special

African American yards at the turn of the twenty-first century.

From the makers' points of view, these yards were special only because they elaborated more than most of their neighbors' yards did on what any home ground should be: a secure place for all generations of the family, including the dead and the as-yet unborn. Yet, further conversations with them reveal significant similarities in their aims and intentions. Mrs. Hamler calls the zone across the driveway her "little woods" and the objects in it her old "junk" and "antiques." She says that these things help her to remember past generations of her family, the work they did, and the hardships they survived. The old iron pots and vases in Mrs. Humphrey's special area belonged to her mother. Mr. Hogue's white circle commemorates his late wife.

While the main area of each yard aims to look neat and show the self-respect of the household in the present time, the zones set apart look toward the past and the future: a past inhabited by beings now approachable only in memory and spirit; a future shaped by hope that the living and the dead will meet again on the other side of the river, which in urban settings is often evoked in the driveway. Characteristically, E. M. Bailey, an Atlanta yard artist, embedded a cast concrete diamond-shaped plaque in his driveway with the inscription "Remember to Die" (see portfolio II, fig. 5) and the diamond-shaped impression on Rev. Hesikiah Allen's grave in Sunbury, Georgia (portfolio II, fig. 1), is bisected by a horizontal line, recalling the Kongo (and wider Bantu) idea that water separates this life from the one beyond and that crossing this threshold takes the soul into the land of the ancestors, *kalunga*.[1]

Care of Land

As Eddie Williamson's comments make clear, yard work accords with the value that land is not empty space waiting to be claimed; rather, any area designated as ground for human life must be made and kept up. Creating and keeping the land asserts a family's roots in the community and establishes the right to have a say about what goes on there. The homes of patriarchs and matriarchs ideally combine the essential ingredients of roots: emblems of connection with the past and signs of accomplishment in the present. The wheels in the Hamler yard that say "we're rolling" attest to the state of the household now, but they also recapitulate the ancestral spiritual:

> I'm a rollin'
> I'm a rollin' through an unfriendly worl'
> I'm a rollin'
> I'm a rollin' through an unfriendly worl'[2]

Such signs also show landscape set apart as "cultivated," distinct from land that is fallow, forested, or "wild" ("in the bushes")— places where obstacles may prove greater than one's ability to overcome them. A yard thus established shows the "outside" world a place where it is possible to round out one's being and fulfill one's destiny despite opposition. If the yard is in the city, the same principles apply: the streets outside may not be especially dangerous, but they remain relatively unpredictable.

Land can shift between the categories of "cultivated" and "wild," both of which have their own integrity, but "ruining" land is an affront to creation and the result of irresponsibility. This comes through in the

words of a gardener from Kentucky in the 1930s: "Plant anything in God's ground by de moon en de crops would grow. Now they jes butcher up God's ground en put ole stinky messy fertilizer on hit an de crops jes burn up. Nobody outer mess wid God's ground."[3]

This philosophy also accounts for the old belief reported by Hamner Cobb: "It is bad luck to turn out a garden; that is, to abandon it and move the site elsewhere in mid-season."[4] Turn-of-the-century accounts also stress an acceptance of forces of chance, such as the weather, which some called fatalistic. However, cultivation of the person involves finding a way to stay positive whatever the climate. Describing conditions in Virginia in the 1870s, the farmer in the passage below talked to himself in a parched cornfield as he cut dry blades from stalks that ripened prematurely because of a drought. He called God "Ole Mas'r," neatly shifting ultimate power out of the hands of the landlord:

> What fur de rain don't come and fill out dese nubbins? De drouth burn de sap out'n'um. Mighty pore craps we make dis year suah; mighty pore 'baccy crap, pore corn crap. I respect ole Mas'r knows best; if we observe de rain and de shine He'll send de weather f'r our craps. De t'ing we got to do is to 'serve our blessin's an not trouble 'bout de rest. Dis is toler'ble good blade fodder, better 'n I observe suah.[5]

Archibald Rutledge recorded a similar view of God and weather:

> One day I visited a wild sandy hummock in the immense wilderness of the great Santee Delta. London Legree and his wife lived there—all alone and many miles from the nearest human habitation. Cleanly, thrifty, self-sustaining, they lived like pioneers amid that vast solitude, surrounded by primeval wilds, a paradise for game. . . . On the eve of my departure, a heavy thunderstorm rolled up, its solemn panoply investing the heavens. Darkness was under it and before it. Standing in the door of his cabin, I was lamenting to London that I should be long delayed in my return home.
>
> "Never mind," . . . he said. . . . "Hanna is stronger than the storm."
>
> *Hanna* is a pure African word, personifying the sun. In that brief sentence, what faith, what hope! . . . How positive in its affirmation of a philosophy of optimism! . . .
>
> On a magnificent mausoleum in the cemetery in Winchester, Virginia, are these sad words: "The shadow was greater than the sunlight." And I contrast them with the brave words of London Legree, "Hanna is stronger than the storm."[6]

Rutledge continues with a further comment on "the plantation Negro," weather, and faith:

> [H]e rarely criticizes the weather, and he does not like to hear it criticized. This is because he accepts all natural phenomena as God's work. Often I have been gently rebuked . . . for complaining of heat or cold, rain or wind. Once when I said to old Rose, "This is a terrible day," she . . . replied, "We must not forget that God made it, sah." This spirit . . . is widened and deepened into an equally calm acceptance of the chances of life.[7]

The same outlook prevailed for some of the gardeners with whom we talked. Mrs. Ruby

Gilmore of Hattiesburg, Mississippi, for example, grew corn, greens, and sugar cane in a vacant lot across from her house. As we discussed the intense June heat, she remarked that last year she watered her corn but it died. This year she said she would not water; she had seen her error and would leave watering to the rain that "God gives in his own time," a sentiment echoed in the clock-like timer she placed before her door and in her regretful acceptance of the shooting death of the grandson whose grave she decorated.

In addition to weather and timing, another aspect of care of land has to do with working cleared ground properly. In her autobiography, Eula McClaney (born in 1913) relates that people used the phrases "one horse," "two horse," and "three horse" to describe the scale of farms in southern Alabama where she grew up, a calculus based on labor rather than acreage:

> We put in a lot of hours and endured a lot of discomfort to get almost nothing. But, that was our way of life. We would start preparing the ground and planting sometime in March. The first thing we do is arrange to get the money to start farming. . . . The owner of those farms, the *"bossman,"* would lend us the money which they referred to as *"letting you have the money to run your crop."* . . . The owner . . . would let us have a little money each month, for maybe four or five months, while we were *"making the cotton."* [8]

Although enslaved people and tenants did not own the land they worked, they had definite ideas about its care. In the years following the Civil War, the term "old field" referred to land that had been ruined by human misuse or neglect. Here, an African American woman from Virginia explains the term to a newly arrived white teacher as they walk down a country road. In this story, "old field" resulted from the negligence and the unwillingness of the planter class to get their hands dirty in earth where African Americans had invested years of labor:

> "Dat am my ole home! . . . Mighty nice plantation in slave time, b't sort o' run down now—heaps o' good lan' turned out ter ole field."
>
> "And pray what is that?" queried Marian.
>
> "Why, when dey don't raise nuffin f'r years an' years, an' de pines done spring up eb'rywhar, an de branch lan's done go ter swamps, an' sumake an' sassyfras choke up de good lan' so it's all a waste o' weeds an' brambles an' dewberry vines, dey calls it 'ole field.' Dar's a big plantation ober yere called King's Ole Field case its all turned to ruin. . . . [Th]e lan' am worked on shares now; an' de men jess picks out de good spots, and don't use de grubb'n' hoe like dey used ter in de ole time. Dere wa'n't no sassyfras 'lowed den ter grow in de cornfield!" [9]

More than recipes for economic success, obligations to land echo those owed to people as well: to ancestors, known and unknown, who invested their labor, sweat, and bones in the land, and to the children who will depend upon it throughout their lives. [10]

The injunction not to ruin land also explains why some gardeners put considerable labor into projects that seem to have little practical reward. Amelia Wallace Vernon, a nurse who vacationed regularly in South

Carolina and who eventually began doing research there in Mars Hill, offers a wonderfully detailed case study. She noticed patches of labor-intensive rice cultivation underway in forest plots laid out and diked generations ago. She found that the elders who worked these plots did not like to eat the rice they produced, nor did they sell it as a cash crop. They "made rice" because they considered it wrong to let cleared, prepared land revert to brush.[11]

On a smaller scale, Gyp Packnett did the same thing in his yard in Centerville, Mississippi, keeping up his vegetable garden (fig. 3.2) even when he did not sell or eat the produce, or know who to give it to. No, he explained, he did not do it just to keep busy or to keep his joints limber—he had plenty of other work to do around the place— but his late wife had liked the

From top:

Fig. 3.1
Gyp Packnet. Centerville, Mississippi, 1995. Photograph by Grey Gundaker.

Fig. 3.2
Gyp Packnet's garden. Centerville, Mississippi, 1991. Photograph by Grey Gundaker.

Fig. 3.3
Gyp Packnet's decorations and fence at edge of cultivated plot. Centerville, Mississippi, 1991. Photograph by Grey Gundaker.

food grown there and some of the plants reseeded themselves so he kept them up. In fact, until the year before his death at the age of eighty-six, he kept the earth turned over and weed-free in two large garden plots, even when no cultivars grew in them. In a sense, his upkeep of the earth was another permutation of the reasoning behind the "decorations" he set at the edges of the plots, including his father's cultivator and other tools (fig. 3.3). A well-kept yard keeps up the ground that oneself and others have prepared.

Separating the Cultivated and the Wild

Archibald Rutledge's account of the yard of a carpenter of great repute in 1930s South Carolina succinctly sketches how making a yard from scratch imprints the distinction between wildness and cultivation on the land, and with it a sense of responsibility:

> A brief drive along a fragrant pineland road bordered by aromatic hedges of cedar and myrtle brought us to Sam Weston's house. It was small, homelike, immaculate. In the front yard trim little flower-beds were laid out; their borders were carefully kept by conch shells. On either side of the door were tied bunches of cape grass, which Sam had evidently gathered on some late trip to the beaches. I noticed that he had about ten acres of land fenced behind his house. The toil required to clear such a tract must have been considerable; for it was land obstinately wrested from the ancient primeval grasp of a moldering swamp. Dankly the swamp glimmered upon the

small, sweet, triumphant clearing that the man had won from it.[12]

With its fences, borders of shells, and broom-like bunches of grass that filter out negativity at the threshold, Sam Weston's house and yard contain many of the material-signs characteristics of sealed, cultivated places. Richard Westmacott found that the African American gardens and yards that he studied in the rural south are multi-productive, with areas designed to aid subsistence tasks and promote self-sufficiency. Laundry is washed and dried in them; hogs are butchered and rendered into food and lard; and plants are grown to please the palate as well as the eye.[13] However, as Mr. Packnett's yard shows, there is sometimes more to the story than either aesthetics or functionality can account for. Some yards contain symbolic materials, and actions related to plant cultivation have cultural dimensions that might seem more ritualistic than pragmatic. As J. Herman Blake reported:

> The Sea Islanders plant many sweet potatoes, which are regularly eaten throughout the year, particularly in the winter months. In the spring, they plant root-potatoes. As the vines mature in late summer, cuttings from the vines are planted to give a fall harvest. We noted in planting [that] the vines were always laid toward a particular side of the row. When we enquired about this practice, we were informed that this was done so that the vines would catch the first rays of the rising sun; they were laid toward the east. Only then did we note that almost all the gardens were planted on a north-south axis so that the crops would always get the first and last rays of the rising and setting sun.[14]

This passage indicates an important aspect of cultivation: awareness of the four directions and proper orientation to them, which is as significant to these gardeners as another calendrical activity, planting by the moon. Such orientation links cultivation of the land to cultivation of the person through balance, purpose, direction, and redirection. As chapter 6 will illustrate, directionality is also important in burial landscapes. Some graves were dug much like holes for planting, so that sunlight would pass into as well as over the hole in the earth that awaited the casket. Yard work registers directionality not only in the orientation of plants but also through signs of the movement of the sun and wind and through emblems of spatial and temporal mastery like whirligigs and wheels.

Wildness, Cultivation, and Behavior

Different kinds of land in themselves serve as material signs because the same features that warrant classifications of space also tell people in a given place what to expect, what the ground rules are for right behavior. Just as African American yard work often proceeds in cognizance of the ambivalent potentials of power, so too the tension between the wild and the cultivated helps to classify behavior as well as the physical landscape. Such classifications need not reflect totally separate worlds but rather gradations that can contrast subtly as well as dramatically. They have distinct characteristics that have persisted over time and adapted to scale and circumstance. The division of space into crossroads and intersections of wild and cultivated land

appears encapsulated within most African American yards like those in portfolios I and III that contain "deep" allusions to spiritual transformation, ancestors, and moral action.[15]

An extreme example was found in the Birmingham, Alabama, yard of the artist Lonnie Holley (portfolio III), who once made his living selling castoffs picked from local landfills and flea markets until he was able to sustain his family on the sales of his artwork. Holley's original home, a one-acre tract of land near the Birmingham airport, was a graphic enactment of the spiritual as well as physical transformations that take place in a wilderness testing ground. "I dig through what other people have thrown away to get the gold of it," said Holley, "to know that grandmother had that skillet and stood over that heat preparing that meal, so when I come home with that skillet, I've got grandmother, 'Grand,' somebody who has authority and is capable."

Perhaps more than any other we have studied, Holley's yard (fig. 3.4) embodied a wilderness zone in which the "natural" and the "human-made" were layered so densely that they were barely distinguishable. In the *Atlanta Journal-Constitution,* Jim Auchmutey described it as "somewhere between a junk yard and an enchanted forest."[16] For Holley, treasures like "Grandmother's Skillet" from landfills provide raw material for the found-object assemblages he exhibits in art museums and galleries around the United States. These constructions are as popular among art collectors as the sandstone he carves to make his more traditional sculptures. When forced to move to Harpersville, Alabama, because the airport needed his land for a new runway, he also encountered some of the vicissitudes of the wilderness. Holley's insistence on living and working in

Fig. 3.4
Lonnie Holley's yard, approaching
the house. Birmingham. Alabama,
1987. Photograph by Judith McWillie.

the Creswell neighborhood of Harpersville, a town of one thousand known for its sod and Christmas tree farms, rather than in an artists' community, resulted in dangerous conflicts with wary neighbors. Auchmutey described one such conflict:

> The uneasiness of the truce is palpable. RG [who runs the neighborhood juke joint] stands in front of his yellow frame house as a chained dog snarls beneath a "No Trespassing" sign. "I kept up that lawn for my sister. That was a beautiful yard when she lived over there. Nice flowers, nice shrubberies. . . . I know the man is an artist, but I think the order of the place could be better."
> On the other side of the road, Holley looks up warily every time he catches a glimpse of movement from [G's] direction. "Those people watch me like a hawk watches a chicken," he says. . . . Above him, the second-floor windows are still shot out. He has replaced some of the panes with a jagged piece of mirror facing outward, as if to guard against evil spirits.[17]

Historically, for rural African Americans, wildernesses were where one could most easily get lost or hide. The swamps and woods around the plantation were thus both dangerous and potentially liberating. In African American folklore of the Sea Islands, the spirits of people who had been killed prematurely or died unnatural deaths wander the forests after dark and shape-shift, becoming "Plat-eyes" (feckless goblin-scavengers who often impersonate animals and other forest creatures) and sulfurous clouds that can suffocate the unwary.[18] In southwestern Mississippi, the area around the Leaf River is sometimes called "the voodoo lan'" because it is swampy ground full of cypress knees and vines.[19] Cemeteries too are classified as "wild" or "in the bushes" throughout the African diaspora, making it easy to understand why strangers are often told to avoid them.[20]

African Americans have also evolved expectations about land use that sometimes diverge from those of European Americans who live in the same territory. For example, for European Americans, there seems to be a consensus that a "plantation" is a unit of

cultivated land, perhaps one of the most strongly marked as cultivated, along with such units as "farm" and "garden." However, African Americans held in bondage on plantations often found them anything but cultivated, according to criteria of moral health. Plantation landscapes were potentially wild places because of the vulnerable position of enslaved people and, later, of black tenants in the social order. Instead of the "coolness" of a calm, cultivated person or place, they radiated a "hot," unpredictable emotional temperature. In Mrs. M. E. Abram's recollection, a deep gully offered a hiding place for Saturday barbecues away from white folks' hearing. But getting there meant running a gauntlet of creatures great, small, and disembodied:

> Dem was sho' schreechy nights: de schreechiest what I ever witnessed. . . . De pastur' was big and de trees made dark spots in it on de brightest nights. All kind o' varmints tuck and hollered at ye as ye gwine along to reach dat gully. . . . One of us see somethin' and take to runnin'. Maybe other[s] . . . wouldn't see nothin jes den. Dats zackly how it is wid de spirits. De mout (might) sho de'self to you and not to me. . . . Dey can take a notion to scare de daylights outtin you when you is wid a gang; or dey kin scare de whole gang; den, on de other hand, dey kin sho de'seff off to jes two or three. It ain't never no knowin' as to how and when dem things is gwine to come in your path right fo you very eyes; specially when you is partakin' in some raal dark secret whar you is planned to act raal sof' and quiet like all de way through.

Dem things bees light on dark nights; de shines de'self jes like dese 'lectric lights does out dar in dat street ever' night, 'cept dey is a scaird waary light day dey shines wid. . . . Raaly de white folks doesn't have eyes fer sech as we . . . does; but dey bees dar jes de same.[21]

Millie Bates spoke of the agitated roaming spirits one could expect to encounter after the failure of Reconstruction:

> [D]e worsest time of all . . . wuz when de Ku Klux killed Dan Black. We wuz little chilluns a playin' in Dan's house. . . . Dan Black . . . de[y] took dat nigger and hung him to a simmon tree. Dey would not let his folks take him down either. He jus stayed dar till he fell to pieces.
>
> After dat when us chilluns seed de Ku Klux a comin', us would take an run breakneck to the de nearest wood. . . . Dem days wuz worse'n de war. Yes, Lawd, dey wuz worse'n any war I is ebber heard of.
>
> Was not long after dat fore de spooks was gwine round ebber whar. When you would go out atter dark, somethin' would start to a haintin' ye. . . . Chile, don't axe me what I seed. Atter all dat killin' an a burnin' you know you wuz bliged to see things wid all dem spirits in distress a gwine all over de land. You see, it is lak dis, when a man gets killed befo he is done what de good Lawd intended fer him to do, he comes back here and tries to find who done him wrong. I mean he don' come back hisself, but de spirit, it is what comes and wanders around. Course it can't do nothin', so it jus scares folks and haints dem.[22]

In the Federal Writers' Project narratives, at least as many interviewees denied the existence of spirits as claimed to see them. However, from a social perspective, actually seeing ghosts or not matters less than the fact that the accounts in which ghosts and frightening spirits occur indicate a world profoundly out of balance. In the first case, members of a plantation community who were essential to its viability had to hide to achieve any semblance of social, spiritual, and probably nutritional balance in their lives. In the second, innocent people again suffered torment. The presence of spirits underscores that more was at stake than personal fear; only a transformed world could begin to put things back in order. Furthermore, whether one saw them or not, the sounds and features of ghosts and spirits became part of a shared iconography of uncertainty, one that seems to have materialized in figures and faces in yards, as we discuss in the next chapter. This kind of imagery also offered a way to show miscreants where their own behavior could lead.

The distinction between wild and cultivated thus shares intelligibility with what Luc de Heusch and Richard Fardon have called a "thermodynamic code" of cosmological relations between "hot" and "cool" behavior,[23] and what Robert Farris Thompson has described as an "aesthetic of the cool."[24] The contrast between a cool face and a hot body characteristic of African and African American dance parallels that between land that is "sweet" like the Weston yard and the dangerously "hot" conditions that Millie Bates recalled and Lonnie Holley encountered. The cool face shows that the body is not out of control; rather, it is managed through states and transitions: "[E]nergy illumines the muscular beauty of the body in motion while the head commands the excitement as a silent emblem of composure."[25] However, the face-body contrast is lost on observers who see dancers as frenzied and hysterical, just as the wild areas within yards such as Mrs. Hamler's or Lonnie Holley's are sometimes mistaken for random mess or unfocused self-expression.

In many respects these formulations also parallel those of Theophus H. Smith, whose *Conjuring Culture: Biblical Formations of Black America* explores the "conjunctive thinking" of the African American "wisdom tradition" that encompasses and affirms the ambiguities arising between such conventional oppositions as everyday and immortal, ordinary and cosmic, and truth and error.[26] Smith reviews African American uses of the trope of the Wilderness to describe the early colonial period, the post-Reconstruction era, and the failure of reforms in the South. He also reminds us that wilderness has been an enduring metaphor for the American experience in general.[27] However, the distinction between wilderness and cultivation is also of formative importance is numerous African societies. M. C. Jedrej has summarized the interplay of these categories of land on the Central Guinea coast, home of the Gola, Bassa, Mende, and Loma peoples who, along with the Kongo, were ancestors of a substantial proportion of African Americans:

> The forest is the location of work and economic production while the settlement is the setting of social events. . . . The forest wilderness is talked about both as a vast cornucopia and as very dangerous, which it is. . . . The vernacular terms for forest derive from terms meaning red: forest is "red-land.". . . By contrast, when one leaves the forest

environment one enters the safety and social order of the settlement. The houses are . . . frequently whitewashed. . . . The whole site is kept clean of vegetation and rubbish. . . . But all this order and control, the reassuring evidence of human ability to use natural products for cultural ends is without power to sustain itself since it is entirely dependent on production from, and the continuing fertility of, the surrounding forest wilderness.[28]

In defense of his yard, Lonnie Holley told Anne Rochell of the *Atlanta Journal-Constitution,* "My message is about our material habits and materials on earth and how we leave this material on earth, and somehow or another it's going to have to be dealt with. When I see my art on exhibit, I see how people are made aware of what is possible, how you can use materials in other forms, other than the forms they were first made out of the mind to be."[29] Perceived as disturbingly disordered by his neighbors, Holley's yard nevertheless resonates, in both its purposes and affect, with older accounts of forests and wildernesses.

In the case of Eddie Williamson, the process is reversed: fallow land installed as a buffer between the city and the Southern Railroad tracks was turned into productive ground, with the result that a cultivated zone became controversial because it was perceived as displaced.

In the Wilderness

The contrast between forest and settlement, wildness and cultivation, is not an evenly balanced one. The forest takes precedence as

the source of sustenance and healing. Sacred groves set aside for initiations served a similar purpose. The heavier weighting of forests pushes beyond duality into a moving spiral consistent with views of the cosmos as a complex and dynamic balance of trans-formative functions (see Lonnie Holley's narrative in portfolio III). This difference in weighting also distinguishes certain African notions of wilderness as an interactive and integral part of creation, as distinct from those Western conceptualizations that treat wilderness either as raw material for human control or as remote and pristine areas that humans should leave untouched.

Jedrev comments that the forest also overshadows the settlement in importance for another reason: "The relationship between this world of mortal humans and the other world of spirit beings is a projection of the relationship between the settlement and the forest." Thus, physically and psychically, wilderness included forests, thickets, swamps, mountains, and times of darkness, as well as occasions when forces beyond human control threatened to break loose. Given human habitation in worked-over, cared-for areas, every other place is potentially the wilder "outside." (As Charles Piot found, for example, "[T]he powers of the tree spirits, the trees, that Kabre attempt to appease and control . . . are those of the outside: These denizens of the wild, whose volatile natures Kabre liken to those of wild animals and creatures of the bush, reside in the community's only uncultivated spaces, its forests.")[30] Gossip is also associated with wilderness because it can sweep one up into the "turbulence surrounding other people's lives."[31]

As Millie Bates's narrative implies, exchanges between material and spiritual

worlds occur in wild places. Today, burial grounds remain such places. Even though individual graves are carefully tended and family members visit cemeteries for that purpose, especially on holidays, we found few people willing to accompany us at other times. "Not a place I like to go," "too many people I don't know there," and "be careful" were commonplace responses. The "wild," set-apart areas in the Hamler, Humphrey, and Hogue yards suggest the separation of graveyards from living space and the association of forests and wildernesses with ancestors and thresholds to transformation. African American folklorist Thomas Talley describes such a place:

> About a mile to the southeast of Caldwell, Tennessee . . . lay a tangled wildwood . . . known among the resident Negro people as the "Haircane." The word "haircane" is a corruption of the English word "hurricane." The trees and undergrowth in this forest were so dense that one, in passing through it by crooked by-paths, could rarely see more than fifty feet away. The bushes and trees were so interlaced and twisted together that the woods uniformly presented the appearance of a recently storm-swept area.[32]

The double voicing in the local name, "Haircane," connotes a springing energy, an active randomness, and a fecundity that words like "forest," with their more static connotations, lack.

The process of "seeking for the church," once practiced widely in the coastal communities of the southeastern United States, makes specialized use of such places. "Seeking" is a practice in which, before baptism, a would-be communicant is sent into the forest or into the cemetery to spend the night with the expectation that they will return the next morning with a revelation. Lay members of the congregation, Spiritual Fathers and Mothers of the church, counseled males and females respectively. They were selected according to their good standing in the community and their talent for spiritual discernment.

In 1987 Eva Mae Bowens of Sunbury, Georgia, described her own encounter with a Spiritual Mother following a night in the forest. "The first time I went out," said Bowens, "I dreamed about a big china closet full of gold, and my Spiritual Mother said, 'You have to go back; you are not ready.' Out there, we had our own special tree and we stood under it or slept under it all night. We had to come to the Spiritual Mother at dawn." Seeking was sometimes repeated later in life during periods of personal crisis, but in the context of conversion it was the primary instrument for determining a candidate's readiness to be accepted into the community as an adult.[33]

Healing potentials and the association of unpredictability with renewal complement the Christian view of the wilderness as a place to recognize one's human limitations and to seek out the help of the Lord to withstand worldly temptations. Samuel Miller Lawton, a clergyman who conducted extensive fieldwork in the Sea Islands of coastal South Carolina in the 1930s, reported how several seekers described the places where they prayed. "Anywhere outdoors away from folks dey calls de wilderness," one said, while another spoke of "Wilderness, like de old fields and pine woods round my house." Still another said, "I pray in de bush and all round in de wilderness."[34]

On the night of an earthquake that terrified South Carolinians in the 1870s,

Sylvia Cannon remembered, "I cut loose from de white folks en went in de woods to pray en see a big snake en I ain' been back since. I know dat ain' been nothin but a omen en I quit off cuttin up."[35] In her portrait of a young African American teacher during Reconstruction, a northern missionary noted: "[His mother] died the winter after emancipation and her son was too young to remember much of her, only this—that she used to take him with her into the thick bushes of the swamp, and there, bidding him kneel beside her, with his little hand in hers, she had again and again committed him to God."[36]

If bush and forest and woods are equivalents of wilderness, so is "the world" in a spiritual sense. Recalling the time before her marriage, the singer Bessie Jones observed: "And you know, woman is the worse thing God ever laid on earth if she ain't right. I can tell you about that too, 'cause I went through it myself. I was out there in the world before I married Mr. Jones; I call it in the bushes, 'cause you're just out there."[37]

"Doing Things Right"

Robert D. "Lightnin'" Watson
Palmer's Crossing, Mississippi, 1991

Palmer's Crossing, Mississippi, is a semi-rural, African American–majority community in the Piney Woods region of southwestern Mississippi and is known primarily as the birthplace of the civil rights leader Victoria Gray Adams. Before the civil rights movement was formally organized, Mrs. Adams began literacy classes for impoverished citizens using the U.S. Constitution and the Mississippi voter registration form as her text-books. "You lived with fear, but you lived above it," she said of the threats faced by activists in those days.[1] Eventually, the community was annexed into the city of Hattiesburg so that, by the late 1990s, the median family income could be calculated at about twenty-seven thousand dollars a year.

Fig. IV.1

Robert D. "Lightnin'" Watson. Palmer's Crossing, Mississippi. 1991. Video still by Judith McWillie.

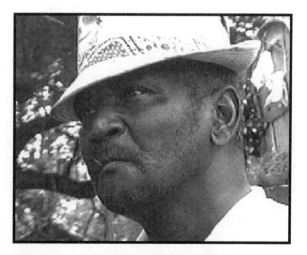

Signs of transition were conspicuous when, in 1991, the Hattiesburg artist D. C. Young introduced us to Robert "Lightnin'" Watson, who was living in a mostly abandoned residential neighborhood in Palmer's Crossing. Bordering his house at the corner of North Hattiesburg Avenue and Perry Street was a tall fence made of packing crates, scrapped lumber, roofing tin, plastic cloth, and carpet remnants (fig. IV.2). Corrugated sheet metal, held in place by wooden braces, reinforced the bottom, bracing the weight and bulk of the structure as it leaned forward towards the street. Where the fence rounded the far corner of the property, a miniature white tire hung from a cantilevered beam (fig. IV.3) pointing to the threshold of the yard where Watson could be seen waving us toward the front gate. "This is what I have got to say," he began. "I'm an old bachelor. My friends call me 'Lightnin''. This is what a handicapped man can do if he don't give up."[2]

Watson told how he had been injured in 1969 while working on a road crew cleaning up after Hurricane Camille. When his workman's compensation ran out, he became homeless, living for two years in a car now installed in the yard and surrounded by plantings of beans, potatoes, greens, and fig trees (figs. IV.4, IV.5). "God took care of me in this car," he said. "For two solid years this was my house. I couldn't get food stamps because I was living outdoors."

The crops in the yard were distributed in every available space: between outbuildings and collected materials, beneath fence posts, and on a terraced mound in front of the car. Saw palmettos, the berries of which were used by Native Americans of the region as a tonic, had forced themselves against the fence. Greens were planted at the edge of a ditch that ran beside Watson's house along North Hattiesburg Avenue, still a relatively busy public road despite the depopulation of the neighborhood.

The centerpiece of the back yard was a scaffold built against the street side of a small shed, its most noticeable feature being a bicycle standing about nine feet off the ground on a platform held in place by four poles (see portfolio II, fig. 26). One of these poles was a television antenna, another supported a white flag, and the two in front were bare but painted bright red. The effect was of a schematic rendering of a cube emerging from the similarly shaped shed that supported the scaffold from behind. At ground level, an automobile seat covered with a quilt sat facing the street, shaded by the "bicycle roof" above. Looking into the yard from the street, the visual conjunction of the horizontal fence decking with the linear transparency of the scaffold made the bicycle appear to float in midair.

"See, I'm not just a man walking along," Watson explained, "You looking at a dead man. This is a man totin' the cross. This cane I'm totin' is the cross." For the past fourteen years, he had stayed in various houses on Perry Street

Above right: Fig. IV.4

Crops on mound near car in Robert D. Watson's yard. Palmer's Crossing, Mississippi, 1991. Photograph by Judith McWillie.

Right: Fig. IV.5

Robert D. Watson and the car he once used as a home. Palmer's Crossing, Mississippi, 1991. Photograph by Judith McWillie.

before settling into this one and working the yard. At age sixty-two, he was drawing disability.

The use of material signs at the site was conspicuous: (a) whirligigs, rockets, airplanes, a "Big Thunder" truck—all images of directional motion—stationed on poles at varying intervals along the lateral plane of the fence; (b) threshold markers, such as horseshoes and twin dolls at the gate; (c) instruments of transmission, including radio antennas wired to plastic figurines; (d) texts and pictures designed to impute warnings, such as a photo of two dogs glued by the front door; and (e) objects set to reverse trouble, such as the inverted jack-o-lantern by the gate that doubled as a bird house. On a six-foot piece of red sheet metal at the northeast corner of the fence, Watson had nailed two large planks in the shape of a cross.

Walking through the front gate, we turned our attention to the yard's interior where the most individualistic aspects of Robert Watson's vision began to emerge. He had an artificial, life-sized boxer named "Champ" stationed at the front door next to a neatly clothed mannequin (fig. IV.6), his "wife," whom he called "Leona," and their spectral children: two life-sized dolls named "Suzi" and "Ira Dean." Figurines—Barbie dolls, animals, cartoon characters, bowling and cheerleading trophies—played along the back-side of the fence between boughs of artificial flowers. He had made a home for himself, incorporating images of the American "nuclear" family as symbols of stability and vindication.

While we were recording the yard on video-tape, a youthful neighbor shouted, "If I have a yard like that, can I be on television?" When asked what he thought of Watson's place, he shook his head and laughed. Watson, however, was undeterred: "I go and do a little work; then I go and lay down some. All these young people can't do what I do." A closer look at the grounds suggested that Watson's afterthought about young people offered an important clue to his motivations. A card on the front door read:

Fig. IV.6

"My wife, Leona." Robert D. Watson. Palmer's Crossing, Mississippi, 1991. Photograph by Judith McWillie.

> Only one life
> It will soon be past, only
> What's done
> For Christ
> Will last

"I was raised from the dead and cast out," Watson continued,

> You got to be born again with the Spirit. He died on the cross to save the world. And I got to save the world. I just look up at that cloud there, and it obey me with this walking cane, through Christ. He said I be lifted up from the earth; I draw all unto me. He showed me to work for you. I went out to the Garden of Eden working for you. And he say he separate the sheep from the goats. This is a dead man you looking at. Dead in Christ. I cried, "Take care of me up in this house." He said, "Don't be 'shamed." I got nothing to be 'shamed of; nothing to hide. He'll give you knowledge. You got to ask for knowledge and understanding. You got to ask that through Christ. See, I don't have

no education, though I have knowledge through Christ. I went out there and worked for myself along these different jobs. I was out on the state highway, out there picking up hurricane damage. Well, that's where I got hurt. That's what I went out with—Hurricane Camille. If you be a Christian, you've got to be born again with the Spirit and the Holy Ghost. This is what led those children over from Egypt; it's what Moses had. See, he said, 'Wear my yoke. Wear my yoke. I am meek; I am low. Suffer, little children. . . . I will give you rest.' See, he made man in his own image. I make him breathe out of my nostrils. And he come to be a living soul. You looking at history here.

The Perry Street community, as Robert Watson had known it, was vanishing but not before he would assemble material signs of its glory. The sorting process yielded a faithful remnant of familiar images refined out of neighborhood garbage mounds, which he regularly cleared away, or given to him by friends. "I ain't no lazy man. . . . That sure gives me the blues when people say 'Get all this junk on out of here.' But I go get their eye," he said.

One of Watson's most carefully crafted works was a booth (fig. IV.7) built into the fence next to the front gate: "I just fixed it up. If I want to take a notion to sit down there . . ." He stopped without completing his thought and then said, "I take anything somebody give me, you know." The booth was lined with a pink polka-dot cloth held in place by nails driven through the undersides of bottle caps. The lining overlapped a barrier across the front, forming a curtain that made the table and chairs inside inaccessible to all but the most agile. Even then, using the structure in a normal way would have meant tearing away the cur-

tain in order to get inside. The Old Testament patriarchs, Moses and Elijah, however, would have recognized the booth's spiritual signature since, according to Matthew, Mark, and Luke in the Bible, the apostles had offered to build one for them when Jesus was transfigured. After that, a cloud opened, and God's voice announced, "This is my beloved son in whom I am well pleased."

Inside the booth was a broken clock with a gold aluminum frame and plastic flowers next to a chromolithograph of Christ the Good Shepherd. "That's the man what give me strength there, the man with the walking cane, Jesus Christ," Watson said, gesturing toward the shepherd's crook in Jesus' hand. "That's why I walk with a walking cane."

A few feet above, a palomino hobby horse "jumped" over the booth, visually activating smaller horse figurines nailed to the fence decking. This pale horse was Watson's most imposing image. Its movement and expression animated everything in its path without compromising the careful symmetries of the booth and the fence. Watson continued, "If I sit down and do nothing, I get to where I have to be on that rolling chariot." He pointed to the wheel chair near the porch. "Then I can get in that rolling chair and still do for myself. I got a walker and all that—see, and then I go to my walking cane." In front of the gate and in places where the fence abutted the asphalt, Watson had swept the street so clean that, given the depopulation of the neighborhood, it looked and functioned more like a patio than a thoroughfare.

"I am willing to do what He let me do," he said. "I did all this and these young people can't do this. See, all of that is my work too. See all that?" He pointed to the dry loose earth piled about two feet high at the bases of most of the trees on the street. These mounds had

Fig. IV.7
Front gate with booth in
Robert D. Watson's yard.
Palmer's Crossing,
Mississippi, 1991.
Photograph by
Judith McWillie.

the same sculptural precision as the elevations around his crops. "Christ said, 'Do unto others and you will have it done to you.'"

When Watson got hungry, we set out in the direction of the thrift store where he took his daily lunches. "Bargains and Blessings. An Outreach of Christian Services Incorporated. Breaking the Shackles of Bondage Through the Living God," read the sign out front. The manager, a white woman in her late twenties, was a lay evangelist who maintained a lot more than a thrift store. "Bargains and Blessings" was a community crossroads where, on any given day, one might happen upon horticultural information, theological study, a hot meal, health advice, and varieties of supplies that could be traded as well as bought. Furniture and clothes were a specialty. The stacks of shoes by Watson's front door, as well as most of the figurines in the yard and on the fence, were collected at "Bargains and Blessings." D. C. Young had discovered the store when she was shopping for a couch and subsequently met Watson on one of her visits. She began photographing

him and, in the process, discovered that he had never seen an image of himself. Accepting one of her prints, he remarked, "You gave me back to myself."

The conversation on the day of our visit focused on stories of miracles and charismatic healings. "For look, I shall give the command and shall shake out the House of Israel among all nations as a sieve is shaken out without one grain falling on the ground" (Amos 9:9), quoted one visitor, a young white minister who was, like Watson, a frequent visitor to the store. He then described the signs of the Holy Spirit as related by the Nigerian evangelist and writer Archbishop Benson Idahosa, who had preached at the "Lord of the Nations" conference in Washington, D.C., three years before. "God has moved his headquarters to Africa but his sub-headquarters are here [the United States]," Idahosa had said. The conference encouraged a long-range plan that would link urban black churches with suburban white churches, which together would serve as a conduit for surplus food.

Across the street from "Bargains and Blessings" was the African American–owned Oglesby and Sims Paint and Body Shop, a converted filling station with a distinctive script painted on its concrete facade, "Give God the Glory." Above the script, a cloud hung over the word "God," while one end of it cascaded down like a waterfall merging with the slogan "Jesus is alive" and the words "Business hours, eight to five" written underneath. A graffiti "bomber" had altered the letters *s* with vertical stripes, turning them into dollar signs.

After lunch, refusing a ride home, Watson walked back to the corner of Perry Street and North Hattiesburg Avenue, past the bedspring fence of a neighbor, the three orange hardhats wired to the side of his own house, and the galloping horse on the gatepost with the red candles and nativity lamb by its side.

Dilmus Hall
1900–1987
Athens, Georgia

As a child, Dilmus Hall blazed sweet gum trees and mixed the sap with his mother's cooking flour to model animals and birds, but his desire to be a full-time artist had to be deferred until the last two decades of his long and mindful life.

After serving as a stretcher bearer in World War I, he toured Europe and then returned to Georgia, vowing to educate himself and his friends about the grand cathedrals and sculptures he had seen. He married his lifelong partner, Zadie ("a Greymore Indian," he said), and although they remained childless, he worked several jobs, including stints as a hotel bell captain and a fabricator of concrete cinder

Fig. IV.8
Dilmus Hall. Athens, Georgia, 1981.
Photograph by Judith McWillie.

blocks, to give her a comfortable life. Then, in the mid-1950s, the loss of his life's savings in a house fire tested him to the limit. He recalled:

> I went into the side yard with a shotgun and put it to my head. I don't know what happened next except that God had other plans. The gun went off by itself and I had a blackout. When I woke up I saw that I had fallen into a pool of water. I came to and from that time on, I didn't drink. And it was a month before I had hearing in my right ear. And when I cashed in the insurance they told me to build a house that would withstand fire. I built this with three hundred dollars' worth of blocks from the Athens Concrete and Block Company.[3] [See portfolio II, fig. 6.]

Hall decorated the exterior of his and Zadie's new house with white and blue diamond shapes and concrete plaques of yellow suns and moons (fig. IV.9). He bordered the porch roof with strips of lattice whittled into points, rendering the effect of an inverted picket fence. The same serrated edges were

Fig. IV.9
Decorations on Dilmus Hall's
house. Athens, Georgia, 1976.
Photograph by Judith McWillie.

repeated in the design of the grounds and yard: in handmade metal awnings mounted over the windows and in an enclosed bridge that connected the tiny front yard to a carport where a hand-painted black and white Ford Fairlane rested most of the time. The back window of the car functioned as a portable display case for a plastic figure of Thor, the Norse god of thunder and lightening who smashed giants with his mighty hammer.

At the entrance to the porch a crucifixion scene was mounted on a support beam. It featured the two thieves and a Jesus painted blue with a toothpick glued across his mouth. The "Cruc-afflliction," as Hall called it, shared its station with an inverted black umbrella that always remained in place regardless of the weather and a set of truncated wooden constructions trimmed with the same blue and yellow paint as the house. On one, a spiraling wisteria vine bisected a bentwood arc like a bow and arrow. There would be more wooden constructions to come and many crucifixions, no two of which were alike, as folk-art col-

lectors began migrating to Hall's door in the mid-1980s.

After Zadie's death in the early 1970s, Hall's color sensibility changed to red and black. In the earliest crucifixions, he had modeled Jesus realistically from Plastic Wood and tar; in later ones, the corpus was a flat wooden plank (fig. IV.10) or a stick, undercoated in silver and finished in red and black, always with the toothpick at the mouth. "I put it there because Christ stopped dying and held death in his teeth," he explained. The one exception to this custom was a found crucifix that he picked from a garbage can and painted black except for Jesus' head and one hand, which he made red, and a blunt yellow pencil, eraser-end out, that he substituted for a missing arm.

Next to the bridge in the yard stood *The Devil and the Drunk Man* (see plate 12), a tableau with life-sized concrete figures: a man slumped over a table with a pint of whiskey in his hand, another man next to him passed out on a bench, and a six-foot red and black devil with a whipping, snake-like tail and a raised

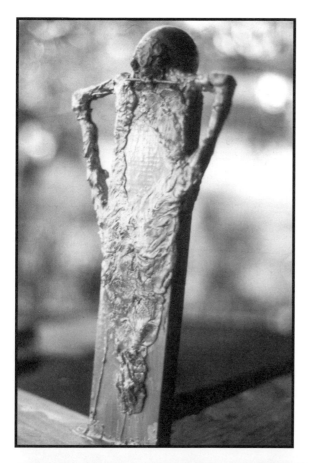

arm poised to crush the clueless men with a sharpened river rock. Hall explained that Satan deceived them by promising peaceful relief only to roar in their ears and "knock them out."

The table that was part of *The Devil and the Drunk Man* doubled as a workspace where, among other things, Hall sculpted a miniature scene depicting the death of Crawford W. Long, a fellow Georgian who, in 1842, became the first physician to use ether for surgical anesthesia. He abandoned this work around 1979 but it remained on the table until a folk art collector purchased it five years later.

These concrete ensembles, along with a sculpture of a pig nursing her young, also made of concrete, were visible from the street

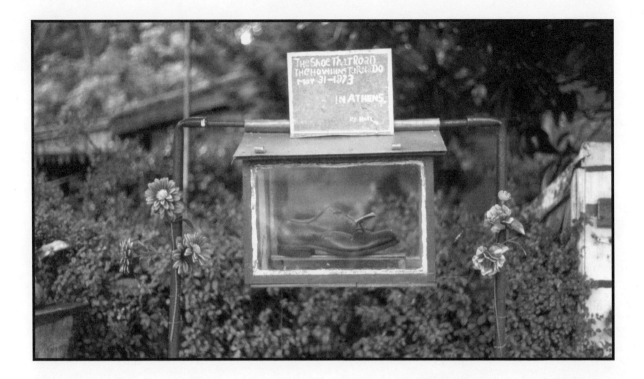

next to a set of abstract wooden structures stationed near the curb (fig. IV.11). If someone stopped to investigate, however, it was usually because of Hall's most celebrated work, a black shoe suspended inside a handmade glass box mounted on a pipe by the curb (fig. IV.12). A hand-lettered sign on top identified it as "The Shoe That Road the Howling Tornado / Athens, Georgia, March 31, 1973." As the storm in question flattened fashionable Athens neighborhoods, disrupting community life and business for months, it blew the pristine new shoe into Hall's yard. Neighbors warned of ominous consequences. "I'll concentrate on it and I'll know what to do," he argued. Within days, an article appeared in the local newspaper with a photograph of him confidently standing next to the shrine and a poem composed for the occasion:

I am a lonely shoe
Without a mate. What will I do?
Over and over as I roll
Oh tornado you are taking your toll

Fig. IV.12
"The Shoe That Road the Howling Tornado," a construction of glass, wood, metal, paint, plastic flowers, and shoe, made by Dilmus Hall in 1973. Athens, Georgia, 1975. Photograph by Judith McWillie.

If someone would be brave
To me and my mate he might save
Sometimes I pass over a limb
Then I say my chance is slim
And swinging so high above
the many demolished buildings
someone dearly loved
Over a limb and through a tree
I say, oh what mercy can be
I look for a second or so
At some tall trees that had to go
Then I look quickly around
There are dangerous wires all over the
 ground
Let all of us pray
That the next tornado will go another
 way

That it will cease to strike here again
The home of the free and many brave men.

At the end of the poem, Hall added, "You may see this shoe at my home, hanging from a glass box, 1001 Dearing Street. Come and see for yourself. It is free for all to see. dilmus hall."

Dilmus Hall's considerable success with the public backfired only once when a thief broke in through the living room window of his unlocked house and demanded the cash he kept in the chest pocket of his overalls. A shot to the lower abdomen sent the intruder running to a nearby hospital and, after a two-week stay, to prison. The police commended Hall, then eighty-three years of age, for his quick thinking and kept him informed about the thief's medical and legal fate. Otherwise, Hall welcomed all visitors if they were willing to listen to his exhortations.

On Sundays, he sat in a school desk at the end of his driveway waiting for both friends and strangers to stop and engage. The rest of the week, weather permitting, he settled in the side yard wearing his signature black jacket and fluorescent orange cap, pointing with a walking cane as he preached. Although neighbors called him "Reverend Hall" for his practical wisdom and preaching skills, he was never formally ordained.

Mildred and Burrell Shaw, next-door neighbors, made him breakfast in the morning. "Bring me some coffee, Mildred, be sure to stick your finger in it to make it sweet!" Inside at night, he drew in his sketchbooks and watched animal documentaries on the Discovery Channel, dramatizing them the next day for patrons of Katherine's Kitchen, a fast-food chicken-and-biscuit restaurant on the main thoroughfare a block up the street. He told Bible stories in vivid, almost cinematic, detail

with embellishments all his own. In his version of Christ's betrayal, for example, Judas Iscariot never hanged himself; he fled Jerusalem only to perish at the hand of a live oak that snatched him off his donkey by the hair. Hall's cadre of loyal admirers named him "Happy Man" and sat transfixed as he recited his autobiography in biblical cadence, transforming the features of one man's life from intimate to epic scale.

Dilmus Hall Narrative

I was born out here not very far from Watkinsville in Oconee County, out there. My daddy came from Virginia after the war there. My Daddy was an ex-slave. When he came here he was two years old. But listen, I don't worry about what went on then. This country had to come through a lot. . . . This country was at the bottom of the barrel when they were paying these British people high taxation. You remember what the Boston tea party represent and come about? That high tax. And they went aboard, disguised themselves as Indians, and they went there and cast that tea in the midst of the sea. Them men, listen, they wasn't gonna be robbed. They wasn't going to have their family robbed and I don't blame them, do you?

My mother would tell you this if she was alive today: I was brought into the world with the assistance of a midwife and my mother had an old rocking chair and a pillow in that chair, and she kept me on it until she got ready to nurse me. The third day, I raised up on that pillow and looked around. And the midwife said to her, "Look at your baby. What could that little thing be looking for at that early

stage of life?" So my mother opened her bosom, but I wouldn't take her breast. She said, "I wonder what this little thing is looking for?" The midwife told her, "This little thing has a job to do—looking around in a world like this. And when he gets some size, you'll find out that he'll be the wisest child you have brought into the world."

I had an idea of America. I went north to Detroit, Michigan, and to Canada. I have seen a lot of the world and I have an idea of America. Was a medical man in the war [World War I] in Rhineland. After the war I went traveling. When I went to Europe, there were many things that we saw over there that the people had made, just like America. And I told some of them, "We are from Georgia. We are over here as dumbbells." I said, "But I ain't going to be a dumbbell when I go back. I'm going to carry something back from here because these people are very glad, in their manufacturing, to show you around." Some of them [the soldiers] say, "I'm not worried about a thing but that boat landing in New York and getting there in one piece." I said, "I am too, but as I foresaid we were dumbbells over here and I'm gonna take something that I can treasure for years to come after this conflict is over. See?" So I based my trip on that one thing, and when I got back here, I put in fashion of what I desired for, you know, and whatever you desire of nature, nature will plug in support for you and make you famous with it. So I came back and began to make these different things [drawings and sculpture]. The more I would make them, the more I would understand about it. See? I have been [an artist] all my life, but the older I

Fig. IV.13

Painting on ceiling of bedroom in Dilmus Hall's residence, made c. 1968. Athens, Georgia, 1984. Photograph by Judith McWillie.

got, the more I understood about it. I been at it since school days. I used to take my father's ax and go out in the woods and blaze sweet gum trees and get that sap and steal my mother's flour and sugar and cure it, and it becomes white. . . . it never gets hard but it gets usable, and I would make different things out of it: little animals, turtles and lizards. You remember [Saint] Paul says, "When you are as a child, you have childish ways," but when you mature, then you reach out to get things that was in that category. You cannot force your way beyond nature. You can't do that. You have to do what you're going to do on this side of the state that nature has set for you. I was cut out to be just what I turned out to be.

And I have to make it where that you'll understand. I make titles for everything I make. I had to make it like that, because that proves the daily life of people. If I may

say I have to go to the Bible for some of it. I have to have something to back it up cause most of it happened before my time. I use what comes from up above. He supply me with the thoughts. I don't make them up. Because all of this happened, it happened before my time. That's the Bible. I use facts. But they're pushing the truth that pushes me on. If I used the make-up of my self I would come short. But I don't do that. I seek and He gives me the answer.

Listen and you'll understand what I mean. Now, there was crucified two other people—one on the right; one on the left. The one on the left criticized Jesus up there on the cross; said, "If thou be the son of God save yourself and come down off that cross. If you come down, we will believe you. First save *yourself* and then save others!" And the other was in agony. He begged mercy. Said, "Father, if thou go into the kingdom that I've heard you talk about, save me, a sinner." The Bible says Christ quit dying. He quit dying and spoke to that fellow on the right and blessed him for pleading like he did and He said to him, "This day thou shall be with me in paradise." See, we had to put that tooth-pick in his [Christ's] mouth to represent the stain of death. Christ stopped dying and held death in His teeth. We've got to fix these things so that an onlooker will understand. You see, an artist is a particular instrument.

They went to Christ and called Him "good master." And He called them back and say, "Why callest thou me good when there is none good but God my father?" They recognized Him being that they approached Him but he correctified them.

That's what the Bible was saying and you got to believe.

David saw Uriah's wife bathing herself and he liked her himself. And there was a war going on, and he got Uriah into the army and sent him away to the hardest part of the battle that were going on. And then David, he climbed a ladder to this lady's room and had relations with her. God didn't send David to hell for committing adultery. He didn't do that. He entrusted him with a lot of his power. Because after that David choked the lion and freed the lambs. See what I mean? So God was too wise to make a mistake. He saw David before he got up there. But He let him adventure until he accomplished what was in his mind to do. Therefore no one is spotless. If you don't sin one day, you sin the next. . . .

I read a lot and get books and get facts. Now the Bible is one of the truest fact books that you can pick up. You can read about Nebuchadnezzar, king of Babylon, and Job, one of God's faithful servants, and you name it. . . . The Bible is the best book. And when you take it as an example, then you have got it made.

God asked the devil did he consider his servant, Job. The devil said, "yes," he'd considered him. But he said if He would take that hedge that He'd built around Job that was his power of protection, he'd cuss you to your face. God said, "Ok, he is in your hands. I'll give his body over to you but his life is my own." Job was afflicted with boils because those boils was of the devil. No quicker than Job saw that his faith could make him whole, then God healed him. Because the devil was of war. He was not of peace. He was of war! The

devil was testing him with the war of the flesh. That was the devil's power. Then God took care of Job and healed him.

Moses threw the law down and God rewrote them by the tip of his finger. He was intending for Moses to go the full limit of His command and when Moses didn't do it God killed him. Took his life from him and went back down in Moses group and ordained Joshua . . . and the sun only stopped one time . . . and that's when Joshua prayed and God stopped the sun for that battle. . . . And Joshua fought the battle and carried the children over to where Moses promised them, over to Canaan land.

When God give you power to go forward you can't do nothing but go forward. . . . There's no way to get around it. Cause when God throw a yoke around your neck, that's His purpose. Nothing for you to do but to wear it. You can't throw it off. What He set out for you to do is the best thing for you to do, get out and go in the direction of Him.

I can have intellection of certain things that I make when I'm wide awake because I'm endowed with that art of knowledge and I don't have to do nothing but be obedient because He have done give you the talent and He comes and visits you and instructs you through your mind and through your understanding about how to see these things. He already done planted the seed, you see, and help you to cultivate it. See? It's easy. You see it in a sensible way. When you plant a seed you don't know how it's gonna come up.

A sower went out to sow and some seeds fell in stony ground and they come up and the sun beared down on 'em cause they didn't have no hold in the earth but the sower didn't hesitate cause he was the sower. And he went on down and he sowed some more and they fell in pretty good and they come up, but he didn't look back. The thorns and thistles they grew up and choked out those. And he sowed three times and he sowed some seeds in rich ground and they come up and beared wonderful because they were in rich ground and he notified his neighbors to come and let them enjoy the fruit of the crop. But if he hadn't put the seeds in the right kind of ground he wouldn't have gotten nothing and that was the point. . . . And that was the ending of his sowing. He did well. When you do well, then it's time for you to stop . . . and wait until a thing approaches you, 'cause you can't do it in one day. . . . God did not create the world in one day though he had the power to do it. The sower, he went on and didn't look back. . . .

What I say is right. . . . If He says something you can put your feet down on it as a firm foundation. You can do that. Not only that but there's thousands of other things. If you trust in the high authority you can go in it and come out of it safe and sound. Because He is too wise to make a mistake and to lead you into battle to be defeated. He leads you in it to gain victory. You're gonna tell somebody else what Hall says here. . . .

At that time, people were fearful of the Romans because they were a mean race of people and they was the ones that crucified Christ. When Christ was on the cross, this old Roman king sat on his seat and looked. And the scripture says it got so dark that you could feel the dark going through your fingers. And he called

someone and they answered him. And he asked the question, "Can you see me?" And they said, "No." Well, that darkness represented the agony that Christ on the cross was going through. So he said, "I can hear you but I can't see you." And he confessed this way: "Surely the man they had on the cross was the son of God!" I say I believe that devil was saved because he confessed. A baby comes in the world with nothing, and when you go, you go out the same way. Have you ever seen a U-Haul behind a hearse? What's for you is for you. It's got your name on it. What's not for you, you cannot get. Oh, honey, that is it!

I don't ever get out of work. This [drawing] will be, when I complete it, Daniel and the Lion's Den. This one, when I complete it, will be known as the upper deck of that house right here. That's from the Bible. The producer [artist and inventor] is counted to be the forerunner of a lot of things. That is your forerunner, the producer. If it's a machine, the producer of the machine don't get the full value. He that trades it after it's complete, he don't get the full value either. But he who puts it operating full of gas and gets to plowing with it, he gets the value because he tells the maker, go make another one, I will enforce it. He is the third man. . . . That's just competition. . . . They don't give me the full value of my drawings but I don't mind.

Chapter 4

Foundations of Yard Work

[The] ancestors that I remember could defy fact out of their profound knowledge of the invisible. The unseen sustained them. . . . They could store apparitions and use unreality. Did a river in flood pour in to drown them? Yes; but those who got out of the water would call it Jordan. "All other ground is sinking sand."

—Lura Beam, 1967

Like a tree planted by the water, I shall not be moved.

—Traditional Spiritual

Like the house in the Bible built on solid rock rather than shifting sand, only homes and yards that rest on a secure foundation endure and stay safe. This has been especially challenging for African Americans in the South, who were forced for generations both to occupy, and sometimes to be, other peoples' property. Even in relatively good times, most lacked the legal protections that white Americans took for granted. Yet despite these constraints, black southerners put their ideas into effect in places that were not always their own, taking moral and practical cues from the values associated with wildness, cultivation, and the dangers of ruin and neglect. Material signs supported these activities, showing how things stood in the household and helping to repel negative factors such as ill health, gossip, envy, and injustice.

This chapter explores the articulation of material signs and land use, focusing on several aspects of the proposed lexicon and organizing principles of yard work: *surfaces, borders, boundaries, thresholds,* and *figures.* Our aim is to sketch ways of striking a balance between the yard and the worlds that surround and interpenetrate it, visible and invisible. We examine what makes a place secure enough to promote the well-being of those within it and show some of the ways practitioners propose to visitors how things ought to be done.

Contemporary yard work pays considerable attention to thresholds and boundaries and carries forward a history of shaping not only the land but also the moral values underlying its care. Encircling, enclosing, and buffering materials, such as trees, plants, fences, and posts, transect the surfaces of yards, defining thresholds and boundaries to what is beneath the ground as well as to what is on it and above it. These materials are significant not only for the ways they connect but also for what remains unseen. Earth is a passage, not a

plane. Vertically oriented borders, fences, and gates function simultaneously as containers, barriers, decoration, and signs of ownership that mediate movement from one area of the property to another. Statuary, ornaments, and figurines engage still other aspects of this process. Yard work can also make people stop and think about their actions and point the way to a well-lived life. A smaller number of homes and yards push positive transformation even further by fashioning the glimpses of heavenly glory on the earth that we discuss in chapter 6. Like a mature and responsible person, such a place is *cultivated* in the fullest sense.

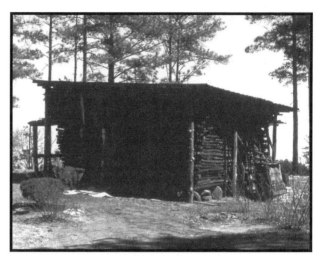

Fig. 4.1

Swept yard and house of Mary Lou Furcron. Oglethorpe County, Georgia, 1989. Photograph by Judith McWillie.

Surfaces

Doing things right involves knowing where to put things and how to take care of them. These concerns are as pervasive in European and Euro-American visual and material culture as they are in those of Africa and African America. But in the African diaspora, the surfaces of the ground and the house have associations that also seem divergent in certain contexts. Whereas, from a commonsensical European American point of view, the surfaces of the earth serve mainly as open spaces between boundaries, empty stages on which things happen, in African American yard work these surfaces are themselves as significant and potentially dynamic as what happens in and on them. We argue that smooth, regular surfaces such as swept sand, packed earth, raked gravel, and clipped grass are not *blank* but *cool;* that is, they are in a state of readiness and composure achieved against the vicissitudes of traffic and hurry (fig. 4.1). The surface of the

ground is as much a "face" of the yard as is its appearance from the street.

This tactile and active approach contrasts with the more passive, frontal positioning of the viewer and the figure-background relationship that has dominated Western visual culture since the introduction of linear perspective during the Italian Renaissance. Western painting and landscape design have existed in dialogue ever since, staging centralized views and vistas. Traditional Afro Atlantic yards incorporate different angles of vision and appeal to other senses. Movement in all directions and activities of many kinds inform their design; a composed vista from the street is only one of many ways to experience what the yard teaches.

African Americans have carried this versatility into the places where they have worked as well as into those where they have lived. Until the effects of the civil rights movement began to be felt in the South, the yards of lower-middle-class and more prosperous whites were usually

planted and maintained by black "yard men" whose efforts received pitifully small rewards. Julian Meade, a journalist from an aristocratic white family, wrote that when he had an afternoon free from teaching high school in his home town of Danville, Virginia, in the early 1930s, "My mother and I, aided occasionally by one of those unappreciated Negroes who work in Southern ladies' gardens for fifteen or twenty cents an hour and eat left-overs from dinner, planted the serpentine borders that edged a new lawn with flowering locusts at one end and a giant oak at the other."[1] Meade describes the grass lawn as "new," as clean swept yards were valued by black and white alike at this time. Several of our consultants in Chattanooga recalled that grass lawns began taking over swept yards there in the 1930s.

A description of a black community in the 1920s by Eldred K. Means noted that each house was "set back in a yard which was full of chinaberry trees, a tree beloved . . . for its thick, umbrella-like shade. The ground around each house had been scuffed perfectly slick . . . and resembled an old derby hat with the nap worn off."[2] In her dissertation, Minnie Clare Boyd wrote, "There were many homes where the criterion of beauty was a clean-swept yard, and tree-trunks white-washed to the lower limbs—chaste and simple, or hard and bare, depending upon the point of view."[3]

Swept yards remained commonplace in the South from the antebellum period until the 1950s, with occasional exceptions continuing into the present. Amelia Wallace Vernon reported: "The yards of African Americans in Mars Bluff were swept daily with a brush broom. They might be swept more often, for the children were given the task, and when the children played in the yard, there was frequently some small child practicing sweeping in imitation of the larger children."[4] Vernon also reported the comments of anthropologist Joseph Opala about the cosmological significance of swept yards in Sierra Leone: "By keeping the yard free of vegetation, you are maintaining the cosmic distinction between town and bush. You are maintaining the distinction between an area of order, harmony, law, and ancestral rule and an area of wilderness chaos. . . . It is a world of constant tension between the town . . . and the bush that surrounds every town."[5] Whether or not the preference for bare earth originated in Africa, it is widespread there.

As a deterrent to insects and other pests, packed earth and raked sand also show that members of the household have paid attention to every square inch of the yard. It is as combed and groomed as human hair. The yard should not only be clean on the surface but also in a deeper sense that renders it open to scrutiny. If the household has any potentially dangerous materials about the premises, they have been properly contained. A thoroughly tended yard also implies that members of the household are vigilant about their own security; it would be hard for someone to scatter powders or hide harmful substances in a well-kept yard because perfect surfaces, like white cloth, mark easily and visibly.[6] The yard should be as clear as an untroubled forehead.

Brooms for sweeping the house and yard were also symbolic as well as practical. Ruby Gilmore formerly made sedge brooms to sell, preferring sedge because "it could dig grass out by the roots." Robert Farris Thompson suggests that the brooms that hang on many southern doors also relate to the straw, liana, raffia, and palm that fringe the tops of doorways across the diaspora.[7] In the

early twentieth century, anthropologist N. H. Thomas reported that in Sierra Leone a broom was hung over the door so that "the house may be clean and no bad sickness come in."[8] A Dutch planter from Suriname who donated two brooms, later characterized as "fetishes," to an ethnographic museum in Amsterdam, remarked that slaves routinely swept the yards in front of plantation buildings and added that "in this sweeping they like to draw a caricature of a visitor, or of flower motifs."[9]

Another reason for sweeping the yard was to obliterate the foot tracks of the people who lived there because, as Zora Neale Hurston has discussed at length, tracks can be picked up and used against someone.[10] Henry Fielding, a funeral director in low-country South Carolina, recalled "dragging a huge tree behind the hearse to wipe out the tire tracks." He participated many times in the practice without asking questions about it, but probably this practice discouraged the spirit of the deceased from following survivors out of the burial ground and back to the homes of the living.[11]

Thus, the reasoning behind clean swept yards combines elements that were practical, aesthetic, social, and spiritual, and could find form in many kinds of materials. Together, the well-tended surfaces in the yard contribute to a home that is sealed: impervious to assault, aesthetically pleasing, and functioning smoothly. The concept of sealing the house is virtually pan-African and includes attention to all entrances and exits, as well as to the surface of the ground. There is every indication that it has retained its transatlantic scope, although the forms involved have changed as sealing adapts to day-to-day circumstances and available materials. Window shutters were once closed to seal the house at night in the United States and are, to this day, in much of the Caribbean. The Caribbean "aesthetic of house and yard," according to Roger Abrahams, "and the house status hierarchy . . . have to do with how tightly the house is 'sealed' against the road. Painting the house, too, is one form of sealing."[12]

In the eighteenth century, the yards of enslaved Virginians in the slave quarter of Carter's Grove Plantation used shells to seal the ground. Rather than sweeping the surface of the quarter bare, residents drew on an abundant supply of oyster shells that combined attractive whiteness with good drainage and announced the approach of visitors with loud crunching noises.[13] Another, quite different variation on this theme is implied by present-day didactic signs in juke joints and pool halls that prohibit the placement of food and drink on the pool tables. These signs derive from the idea that the green surface of a pool table constitutes an indoor sports field that should be maintained without debris of any kind. In any case, the ideal of a clean yard remains unchanged, although now concrete sometimes replaces swept earth, and green indoor-outdoor carpet enhances the surface of walks, patios, and carports. Grass growing in the cracks of pavement remains as unacceptable as ever.

Among whites, the rationale for swept yards was economic as well as aesthetic and hygienic. From the point of view of cotton planters, grass was a pest. A mid-nineteenth-century visitor from the North remarked of a plantation, "I see now what gives this garden such an unnatural artificial appearance: there are no grass plots or strips of green anywhere; nothing but white and bright colors." The planter host replied that the

only grass available in the hot climate was Bermuda, and "it is almost proscribed . . . for it is death to cotton and almost everything else. . . . It spreads with the greatest rapidity, and nothing but fire can destroy it."[14]

In contrast, several of the African American homeowners we interviewed in the former cotton belt of the South expressed a strong preference for Bermuda grass. Ruby Gilmore of Hattiesburg, Mississippi, spent her childhood living on cotton plantations that her father and mother worked for shares. She described the heat in the fields and the way that the grass cut into her hands when she weeded between the rows. When she and her husband bought a house in town, they immediately planted Bermuda grass that rapidly spread across the lot. When her husband died and Mrs. Gilmore began filling her yard with recyclables, the grass suffered. But still it survived, as she showed, pulling back a plastic sheet to reveal the root systems of the grass zigzagging over the hard ground like a net. Her comment was striking compared to the planter's: "It's like black folks; it takes a lot to kill it."[15]

Mrs. Gilmore's interest in Bermuda grass is also telling because it indicates that the grass in the yard is not there just to make a flat lawn. Like raked sand and packed earth, it is three-dimensional: it holds the yard together, knits and binds it.

Borders and Boundaries

Borders give texture to surfaces and definition to boundaries. In addition to marking off areas of space within the yard according to their function (driveway, flower bed, walk, etc.) they also differentiate wild from cultivated zones within the space. Borders also extend linearly and thus can involve interplay of regularities and variations along a single trajectory and alongside other surfaces. A border can have "off-beat phrasing," "high affect" contrast of color and material, and "staggered entry"—like Richard Allen Waterman's list of characteristics of African music.[16]

In the antebellum period a white traveler in the South reported: "A straight line, also, bothers them. I was told of a black gardener here, who could not be taught accurately to lay out his paths and spaces at right angles."[17] Yet, as many illustrations in this book show, straight lines have their place. Thus, one needs to know more about where this gardener was told to put the path and who was likely to follow it. It is possible that the gardener viewed crooked paths as a means of deflecting negativity.

When interviewers visited the homes of formerly enslaved African Americans during the 1930s, several remarked upon fences and walls. For example, one interviewer of a Greenville, Tennessee, resident had this to say: "Joseph Leonides Star no longer works at the shoemaker's trade. He writes poetry and lives leisurely in a three room shanty, in a row of shabbier ones that face each other disconsolately on a typical Negro alleyway that has no shade trees and no paving. 'Lee's' house is the only one that does not wobble uneasily, flush with the muddy alley. His stands on a small brick foundation, a few feet behind a privet hedge in front, with a brick wall along the side in which he has cemented a few huge conch shells."[18] Star, a Freemason, published his poetry in the Knoxville newspapers and wrote a book on the deaths and important events that had occurred in his lifetime.[19]

Fig. 4.2
"Off-beat" bricks at entrance to home. Chattanooga, Tennessee, 1986. Photograph by Grey Gundaker.

Bottles often formed the borders in African American yards in the nineteenth and early twentieth centuries. Marie Campbell recalled a large swept yard with flower beds enclosed with old bottles.[20] When teacher Lura Beam visited the families of her students in Wilmington, North Carolina, around 1910, she noticed that middle-class African American yards favored violet-lined brick walks and circular beds of marigolds marked off by bottles stuck neck-down in the earth.[21] When Zora Neale Hurston mentioned decorative bottle borders in her short story "The Gilded Six Bits" (quoted in chap. 5), she implied a moral climate as well, noting that the borders and profuse flowers were touchstones of integrity in contrast to the seductiveness of an imitation gold coin.[22]

Because bottles previously served as containers, their reuse in the yard inherently involved the transformation for a new purpose. Reuse was ideally suited to material comment, even critique.[23] Sometimes, as in the example below (taken from an *Alabama Review* article by Henry P. Orr), the

transformation was especially significant because of what the bottles had been used for and who had used and discarded them: "At the Sevens home in Tuskegee [Alabama], an open oval area in front of the steps had crescent shaped beds bordered with the ale bottles left empty on the grounds by Federal troops quartered there."[24]

These yards probably looked much like the one that African gardeners prepared for a European doctor in about 1900 by enclosing the space in borders and swept earth (fig. 4.3). Despite the difference in climate and the relatively independent development of garden design in eastern Nigeria and the southern United States, this yard looks much more like southern yards then and now than those in the colonizers' homelands. The common denominator, of course, is the African and African-descended labor force that not only kept up the yards of whites on both sides of the Atlantic but also often created them. An American visitor to the Congo port of Baman complained: "[There] were the bungalows and gardens

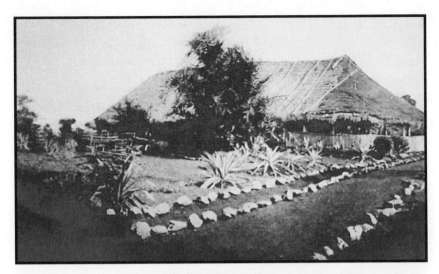

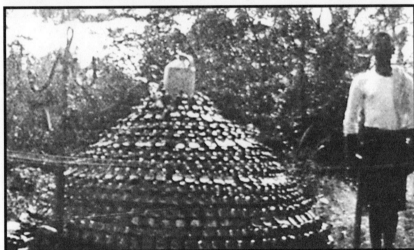

Top left: Fig. 4.3
African yard. Eastern Nigeria, c. 1900. Photographer unknown.

Left: Fig. 4.4
Tower built by Nigerian servants at club for British officers. Eastern Nigeria, c. 1900. Photographer unknown.

of forty white men and two women. Many of the gardens . . . were neglected, untidy, littered with condensed milk tins. Others, more carefully tended, were laid out in rigid lines. With all tropical nature to draw upon, nothing had been imagined. The most ambitious efforts were designs in white washed shells and protruding beer bottles."[25] In the same part of Nigeria, around 1900, African servants at a club for British officers built the striking tower shown in figure 4.4 with bottles that their colonial overlords had emptied of gin.

Plants also make effective borders and boundary markers, as do the sword-like leaves shown in figure 4.3. These have well-known associations with warning and protection. The long thorns of the dwarf ironwood communicate pointedly in many locales around the diaspora.[26] In Jamaica, John V. Watkins has observed, "There may be a plant of overlook pea, *Canavalia ensiformis*, to keep the provision ground from being bewitched. In the mango tree hangs the Obeah bottle charged with filthy liquid which contains the essence of toad

and spider."[27] Watkins noticed that in "the tiny spaces in front of Cuban homes . . . Very often a huge plant of Angel's Trumpet, *Datura arborea,* will dominate the door yard. This tree . . . is widely planted in the Antillean islands—as well as in our own southland."[28] In the United States, the flowering vines known as God's Trumpet, Angel Trumpet, or Trumpet Flower *(Datura suaveololens)* are popular for trellised gateways and beds. Richard Westmacott's study of African American gardens and yards pictures God's Trumpet in a border alongside a silver sewing machine in the yard of Fox and Juanita Fleming in rural Georgia.[29] More recently, these related plants have been reclassified as *Brugmansia.*[30] However, reclassification does not alter their salient qualities, for these plants have vernacular names that call to mind spiritual powers, and they are highly toxic, containing atropine alkaloid poisons with a history of accidental as well as intentional use. *Brugmansia* also have a sweet, cloying scent, especially at night.[31]

Westmacott has also discussed fences in rural southern yards and linked their irregular appearance to those in West Africa.[32] The Spanish military slang term *palo,* a palisade of stakes driven into the ground, is also the name for Kongo strains of Afro-Cuban religion.[33] The materials used in palo attack on behalf of the user, or barricade him or her with protective substances. From the standpoint of palo practice, a greater range of materials can conceivably accomplish a greater range of work. Thus it is tempting to speculate that fencing that looks, and is, haphazard in design and accretive in content has its advantages—something for everybody, coming and going, in the material language of protection and rebuff.

The white local-color writer Effie Graham gives a rare, detailed account of such a fence, useful despite her condescending tone:

Although the house was largely Unk Junk's handiwork, the yard, even to the fence about it, was surely Aunt June's own. To her it owed its wealth of horticultural outlawry, and its barbaric decoration. 'Twas she who had begged the plants and flowers and toted them home. 'Twas her hand that planted, watered, and coaxed them into bloom. From her lips, too, came those quasi-philosophic tellings of where, and how, and of whom she obtained the riches of her garden spot.

Many a stranger . . . halted to listen as she pointed out her treasures, and went away chuckling at the strange truth and humor of her talk.

"Yes, suh, my fence take me right smaht spell, but I guess 'twill las' me," she would say. . . .

And such a fence! Woven wire clutched its metal tendrils about pap-paw stakes. Discarded bank fixtures neighbored the wooden slats from a corn crib. Cellar gratings clasped hands with ornamental pickets. Barbed wire snarled its way through it all and held the motley mass to the task of guarding the dooryard. . . . She knew about it, too, every splinter of it.

"You-all askin' bout dem white pickets over dar," she would say. "All dem pickets done come from de bury-in'-yard"[34]

Elijah Davenport's fence, photographed in 1985 in Clarke County, Georgia, is not so different (see plate 2). Nor is the St. Lucian fence shown in portfolio II (fig. 24), or those

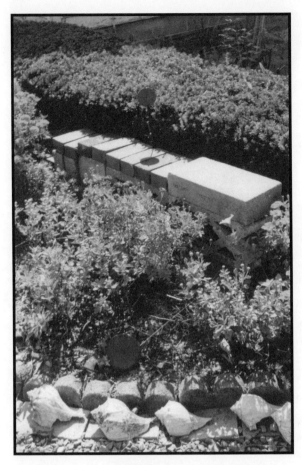

Fig. 4.5
Detail of shell borders in rock garden with spotlight
bulb in Marie Taylor yard. Delaware, 1988.
Photograph by Grey Gundaker.

that enriched the landscape. All the members of Mrs. Taylor's family helped gather the shells and stones that her husband, a contractor, cemented in place, culminating in a terraced, spiral rock garden. Mrs. Taylor said that after his death and, later, that of her daughter, she began to see these borders as a kind of memorial. Now, a broken earthenware jug, like the ones formerly placed on graves, marks the center of the spiral. She also placed brilliant reflectors in a border of bricks and flowers (fig. 4.5).[35]

Boundaries and borders often have extra physical and visual anchors at the four corners. A white Alabama leader of the Garden Club movement, Mrs. Belt White, reported:

A study of the development of flower culture in our little city for the past hundred years is quite interesting. In those early years of struggle the first attempts at flower growing were, of course, simple and unpretentious. Most of the work had to be done by the women themselves, for the men were too busy clearing the land and getting it under cultivation. For the most part the yards had no plan. The one paramount thing was they must be swept clean. This was one of the standards of measurement for a housekeeper. To possess a white, sandy, level yard was a thing greatly coveted. . . .

Some families who had slaves were more comfortably fixed [from the slaveholders' point of view], had gardens that were more formal, and more pretentious, showing the influence of the old English gardens. I have a very vivid picture of my Grandmother Park's garden, which was of this type, and was planted in the early forties. It was a flower and

of yard workers Clarence Burse in Memphis, Tennessee, and Ruby Gilmore in Hattiesburg, Mississippi. (See portfolio II, figs. 22 and 23.)

Laying out a border of stones, a lawn, or a flower bed also makes the landscape into a map of how one would like things to be, compared with how they were before. Marie Taylor of Delaware placed borders around all the trees and flower beds in her yard, making the whole area like a colored-in drawing that changed hues with the seasons. Even the materials in the borders had histories

Fig. 4.6
Porcelain sink on stone pile
in Carroll Kinney's yard.
Central Virginia, 1989.
Photograph by Grey Gundaker.

vegetable garden combined. The plot comprised one-half acre. It was divided into four squares by double walks. These walks were bordered with Iris (then called Flags), Narcissus, and Jonquils. In some corners of these squares were grown herbs of medicinal value—as was true of all gardens—sage for making tea and for seasoning; horehound, to put in candy for colds; catnip, used for tea for babies; rhubarb, for bitters; horse radish . . .[36]

Although the garden of the author's grandmother contained English influences that the author named as such, it also may have had unmentioned African ancestry. At the very least, the enslaved people who worked there would have noticed and approved of design features like the built-in central crossroads and placement of herbs at the four corners of the beds.

Attention to the four corners of a yard or room remains vital in African American aesthetics. Mrs. Joyce Johnson of Chattanooga, Tennessee, remarked that the previous owner of her house "knew how to do things right. She put a big rose at each corner of the fence."[37] African diasporic formulas for spiritually cleansing rooms often involve blowing smoke, spraying perfume, and pouring libations of water or liquor in the corners of a room.[38] The herbs and cleansing rituals help to seal the space just as four knots help to seal a "luck ball" or amulet.[39]

Pipes, which also have a history of use in African American cemeteries as burial markers, are especially popular at corners and gates of yards, as are columns, piles of stones, and reflectors, often in combination.[40] Carroll Kenney of Louisa County, Virginia, combined piles of stones with a porcelain sink in front of his house where the corner of the yard intersected the driveway (fig. 4.6; see also portfolio II, fig. 34).

Stones certainly have numerous associations that lend themselves to yard work. They represent stability and endurance and are sometimes brought from the birthplace of the owner of the house. Likewise, in the past, Africa was spoken of as "the Rock."[41]

A name such as the Tried Stone Baptist Church in Chicago also recalls a Biblical passage that says, "He is a stone who is a tried stone."[42]

The threshold, like the crossroads, is both a meeting place and a parting of ways, a zone of transition and a potential buffer against intrusion. Because thresholds lead to and from somewhere, they are focal points of action and mediation. With this in mind, the female pastor of a Pentecostal church in a segregated Oklahoma town dressed the doorway of the house of the principal of the African American high school who had just arrived from the north. According to William Owens, "Sister Brackett had a small bundle tied up in white cloth, 'Sweet-smelling yarbs,' she told [him] as she tied the bundle to a nail on the wall. 'May it bring good luck to your house.' Then she hung a motto over the door. Stepping back and raising her hand, she read the words in her preaching voice: 'Be Vigilant.'"[43]

A dressed threshold is one of the yard arrangements most likely to have moral and religious associations. The object arrangements that mark the entrance to yards vary considerably, implying a wide range of ways that their makers view neighborhoods and potential visitors. Wrought-iron door and window coverings add "prestige and protection," according to an advertisement on WNOO radio in Chattanooga.[44] A spiritual doctor from the 1930s recommended placing a fork by the door or gate to keep thieves away and stop people from gossiping.[45] Other protective devices against conjure, witches, and negativity include a broomstick over the kitchen door and sprinkling doors with chamber lye and salt.[46] Some yards include actual stop signs that spell out this message. Gyp Packett and Bennie Lusane both used red reflectors and stop signs near walkways to their houses that glow like fire and like animal eyes in the dark. The thresholds to both yards are also watched by human, animal and spirit figures. Raffia, fans, streamers, grids, cross marks, and *x*s and *o*s on screen mesh also filter access. Charlie Jackson of Memphis placed a doormat that reads "Safeway" just inside his gate (fig. 4.7). He also surrounded his house

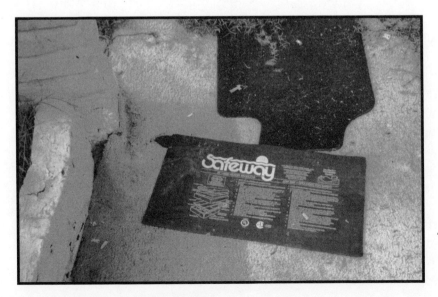

Fig. 4.7
"Safeway" sign at entrance to porch of Charlie Jackson's residence. Memphis, Tennessee, 1998. Photograph by Judith McWillie.

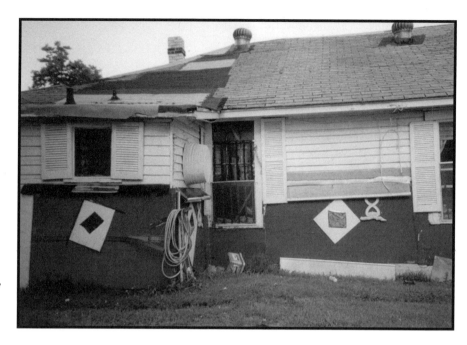

Fig. 4.8

Mirrors on side of Charlie Jackson's house. Memphis, Tennessee, 1998. Photograph by Judith McWillie.

with mirrors mounted on the exterior walls (fig. 4.8), a device that deflects whatever motivations visitors bring to the house back upon them.[47]

Reflective Surfaces

George Kornegay of Brent, Alabama, placed a horizontal wall mirror, elevated in a frame with a crucifix and clock mounted on it, in an arched gateway in the center of his yard (see plate 5). He explained that it revealed the faces that viewers would show to God if the Second Coming of Jesus were to come at this moment. Clarence Burse of Memphis nailed a similar mirror to a tree in his front yard in a vertical orientation, but his explanation was that he could keep an eye on the café down the street by gazing at its reflection from an easy chair in the living room. On a small scale, silvery hubcaps and

dimes share the shine of a mirror; both have protective uses.[48]

The practice of placing a reflective barrier on the outside of the house dates back well over a century, and probably much more. An account published in the early 1880s describes the house of "Aunt Mely," which "seemed to hang together by attenuated threads," yet "on the outside Aunt Mely had nailed a shining sheet of tin." Possibly, residents of "Tin City," a desperately poor community in Great Depression–era Savannah, also saw reflective surfaces as protective; certainly, it provided better protection against the wind than scrap wood siding.[49]

Again, transatlantic parallels are suggestive. Elliot Lieb and Renee Romano have reported that tropical Africans often use "mirrors to combat witches, who are said to be repelled by their own images."[50] Writing in the early years of the twentieth century, R. E. Dennett reported that among the Bakongo, "It is 'xina' (a forbidden thing) to

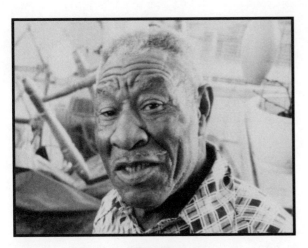

Fig. 4.9
Clarence Burse. Memphis, Tennessee, 1983.
Photograph by Judith McWillie.

Instruments of Mediation

All of these materials and procedures draw on and contribute to a persistent and dynamic tradition of mediating the entrances and exits of homes and yards as well as access to psychic spaces and the human body. Labelle Prussin has written that "the entrance is the mediator; it marks the point where man makes the transition between exterior and interior, between the unknown and the known. . . . Throughout West Africa, all rites and rituals relating to change or transition in man's existence occur at the entrance."[53] Similar intentions echo clearly through numerous descriptions, some dating back nearly a century, some transatlantic like the passage that Thompson quotes from Abbé Proyart's *History of Loango,* published in 1776: "All, after having cultivated their field, take care, in order to drive away sterility and evil spells, to fix in the earth, in a certain manner, certain branches of certain trees, with some pieces of broken pots. They do more or less the same thing before their houses, when they must absent themselves during a considerable time. The most determined thief would not dare to cross their threshold, when he sees it protected by these mysterious signs."[54]

throw the light reflected from a mirror upon a person, and when the light passes across the face of an individual he cries out: 'Leave me alone. I have ndudu medicine in my body.' It is not a crime but more in the nature of an insult, to throw this light upon a person. Bits of looking glass are to be found in trees and in the eyes and stomach of many minkisi fetishes."[51]

Jim Haskins has mentioned a residual fear of mirrors lingering from his childhood in Alabama, perhaps because of procedures like the following one, described to Harry Middleton Hyatt by a spiritual doctor in New Orleans: "You works with a mirror. You takes a mirror and you bury it at the fork of a road. Understand? And you let that mirror stay there for three days and afterwards you digs this mirror up, and you don't want to be the first to look into it. Let a cat, either a dog, look into it first. Then after that you can know just what you wants to know through this mirror, if anything coming against you."[52]

Thompson's interpretation is that the broken pottery alludes to the world of the dead, where broken things are made whole again. In the 1920s folklorist Newbell Niles Puckett remarked that "all through the Black Belt broken crockery is used as the chief decoration for Negro graves. This seems to be a direct African survival. . . . I have observed this sort of decoration all through the South."[55] In a personal communication,

Thompson also interpreted the open-centered tires and wheels in trees and on posts beside gates and gardens in the United States and the Caribbean the same way, a reading born out by both the positioning of the wheels and the other materials placed with them.[56] In contrast to the wheels with spokes that signal motion or the whirligigs that move around the four directions or the tires that enclose plants, the salient feature of wheels with open centers is their glaring emptiness. To underscore the point, often they are slung rather casually over the stump of a dead tree, held in place by bare wood poking through the hole. Like broken pots, open portals to the world of the dead warn potential thieves where they will end up if they transgress. A wheel observed beside a vegetable garden in Nassau in the Bahamas was an automobile tire rim painted with red gloss enamel.

Another wheel doubled with the Christmas wreath it once was, a function now contradicted by the "No Trespassing" sign that hung beside it, translating it for anyone who misses the message of the circle alone. In terms of the indirection

and avoidance of spoken words customary in such matters, this arrangement is quite explicit. The man in Mississippi who hung the wreath in the tree beside his driveway also arranged tall white columns made of plastic buckets on either side of his front steps, marking the approach to his door with emblems of dignity and authority like the white columns on the porches of the neo-classical houses of Mississippi planters. Similar columns occur at the entrances to homes in American Beach, Florida, and Athens, Georgia. Another pair at the entrance to Oskar Gilchrist's house (fig. 4.10) in Nichols, South Carolina, serves the same purpose.

During the plantation era, enslaved people planted sweet basil on either side of the cabin door. Says Francis Doby of Louisiana: "We called sweet basil by another name . . . we called it *basilique,* and it sure was good to have 'round the house. They got two kinds of basilique, you know, the papa plant what's got them long, thin leaves, and the mamma plant, what's got round, flat leaves. You got to put them both in the ground at

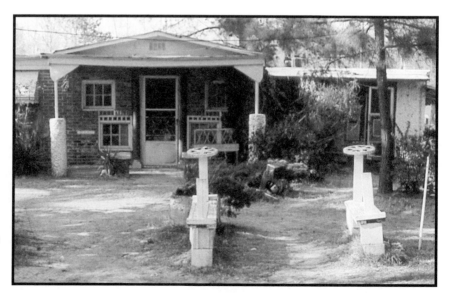

Fig. 4.10
Silver painted posts at entrance to Oskar Gilchrist's house. Nichols, South Carolina, 1991. Photograph by Judith McWillie.

the same time so they'll get together and grow. And when you got them in your yard you sure is got good luck for yourself all the year round."[57]

Trees

Carefully tended and bounded surfaces make any plant or tree stand out more strongly. In African American yards, borders of stones, bricks, and fencing often encircle the trunks of trees, just as they often enclose graves. Trees, the dead, and higher powers have intricate connections. Ishmael Reed referred to trees at crossroads as "celestial elevators."[58] Structurally, trees connect the sky with the surface of the earth and the regions beneath it, lending themselves to serving as altars and symbolizing an intersection, or crossroads, of spatial and metaphysical zones.[59]

African American yards like that of Edward Houston of Center Star, Alabama, reinforce this idea through redundant use of material signs of directionality and motion on trees and around their bases: a whirligig, a steer skull elevated on a pole, and wheels, hub caps, and tires throughout the yard.[60] This yard of about an acre included four huge oaks. On one, Houston mounted reversed red and white shoe soles (souls) as if they were walking up the trunk (fig. 4.11). Beside another he built a rocket ship pointing toward Heaven (fig. 4.12). A third stood

Top right: Fig. 4.11

Shoe soles nailed to tree in Edward Houston's yard. Center Star, Alabama, 1990. Photograph by Judith McWillie.

Fig. 4.12

Rocket-shaped object by tree in Edward Houston's yard. Center Star, Alabama, 1990. Photograph by Grey Gundaker.

knee-deep in chrome hubcaps and iron
wheel casings. The fourth was hollow, its
interior filled with the type of vessels more
often left on graves.

This use of the tree as a container for
materials associated with the dead recalls a
protective formula recorded in the 1930s that
calls for inserting the hair of a deceased
person into a tree: "If . . . you don't want his
spirit to bewitch you after he is dead, take
some of his hair after he is dead, bore a hole
in a tree, put the hair in that hole and plug it
up. He will never harm you."[61]

Diverse African peoples from
Senegambia through Angola associate trees
with the ancestors.[62] Similar associations
persist in the United States. Luisa Teish has
written of the energy of the ancestors in
"wood that groans."[63] Gyp Packnett of
Centerville, Mississippi, called a cedar in
the center of the yard his "family tree." He
tied it in chains and suspended the weights
of an old cotton scale from its branches to
show that his enslaved ancestors, as he put
it, "took the weight and come on through."[64]
Writing about low-country South Carolina,
Donald Grey remarked on "a dead live oak
tree . . . standing deep in the palmetto
thicket, its bare limbs covered with a foliage
of rags and papers and strings of odd
objects."[65] Trees can also serve as transitory
memorials. When the patriarch of the
extended Bullock family died at his home in
the North Carolina piedmont, his widow and
children hung the dress suit that he wore on
Sundays as a church elder in the large oak
tree at the end of farm's driveway. All day
and all night a steady stream of automobiles
passed slowly by, as members of the com-
munity paid their respects.[66] The association
of trees with the dead is also suggestive in
light of what Wyatt MacGaffey has written

about the Kongo people: "[H]ollow trees
are both the origin of mankind . . . and the
abode of the ancestors. . . . The banana
tree by the water's edge is a common
representation of the soul at the juncture
of life and death. The banana 'tree' itself,
by the abundance of its fruit and the brevity
of its life, stands throughout Central Africa
for the cycle of human existence."[67]

Qualities associated with particular
species of trees make them well suited to
represent or stand in for other entities, as
the banana does for the human being. In
Haitian Vodou, different "lines" of Iwa, spir-
its, and domains of practice have developed.
These lines have been partly influenced by
the differing cultures that contributed to
Vodou's development and partly by the
highly decentralized and localized nature of
the religion.[68] As Serge Larose has explained:

Each "nation" has its own tree of
predilection. Guinea is often said to live
in the calabash tree, while Magic and bad
"points" dwell in fig trees. The calabash
tree is never very tall. Its gourd-like
fruits are described as "the vessels of the
first creation." But the important thing
about them is their underground root
system, which is always described as
larger and more ancient than the visible
trunk would seem to suggest. . . . One
always stresses its ability to survive any
cyclone; it may lose its branches and yet
the trunk never ceases to regenerate
others. It is also a very useful tree,
planted a long time ago by some
ancestor. One often passes from that
tree to a discussion of his ancestors. . . .
[p]ointing at a calabash tree in the middle
of the yard: "You see that calabash-tree.
It protects you. It protects the yard. . . ."

The calabash tree is perhaps the best representation of the way Haitians look at Guinea through their ancestors and relate to it through generations and generations of them. The fig-tree connotes quite different values and provides sanctuary for demons and vampires.[69]

Figs often sprout from seeds that squirrels, birds, and bats drop onto other trees. Eventually they build root systems that enclose and kill the host tree. According to Larose's informant, harmful magic spells—or "Points"—are "similar to fig-trees . . . illegitimate power springing up from nowhere."[70]

Although Haitian tree symbolism differs in many ways from that of the African American South, parallels exist as well. For example, the chinaberry echoes the benevolence of the calabash. In the days before air conditioning, when much of the labor of housekeeping went on in the yard, the tree's thick foliage and canopy of shade were not only protective in a metaphorical sense; they made an outdoor roof against sun and rain. Although we have not heard of a specific species of tree in the United States analogous to the fig, with its association with magic *pwe* in Haiti, there is no shortage of evidence that people turned to sacred groves and special trees in times of trouble. An anonymous novel, published in 1871 and purporting to be the recollections of a free man of mixed blood, asserts:

Everyone accustomed to mingle with the [N]egroes upon Southern plantations . . . was aware that they had retained many of the customs of their African ancestors. Not the least common of these was a belief in demons which exercised a supervisory control over humankind. The usual habitations of the goblins and spirits were supposed to be in groves or trees, and these, in consequence, were regarded with extraordinary reverence. From whites the existence of this veneration was carefully concealed; yet there was scarcely a plantation without its sacred grove, which was looked upon as sacred because of the imputed residence of some deity. To this the poor bondsmen, when least suspected of an inclination to paganism, would secretly resort on occasions of unusual anxiety, to bestow their native offerings, and to implore the kindly intercession of the invisible spirit.

In this regard "Massa Ruy's plantation" was not an exception. It had its sacred grove and its goblin's tree. Not far from the mansion stood a collection of dark magnolias, one of which had a top that overlooked the others and foliage so dense that a deep shadow always slept beneath it, was looked upon as the chosen abode of the controlling demon of the place. This had been the destination of many a midnight pilgrimage when trouble had entered the cabin of the slave, and numerous were the offerings that had, from time to time, been left beneath the wide-spreading branches of the great tree, in the hope that the patron deity might be induced to restore health to the wasted body, or love to the alienated heart, of the cherished one.[71]

Folktales and myths around the world tell of spirits and trees, people becoming trees, and trees becoming people. Hollow trees figure in numerous stories of self-liberation

from slavery and escape from the plantation; Gippy Plantation in South Carolina is said to have received its name in 1852 from the swamp where an old man, "an inveterate run-away," lived.[72] The silk-cotton tree or kapok *(Ceiba pendandra)* grows to huge size throughout the American tropics. Its branches harbor spirits, its trunk is sometimes dressed with cloth and its buttress-like roots form enclosures for offerings.[73] In Haiti a circle of (often white) stones or cement around the base of a tree reveals it to be a *reposoir,* residence of lwa or ancestral spirits.[74] Our research suggests that the tulip poplar, which also grows very tall, serves, or formerly served, some of the same purposes north of the growing range of the silk-cotton. Certainly, primary-growth forests of this tree must have impressed Europeans as well as Africans, influencing Thomas Jefferson to name one of his plantations Poplar Forest.[75] African Americans chose specially shaped and configured trees as sites for worship and construction of brush arbors (which double-voice as hush harbors).[76]

Whether painted, adorned, or carved, trees lend themselves to adaptations that help to define the character of the landscape. For example, a tree stump carved into a cross stands near the entrance to the yard of the Shepherd family in Athens, Georgia. The carving was a visual gift from the man the Shepherds had hired to landscape their recently purchased home. In the mid-1980s, Rachel Presha of Suffolk County, Virginia, dressed the trees on her land with purple ribbons and painted the same color on the bases of telephone poles along the highway that approached her property. As a result, Presha, who lived alone, became known regionally as "The Purple Lady." She also wore purple clothing. She adapted the more widespread tradition of whitewashing the bottoms of the trees to the more contemporary gesture of painting telephone poles. This sealed her identity while at the same time memorializing the fact that telephone poles are made from cutting down trees that, even in their newer incarnation, bear messages. She also tied protective bundles in the trees in her yard.[77]

Usually, offerings placed at trees are not for the trees themselves but for the powers that inhabit or move through them. Compare, for example, with the Bamana peoples. Their villages, according to Pascal James Imperato, "generally possess protector spirits, known as *dassiri* which reside in such material supports as trees, animals, or unusual rock formations. These spirits act to counteract the *nyama* [force freed to roam by death] of animals, men, and inanimate objects which seek to harm the village as a whole. In many villages the *dassiri* is an acacia tree *(Acacia albida),* but it may be any type of tree."[78] J. H. Nketia's account of drum making in Ghana illustrates the virtually inseparable relationship of spirit with material. In this cultural practice, Nketia explains, the wood is, in effect, a material sign for the forces that have shaped it:

> Among the Akan when a tree, usually the *tweneboa,* which has a cedar-like wood, is to be cut down to make a drum, . . . in the old days a sacrifice of an egg was made to the tree and prayers for protection from harm were said before the tree was cut down, for the Akans held it to be a tree with a "powerful spirit." . . . Even when such a tree has been cut down and its wood used, the finished drum is still identified with the spirit of the wood. Accordingly

drummers, particularly those of courts and warrior organizations, like to begin their performances with invocations to the spirit of the wood and to the many spirits capable of interfering with their work, including those of past drummers.[79]

These West African ideas may seem remote from activities that go on here. However, from a philosophical standpoint, similar ideas inform much of the yard work that involves finding and using wood. Edward Houston "planted" inverted root clusters on iron stands in his boxwood garden, singling out their intricate, knobby forms for attention as if they were prize flowers or ornamental sculptures (see portfolio II, fig. 44).

The late Ralph Griffin and Bessie Harvey, both well-known artists who made works for their homes and yards, also sought wood that instructed the sculptor about the character of the finished product. Griffin lived in rural Girard, Georgia. In the 1970s he began making sculptures from fallen trees, drift-wood, and metal, placing them in his yard as part of an ensemble of white-painted rocks, found-object constellations, and gardens. His root constructions called living presences into being (see portfolio II, fig. 45). He retrieved much of the wood he used from fallen trees in cemeteries and from Poplar Root, a stream that crossed his property. Such wood, he said, dated from a past he called "old experience ages." He continued:

A lot of people ask me where I start when I make one of these. The first thing I do is to get the eyes. When I get his eye I can make him come out of the root. I can bring a man out of it, then make heads on heads. It seems like a dream until I get it made. They called

me the Root Man when I started this stuff and I'm the only person in these parts doing things like this. People still come over and ask me to help them with their dreams and all, but I don't go that far; and I am one who is pretty wise about that kind of thing. I believe that the more I do this, I could maybe shake your hand and give you all the luck you want. I'm real for that, but I don't go that far. I feel just like the astronauts exploring up there; I just want to see what I can find in these roots and things.[80]

While Mr. Griffin said he stopped short of doing healing and dream interpretation, Bessie Harvey did see doing "spiritual work" as a result of having been healed by God and as an effort to help heal others. She began making art in 1972 after recovering from diabetes. Her work process identified the "soul" of each of the figures she exposed in pieces of wood, sometimes giving them both public and private names.

In addition to the notion of spirit shaping the wood, there are several other probable precursors to the relationship between spirituality, prayers, and wood in recent art and yard work. Visually, there are the evocative shapes of roots and branches reaching toward earth and sky, which resemble the transatlantic gesture of spread arms and fingers in African American worship.[81] Also, during the antebellum period and up to the present, seekers of religious conversion, visions, and answers to prayers chose their own forest places and special trees to pray under, as described earlier by Eva Mae Bowens.[82] In much of Central Africa, including Kongo-Angola, bent and twisted wood and roots especially revealed

the handiwork of the creator. This was especially true of wood that entwined, and thus "twinned," a key characteristic of *simbi*, whitish spirits who dwell in the waters of ancient and ancestral places.[83] In nineteenth-century Virginia, such wood marked a special, sacred place for burials. Regarding a baby who had died, a formerly enslaved woman said, "Dey buried 'im dat ebenin' outen dar whar dem two big trees grow t'gedder on de hill yonder—de twin-trees, ye know!—dars heaps o' black folks buried dar!"[84]

In principle, if not in terminology, the association of twisted and bent wood with creation and the Creator endures not only for artists such as Bessie Harvey and Ralph Griffin, but also for members of the Mt. Olivet Apostolic Church in south-central Virginia, where an unusual pine tree still grows, its trunk extending upward about six feet, then zigzagging down to touch the earth again before rising once more. When the land was cleared for a new church, nearly all trees near the site were cut down. However, this special pine was spared. Perhaps to echo the shape of the tree, one of the two lanterns positioned on either side of the doors to the church was inverted; thus, while one lantern pointed up to Heaven, the other pointed down to earth. (This is the type of purposeful action that makes little sense in Euro-American terms, but it is perfectly logical as a contemporary "riff" joining the venerable Kongo gestural and graphic sign of the intersection of worlds with the Christian God's omnidirectional power.)[85]

In the early 1930s some of the most famous tree forms in African American visual culture were placed by Cyrus Bowens in his family's cemetery plot at the Sunbury Missionary Baptist Church in Sunbury, Georgia. Cyrus Bowens's nephew, Eddie

Bowens, told Judith McWillie that his uncle selected wood that had been shaped by the forces of nature during an ice storm (see chap. 1). The graveyard depicted in Julie Dash's film *Daughters of the Dust* is based on photographs of the Bowens plot similar to the photos reproduced in chapter 1.

Trees also hold signs, writing, and enigmatically combined letters. In East Texas some trees were said to have the "money sign" on them. Such signs might be as simple as an *x,* but sometimes they have more elaborate designs. The trick is to recognize them. Stories abound in which a tree stands over treasure; Edgar Allen Poe's "The Gold Bug" is perhaps the best known. Lonnie Holley placed giant cutout red letters up the trunk of a tree in his yard, extending them into its branches. He explained that "in the

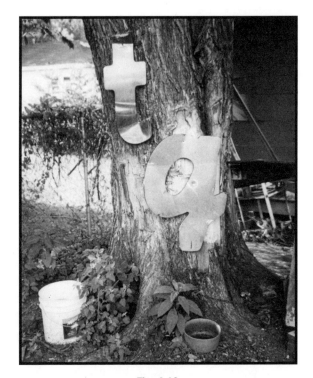

Fig. 4.13

Letters in tree at Charlie Jackson's residence. Memphis, Tennessee, 1998. Photograph by Judith McWillie.

future, there's going to be a new language and a new code."[86]

In Memphis, Tennessee, at the edge of the Orange Mound district, Charlie Jackson's yard contained a tree with the twenty-four-inch aluminum letters *t* and *g* ascending the trunk (fig. 4.13). In the context of the yard as a whole, the tree stood in a private space near the back gate. This is a common place for evocations of the cemetery in yards, suggesting that the tree may be a shrine. A tree in the yard of the Johnson family of Lightfoot, Virginia, gained commemorative implications from the license plates nailed to its trunk. Stretching back two decades, they show how long the family members have come and gone from this property and call to mind numerous stories of cars and travels. Trees and plants in African American yards also represent individuals and register their well-being. A Federal Writers' Project worker reported on the surroundings of ninety-eight-year-old Martin Richardson in 1937:

> In front of his shack is a huge, spreading oak tree. He says that there were three of them that he and his wife tended when they first moved to Jacksonville. "That one there was so little that I used to trim it with my pocket-knife," he states. The tree he mentioned is now about two-and-a-half feet in diameter.
>
> "Right after my first wife died, one of them trees withered. . . . I did all I could to save the other one, but pretty soon it was gone too. I guess the other one is waiting for me," he laughs, and points to the remaining oak.[87]

Fifty years later, Mary Lou Furcron planted and maintained shrubs she called by the names of her ancestors. In this way they remained palpable presences on the land where the family settled.[88]

Johnson Smith of Lumberton, Mississippi, also identified with a tree in his yard, a pine that he planted himself. He told Grey Gundaker that he could foretell her (Gundaker's) visits by the voice of its needles in the wind.[89] Once, when he was away from home, his wife hired someone to prune its lower branches because she was tired of the mess Mr. Smith made in their yard with his junk business. When he died in 1994, the tree began to lose its needles and in the windy fall of 2002 finally toppled over, crushing the roof and poking its branches into the vacant rooms where Mr. and Mrs. Smith had spent their sixty years of married life.

Mr. Smith's life involved relating to other people, not just standing alone, so his tree testified to the ups and downs and the goings and comings that gave character to his days. Mr. Smith also discussed many of the main events of his life in terms of trees and other plants. In old age he raised plants in pots that he often placed in chairs as if they were guests sitting at leisure in his yard. As a young man he had worked in the turpentine camps of the pine forest and had driven melon trucks throughout the Southeast. He explained that in the 1920s and 1930s people used pine branches to show that they had traveled from one part of the state to another: "See, the pines in the hill country is different from the ones in the Delta, so you'd decorate the car with branches from one place and take them home to the other, depending on where you come from."[90] More was at stake here than the prestige of travel: a person who traveled with a group of friends was sociable and one who returned with something to show for it had made good use of the experience. (Mississippi pine branches on

cars thus have a social function in common with today's mobile phones, showing that the bearer is well connected and in demand.)

Some of the most widespread practices in the African diaspora linking trees and individuals establish the relationship near the time of a person's birth. A white planter's son, John Sale, wrote in his memoirs that his black nurse planted a "name tree" for him, setting the sapling into the earth just as the morning sun rose over the horizon. In his book *Gardens of the Antilles,* John V. Watkins noted that in Jamaica, "Growing on the steep mountain-side of the island are scrambled, indescribable tangles of breadfruit, cacao, coffee, akee, plantain, banana, coconut, and seedling mango. Every tree in the small yards on the mountain-side may belong to some individual within the family group, as a well-established custom here is to dedicate a yard tree to a newborn infant by burying the umbilical cord and placenta beneath the tree on the day of the child's birth."[91]

Plants and trees may also be activated to work for or against people, and people may activate substances to look out for plants. For example, Killion and Walker recount the story of a woman who was "fixed" by a "dressed" peach tree and was advised to cut it down.[92] A spell from Illinois instructed a man to get rid of his wife by putting some of her monthly rags in a hole in a tree and sealing it up. As the tree withered so too would the wife.[93] To protect her pecan tree, Mrs. Ruby Gilmore of Hattiesburg, Mississippi, dressed it with a crossed spoon and knife and a piece of plastic shaped rather like human shoulders. As she remarked, "If something works to keep away squirrels, it will probably make nosy people stop and think too."[94]

The trees that people live with are beings that they come to know and love. When a tree dies or is cut down, the loss can be devastating. When the pine forest around Mary Lou Furcon's home was cut down by a lumber company, she discovered that she did not own the land she thought of as belonging to her family. Soon after, she became too ill to live alone and had to move into a nursing home. Inez Faust's front yard formerly enjoyed expansive shade from its centerpiece, a large oak. When the tree died, Mrs. Faust built an elaborate enclosure with red bushes at the four corners and a red wagon wheel with a wash basin on top where the tree had been (see plate 1).

Figures, Watchers, and Guardians

It is clear from the history of garden ornaments that members of many ethnic groups —rich, poor, and in-between—favor statuary in their yards and gardens. While also decorative, figures give a visual focus: something to see at the end of the path, something for flowers to surround. Obviously, statuary can be extremely expensive; obviously, too, its functions and appearance change with the times and the neighborhood. Casts of Greek gods and goddesses were popular in elite English gardens and remain so in elite African American neighborhoods from Atlanta to New Orleans. Casts of Jesus, the Virgin Mary, and the saints, made initially for Roman Catholic consumers, have been adopted by African American evangelical Protestants as well, not as denominational markers but as ways of populating the space with role models of righteousness.

Statuary is a status symbol that also reveals something specific about its immediate context of use. As industrialization and urbanization shifted more Americans into the cities and suburbs, figures of deer, squirrels, and rabbits became popular ornaments. African American homeowners have participated in these trends. In terms of the foundations of yard work, statuary helps to show from a distance that the yard receives special attention. During the 1950s a white author named Frances Gray Patton described the most affluent African American neighborhood in Durham, North Carolina: "I know Lincoln Heights, where the dwellings are likely to have fluted porch pillars, cut glass fanlights, and lace curtains in their windows, and to preserve on their lawns, like symbols of stubborn gentility, the iron deer that once graced the grass of the original tobacco magnates of Durham."[95]

Patton seems to share with many white southern writers of her era a virtual reflex to match any sign of African American aspiration with a put-down. However, we suspect that one reason Greek statues stay so popular is that they have a very *au courant* appeal that has nothing to do with ancient Greece or aspiration to imitate whites. Along with being highly visible, these gods and goddesses are extremely "cool" and elegant in tone and posture. They have as much potential to serve as role models for the behavior expected of guests to the household as do high-fashion models as avatars of style or the little plastic monsters in some yards that suggest the nasty consequences intruders will encounter. But more on that later. During the same period as Patton, William Mahoney recorded statuary in a fictional passage with an ethnographic ring in his novel *Black Jacob*. Dr. Jacob Blue walks through a black section of Matchez (surely, Natchez), Mississippi, near the river:

> Jacob passed a ragged-haired man in a gigantic overcoat who begged a quarter and then backed away from him bowing. Sitting on porches covered with green potted plants old men called—how-do' to him. Sticking up from the little clay and dust yards were porcelain images of ducks, the white Virgin, black boot blacks, black dogs, white Jesus and other assorted colorful characters. These were the houses of the mill, waterfront and factory laborers, who were constantly in search of a home with grass and trees around it but who were limited to houses used by other races who left their mark; a crucifix left on the wall by an Italian Catholic railroad family, a dusty trunk left by a Swedish logger.[96]

Doubtless there are many reasons why plaster, concrete, and plastic chickens are popular decorations in contemporary yards, (see fig. 4.14) but when a chicken figure looks upright and watchful like a guardian of the yard, it probably is. In the yards of the southern United States and the West Indies, "frizzled" chickens, a breed with curly ruffled feathers, were the traditional guardians against pests, powders, and conjure bags. The breed favored in Jamaican Obeah was called "Senseh."[97] John Szwed explained that the jazz musician Charlie Parker was nicknamed Yardbird, a vernacular term for the household's frizzled chicken, because he looked disheveled.[98]

Thus, the "colorful characters" that Mahoney mentioned make allusions beyond decoration. A secure yard is one that is *well looked after*. Ruby Gilmore explained that

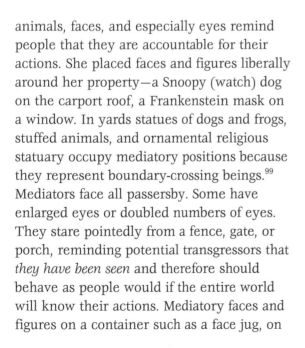

Fig. 4.14
Plastic chicken in Annie Sturghill's yard. Athens, Georgia, 1987. Photograph by Judith McWillie.

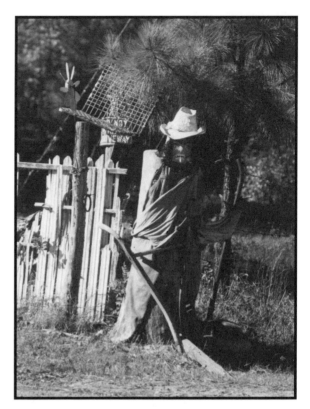

Fig. 4.15
Watcher figure. Central Georgia, 1989. Photograph by Judith McWillie.

animals, faces, and especially eyes remind people that they are accountable for their actions. She placed faces and figures liberally around her property—a Snoopy (watch) dog on the carport roof, a Frankenstein mask on a window. In yards statues of dogs and frogs, stuffed animals, and ornamental religious statuary occupy mediatory positions because they represent boundary-crossing beings.[99] Mediators face all passersby. Some have enlarged eyes or doubled numbers of eyes. They stare pointedly from a fence, gate, or porch, reminding potential transgressors that *they have been seen* and therefore should behave as people would if the entire world will know their actions. Mediatory faces and figures on a container such as a face jug, on

a house, or on an enclosed residential landscape, assert that the interior is off-limits to intruders. On a country road near Augusta, Georgia, we encountered the life-sized, hot-blue masked figure in figure 4.15, accompanied by a vacuum cleaner (to sweep up intruders?) and fans (to blow them out?). A college student in one of our classes discussed her grandmother, a Virginian of African and American Indian descent, who became worried about her safety living alone after her husband died, saying that she lined the edge of her front porch with stuffed animals, all looking out at the road. When the grandmother died, the family took the stuffed animals to the funeral home and passed them over the casket. When the

casket was interred the animals were placed on the grave.[100]

From a transatlantic perspective, yard makers have had many vectors of association to draw on for figural images. For example, R. E. Dennett discusses the Bavili Kongo "home-protecting" minkisi "zinkondi," which in figural form are called *mpumbu.* They are wooden figures of men and women approximately eighteen inches high and go through an elaborate ritual of consecration that includes the placement of herbal decoctions in their eyes and nostrils.[101] Other resources include small statues such as those on Kongo graves called *n'tadi,* related to the verb *tala,* meaning "to look at or watch."[102] The watcher or Watchman is also a community role, a guardian of group well-being. In the past it was usually the responsibility of male church leaders and lodge and burial society officials. The title dates back at least to the camp meetings of the nineteenth century.[103] In Liberty County, Georgia, by 1811, certain "intelligent, pious, and prominent male members" of the "colored churches" were assigned the titles of "Superintendent or Watchmen for the rest," and each was in charge of discipline for several churches.[104] More recently, according to Jason Berry, members of a Spiritual Church congregation in New Orleans conferred the title on their protective Indian spirit, Black Hawk. The congregation and leaders chanted "to the Indian—'Black Hawk is a *watchman!* He will *fight* your battles!'" Later, "Deacon Lastie introduced the young Reverend Anderson as 'our Black Hawk *demonstrator.'* He came to the podium chanting the words *'Black Hawk is a watchman'*—with people in the pews calling back the refrain—*'He's on the wall!'"*[105]

The congregation's response—"He's on the wall!"—shows that they knew the charac-

teristics and cosmological position of watchmen well enough to recognize them through allusions. The wall the congregation referred to is the mighty wall of vision in Isaiah from which the Old Testament prophets ("Watchman, what of the night?") surveyed the future of the chosen people. A watchman is a kind of initiate who has undergone transformation from ordinary standing to membership in the class of "people who know." Personally, the scales have fallen from the watchman's eyes; socially, others acknowledge this fact. Materials in the yard may thus signal that such a person lives there, as may extensive use of the colors of sight, pulsing action, and pure intentions—blue, red, and white respectively.[106]

For example, another characteristic of the watchman is that he (or occasionally she) knows that history is God's clock; that is, a clock is the face of God's time. Clarence Burse and Bennie Lusane used clock faces extensively in their yards (fig. 4.16). Z. B. Armstrong "taped" (drew intricate grids on) clocks that he built to mark the hours until the Last Days (fig. 4.17). Watching and watchers involve management of gaze. The eyes communicate more information about a person's state of being and accessibility to others than any other part of the face, whether they are accentuated by the beaded veils of Yoruba royalty, the dark glasses of marchers in a New Orleans jazz funeral, or the pair of glasses with one lens missing that Bennie Lusane attached to a pine tree in his yard.[107] Johnson Smith drew attention to the eyes of the lion statue on his stoop by painting them light blue, the color of special sight. Roger Finney of Macon, Georgia, did the same thing.

A panoply of folktale characters stands behind yard watchers and other figures, like

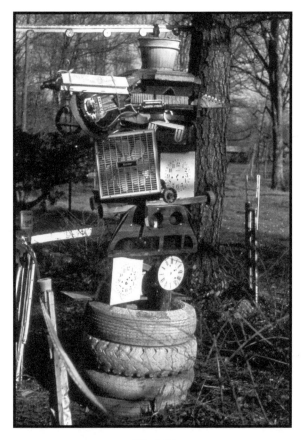

Fig. 4.16

"The Wishing Well," construction in yard of Bennie Lusane. Royston, Georgia, 1989. Photograph by Judith McWillie.

Fig. 4.17

Sculpture by Zebedee Armstrong: wood, felt tip pen, and found objects. Thomson, Georgia, 1987. Photograph by Judith McWillie.

the toys and stuffed animals that find their way into yard displays. Today, popular culture is also a major source—for example, an Incredible Hulk doll that Victor Melancon stationed beside his front door. Adults used story characters to discipline children, including some yard makers when they were young. Mary Ethel Smith, the wife of Johnson, disavowed any part of the mess, as she described it, that her husband made in their yard in Lumberton, Mississippi. But she was a renowned storyteller, and until she became too infirm with diabetes to entertain them, she gathered in flocks of children for after-school story sessions on her front porch. She especially told stories about scary creatures that appear suddenly in the bushes—not unlike the faces that coalesce suddenly out of the castoffs Mr. Smith arranged in the yard—and about talking animals that recalled the blue-eyed lion beside the Smiths' steps.

Stories of the sort that Mrs. Smith told tap a vast array of personality types and stock characters: the tricksters John and Brer Rabbit, the hungry preacher, and the irritating bedbug (or relative) who drives people out of their homes. Such characters helped to set social limits. Interviewed in the 1930s about his plantation childhood in South Carolina, Gus Feaster recalled, "When us was very little, ma say at night when she want us to go to bed

and we be playing marbles, 'Better come in de house or Raw Head and Bloody Bones'll git you.' From den on I is seed spooks."[108]

In 1877 William Owens reported, "The time was . . . when one of the objects most dread among our seaboard negroes was the Jack-muh-lantern. This terrible creature— who on dark, damp nights would wander with his lantern through woods and marshes, seeking to mislead people to their destruction —was described by a negro who seemed perfectly familiar with his subject as a hideous little being, somewhat human in form. . . . It had great goggle eyes and thick, sausage-like lips that opened from ear to ear."[109] Or, as Squire Irvin of Mississippi told an interviewer during the 1930s: "The old folks told us stories about spirits walking at night, Jack O' lanterns and all them spooky things. . . ."[110] Sam Doyle, an artist who lived on St. Helena Island, placed paintings of the jack-o'-lantern on the perimeter of his property. (These paintings were later valued and purchased by collectors.) It takes only a very small leap of the imagination to connect Raw Head with the Frankenstein mask and Bloody Bones with the cardboard skeleton that Ruby Gilmore used to warn away thieves, or the jack-o'-lantern with the pumpkin face that Victor Melancon drew for his front door.[111] These guardians "mask" behind the more familiar history of American holidays and the homemade and consumer products created for trick-or-treat.

Since children and teenagers most often step carelessly on plants, cut corners across yards, wear ugly paths in the grass, and generally act up, it is hardly surprising that yard makers expect young people to connect watchful statues and images with lessons about minding one's manners. Nevertheless, the role of the yard as a magnet that draws

children and curiosity seekers to its threshold must not be underestimated. Most of the yard workers we interviewed invited neighborhood youth to enter their property and engage in discussions about how to do things right, and many of them also regularly counseled teenagers who sought them out for their advice and wisdom.

Story characters and statuary can also serve as shorthand definitions of the person based on values rather than surface appearances. Consider the references to folklore, religion, and politics that Sojourner Truth folded into animal imagery at the Fourth National Women's Rights convention in 1853:

> Is it not good for me to come and draw forth a spirit, to see what kind of spirit people are of? I see that some of you have got the spirit of a goose, and some of you have got the spirit of a snake. I feel at home here. I come to you, citizens of New York, as I suppose you ought to be. I am a citizen of the state of New York; I was born in it, and I was a slave in the state of New York; and now I am a good citizen of this state. I was born here and I feel at home here. . . . Now, women do not ask half a kingdom, but their rights, and they don't get 'em. When she comes to demand 'em, don't you hear how sons hiss their mothers like snakes[?] . . . I can see them a-laughin' and pointin' at their mothers up here on the stage. They hiss when an aged woman comes forth. If they'd been brought up proper they'd have known better than hissing like snakes and geese.[112]

The hissing goose in Truth's message is rude and ungrateful to elders, but geese are also

intensely territorial watchers, as personal experience with them quickly shows. Is it any wonder that plastic geese guard hundreds of front porches?

Dwarves, garden gnomes, cherubs, and statues of cherubic children are popular with gardeners from many countries and ethnic groups. But the positions and configurations of these figures on the property vary, and positioning implies something about functions and intentions. Although we have not made a quantitative comparison, we have noticed a fairly consistent difference in orientation of such figures in black and white American yards. Whereas the figures in the white yards, as often as not, face each other in a more or less conversational way, those in African American yards usually stand parallel to each other and face the street. While exceptions certainly occur, the difference seems significant nonetheless. It is consistent with the contrast between the "Western" frontal orientation to views and the "African/African American" spatial orientation to multiple surfaces and directions that we discussed earlier in this chapter. Whereas the figures in European American yards tend be arranged to be looked *at,* the figures in African American yards are more often arranged to *be lookers* that make eye contact with anyone who approaches. The figures that Joshua Williams collected and mounted on the wall he had built around his front yard in Beech Island, South Carolina, all look outward (fig. 4.18).

Negative or wild spirits were not only fierce or prone to shape-shifting when seen, but also described as heavy. A Texas story-teller reported to folklorist Martha Emmons on a very heavy "little man" beside a gate:

Fig. 4.18
Watcher figures on fence of Joshua Williams. Beech Island, South Carolina, 1989. Photograph by Judith McWillie.

> I used to help old man Evans haul stuff, and ever' evenin' we would cross Pinoak Creek right down yonder at the bridge. Ever' evenin' right at dusk when we'd come along there I'd see a great big possum. One day as we were coming this way I told old man Evans that if that possum was there when we went back that evenin' I was gonna catch him and take him home with me.
>
> Well, that evenin' when we got there, there was a gate that we had to open, and when I got out to open the gate I looked for the possum. Then I fastened the gate back and went over and reached for the possum. But by that time it was a little itty man, just about so high, not a possum at all. I didn't want *him,* not a bit; so I jumped back into the truck and slammed the door to.

But that little man was already in that truck; and old man Evans couldn't get that car out of low gear no more than nothin'. It was just a-pullin' hard, but we didn't have no load. By the time we got home the truck begun to pick up speed, and we looked around and the little man had disappeared.[113]

Considerable reinforcement for gnomes and dwarves in yards comes from African American tales and visionary narratives involving the "little man."[114] A photograph taken early in the 1960s of a burial plot in the cemetery of the Sunbury Missionary Baptist Church shows a porcelain commode with a statue of a dwarf standing inside. While the author of the article in which the photo appears found this figure humorous, even grotesque, the presence of a small guide at the threshold to a water-filled conduit to the other world makes perfect sense in light of conversion visions that Samuel Miller Lawton recorded in the same region. In these visions, a little white spirit-guide shows the convert the way to Heaven over a flowing torrent.[115] Nation of Islam leader Elijah Muhammad, who was born in Georgia, also stressed the fact that the Bible says that Elijah was a little man and that he himself was the "Little Fellow" whom the Bible promised.[116]

Annie Sturghill's yard in Athens, Georgia, contained many references to human bodies at thresholds; the most notable was at the corner of the house where she wrapped a quilt around an upright ironing board and dressed it with rope to resemble a standing human being (see portfolio V, fig. 10). In another instance, Mrs. Sturghill configured various found materials and stones to resemble a seated lady at the door to her porch, a possible analogue with Sturghill herself, who was accustomed to sitting in her yard in the afternoon and greeting visitors (see plate 13).

Scarecrows—such as Elijah Davenport's, also near Athens, and those of Hawkins Bolden in Memphis—reinforce a continuum of figural images in yards that range from frightening to heroic, spiritual, and ancestral. However, this continuum remains invisible to viewers who experience these works in isolation, rather than in the context of biblical and transatlantic visual and philosophical traditions. Bolden, blind since childhood, gave extra attention to the primacy of spiritual sight over ordinary consciousness in both the form and content of his figures. In his words: "Sometimes I take all kinds of old buckets, garbage can tops—all kinds of stuff. I've been getting all this old carpet to make tongues out of it. . . . And all those wires? These buckets: I make eyes on them. They have four eyes. Some have three—a middle eye. I make them so they see good. The third eye sees a lot, you know. And I have milk cans tied together. When the wind comes, it sounds like a bell."[117]

In summary, figures near doors and gates are ideal reminders that thresholds hold out double-sided potentials for transformation. Thus, some figures embody the kinds of "other" one should expect to encounter when passing through. Figures (such as saints, Jesus, Moses, Mary, and cool Greek gods and goddesses) can also prefigure the kinds of "selves" one can expect (or hope) to become along a particular avenue of transformation. In this way, bright or naturalistically colored animal figures and hot monster-masks near the doors and windows of homes remind visitors that no action is truly hidden and that breaking in will put them outside the pale of

human community. The cool, composed faces of religious figures painted silver or white, or left the neutral colors of stone and concrete, mark a trajectory of cultivation and accomplishment that match the coolness of well-cared-for earth and calm water. This complementary relationship is consistent with both African and African American acknowledgment of the two-sided potentials of power (fig. 4.19) and with the Christian idea that human beings are always in danger of temptation. Yard figures refer to a spectrum of powers, any of which could help or harm, depending on one's point of view.

Taken together, yard works and verbal genres such as folktales, Bible stories, and personal narratives yield a richly varied cast of characters. From some yards and stories it is clear that these characters occupy positions relative to each other, exhibiting characteristics such as fierceness, trickiness, and goodness. For example, buried-treasure tales and visions often contain a sequence of animals that the seeker must pass through:

first dogs, then "snakes, and, last of all, fiery-mouthed bulls."[118] Relative to forms of figuration that are mainly decorative and those that seem welcoming, the faces associated with wild happenings and spaces become progressively less human and more monstrous, with distorted features and fangs, and, at the extreme, only a skeletal or ghostly presence. Just as these images suggest "hot," unpredictable behavior, the wild places they inhabit are easy to get lost in, morally if not physically.

In contrast, figures associated with cultivation range from cherubs and happy children, to role models such as Dr. Martin Luther King Jr. (see portfolio II, fig. 27) and the Kennedy brothers, to religious figures, growing increasingly "cool" in composed demeanor and visually abstract to the point where individuality disappears and the face of Jesus in glory becomes a simple shining disk (fig. 4.20).

Below: Fig. 4.19
..
Suitcase shrine for Michael Jackson, made by Lonnie Holley. Birmingham, Alabama, 1986. Photograph by Judith McWillie.

Right: Fig. 4.20
..
Construction in Mary Tillman Smith's yard. Hazlehurst, Mississippi, 1986. Photograph by Judith McWillie.

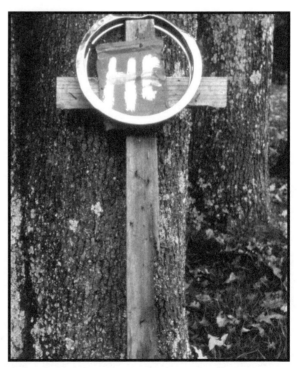

Transforming Times and Places

Bennie and Elizabeth Lusane
Royston, Georgia, 1993

The Lusane Café on Daniel Street, on the south side of Royston, Georgia, was one of the first black-owned businesses in Franklin County. Bennie Lusane (d. 2002) built it when he got out of the army in 1946 and moved his new wife, Elizabeth, to Royston from their home in southern Georgia. The Lusanes later adopted two daughters, Shirlean and Eliza Bell, and Bennie took a job doing construction while Elizabeth ran "the store." Mrs. Lusane points with pride to the fact that their café fed most of the workers who built Curry Homes, the local federal housing project. "James Brown even came in once," she remembered, "in the early days, when he was living with his first wife in Toccoa." In addition to managing the Lusane Café, Elizabeth Lusane also became an Avon lady, while her husband established a licensed cab service.

"We integrated this town," said Elizabeth Lusane in 1999. "When we first come up here from Americus, it seemed like the colored people here were scared to do anything, like living in a dungeon."[1] She continued:

Colored doctors and teachers had new cars, but they parked them until they got ready to go to a meeting, or church, or out of town. They had old cars that they used for everyday. But I didn't know that, and I drove the new one my husband gave me all the time.

One time I went up to Wray's Drugstore, and they told me I had to use the back door. I said, "What do I have to go around to the back door for? What I want is in the front." And they said, "You don't dress up like that till Sunday." My mother had bought me some of those pretty clothes, dresses that was pleated in the front. And I had all of my nice clothes and plenty of dresses, and I wore them every day. And I was the first one that went in

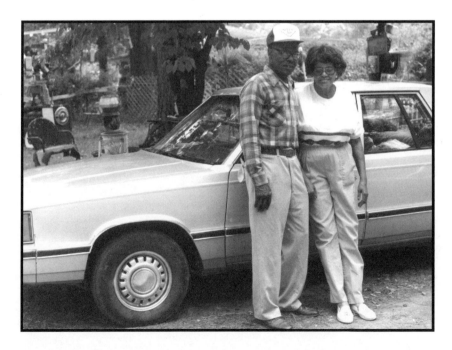

Fig. V.1
Bennie and Elizabeth Lusane.
Royston, Georgia, 1993.
Photograph by Judith McWillie.

Fig. V.2
Lusanes' yard.
Royston, Georgia, 1993.
Photograph by Judith McWillie.

that front door at Wray's Drugstore. Rose White and Maybelle Bruce was cooking in the kitchen. They was black ladies and they told me to go around to the back, but I came in the front and, when I did, they cheered me. I said, "What I want is cosmetics. They're in the front." I sat there and looked at the colors of the nail polish I wanted. Come to think, I guess that's what put me in the business of Avon. I been with them forty years now.

"I came up here from Americus, Georgia, after I got out of the service," said Bennie Lusane. "I was in the South Pacific in World War II. I was in Australia and the Philippines. I built every bridge on Highway 29 and I-85 from here to Atlanta. I built this house—I mean I had a man build it—at the same time I built the café. And I had a cab."

"I was scared for my husband," said Elizabeth Lusane, "but he had that army blood in him with all those shots and things. He was the first one that made transportation for the black people in Royston. And the white men were driving a cab, and they tried to run him

off the road. And the colored women were getting in the cars under them white men. And they [the white drivers] were trying to run him off the road and 'cause he was getting all their customers. And he said, 'They gonna have to kill me first.' He said he had a license to go anywhere he want to."

At age seventy-five, in 1999, Bennie Lusane had become a man of few words, but he had a stark sense of humor even though he preferred not to bring up the past. "You still scared," chided Elizabeth Lusane, to which he replied, "I don't mind what you say, only that you talk too loud." He motioned towards the front door and suggested we go outside and look at his work.

The house was within easy walking distance of downtown. Entry to the yard (fig. V.2) was through the driveway between two concrete statues of the Virgin Mary, both mounted on stone pedestals, one fully intact, the other with a concrete dove in place of the head (see portfolio II, fig. 16). Elizabeth Lusane explained that vandals had knocked the head off, so her husband molded the dove from concrete and replaced it. A third Mary statue, painted red, stood at the south corner of the property

where it was clustered with two more concrete doves, also painted red. Lusane set yellow warning lights in front of the statues near the driveway. He commented that he didn't know that they represented the Virgin Mary; he had gotten them on his travels building bridges and put them there because he liked the way they looked. He said the same about most of the elements of the yard. "I found that rock over there when I was building the bridges, and I brought it up here to the house in a truck." He pointed to a giant rock, worn smooth in a river bed, that he had painted red and mounted on a piece of polished granite sunken into a homemade stone base (fig. V.3).

His stone work and his collection of specially shaped rocks retrieved from sites he had visited were the genesis of the decorated yard that he began the year he built the café and the house. In front of the house, near the curb, the river rock's shape gave it an anthropomorphic presence, especially at night, when it was illuminated from behind by the spotlights Lusane had strung across the yard to showcase his work. Both he and Elizabeth Lusane referred to the things in the yard as "What Nots."

The river rock sat at the terminus of a lattice fence that, in the early 1990s, had a circular steel disk and a highway warning sign on it, blocking access to the yard. Near it a piece of polished granite, arched on top and upended on a birdbath base, supported a rough concrete slab in which Lusane had constellated some yellow rocks in the shape of a cross (fig. V.4). Elizabeth Lusane interpreted it as a "woman with her arms stretched out" rather than the cross of Jesus.

In the yard itself, individual works were posted throughout a carefully maintained lawn. Near the house the yard was bordered by more polished, and unengraved, granite grave stones.

Fig. V.3
Red-painted river rock on stone pedestal by Bennie Lusane. Royston, Georgia, 1991. Photograph by Judith McWillie.

Several small works, variations on the theme of containers and planters, were either raised on hubcap pedestals or set in modified garden chairs dressed with a combination of elements similar to the sculptures: reflectors, bottles, toys, carpet remnants. Lusane's work with found objects had begun in about 1981 when he and his wife closed the café. "I told him, 'I can't hardly take care of it by myself and you off on the weekend,'" said Mrs. Lusane. "'You got a cab business to do. And the kids are in school. It's just more than I can do.' And so we just closed it." And almost immediately, Bennie

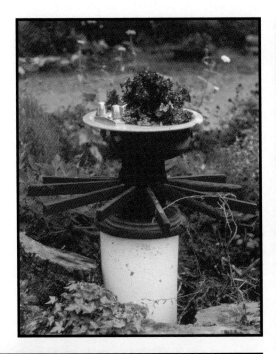

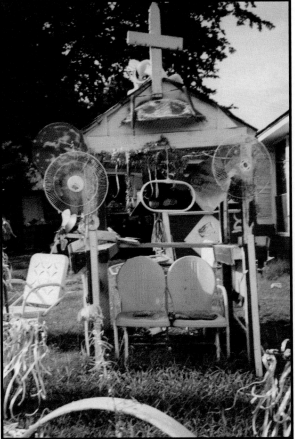

Top left: Plate 1

Monument to fallen tree by Inez Faust.
Arnoldsville, Georgia, 1991.
Photograph by Judith McWillie.

Above: Plate 2

Wrapped and tied fencing by Elijah Davenport.
Clarke County, Georgia, 1985.
Photograph by Judith McWillie.

Left: Plate 3

Special seat in Charlie Jackson's yard.
Memphis, Tennessee, 1996.
Photograph by Judith McWillie.

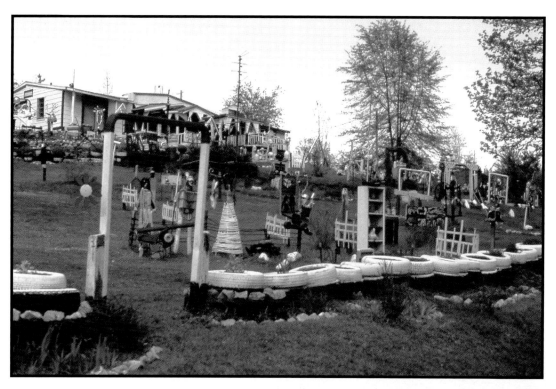

Above: Plate 4

View of Rev. George Kornegay's yard from
Bear Creek Road. Brent, Alabama, 1992.
Photograph by Judith McWillie.

Right: Plate 5

Monument with mirror, crucifix, telephone,
and clocks by Rev. George Kornegay.
Brent, Alabama, 1992.
Photograph by Judith McWillie.

Above: Plate 8
.........................
Wess and Sue Willie Lathern with
"The Fair." Oakman, Alabama.
Photograph by Judith McWillie.

Right: Plate 9
.........................
Cross with bottle, flower, and electronics
by Wess Lathern. Oakman, Alabama, 1991.
Photograph by Judith McWillie.

Left: Plate 10

Object with jar, rocks, lightning rod,
and aluminum foil by Bennie Lusane.
Royston, Georgia, 1989.
Photograph by Judith McWillie.

Below: Plate 11

William Winston's yard.
Central Virginia, 1998.
Photograph by Grey Gundaker.

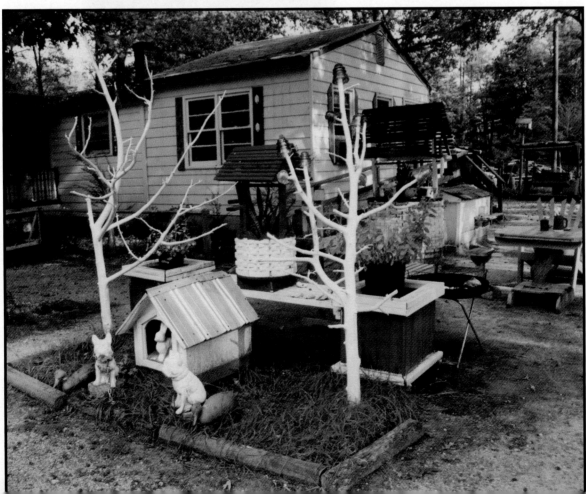

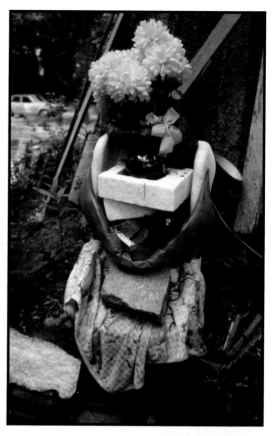

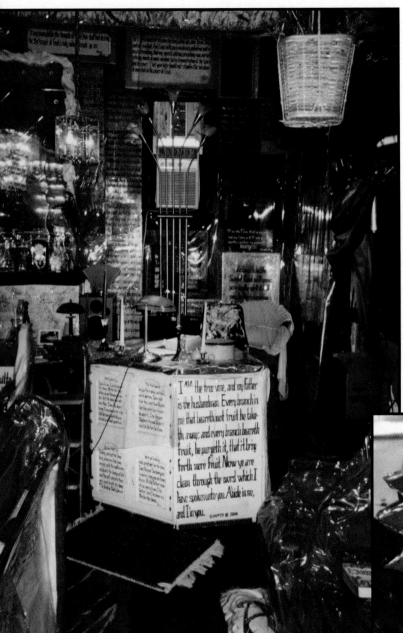

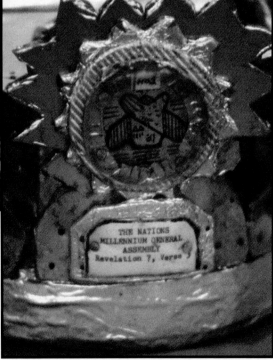

Left: Plate 15

The Seventh Church of Christ, created by Samuel Smith and sustained by his wife, Delores. Freeport, New York, 2002. Photograph by Grey Gundaker.

Below: Plate 16

Detail of a crown from James Hampton's *Throne of the Third Heaven of the Nations Millennium General Assembly* (made c. 1960). Washington, D.C., 1985. Photograph by Judith McWillie.

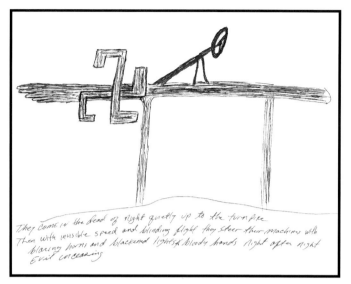

They come in the dead of night quietly up to the turnpike. Then with invisible speed and blinding flight they steer their machines with blaring horns and blackened lights. Bloody hands. Night after night. Evil unceasing.

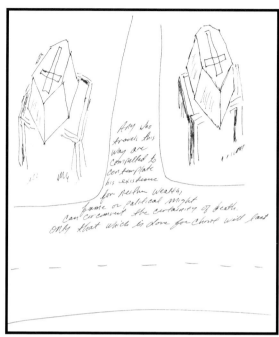

Any who travels this way are compelled to contemplate his existence for neither wealth, fame or political might can circumvent the certainty of death. Only that which is done for Christ will last.

Plate 17
......................

"They come in the dead of night quietly up to the turnpike. Then with invisible speed and blinding flight they steer their machines with blaring horns and blackened lights. Bloody hands night after night. Evil unceasing." Painted wood assembly mounted ten feet above ground on eight-foot parallel poles, entitled "Evil Unceasing."

Plate 18
......................

"Any who travels this way are compelled to contemplate his existence for neither wealth, fame, or political might can circumvent the certainty of death. Only that which is done for Christ will last." Two caskets raised on biers, painted wood, entitled "The Way." Main entrance to grounds of Saint Paul Spiritual Temple.

Plate 19
......................

"Here is the riddle of life— one answer is already given, but which way do the cradle and cooling board travel? There are nine possible directions, neither of which is wrong. However, one's answer reveals his level of understanding." Wood and bamboo assembly with dolls (forty feet by twenty feet), entitled "The Riddle of Life."

Credit for Plates 17–19:
......................

Community of the Saint Paul Spiritual Temple, Memphis, under the direction of Bishop Washington Harris. Sketches and commentary by Pastor Marvin White, 2004.

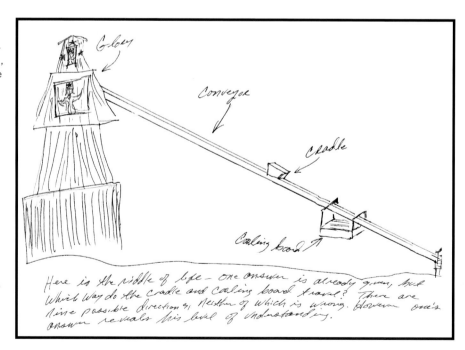

Here is the riddle of life - one answer is already given, but which way do the cradle and cooling board travel? There are nine possible directions, neither of which is wrong. However one's answer reveals his level of understanding.

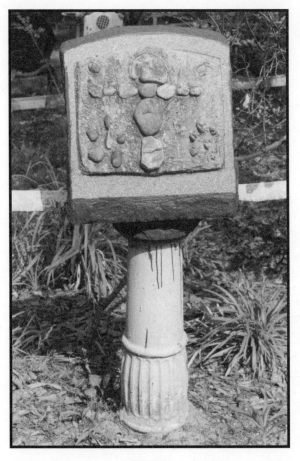

Fig. V.4
Constellation of stones in Bennie Lusane's yard. Royston, Georgia, 1991. Photograph by Judith McWillie.

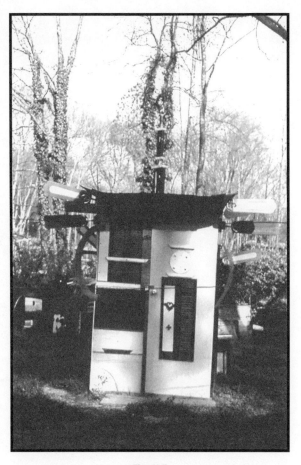

Fig. V.5
Monument to the Lusane Café by Bennie Lusane. Royston, Georgia, 1991. Photograph by Judith McWillie.

Lusane took what materials he could salvage from the café and built a monument to it in his back yard, attaching oversized ceiling fan blades that protruded from the sides like outstretched wings (fig. V.5).

Then he made the "The Wishing Well," (see chap. 4, fig. 16) the first of his What Nots made from discarded commercial objects. "The Wishing Well" was an eight-foot-tall monument braced by four whitewashed tires stacked to hold two red wooden posts. The tires stabilized a tower composed of a highway caution sign, printed clock faces, an electric floor fan still in-side its square plastic casing, plastic coat hangers, an automobile drink caddy turned forward to show its recessed circles, blue aerosol can lids nailed to the ends of wooden two-by-twos extending in the four directions, flashlights, a chrome waffle iron, a car radio, flower pots, and, on top, a Fender electric guitar.

Like all of Lusane's What Nots, "The Wishing Well" was a work in progress that went through several incarnations during our fifteen years of documenting the site. But the tires, fan, clock faces, directional blue disks, and guitar continued to be its essential elements. As

the guitar aged, Lusane cut out a piece of plywood in its shape and set two boards running the length of the body and neck in order to bolt it to a support beam. The 1989 photograph in chapter 4 (fig. 16) shows the brown and gold guitar sparkling and intact. By 1994 its wooden laminates were coming apart. By 1997 the paint was gone, and it had become driftwood recognizable only by its shape. By 1999 the elements had reduced it to powder. The printed clock faces, configured as a large square, then became the most prominent element of "The Wishing Well." Lusane could easily replace them by getting new ones from the clock factory in nearby Franklin Springs.

The What Nots were generally built to last, though not to be frozen in time as museum pieces. The shift in 1981 from natural elements like rocks and concrete to brightly colored commercial objects disturbed Elizabeth Lusane, who complained that "anything I set down, if I don't watch it, he puts it in one of his What Nots." When asked what the citizens of Royston thought of the yard, given the already high profile of the Lusane family, she replied, "You call it history. They called it a mess—junk."

Bennie Lusane's most recent cab, a 1973 Cadillac Sedan de Ville, was a portable version of his yard. The interior door handles, the antenna, and the back windows were filled with more What Nots, along with hand-lettered signs and pieces of colored plastic glued to the upholstery on the doors. One read: "Please don't make fun of my work because everything I do I try to do it good. If you don't believe it, please try me." This sign was posted above a quotation from Samuel Johnson: "Great works are performed not by strength, but by perseverance." Above, on the dashboard, was a toy alligator with its mouth taped shut, a plastic finger with a red polished nail pointing skyward, and a sign that said, "God Loves You" (fig. V.6).

Fig. V.6
Items on the dashboard of Benny Lusane's cab. Royston, Georgia, 1990. Photograph by Judith McWillie.

Riders were encouraged by another sign framed in red duct tape. It read: "Be Good. Let's make a deal. A nickle is a nickle and a dime is a dime. Give me some of yours and I will give you some of mine." In other inscriptions Lusane was more direct: "If you don't like my shit. Please look at it another way." Lettered discreetly in pencil, this admonition was clustered inside a What Not composed of a broken watch, a comb, plastic bottle caps, colored hair pins, a metal chain, and a green ball point pen, all fused with tape and glue into a pyramid shape on the dashboard. This sign was almost subliminal compared to the poem lettered in black magic marker above the glove compartment on the passenger side: "Hey Girls, stick out your 'can.' Here comes the Decoratin' MAN."

The jazz critic and author John Szwed, when shown photographs of Lusane's work in 1990 while he was developing an essay about him, recognized this sign as a paraphrased reference to the Luis Russell song "New Call of the Freaks," an interpretation reinforced by

the miniature garbage can Lusane had hung from the rearview mirror above.[2] Szwed pointed to the last line in the original Russell song, "Here comes the garbage man," and began to look for more musical references in Lusane's work. Reviewing the yard, he remembered that Anthony Braxton, the renowned jazz composer, had developed his own system of titling his compositions[3] consisting of "miniature drawings perhaps not coincidentally filled with many of the same elements as yard art—wheels, lights, images of motion, small figures, containers, and shapes elaborately wired together" (fig. V.7). Szwed concluded:

It would be tempting to suggest recklessly that Bennie Lusane's and Anthony Braxton's arts are "about" the same thing, that they derive from common sources and have benefited from the same experiences so as to converge on common grounds from circuitous routes. But, more cautiously, all I want to say is that what they share, and what we can most effectively learn from them together, is that they both have come to employ creole ways of doing things and making meaning, ways which have resulted in producing a kind of art that Umberto Eco called the "open work": a creation susceptible "to

Fig. V.7
A selection of Anthony Braxton's diagrammatic composition titles for works he wrote between 1984 and 1986. Transcribed from Graham Lock, *Forces in Motion: The Music and Thoughts of Anthony Braxton* (London: Quartet Books, 1988), 366–69, for exhibition catalog. INTAR Latin American Gallery, 1991. Used with permission of Graham Lock.

countless different interpretations which do not impinge upon its unadulterable specificity," a work which offers an unusually high degree of possibilities in the amount of information provided and in the form of ambiguity entailed, and one which makes every reception of it "both an interpretation of it and a performance of it, because in every reception, the work takes on a fresh perspective for itself." Part of their message then, what they are about, is that these works must be approached in their own terms and in terms that are culturally relevant to them. What they teach us is how to look and hear again.[4]

To look, to hear, and to remember. In 1999, we asked Bennie and Elizabeth Lusane, "Why do you think you have been able to live your lives relatively unmolested in the face of racial threats and your high profile in a small town? Did the yard protect you?" Elizabeth Lusane replied, "Yes, I believe it did, and we prayed a lot, you know, you have to pray."

We could not let go of the idea that the power of the yard was much more than its brilliant use of carnivalization as a means of defusing prejudice and ill will. We had interviewed a neighbor who recalled that Bennie Lusane went out into the yard at night to "call them out." "Like the names in the Bible, Ezekiel, Jeremiah?" we asked. "Not those names, but some like them," he said.

On the south side of the house, set apart from the rest of the yard, was Lusane's most mysterious work (see plate 10). It resembled the call boxes stationed along the interstate highways he had helped to build. A twisted steel rod with a small sun on top (a lightning rod?) was fastened to a short wooden post so that it rose about six and a half feet above ground. Layers of aluminum foil were wrapped around the midsection, fastened in place

with nails driven through red plastic bottle tops. Lusane nailed a plastic "Fasteeth" bottle below the foil and a Maxwell House coffee jar above it, braced in place by an L-shaped armature of red plastic. The row of stars on the Maxwell House lid rotated around the top, creating a sensation of movement reinforced by the spiraling metal rod. Inside the jar were more yellow-colored rocks like the ones in figure V.4. Over a ten-year period, we repeatedly asked Lusane to explain this object, and he always gave the same answer: "I tell you what I used to tell them about this stuff. I tell them they're What Nots. They're for damned fools who don't know what not to ask."

Annie Sturghill
1912–1991
Athens, Georgia

Annie Sturghill of Athens, Georgia, had longstanding connections with local artists and scholars, beginning with her employment as the housekeeper of Lamar Dodd, a painter who founded the University of Georgia's School of Art, now named for him. Mrs. Sturghill lived near the university, and her yard was visible from behind the Varsity, a popular drive-in restaurant, frequented these days more by townies than by the students who made it a local legend in the 1950s. "I been always liking the yard ever since I was five," Mrs. Sturghill remembered in introducing herself. "You know, I was born in the country up in Jackson County, and my daddy was one of those folks who made what he used."[5] She elaborated:

He owned about 125 acres of land in Jackson County. He had a shop, a workshop, and he made his hoe what he digged

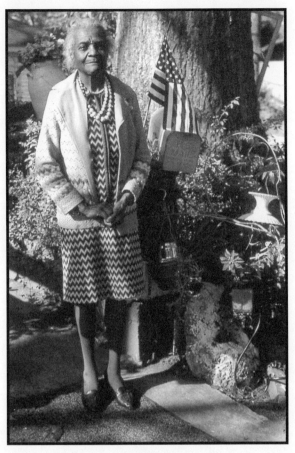

Fig. V.8

Annie Sturghill. Athens, Georgia, 1990.
Photograph by Judith McWillie.

We lived out next to a white farm. One day our cow had got out and got into some part of his [the white man's] crop. And he told my Daddy, "Louis"—my Daddy named Louis Mack—he said, "I'm going to put the Ku Klux on you." My Daddy told him, "Send 'em. I ain't gonna die with a bullet in my back; I'll die with one in my breast." I was thinking about that this morning, thinking of what he'd said.

Now I ain't never tried to *be* somebody; I feel like I was *born* somebody. I was in his family and I was born somebody. So thank God for what was born in me. Somebody told me I must have got a lot of Indian in me too because Indians decorate with bottles. I say I decorate with these bottles because that's all I can get my hands on. I decorate with bottles 'cause bottles are different colors. If I want green I get a Seven Up bottle.

I say, after all, we're made from dirt; that's what we are all going back to—dirt. Now, I don't care if anybody don't like what I got going on here. I like to enjoy lookin' at it. I look at God's sunshine hitting all this metal, and I enjoy it. I don't care if anybody likes what I've got going on here, I enjoy looking at it 'cause I'm trying to make out of life what I can get out of it, not what *you* can get out of it. 'Cause there ain't no two persons alike. We don't think alike. My Daddy, he used to say even twins ain't alike. You can think they're alike but if you keep on looking at them you can tell John from Jim. So that's the way it is—there are no two peoples alike. You can enjoy it [the yard] and I can too. I walk to church, and you go in your airplane. Still, I get there. Thank God I got feet. It ain't *how* you get there, it's *what* you do when you get there. I don't care if you got nine hundred

with and his planter what he planted with. That's what my daddy done, you see. Jackson County [is] near Jefferson, Georgia, 'bout four miles south, on this side of Jefferson. My father was Louis McCleskey, and they call him "Mack." "Mack McCleskey" they called him. All his business come in the name of McCleskey, but we called him "Mack" for short. Oh, he had it all. He had a hundred and three or a hundred and four acres of land out there. He made his own syrup, he thrashed his own wheat. Had a thrasher. He had five or six head of horses.

houses. My Father [in Heaven] is rich in houses and land. And He hold a gift in His hand. If I can make more out of it and beautify His world, let me beautify it. I don't owe it to man; I owe it to God. When God shaped us up and breathed the life into us, we became a living soul so now God can do anything He like, like that. And I don't care if anybody don't like what I got going on here 'cause I'm trying to make out of life what I can get out of it. Not what *you* can get out of it. As long as you know how to thank God, you're above everything else.

Mrs. Sturghill's practice of reciting verse on stage at the neighborhood community center found another outlet in her yard, where she greeted visitors with recitations that doubled as both art and exhortation:

> To a preacher life's a sermon
> To a joker life's a jest
> To a miser life is money
> To a loafer life is rest
> To a soldier life's a battle
> To a teacher life's a school
> Life's a great thing to a thinker
> But a failure to a fool
> Life is just a long vacation
> To a man that likes his work
> But it's constant dodging duties
> To an everlasting shirk
> To a constant faithful worker
> Life's a story ever new
> Life is what you make it
> Friends, what is life to you?

The good counsel celebrated in Annie Sturghill's recitations extended to her conversations as well:

> Arthritis, sugar, and high blood is the devil's product. And anytime we buy the devil's product, it's a bad thing. We didn't used to hear about no sugar—just eat what you want to, no dieting. Now they say, "You can't have this; you can't have those." All that stuff is the devil's product. If you want to buy into it then go on and suffer with it. And I'll tell you what the devil's product consists of: it consists of jealousy and hatred. All that hatred and jealousy; that's fertilizing it. If you get all that hatred out of it and all that jealousy, and all that digging ditches over one another, there wouldn't be no arthritis, wouldn't be no sugar, no high blood. Anytime you buy the devil's product, you've got it.

During the 1980s, drawing classes from the university often went to Sturghill's house to make studies of her "Yard of Colors," as she called it, in charcoal and pastels. The students were accustomed to working from the "still life," a set of objects and props assembled for the study of composition and form, something Mrs. Sturghill had observed at Lamar Dodd's house. Annie Sturghill's yard (fig. V.9) was not just a change of venue for these students. It was also a respite from the social detachment encouraged by conventional art training and a lesson in the relative nature of art world taxonomies and values.

The conversations Sturghill had with these students and with other local artists influenced her as well, since the "Yard of Colors" contained many elements more related to aesthetic play than to orthodox yard work. Sturghill was especially gifted in making visual analogies and puns. One day in the autumn of 1987, she substituted red plastic spoons for the geraniums that had once occupied a planter. She stretched a red athletic sock over a plastic windshield scraper and set it below some cups

wired to an aluminum frame. The animated effect of liquid pouring out of a container complemented her earlier tendency to create stasis by stacking inverted pots on sticks and bordering the front of the house with square blue bottle grids.

One of Sturghill's earliest compositions was a small seated "lady" sitting by the door of her screened porch. The head was a bowl of yellow chrysanthemums, the torso a plastic block with a vinyl sling attached. The sling rested on a granite slab that sat on top of a draped cloth apron. Sturghill's imagination had transformed these elements into the demure posture of a woman with hands folded over a book in her lap, a posture not unlike Sturghill's own as she rested in the yard most afternoons and received visitors (see plate 13).

In a feature entitled "Annie Bell Sturghill Makes Lawn Art Out of That Which Others Throw Away" in the *Athens Banner Herald,* Conoly Hester wrote:

> Mrs. Sturghill is seventy eight years old, small of stature and emphatic in manner.

She is so emphatic that people often think she is angry, but she's "not mad at anybody," she tells you. And if there is something about her life she doesn't like, she makes the best of it. That is why the six to eight feet of yard between the curb and her house at 820 Reece St. is decorated not only with planted chrysanthemums but also colorful plastic poinsettias, stuffed animals, empty Varsity cups, a plastic hen, place mats and hats and dolls, and a 78 RPM record suspended from coat hanger wire. "My yard is so close to the street, the more I have makes it look bigger," Sturghill said. "I just do anything for decoration. I go to the Varsity and pick up things. I love colors and red is my favorite color. Anything red, don't put it around me, because I'll put it in my yard."[6]

Hester further noted that the yard contained "mementos of Jackson County, in the form of rocks and pieces of pipe, painted white."

Material signs such as these were the armature of the yard, but Sturghill had always

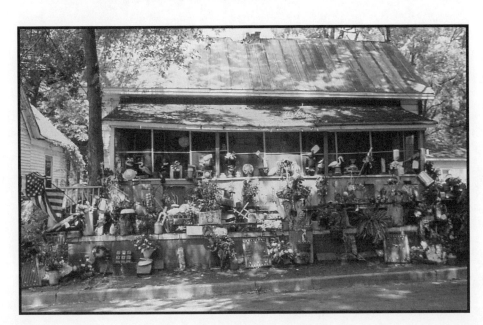

Fig. V.9
Annie Sturghill's "Yard of Colors." Athens, Georgia, 1987. Photograph by Judith McWillie.

operated on the boundaries of tradition and invention. She used color to compose associations between objects, irregardless of their original function, similar to the way a painter would. For example, a gray papier-mâché flower stand was hollowed out, and a red baseball bat was placed inside it. Sturghill took a bent coat hanger and sculpted a piece of magenta satin into an elongated, twisting figure with color establishing the tension between the rigid bat and the free-formed revenant that vamped in front of it.

While Sturghill had a full repertoire of aesthetic tools, she also made wry social observations using magazine photographs juxtaposed with three-dimensional objects. A group of marching grenadiers from Buckingham Palace was propped behind a stream of chalkware ducks. A fashion model wearing a flowing red evening dress glided over the top of a 1950s-style dinette chair with a plush velour cushion on the seat. An ironing board placed upright against the house was covered with a quilt and bound with rope to resemble a standing human figure (fig. V.10).

"They remind me of people," she said of these constructions, "because today they might speak to you and another time they ain't said a word. I appreciate it when somebody come by and speak to me."

The screened porch that spanned the front of the house gradually became an extension of the yard. Around the spring of 1990, the centerpiece of the yard was a birdbath tower stacked with pots and jars and a life sized plastic hen on top. By summer, the hen had been moved to a shelf inside the porch next to a distinctive twelve-inch turquoise bottle embossed with a beaded pattern. Sturghill glued a feather to the top and called it her "peacock" (see plate 14).

There were other more obvious correspondences. "Sometimes I put the egg crate next to the hen because the egg come from the hen," Sturghill said. "And I learn every day how to do it in another way. I lay in bed and think about it." But direct correspondences like hens and eggs were less evident than Sturghill's visual "rhyming" (her "peacock," for example), an analogue of her habit of reciting verse. "That's what I entertain myself with," she explained. "I'm here today and still on my way because I trust in God every day."

Fig. V.10

Quilt wrapped around an ironing board in Annie Sturghill's yard. Athens, Georgia, 1988. Photograph by Judith McWillie.

Sturghill's need to invent meant that she had to strike a delicate balance between influences and encouragement from the artists who visited her and the day-to-day necessities of life for a widow in her late seventies. Her artist friends applauded her spontaneous creations while neighbors and family were more concerned with the ambiguities the Yard of Colors was introducing into their lives as they strained to look out for a loved one's safety and well-being. But Sturghill was insistent. "I have been married three times and all of 'em are dead," she explained. "God done took all three away from me. I have a clear conscience, though, 'cause I did for all of them. My daughter says, 'Why don't you put out more real flowers?' I tell her I plant a real flower for every artificial one." After two years of drought, however, she had noticed that her plastic flowers were still vibrant while the real ones had died off. From then on, the emphasis of the yard was on what she called "my artificial things":

> God made the real ones and He fixed it so [that] man made the artificial ones. So all of it belongs to God. The Bible say the earth is the Lord's and the fullness thereof, and so everything that dwells therein belongs to him. So artificial flowers are here and the real ones are here, so I decorate 'em all according to His will. I have folks come by and say, "I didn't know that flower bloomed this time of year." They feel the flowers to see if they're for real. Folks ask me would I decorate for money. I tell them, "No, I decorate my place one day, and the next day I go back and change it. Whatever I do today and don't like it, I do it different tomorrow."

As Sturghill's health failed and she was no longer able to tend the yard as frequently, nature began to dissolve the fabric, paper, and other perishables she used. Her children, becoming concerned about the upkeep of the property, tried in vain to persuade her to stop adding more objects and scavenging scrap wood from neighborhood construction sites. One of her daughters then had to make the difficult decision to call in a neighbor with a backhoe. What might have been an act of destruction, however, turned into an unanticipated

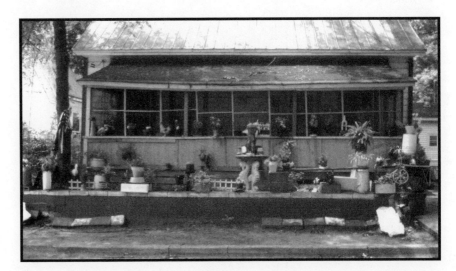

Fig. V.11
Annie Sturghill's yard after demolition. Athens, Georgia, 1990. Photograph by Judith McWillie.

revelation when the neighbor destroyed the purely "decorative" dimensions of the yard, leaving only its traditional elements intact: the whitewashed stones from Jackson County, the ceramic pipes and wheels at the edges of the property, a few inverted pots on sticks, and an American flag. Sturghill had always vowed to take the yard down herself if either the neighbors or her church complained but with the proviso that the request be made in the form of a signed petition. No petition materialized. So a few days behind the backhoe, she began again (fig. V.11). "They don't have to come up to Reece Street," she said. "Go over to Broad Street or Hancock Street. I love what I'm doing."

Annie Sturghill continued in the yard until a few weeks before her death in 1991. As a memorial, her daughters distributed a card of thanks and remembrance to all her friends. It was an eight-by-ten-inch print with a rose in the center surrounded by quotations from the Bible: "The fear of the Lord, that *is* wisdom; and to depart from evil *is* understanding" (Job 28:28). It had a drawing of Christ in the forest, an excerpt from the Twenty-third Psalm, a list of surviving family members, and a reminder, also from the Book of Job, that "God gives songs in the night" (Job 35:10).

Chapter 5

Transformation and Safety Zones

Yard work involves many dimensions of labor and expression, but the yards in this book emphasize two interdependent ideas. First, they assert that land should be both protected from negativity and protective of its inhabitants. Second, they emphasize the dynamics of transformation: from seed into garden, from raw material into art, from existence into well-lived life, from willful individual into responsible adult, from burden into affirmation. Small, incremental changes add up, but transformation involves something more: a new name, a movement through a threshold into a different place. Transformation can be part of ordinary events, but to live up to its name it must also link the great with the small, the life-altering with the mundane aspects of everyday life.

Transformation involves a change of direction that, like the double faces of power and the interrelation of wild and cultivated land, can go either way. Purpose and direction are therefore crucial. Material signs in yards, whether plants, printing, or statuary, remind viewers that we are accountable for our actions. But some yards go beyond this, offering models for improvement, informed by personal insight, social responsibility, spiritual and religious conviction, and a

Fig. 5.1
William Winston. Central Virginia, 1998.
Photograph by Grey Gundaker.

sense of justice. In this sense, yard work is an epistemological enterprise that transmutes lives and worlds.

In central Virginia, William Winston hinted at this idea when he created a miniature homestead within his swept yard in which a toy well was elevated on a shelf behind a small doghouse and two white-washed trees (see plate 11). He added figurines of rabbits, dogs, and ducks and contained everything within a singular plot of grass bordered by wooden planks.

Winston's actual well and doghouse, larger in scale, stood behind this assembly as a mirror image of it.

Transforming Times and Places

Many of the people we have met are motivated to work in their yards not only for exercise and personal enjoyment but also in the hope of making things better, starting at home and then turning outward. For many of them, and throughout African American history, this has meant coming to terms with oppression and seeking a positive outlook in even the most soul-daunting circumstances.

Yard work has been bound up with opportunities for stable living conditions, control over personal space, and ownership of homes and land amid a barrage of threats to person and property. Along with education, land ownership has been integral to transforming a burdened past into a hopeful future. Just as the surfaces, boundaries, trees, and figures discussed in chapter 4 anchor yard work physically and expressively, these struggles contribute to its social and political foundations. One pattern seems clear over the century from approximately 1860 to 1960. As each generation of African Americans struggled to gain a foothold on the land, often successfully against great odds, a new wave of obstacles arose: Klan violence; white-collar crime, such as fraudulent land titles and title searches; insurmountable tax burdens; lack of old-age pensions; suburban sprawl; rezoning; and urban "renewal," to name just a few.[1]

In the years following the Civil War, black property ownership in the South soared despite the efforts of white planters to maintain a dependent labor force of tenants and sharecroppers. During the first decade of the twentieth century, just before segregation laws reached full force, black ownership of farmland in the South increased by 150 percent.[2] However, this trend was short-lived. In 1940 the Illinois Writers' Project summarized the results of white backlash and the advent of the Great Depression:

> The number of Negro farm owners, small at the beginning, increased by 1910 to 218,972. A sharp drop began in 1924, and by 1930, of 882,850 Negro farm operators, only 181,016 were owners. . . . The Negro farm population of the South between 1920 and 1930 decreased 9.6 per cent, between 1930 and 1935, 2.2 per cent. It is significant that during the same period the white farm population decreased only 3.8 per cent (1920–30), but increased 10.1 per cent from 1930 to 1935.[3]

It seems a reasonable inference from these numbers that land during this period was changing hands from black to white. Further:

> The destitution of most of the Negro tenants, sharecroppers, and owners is incredible. The exhaustion of the soil through the one-crop system, the unequal fight against the boll weevil, illiteracy, the absence of money, lack of modern machinery, . . . difficulties of the individual farmer in getting credit, high prices and exorbitant interest rates, . . . inadequate diet causing disease and abnormal death rates—these are the evils of the dispensation under which the Negro farmer lives.[4]

These were the conditions into which most of the older African American men and

women we interviewed were born; most were born between 1908 and 1945 in the rural South. Even those in better circumstances found that the danger and injustice that farmers and urban workers battled affected the climate for all. In many regions constraints on land use continued unabated even though resident labor was supposedly free. In the early years of the New Deal, for example, tenant farmers in the Yazoo delta of Mississippi were required to plant cotton right up to their front porches. Monocropping was so strictly enforced that tenant farmers were not even allowed vegetable patches. A teacher commented to the anthropologist Hortense Powdermaker: "Occasionally some cropper would fool the landlords and plant a patch way off where it couldn't be seen. If he was caught, he would be punished."[5] This practice continued the pattern, examined in chapter 3, by which African Americans resorted to the woods and uncultivated parts of the landscape. While it would be a mistake to see yard work as a mere reaction to threats and losses, today as in the past it often unfolds in dialogue with them. Yard work offers a way of showing others—those willing or able to get the point—how to rise above difficulties and begin anew.

Naming and Renaming as Modes of Transformation

As many historians and anthropologists have pointed out, naming is a form of power, of defining oneself and one's world. It asserts authority and transforms undifferentiated matter into material with an identity and cultural associations with other named things. In yards old objects are "renamed" through new uses, a physical act with important verbal analogues. Mechal Sobel has shown how, as far back as the seventeenth century, people of African descent in Virginia employed their own names for places and things and thus, at least to some degree, asserted dominion over them.[6] But for generations the potency of naming was dangerous for African Americans to assert outside their own communities.

As the nadir of Jim Crow drew near, plantation tales and dialect poems were popular among whites, appealing to their nostalgia for the Old South and the Lost Cause. Now-famous African American authors like Charles Chesnutt and Paul Laurence Dunbar worked in these genres, pushing the envelope through double entendres and layered references. A little-known African American writer and clergyman, Reverend I. E. Lowery, went as far as anyone with his double-voicing.[7] So skilled was Lowery at channeling different interpretations toward different audiences that he managed to get a book filled with biting vignettes of planter hypocrisy published by whites in Columbia, South Carolina, for their own consumption. In classic Lowery doublespeak, he describes the way the master of the plantation where he grew up, Mr. Frierson, "looked after the morals of his slaves. . . . He had it understood on his plantation that there should be no little bastards there. . . . When the boys and girls reached a marriageable age he advised them to marry, but marry on the same plantation, and he would see to it that they should not be separated." "Little bastards" and those who did marry off the place, however, might well be sold. Thus, Lowery exposes Frierson's coercion to maximize his investment under the guise of applauding "morality."[8] The following passage, which deals with names

and places, is a more subtle instance of Lowery's signifying:

> [T]here is another thing that goes to show that the owners and managers of this plantation were people of education, culture, and refinement, and that was that even the fields were given names It was necessary that these fields should all have names so it could be ascertained where the hands were working. Or where the horses or cows were being pastured. There were six horses and two mules on the place, and they too, all had names. There was "Old Reuben," "Old Gray," "Old Lep," "Fannie," "John," and "Charlie." The mules were "Jack" and "Ginnie." . . . It will be noticed that the word "old" precedes the names of these horses. This does not signify that they were naturally old, but it is simply a designation given to them by the slaves, and the white folks accepted it and so styled the horses also.[9]

Lowery concludes, "The slaves were adepts at giving nicknames to animals, to each other, and even to the white folks. But the white folks seldom caught on to the nicknames given to them."[10]

Although Lowery opens the passage by saying that whites named fields because they were so refined, he immediately undercuts this refinement: In fact, fields were named to keep track of enslaved "hands" and animals. Further, whites named enslaved people in the same spirit as the fields and stock. However educated and refined they may have been, therefore, they nevertheless did not have the last word in naming anything, even themselves.

Lowery's text also suggests something interesting about even those names that have been called "slave names"—European-sounding names that seem to be adopted from a slaveholder. Importantly for enslaved people, these were above all *place names*— "the old Jackson place," "the old Frierson place"—for lands they helped to make profitable and communities they helped to build. In times of population movement and separation of family members, this type of name communicates a location far more likely to lead to information about missing relatives than would the name of the nearest town—which, in any case, enslaved people might not have visited. Names like the Old So-and-So Place designate a home place, not because So-and-So owned it but because the land in a sense also "belonged" to those forced to labor there and those buried in its soil.[11]

In an essay entitled "The Song that Named the Land," Thompson notes that yard shows also "name" by asserting identities and projecting them over territory, like the field cries, hollers, and songs that Frederick Law Olmsted heard echoing from one plantation to another, from "Carolina to Kansas, resounding as the mood went up, from river to river."[12] African American place-naming of the antebellum era also often refers to trees, a pattern that North Carolina historian Alice Eley Jones relates to the sacred trees and groves that mark villages in many parts of West and Central Africa.[13] Carter's Grove plantation in Virginia, for example, carries forward a name that has fit both white and black naming patterns since the eighteenth century.

In contrast to houses in Britain and American planters' mansions and rural estates, most American houses and yards do not have names. However, house numbers and street names serve many of the same functions as house names. As with running

"An house . . . made with hands"

Fig. 5.2
Frontispiece from *The "Passin'-On" Party* by Effie Graham (Chicago: McClurg, 1912).

electric lines and digging sewer systems, many municipalities were much slower to put up street signs and house numbers in African American neighborhoods than in those of whites. Some residents remedied this by supplying numbers of their own. An elderly couple in early-twentieth-century Kansas placed a printed sign—004&—over the door of their improvised house made of scraps and found materials (fig. 5.2).

The author of the description, Effie Graham, captioned it the "house . . . made with hands," inverting a passage in the Bible describing Heaven as "a house *not* made with hands."[14] She considered the numbers non-

sensical. But 004& is no more nonsensical than the numbers on car license plates, themselves a kind of name substitute. A slightly later report from the 1930s describes a license plate affixed to a house and the signifying message it communicated:

There is no street sign or number on any of the ramshackled frame cottages that seemingly lean with the breezes . . . along the alley that winds through the city's northernmost boundary and stops its meanderings at the doorstep of "Uncle Andrew" Moss and his wife "Aunt Mollie." The city directory of Knoxville,

Tennessee, officially lists the Moss residence as 88 Auburn Street. It rests upon its foundations more substantially, and is in better kept condition than its neighbors. In lieu of a "regular" house number, the aged Negro couple has placed a rusty automobile license tag of ancient vintage conspicuously over their door. It is their gesture of contempt for their nearest white neighbors who "don't seem to care whedder folkes know whar dey lib an maybe don wants em to."[15]

The reasoning here is that a house number, like a person's name and title, is a sign of self-respect. A name is a mark of destiny. As Dilmus Hall of Athens, Georgia, put it in a conversation in his yard in 1987: "What's for you, you're gonna get it. It's got your name written on it. What's not for you, don't worry about it." The outside of Hall's house bore a sun, moon, and wooden diamonds that he painted blue, white, and yellow. He also demonstrated the significance of the destiny on which his own name was written by mounting "The Shoe that Road the Howling Tornado" in a glass case beside his mailbox (see portfolio IV, fig. 12).

Respecting Places

Self-respect aligns with the moral imperatives to use land and labor for good purposes and to transform the world for the better. As we have seen, these imperatives pull into their vortex much that seems to have little or no connection to yard work, at least from the perspectives of academic fields that focus on landscape design, art production, or aesthetic self-expression. Yet, from the perspectives of religion and ethics, yard work

is thoroughly linked to land use for the betterment of the community, and to the premise that actions in the present set the tone for the future. This is clear in the remark of Prince Johnson, a depression-era interviewee and farmer who was cheated out of his land by a seller who "never made me out no bond for title." Johnson explained, "Any man what would do the like of that can't 'speck their children to come to no good."[16]

Righteous use of land and righteous treatment of other people go hand in hand, with results that profoundly affect future generations. During the first decade of the twentieth century, Sam Daily and Paul Moss, African American landowners, responded to a judge's call for aid to delinquent youths. Describing their efforts in 1914, L. H. Hammond wrote:

Daily responded, donating himself, his family, and one hundred and twenty-five acres of land [in Ralph, Alabama]. . . . [H]e took about three hundred boys from the Birmingham juvenile court, paid their way to the railroad station nearest his farm, clothed them, taught them industry, cleanliness and honor. . . . The most curious thing about this enterprise is the fact that this poor Negro, who was never able to finish paying for his own farm, spent years of his life converting lawbreakers from a public liability to a public asset without receiving any public money. . . . Paul Moss [of Augusta, Georgia] . . . gave up an excellent income as a mechanic to devote his life to aiding Negro waifs and juvenile delinquents. He put all his savings into a small farm, where he has supported his charges with a little help from a few whites of the city and one or two

Northern visitors. He is able to give the boys not much book education, but teaches them practical religion and a few trades. In the last six years he has sent out one hundred and sixty boys.[17]

Sam Daily and Paul Moss took on projects that changed hundreds of lives. As far as we know, neither produced anything that might now be called a yard show or art, but they mobilized land and resources for regenerative purposes. In this respect they are part of the same network of practice as the yards described in portfolio I and chapter 6, or the work of James Hampton, who also created a zone of spiritual and material renewal under the banner "Fear Not," with his *Throne of the Third Heaven of the Nations Millennium General Assembly*[18] (see portfolio VI).

On a more modest scale, yard makers use plants and found objects to make neutral space into a positive environment, as in the yard Zora Neale Hurston introduced in her short story "The Gilded Six Bits":

> It was a Negro yard around a Negro house in a Negro settlement that looked to the payroll of G and G Fertilizer works for its support. But there was something happy about the place. The front yard was parted in the middle by a sidewalk from gate to door-step, a sidewalk edged on either side by quart bottles driven neck down into the ground on a slant. A mess of homey flowers planted without a plan but blooming cheerily from their helter-skelter places. The fence and house were whitewashed. The steps . . . scrubbed white. The front door stood open to the sunshine so that the floor of the front room could finish drying after its weekly scouring. It was Saturday. Everything clean from the front gate

to the privy house. Yard raked so that the strokes of the rake would make a pattern.[19]

Minnie Hite Moody, a white local-color writer, opened a novel set in Georgia, *Death is a Little Man,* with these words:

> Even on Judith Street the women try to make the door yards pretty, carrying water from the branch to revive the few cherished geraniums and begonias that in summer droop in the noon-heat of a blistering day. Eenie Weaver has the fanciest dooryard, with a fine hydrangea in a tub at one end of the slanting porch, and love-entangled trailing from old cooking pots suspended from the ceiling. Her yard is swept clean and bare; the walking-path is set off from the yard by a double row of broken tiles salvaged from the dump and outside the tiles is a thin spiky file of gladioli.[20]

Although these passages usefully sketch what some African American yards might have looked like in working-class areas of American cities during the 1920s through the 1960s, they are especially telling because the authors use descriptions of yards to foreshadow the personalities of the characters who made them. This means that by the time that Hurston and Moody wrote, conventions for a well-kept yard were sufficiently established to read as material signs of a stable and optimistic character.

Of course, plants may be grown in the yard for purposes other than food and deco- ration. Indeed, their beauty may matter little compared to their healthful benefits. The following passage published in 1877 describes the garden of a mulatto Creole cook and healer in Louisiana early in the century:

[It] had all the old-fashioned French flowers in its funny little beds; each bed was carefully bordered with red bricks, and inside of the bricks grew, around each bed, a double row of violets, now all blossoming and very fragrant. There were lots of mignotte, and of carnations, of clove pinks and pansies; also bunches of fleur d' lis in the corners. Lizbette used to make calamus of the sweet flag-roots, and she used the violets and rose leaves for tisane. She also used the lavender and verbena grasses among her linen; and of the fennel and grape leaves she used many to green her pickles. Marigolds and sweet bay and rosemary served for seasoning soups; and the glorious lilies, the candidum, which reverent painters put into the Virgin's hands, Lizbette made into a fine healing salve for cuts and burns. So it was that they grew, Lizbette believed. What did she care of their beauty? Lizbette was eminently practical in all her ideas.[21]

The borders of herbs and flowers in this garden have well-known African parallels, including the use of red brick dust for protective borders and the creation of enclosures for medicinal plants. For example, the Akan of Ghana make living fences by transplanting saplings with healing properties in a tightly knit enclosure around the house. These saplings and smaller herbs planted in the yard mirror those also transplanted to the area of sacred forest where the family's dead are buried.[22]

Plants, crops, and other growing things embody processes of transformation as they evolve from seed to mature plant to bearer of fruit, and as material signs they extend these processes through metaphor and metonymy to humans. For example, Josephine Anderson of Tampa, Florida, told an interviewer in 1937 about her daughter, Teeny:

> Use to worry Teeny right smart, seein sperrits day an night. My husban say he gonna cure her, so he taken a grain o' corn an put it in a bottle in Teeny's bedroom over night. Den he planted it in the yard, and driv plenty sticks roun de place. When it was growin good, he put leaf-mold roun de stalk, an watch it ever day, an tell us don't *nobody* touch de stalk. It raise three big ears o' corn, an when dey was good roastin size he pick em off an cook em an tell Teeny eat ever grain offn all three cobs. He watch her while she done it, an she ain never been worried wid hants no more. She sees em jes the same, but dey doan bother her none.[23]

Mobilizing Materials

When viewed in terms of a larger network of values and practices, yard work is extremely flexible in its scale and materials so that, although ownership of property is the ideal, the transformative goals of yard work can go forward without it. "Yards" can be miniature. They can also be mobile. They may not even be yards in the strictest sense, as with the rolling yard show of Harvey Lowe (fig. 5.3).

When we met Mr. Lowe in 1987, he had been retired for some years but still occupied a tenant house on a cotton plantation in the Mississippi Delta. Since his yard fronted Highway 61, which runs from Memphis to New Orleans, many people in cars passed

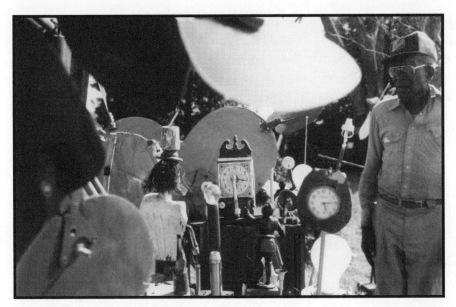

Fig. 5.3
Harvey Lowe with his portable yard. Shaw, Mississippi, 1987. Photograph by Grey Gundaker.

by, and since Mr. Lowe now had time on his hands for the first time in his life, he wanted to meet people. As a tenant, however, Mr. Lowe did not have a yard of his own. His solution was a large red box on wheels covered with figures, clocks, and whirligigs that a strong wind set in motion. He explained that in good weather he rolled this construction into the yard—where we saw it as we drove by—and in bad weather he rolled it into the barn that also housed his workshop. If he moved in with his son, who lived in town, he could take his "yard" with him, even though he could not take his house. In the meantime his "conversation piece," as he called it, was very effective in luring visitors to his door.

It is intriguing to consider the transformation of ordinary materials in yards along with, or as an evolving relative of, the transformation wrought by the "spiritual poets" that John Lovell Jr. discussed in *Black Song*. In a section called "Objects as Devices," he shows how enslaved people, in the spirituals they composed, transformed the meaning of

commonplace objects such as hammers, nails, ladders, nets, gates, rods, keys, and brooms, as well as places such as roads, streets, and lanes, and modes of transportation ranging from trains to chariots.[24] The interplay between imagery in performed texts and physical materials has indeed remained vibrant over the generations.

In places like the Mississippi Delta, economic conditions made it feasible to own a car even when owning land remained the prerogative of planters who extracted income from rents and sharecropping. By the mid-twentieth century the car had become a moveable home. The popularity of the Buick Electra 225 and the Cadillac Coupe de Ville, both substantial machines, befitted these conditions since a regal car was not only a symbol of success but also, because of its portability, an extension of the human body itself. In the 1950s, the Dixie Hummingbirds, a Memphis gospel group, celebrated these developments with Jessie Archie's song "Christian's Automobile," in which driving a car becomes a metaphor of the soul's journey

to Heaven: prayer is described as a "driver's license," while faith is the "steering wheel."[25]

Sometimes it is the car—or, in the case of Extrus Cropper of Pokomoke City, Maryland, the pickup truck—that is transformed. To the great pleasure of his grandson, Mr. Cropper adorned his trees with stuffed animals, birds, and ornaments; however, his yard was not on a main road, and he wanted to take his message farther afield. So he covered two trucks with stuffed animals, plastic super-hero figurines, and other toys, and drove them for special occasions and local parades. His message, he explained, was that people can change their ways and that kids need care, fun, and attention in a time when drugs were rampant, even in a backwater like Pokomoke. Importantly, as our conversation continued, it became clear that Mr. Cropper assumed that this message would be self-evident to anyone who saw his work and that, having wrought a transfiguration of the trucks and the yard, he was also helping to change people's lives for the better by bringing them signs of jubilation. When they reuse found materials, most practitioners also seem to take it for granted that everyone will immediately get the analogy between new lives for objects and people because virtually the whole community, at one time or another, has heard many of the same songs, adages, and parables and has seen the same pop-culture icons in movies and on television. As Mr. Cropper put it, with an amazed expression, "Why else would I do it? Why would anybody do it?"[26]

Yard work treats objects as mobile, moving them from one location to another both within and outside of designated spaces and transforming their meanings in the process. Sometimes the objects relate to the occupation of the practitioner. For example, a planter-author mentioned visiting a man who had been sold to the Central Georgia Railroad and continued to work for them for many years after the Civil War and Emancipation: "'But come back in de yawd—' Into the fenced yard piled high with many articles of quite humble nature Uncle George leads you. He picks up a jagged oak post. He tells you that along in the 'eighties when they tore down the old platform he chopped off this corner post to preserve it as a souvenir. 'It's gettin' a little ole, same as me. . . .'"[27]

Surely this man commemorated not only a place but also the years of labor he and others invested there. Victor Melancon, a former General Motors line foreman and United Auto Workers Union shop steward whom we have already mentioned, did much the same. He lined the front of his house with hubcaps from the car models he worked on before the factories that made them closed down (fig. 5.4).

Women also linked their workplaces and the people they knew at work to objects in their yards. The woman quoted below worked as a domestic in Kansas:

> [See] dat beeg brack ting wif de ferm in, clean back under dat bush? Dat's ole Marse Molton's ole iron wash pot. Used to scald hawgs in it and cook Indian mess an' free bar-berry-cue for niggers 'lection times. . . . None of de fam'ly lef' no mo', 'cept Miss Liza. She nevah foun' her no ole man. . . . [S]he given me dat ole pot. 'Plant sompin' in it, so's you-all reco-mem-ber me . . .' she say. 'I certain suah done dat,' I say. So I plant dat ferm—maiden-haih-ferm, dey call it. Dat suah suit ole Miss Liza. . . .[28]

Note that the name of the fern fits a memorable characteristic of Miss Liza

Fig. 5.4
Victor Melancon's yard.
Hammond, Louisiana, 1988.
Photograph by Grey Gundaker.

herself. The woman's affirmation "I certain suah [sure] done dat" compares with "Uncle George's" choice of words and with Ruby Gilmore's comment about Bermuda grass: "Like black people, it's hard to kill." These assertive phrases and the actions they represent tie the physical materials in the yard to important issues about life in general. Weighty, formulaic phrases also bring closure to part of a conversation: the material sign grounds the speakers' authority to have the last word.

Stop and Think

Narratives that occasionally include brief descriptions of yards were collected during the 1930s as part of a massive effort by the Works Progress Administration (WPA) and the Federal Writers' Project (FWP) to interview people who had been enslaved during the previous century. Although their numbers were diminishing and many were reticent or selective about the aspects of life

under enslavement they would discuss with the interviewers, who were usually white, these elders provided a seemingly inexhaustible store of information about their pasts. The following account of a yard in Florence, South Carolina, in 1937 comes from the notes of an FWP interviewer. Here a woman put up a sign, giving her the last word on who should approach her home:

> Aunt Sylvia has a large sign in her front yard. It seems she took the frame of a large picture and inserted a piece of pasteboard in it. She explained that this is a warning to evil doers not to molest her. She says they must not come past this sign. The words on the sign were somewhat illegibly written. The inter- viewers were able to make out these words: "This is a house of the Lord. Don't go pass. This is a house of the Lord. . . ." Sign is dated March 1, 1937.[29]

Lacking more information about Mrs. Sylvia Cannon's background, one might think that the sign she made was merely an isolated gesture, but fortunately Mrs. Cannon

explained her circumstances to the interviewers. Although she had formerly believed that she owned the house she lived in, Mrs. Cannon (who was eighty-five years old at the time of the interview) eventually discovered that she was the victim of a rich white man's greed:

> I thought dis house been belong to me, but dey tell me dis here place be city property. Rich man up dere in Florence learn bout I worth over $1500.00 en he tell me dat I out to buy a house dat I was gettin old. Say he had a nice place he want to sell me. I been learned dat what white folks tell me, I must settle down on it en I give him de money en tell him give me de place he say he had to sell me. I been trust white folks en he take my money en settle me down here on city property. . . . Yes, mam, I pay dat man over $900.00. Been payin on it long time en got it all paid but $187.00 en city found out what dat man done. City tell me just stay on right here, but don' pay no more money out. . . . Couthouse man tell me day I ought to drop my thanks to de heavenly Father dat I is free."[30]

The confidence scheme perpetrated on Mrs. Cannon was commonplace in the Jim Crow South. Even the man at the courthouse who permitted her to remain on city land told Mrs. Cannon to "drop" her thanks to God for the freedom that, in his view, had made her vulnerable. It is small wonder that protection of person and property has remained a motivating factor in African American yard work throughout its history because, as African Americans have recognized, the true aims and potentials of human beings, whether positive or negative, may be hidden from view. Such hidden motives might take the form of the con artistry, cloaked in white authority, that lured Mrs. Cannon into harm's way, or they might be present in whites whose advice she had trusted but who also had enslaved her.

By placing the sign in front of her house, Mrs. Cannon established a buffer between her home and potential wrongdoers. But by making the broad assertion that "this is a house of the Lord," she did not accuse anyone in particular of wishing her ill. Thus she avoided accusing well-meaning visitors and responded to the contradictions of her situation. She also avoided calling anyone's name except the Lord's. The heavenly Father whom she thanked for freedom was apparently the only truly trustworthy being in her world.

Since calling or writing a name is potentially a form of invocation, it is not a good idea to do so unless one is absolutely certain that one wants that person to come. Calling against someone or "out of" somebody's name by speaking untruth can bring onto the caller even more trouble than he or she started out with. Even when people do not believe in or know about such consequences, good manners still call for indirection.[31]

Mrs. Cannon opted for a classic mode of African American indirection. She imposed a middle ground between two opposing principles of social interaction, as expressed in the proverbial warnings of early twentieth-century blues and ballad songs:

> Everybody grin in yo' face . . .
> ain't no friend to you.

And:

> Never drive a stranger from your do'.
> He may be yo' best friend; you never know.[32]

This second phrase complements the biblical reminder that "ye know not the day nor the hour when the Son of Man cometh" (Matt. 25:13). Always try to do the right thing because any action may be your last.

Posted Posts and Safety Zones

Mrs. Cannon's story shows that making a yard safe can involve physical barriers, but ultimately it involves knowing and even changing human intentions by striving to make people aware of the place they are in ("where they're at") in the philosophical sense and by working towards making residents and higher powers aware of this too. This means challenging people to stop and think as the watcher figures discussed and illustrated in chapter 4 do. The matches and chunks on the gatepost in Kentucky, discussed in chapter 2, performed a similar function.

Like Mrs. Cannon, but fifty years later, Mrs. Ruby Gilmore lived alone and had been the victim of thieves. But unlike the man who robbed Mrs. Cannon by trickery, these thieves took the direct approach, climbing her fence on Sunday mornings while Mrs. Gilmore was in church and using their loot to barter for whisky with the bootlegger down the street. To warn them off, she made a materially punning "Posted" sign on a post painted light blue ("God's color") with a handmade sword attached (fig. 5.5). The hilt of the sword doubled as a cross. As time passed, other objects came and went around the sign, including a jack-o'-lantern and Christmas decorations. Although Mrs. Gilmore's hoarding of recyclable wood and cans irritated some of her neighbors,

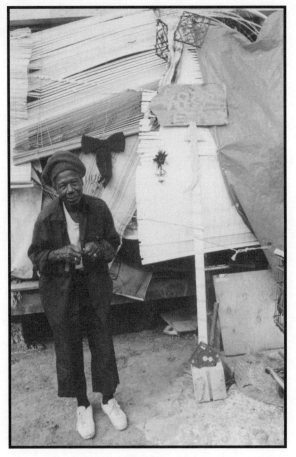

Fig. 5.5
Ruby Gilmore. Hattiesburg, Mississippi, 1988.
Photograph by Grey Gundaker.

most had adopted protective strategies of their own, such as bars on the windows, watchdogs, and fences.

Standing in the Safety Zone

Ultimately, the personal goal of many yard workers goes beyond sealing *out or against* something or someone. Their goal, rather, is ensuring a place where the positive forces summed up in phrases like "God's

love" can thrive. The house and yard of Mrs. Jackie Jones, a nurse and pastor's wife in east Tennessee, illustrates this outlook. All the materials adorning the yard combine to project personal success and spiritual assurance. Painted, planted, and maintained by Mrs. Jones, white stones line the sidewalk, and welcome mats carpet the walkways and porch, marking off the "safety zone" (a term we take from interviews and the gospel song phrase) that extends from porch to street. Throughout the long growing season from April through October, the aromas of flowers and well-tended earth fill the air like mild, cleansing incense. Visitors must move through borders and flower beds past a shining angel birdbath and across several mats to reach the front door. If they read the message on the mats, the result is like a visual chant: "welcome, welcome, welcome . . ."

The comforting environment of this yard contrasts dramatically with the deteriorating neighborhood around it. If its safety zone is effective, it is because the space is saturated with reiterations of acceptance and allusions to Christian love that make hostile intrusion unnecessary. Nevertheless, the house is also well guarded and sealed with iron bars because, as several homeowners have explained to us, a house that is too open could lead others into temptation. An important part of adult responsibility is heading off circumstances that bring out the worst in other people. All forms of beauty, finery, grandeur, even showiness—what Zora Neale Hurston called "decorating the decorations"—can usefully engage trajectories

of aspiration and hope.[33] But access should not be easy. In any case, real accomplishment cannot be stolen because, like health, it is a blessing rather than an exploit. Making a safety zone visible can therefore be a material mode of praise and thanksgiving whose very defenses testify to gratitude.

As far as right living is concerned, there is no necessary connection between spiritual well-being and a decorated or embellished house. Many homeowners prefer simplicity, choosing to spend their time and money on children and grandchildren and on donations to the needy and the church. Too fine a home may even keep some people from getting out to visit or help others.[34] However, Ruby Gilmore, Jackie Jones, and Sylvia Cannon all transformed signs of warning into affirmations of faith. Through her yard each woman demonstrated methods of reversing negativity. In this way verbal allusions, objects, and placements frame spaces and actions as "this" instead of "that," eclipsing old habits with new visions of the world.

Though speculative, it is interesting to compare the emphasis on blessings and positive attributes of the divinity in yards in relation to Samuel Miller Lawton's analysis of the frequency of occurrence of attributes mentioned in prayers in Sea Island churches in the 1930s. In the 103 prayers he studied, the notion of the deity giving spiritual blessings occurred 104 times, physical blessings 21 times, and punishing the wicked only 3 times.[35] Like Mrs. Jones's yard this seems to give Christianity a positive emphasis instead of one of fear.

The Light of Heaven on Earth

John Bunion "J. B." Murray
1908-1988
Glascock County, Ga.

J.B. Murray was a lifelong farmer who lived in rural Glascock County, Georgia, near the community of Mitchell, a few miles from the shoals of the Ogeechee River. When he was approximately seventy years of age, believing he had experienced a vision from God, he began writing a non-discursive script on adding machine tape, wallboard, stationery, calendars, wood, sketchbook pages, craft paper, and carefully selected objects such as stove tops, television picture tubes, and automobile headlights.

He described the writing as "the language of the Holy Spirit, direct from God" and interpreted it using water from the well in his yard as a focusing device. Although he lived a solitary existence, far removed from the galleries in New York, Europe, and Japan that eventually exhibited his work, he made over a thousand paintings in the last ten years of his life, introducing his spiritual script into fields of color and abstract figures that, he said, represent "the evil people; the people that's dry tongued; they don't know God."[1]

In her biography of Murray, *In the Hand of the Holy Spirit: The Visionary Art of J. B. Murray,* Mary Padgelek reports that he became a farm laborer at the age of six when he was forced to quit school after attending for one month. In 1929 he married Cleo Kitchens and fathered eleven children, five of whom predeceased him. As Padgelek writes, "Murray lived with his son, Ray, after retirement during which time he built a separate house on the same property. . . . He grew his own food in his garden and drew water from a well in his yard. . . .

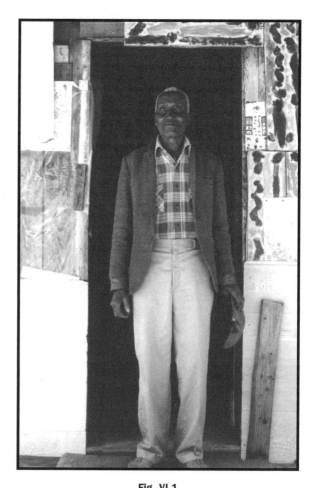

Fig. VI.1
John B. "J. B." Murray. Glascock County, Georgia, 1986.
Photograph by Judith McWillie.

[He] grew up, raised a family, and later produced his art in an area where both white and black citizens knew him and knew his family through several generations. He left this area only once, when he and William Rawlings, his physician and friend from nearby Sandersville, went to Atlanta when Murray was included in a group art exhibition at the Piedmont Art Festival in 1986."[2]

During two interviews with Judith McWillie at his home in 1986, Murray agreed to talk about his experiences. He accepted curiosity about his "spiritual work" with characteristic

poise and patience, answering questions with ritual more frequently than discourse: "I was outside in my potato patch and the sun come right to me; turned everything yellow-like. I took up to hose it and He turned it [into] rainbow colors. It was then I began to write these letters."

"Alright, now I write some." He began with the Lord's Prayer, adding, "Answer us, Lord! Give me a louder word up!" and then slowly drew a meandering, continuous line in felt-tip pen on white sketchbook paper, rotating the page as his hand released the mark, explaining, "It's the language of the Holy Spirit, direct from God."

The image developed from a smooth, uninterrupted line until he suddenly stopped and discharged his familiar "letters" with mounting speed, then finished by introducing dots throughout the composition. "Lord, I thank you, Jesus, for blessing me to do this spiritual work," he said. "Your word, your name, your power. I will trust in the Lord till he comes, say, 'Well done.' Plenty of good room round my Father's throne."

We can only speculate about J. B. Murray's contact with spiritualist practice in Glascock County, a region of central Georgia with a rich oral tradition concerning its healers and "root doctors" and a place where African Muslims are known to have been among the population of slaves brought from the Atlantic coast in the mid-nineteenth century. There are many Muslim-influenced ceremonies and art forms in which God is "evoked elliptically through cryptic letters."[3] Nearby Sandersville, Georgia, is the birthplace of Elijah Poole, who later became Elijah Muhammad, founder of the Nation of Islam. Murray refused to discuss spiritualism except to strongly disavow it, saying, "Hoodoo works by hands, and it don't matter if they [the people it targets] be good or bad. But Jesus

Fig. VI.2
J. B. Murray's spiritual script, c. 1983.
Photograph by Judith McWillie.

is stronger than hoodoo." Once he attempted to distribute sheets of the language of the Holy Spirit at his church, but he was ostracized for "acting religion." Eventually, however, he was invited to lead prayer there.

At his home in 1986, he interpreted the language of the Holy Spirit by visually focusing on the motion of water in a grape juice bottle held over a drawing or a page of script like a lens. "You've got to be pure at heart to see God." Visitors were then invited to do the same.

After asking God if his actions and interpretations were pleasing to Him, Murray began to pray: "Lord! Is my mind right to say what's on this paper now? If it is, Lord, give me a louder word up. I thank you for the knowledge you gave me to go by. You gave me a mind to ask you questions through the water."

The following narrative comes from videotapes of two visits in 1986.

J. B. Murray Narrative
April, May 1986

When I started I prayed and I prayed and the Lord sent a vision from the sun. Everything I see is from the sun. He showed me signs and seasons and He tells me. Then He turned around and gave me a question to ask Him and, when I asked Him, I wanted to see my mother. He brought her before me and two brothers. . . . And the three come up as a shadow—a Spiritual Shadow, ain't like us, ain't like our body.

He came to me slowly, over a period of time, came in a vision and a likeness, and in a veil. He spoke to me, "Before my word shall fail, heaven and earth shall pass away." And I said, "Lord, I didn't know I was that close to you for you to bless me with this blessing."

It was then I began to write these letters. Different writing represents different languages and folks. It's the language of the Holy Spirit, direct from God. God put the instrument in my hands and it rules and guides my hands to do this. I wasn't doing it myself; it was the Lord that used me and that changed these different writings to different letters and drawings. It's like He uses different verses and prayers

Fig. VI.3
J. B. Murray painting, 1986.
Photograph by Judith McWillie.

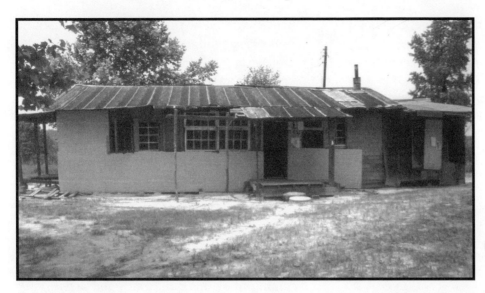

Fig. VI.4
Murray residence, 1986.
Photograph by
Judith McWillie.

and psalms— the same. The Holy Spirit comes to do the Lord's work.

I pray every hour of the night. The Lord wakes me up at different hours in the night and I say, "Lord have mercy on me. You are my all in all." I feel uplifted every day and night. I know I have a God on my side and I know I have a God to serve. Jesus, use the instrument of my fingers!

The Lord told me I had to be hung. You have to hang on to God for trouble to pass over. When He told me I had to be hung, tears come to my eyes. And my mother—she was dead—her Spirit cried, "Lord, take care of my child!" See, Spirit will talk with Spirit. And when I left there, the eagle crossed my eye—a Spiritual Eagle. The eagle can see farther than any other bird in the world and that's why I can see things some more folks can't see. What I see between here and the sun is in a twinkle.

The red line [in a painting] is torment and those lines lead into torment and there's no way out. It's "up and down" in torment. Torment is a dead end for the souls and my red line leads into torment.

I have faith. He is other help I know. There is nothing He starts but what He don't finish. Like death comes in the twinkling of an eye, His word and what He tells you comes in a twinkle. And every knee shall bow. Anything you give me to do in the Spirit, Lord! You said, "Love your neighbor as you love yourself." And I know you gave me a neighbor to pray for me and anything a praying neighbor does, the Lord will bless you for it. Bless us, then, who pray to you with honest prayer. Amen.

Water saves.
You can't hinder water.
Water will soak down and come up in
 another place.
If you build up, it will rise and go over
 where you build up.
So the Lord is strong. You can't back
 Him up.
And you can't go over him. That's
 the Lord.
And He spoke with water.
Water obey God better than
 anything in the

World and water's the strongest thing in
the world.
It can rain and below and where the
water falls,
Part of the Earth will be dry.
Go you out further and you'll strike
a stream.
Go below that stream and you'll strike
a dry spot.
Jesus. He moves in mysterious ways
and wonderful forms.

Signs: some speak of rain; some speak
of His coming back. His word won't fail
because the Earth is His footstool. Earth
always stands. Earth is the Lord's.

James Hampton

1909–1964
Washington, D.C.

Where there is no vision the people perish.
—Proverbs 29:18

In 1950 James Hampton, a maintenance worker for the United States General Services Administration, rented a small unheated garage in the "Shaw" neighborhood of northwest Washington, D.C.,[4] and over the next fourteen years created *The Throne of the Third Heaven of the Nations Millennium General Assembly,* a luminous visionary monument that the art critic Robert Hughes has said "may well be the finest work of visionary religious art produced by an American."[5]

Hampton was born on April 8, 1909, in Elloree, South Carolina, a small tenant-farming community in the Santee River Basin, where stone markers in African American cemeteries are sealed with brilliant silver paint and hand-inscribed with wave forms resembling water (see chap. 6, fig. 4).

His father was a traveling preacher and gospel singer whose work kept him away from the family most of the time. In 1931, when Hampton was twenty-two years old, he left Elloree to join his brother, Lee, in Washington, D.C., where he found work as a short-order cook.[6]

"Shortly after his arrival he received his first religious vision," noted Lynda Roscoe Hartigan,[7] former curator of drawing and painting of the Smithsonian American Art Museum, where *The Throne* was exhibited after its discovery in 1965.[8] Hartigan suggests that for a young man coming from the rural south and arriving for the first time in a bustling urban center, religion provided Hampton with "a sense of refuge and community in a city's foreign setting."[9] Although he was raised as a Baptist, wrote Hartigan, Hampton "frequented but did not join any of the neighborhood's organized black churches. A. J. Tyler, minister of Mt. Airy Baptist Church between 1906 and 1936, however, made a lasting impression on the newly arrived Hampton," as did the home altars on dressers and tabletops and the many storefront churches in the Shaw neighborhood.[10] "In 1928," Hartigan wrote, "Tyler's congregation opened a handsome new stone church. Its facade bore the phrase 'Monument to Jesus' in large gold lettering. Tyler believed that his church should be a monument to Jesus in America's capital, a quintessential city of monuments."[11] When Tyler died in 1936, in appreciation of him, "Hampton included the minister's name, as well as the phrases 'Monument to Jesus,' 'Tyler Baptist Church,' and 'St. James Pastor' on labels attached to many parts of *The Throne.* In creating his assembly of objects, Hampton celebrated Tyler's dedication and spiritual goal as a source of his own sense of mission," according to Hartigan.[12]

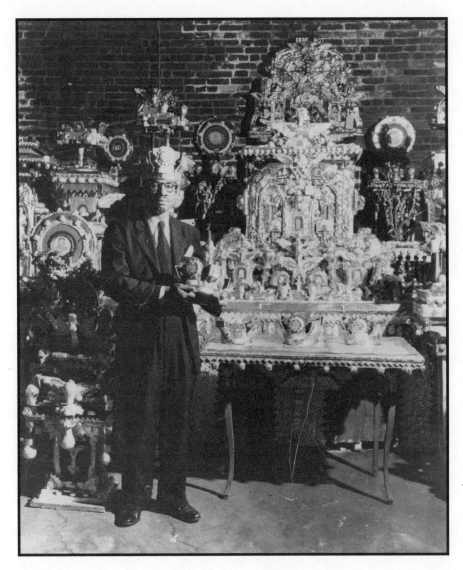

Fig. VI.5
James Hampton in his garage with *The Throne* in progress. Photographer and date unknown. Courtesy of the Smithsonian American Art Museum, Washington, D.C.

After becoming established in the Shaw neighborhood, Hampton found a secure position as a janitor with the General Services Administration. When World War II broke out, he joined the army and served with the 385th Aviation Squadron in Texas, Seattle, Hawaii, Saipan, and Guam, doing carpentry and airstrip maintenance.[13] Honorably discharged in 1946, he returned to his job with the General Services Administration and settled in his old neighborhood, only to lose his brother two years later. In the bereavement period follow-

ing Lee's death, working alone in the rooming house where he lived, he expanded on a small plaque he had made in Guam in 1945 and began to create the first elements of *The Throne*: wooden plaques referencing the law of Moses, the prophets, and the apostles, along with sculptures of the winged creatures that would later contribute so much to the monument's visual unity.[14]

As the room became more crowded, he needed space, but it is also obvious from the memories of coworkers and neighbors that he

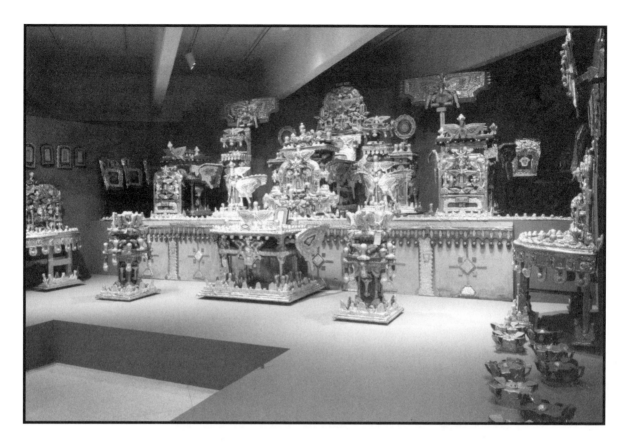

Fig. VI.6
Installation view of *The Throne* with front panels intact.
From Naives and Visionaries, organized by Walker Art Center,
Minneapolis, Dec. 1, 1974–Jan. 26, 1975. Photograph
courtesy of the Walker Art Center, Minneapolis, Minnesota.

saw his work as more than "self-expression" or a palliative for grief and loneliness. Its spiritual dimensions were becoming social, and it was now necessary for him to take his vision to the people. He found the garage, a former stable, in an alley behind Seventh Street and rented it from Meyer Wertlieb, telling him, "This is my life. I'll finish it before I die."[15]

Lynda Hartigan spoke with a woman who had worked with Hampton in the 1950s; she "recalled that he was diligent and seemed religious, yet he seldom mentioned religion at work and did not press his convictions on her when she visited the garage. Hampton told her that he wanted to be a minister when he retired. . . . Another woman who brought food to Hampton maintained that he once tried to attract attention to his project by contacting a local newspaper."[16]

The 180 components of *The Throne* are made from appliance parts, glassware, light bulbs, insulation board, cardboard cylinders, blotter paper, and furniture parts collected from curbside waste or purchased at local thrift stores. These were then wrapped in gold and silver aluminum foil. Hampton was a familiar sight in Shaw, towing a wagon filled with the day's discoveries or carrying a paper bag for collecting bits and scraps of foil from the waste baskets he emptied at work and from the streets: cigarette pack liners, discarded store displays, and food wrappings. It is said that

sometimes he even paid drinkers a few cents for the foil on their wine bottles,[17] which he wrapped and wove into every element of *The Throne,* filling gaps with designs, drawings, and inscriptions written in an indecipherable script. Many of his notebooks and ledgers contained this script, and although most of them are presumably lost, one entitled "St. James: The Book of the 7 Dispensation"[18] survives in the Smithsonian collection (see portfolio II, fig. 38).

Dennis Jay Stallings has researched Hampton's script, comparing it with Gullah and African syllabaries and making a statistical analysis of the frequency of its finite number of recurring "letters." But while some "words" repeat in the superstructure of *The Throne* and in the pages of Hampton's notebook, no viable translation exists.[19] Like *The Throne* itself, Hampton's script challenges static and immutable orthodoxies while remaining faithful to Paul's description of "The Third Heaven" in 2 Corinthians 12:2–4, the only mention of it in the Bible. Those verses read: "I knew a man in Christ more than fourteen years ago (whether in the body I cannot tell, or whether out of the body I cannot tell, God knoweth). Such a one was caught up to the third heaven. And I knew such a man (whether in the body or out of the body I cannot tell, God knoweth), and how he was caught up into Paradise and heard unspeakable words which it is not lawful for a man to utter." Paul's reference to a third heaven is rooted in his Judaic ancestry; the imagery predates the Christian era.[20] But building on this reference in Corinthians, some Protestant denominations teach that a boundary exists between two lower heavens and a third heaven where God reigns on his throne. The physical world as perceived by the senses is the lowest heaven, according to Douglas Ward, while "the second heaven is composed of water, a great sea, a firmament divid-

ing the earth from the heavenly beings. . . . So often, these waters were understood to be gathered to await the coming day of judgment when they would once again be loosed to destroy the unrighteous. However, the third heaven was beyond the sight of human beings. It was the dwelling place of God and his attendant heavenly beings whom he would send to protect Israel and the righteous."[21]

Hampton worked on *The Throne* at a time when Christian ecumenism was front-page news (the widely publicized Second Vatican Council was in session from 1962 to 1965), and his decision not to join a particular church may, in some measure, have been influenced by his vision of an imminent synthesis and unity within the "general assembly" of the faithful. His enthusiasm and hunger for knowledge extended to denominations that, in the United States, are not predominantly African American, such as Roman Catholicism. One of the elements of *The Throne* commemorates the dogma, as proclaimed by the pope on November 2, 1950, of the Assumption into Heaven of Mary, the mother of Christ. "This design," Hampton said, "is proof of the Virgin Mary descending [*sic*] into Heaven, November 2, 1950. It is also spoken of by Pope Pius XII."[22]

The title of the surviving notebook, "St. James: The Book of the 7 Dispensation," written in English with blue ink on the cover, offers another clue to Hampton's beliefs and may also provide a hint of its content. Dispensational Premillennialism, a Protestant movement originating in the nineteenth century with the teachings of the British minister John N. Darby, "divides the scheme of God's redemption into various dispensations, or periods of time during which God tests man in respect to his obedience to some specific revelation from God," according to Lonnie Kent York in his "History of Millennialism."[23] York

further states, "Each dispensation has its own determinate system of salvation, which allows future dispensations to possess a different scheme of redemption."[24] York lists the seven dispensations as "innocencey [sic], conscience, human government, promise, law, grace, and the kingdom."[25]

Hampton's appetite for theology, his ability to integrate complex and subtle interrelationships and correspondences within *The Throne,* establishes his work as an intellectual achievement as well as a spiritual and aesthetic one. On King Solomon's Tablet, one of the wall plaques to the left and right of the central installation, he lettered the word "Jesus," with rays of glory sketched around it, hovering above four lines of spiritual script with Moses' tablets of the law numbered in Roman numerals beneath (fig. VI.7). Hampton's evocation of three dimensions of Christian revelation—the Old and New Testaments and the revelation of the Holy Spirit operating in linear time, but yet to be fully apprehended, is one of the most specific theological proposals of *The Throne.*

The bilateral symmetry of *The Throne,* with its matching pairs of tables and other elements, echoes the symmetry of the human body[26] and creates parallels between the Old and New Testaments, with the left side labeled "BC" and the right, "AD." The plaques found mounted on the left wall of the garage, observed Stephen Jay Gould, "bore names of the prophets, and a corresponding row on the right, the apostles," representing the old and new law.[27] But the progenitor of the visual imagery of *The Throne* is the book of Revelation, which holds many clues to Hampton's beliefs and methodologies, including God's instruction to John that he record his visions in a book (fig. VI.8). Below is a list of images in *The Throne* and their corresponding texts from Revelation:

Stars

"I, Jesus, have sent mine angel to testify unto you these things in the churches. I am the root and the offspring of David, and the bright and morning star." (Rev. 22:16)

Winged, Insect-Like Creatures

"And the shapes of the locusts were like unto horses prepared unto battle; and on their heads were, as it were, crowns like gold and their faces were as the faces of men." (Rev. 9:7)

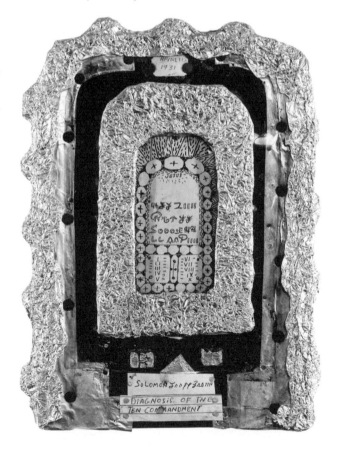

Fig. VI.7
King Solomon 's Tablet from *The Throne*, c. 1945–1966. Courtesy of the Smithsonian American Art Museum, Washington, D.C.

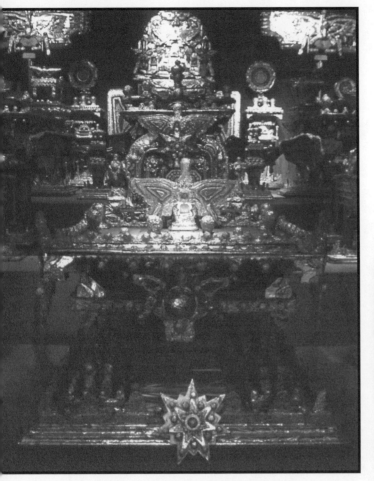

Lamps

"And out of the throne proceeded lightnings and thunderings and voices: and there were seven lamps of fire burning before the throne, which are the seven Spirits of God." (Rev. 4:5; see fig. VI.9)

Crowns Placed on the Floor around the Perimeter

"The four and twenty elders fall down before him that sat on the throne, and worship him that liveth for ever and ever, and cast their crowns before the throne, saying, 'Thou art worthy, O Lord, to receive glory and honour and power: for thou hast created all things, and for thy pleasure they are and were created.'" (Rev. 4:10–11; see plate 16.)

Open Books

"And I saw in the right hand of him that sat on the throne a book written within and on the backside, sealed with seven seals." (Rev. 5:1)

"And they sung a new song, saying, Thou art worthy to take the book, and to open the seals thereof for thou wast slain,

and hast redeemed us to God by thy blood out of every kindred, and tongue, and people, and nation; And hast made us unto our God kings and priests: and we shall reign on the earth." (Rev. 5:9–10)

Disembodied Eyes

"And before the throne there was a sea of glass like unto crystal and, in the midst of the throne, and round about the throne, four beasts full of eyes before and behind." (Rev. 4:6)

Although *The Throne* was probably left unfinished when Hampton died of stomach cancer in 1964, he left diagrams related to its composition, a drawing on a chalkboard in the garage (fig. VI.10), and quotations tacked to a bulletin board ("Where there is no vision the people perish"), evidence that he fine-tuned his beliefs with the same precision and tenac-

ity that he applied to his work. Here Lynda Hartigan describes what happened to *The Throne* after his death:

His sister (who saw *The Throne* for the first time when she came north to claim her brother's body) had neither the resources nor the inclination to transport or preserve the work. Fortunately, the garage owner, hoping to rent the garage without destroying his tenant's project, sought to bring it to public attention. He contacted a reporter who wrote an article for a local newspaper. He also advertised the garage for rent, and, coincidentally, a Washington photographer responded. Eventually, news of *The Throne* spread to staff members of the National Collection of Fine Arts, and the work was acquired for the museum.[28]

In a 1986 interview at the Smithsonian American Art Museum, Mrs. Otelia Whitehead

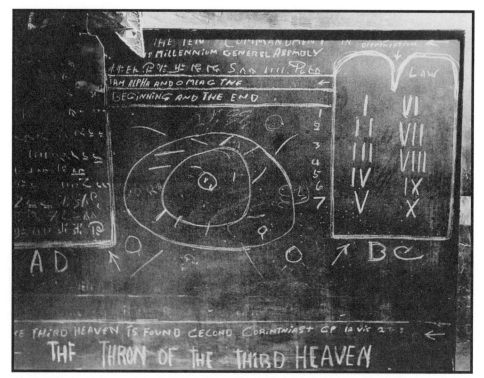

Fig. VI.10

Drawing by Hampton found on chalkboard in garage, c. 1966. Courtesy of the Smithsonian American Art Museum, Washington D.C.

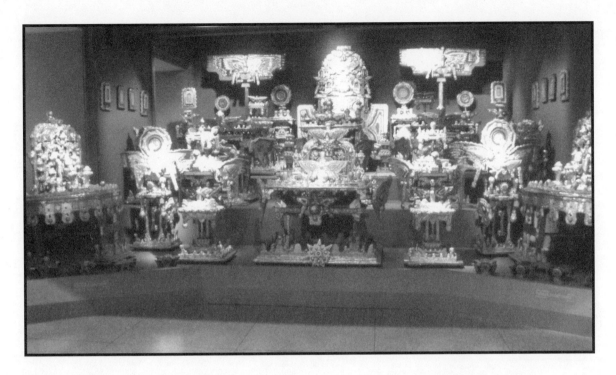

Fig. VI.11
.................
Installation of *The Throne* in the Smithsonian
American Art Museum lobby. Washington, D.C., 1985.
Photograph by Judith McWillie.

told Hartigan and Judith McWillie how a taxi driver had asked if she wanted to see "a man who is a mystery."[29] He then took her to the garage to meet Hampton. During repeated visits, Mrs. Whitehead watched him work on *The Throne* and saw "more than twenty notebooks" filled with the spiritual script. Hampton told her that each evening, as he rounded the corner of the alley to unlock the garage, he met Christ, who then "divinely guided" him. He invited her and others to approach *The Throne* on their knees and to sit on the Mercy Seat,[30] a chair mounted directly under the monument's highest point where a sign reads, "Fear Not." In asking Mrs. Whitehead to sit on the Mercy Seat, Hampton suggests that the third heaven is not inaccessible to humans. Christ in his dwelling place invites the people of God to join him where the regenerative power of the Holy Spirit

heals and restores, as in the words of the prophet Samuel: "He raiseth up the poor out of the dust, and lifteth up the beggar from the dunghill, to set them among princes, and to make them inherit the throne of glory, for the pillars of the earth are the Lord's, and he hath set the world upon them" (1 Sam. 2:8). James Hampton created *The Throne of the Third Heaven* as an interactive instrument of transformation, not only for himself but also for the people of the streets of Shaw and beyond whose voices must surely have filtered into the dimly lit garage as he worked each night in the silence of bright glory.[31]

Chapter 6

Bright Glory

Ma say, "When I gone I ax the Master when he take
me, to send a drop o' rain to let true believer know
I gone to Glory!"

—Mom Hagar Brown, c. 1937

They talks to me through my memory.

—Bennie Lusane, 1988

All that Glitters

Quartz, tin foil, light bulbs, silver; white-
ness, shine, glitter of sunlight on water:
these are visual and material mainstays of
natural beauty, personal protection, and
decoration.[1] But in certain yards these
flashing materials also become invocations
of divinity—of glory, the light of Heaven on
earth—and diamond-star-soul signs of ances-
tors whose brilliant lives continue to shine
in present-day remembrance.[2] For those still
living, flash marks moments of transcendence
and liberation—of crossing over. Brightness
invites immersion in an array of expressions
that can be as expansive as James Hampton's
*Throne of the Third Heaven of the Nations
Millennium General Assembly* (portfolio VI)
or as compact as the core of the crystallized
glass in Estelle Hamler's yard (portfolio I).

The association of reflective materials
with joy and Heaven in African American
yard work tops the dematerializing point of
the pyramid of practices and iconography
discussed in the previous five chapters.

Ultimately, this association emerges from
the ways specific practitioners conceptualize
spirit. But recent scholarship suggests that the
flash of the spirit, in Robert Farris Thompson's
wonderful phrase,[3] also comprises a visible
point of convergence between indigenous
West and Central African cosmologies and
the Christian cosmologies of Kongo-Angola,
and other parts of Africa from the sixteenth
century onward, and of Protestantism and
Catholicism in the American South.[4] Thus,
flash refracts African-inflected perspectives
into the heart and practice of Christianity in
African America. At the same time, Christian
and biblical precepts of the "the way, the
truth, and the light" and "the Light of the
World" infuse older, transatlantic notions of
matter and spirit with fresh purpose.

The persistence of this imagery depends
on a much larger network of associations
than those circumscribed by specific yards or
even specific Bible passages. When Sylvanus
Hudson of Augusta, Georgia, decorated his
house with shimmering curtains made from
linked soda can tabs and contributed his
mosaics of native quartz and mirror chips to

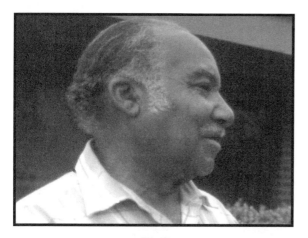

Fig. 6.1
Sylvanus Hudson. Augusta, Georgia, 1987.
Photograph by Judith McWillie.

Looking back to the nineteenth century, the material world offered endless opportunities for those attuned to the significance of flash. For enslaved people, emancipation was certainly a peak event, if not the greatest event, of many lives, and an occasion that called for flash. As one woman remarked, "Grandma told us about freedom. . . . Mrs. Brown's girls . . . they come to the house . . . and said 'you free.' . . . Grandma said that night she melted pewter and made dots on her best dress. It was shiny. She wore it next day cause she was free."[5]

his church (see coda), he attended to the call and response of flash and glory and testified to the deep cultural grounding that African Americans encounter throughout their lives in words, stories, and songs circulating through churches, communities, homes, and popular culture.

Flash imagery and associations of whiteness and brightness with divinity draw on biblical, transatlantic, and personal sources. For example, Joanna Thompson Isom, a remarkable widow with a monthly pension of fifteen dollars who managed to redeem the delinquent taxes on her house and support two grandchildren during the Great Depression, recalled several visions she had while ill with a fever. In one, the

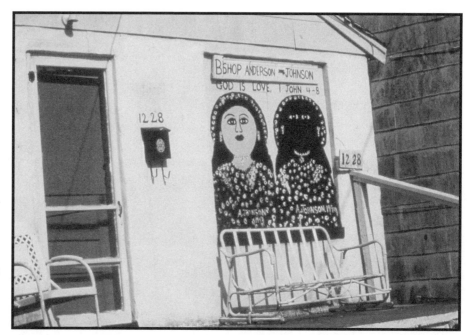

Fig. 6.2
Painting by Elder Anderson Johnson. Newport News, Virginia, 1995.
Photograph by Grey Gundaker.

Lord appeared with a shining light around his head. In another, she saw "angels playing on golden strings stretched all over heaven."[6] When asked by an interviewer from the Federal Writers' Project if there were black angels in Heaven, she replied spiritedly that in Heaven "everything is pure white and everybody is pure an' white."[7] It seems highly unlikely that she equated this type of whiteness with the paleness of Caucasian skin, given her pointed remark earlier in the interview that "white folks bleed when cut just like anybody else and have to stay out of the sun to stay light and preserve their social station."[8] In contrast to pink and tan Caucasians, the whiteness of Heaven erases racial inequality in the glow of sacred light. This attitude comes through in paintings by artists such as Elder Anderson Johnson of Newport News, Virginia, and Sister Gertrude Morgan, a street preacher, artist, and musician from New Orleans. Both represent human skin colors with pink and brown paints, while heavenly robes and wings are pure white, or in the case of Johnson, red, black, and white with spots connoting the twinkle of heavenly light (fig. 6.2).

The whiteness of things in Heaven is one more permutation of their brightness, a quality that clear water, clean linens, fresh paint, chrome, brass, gold, and silver reflect as well.

I Got a Glory

Yard work that involves glittering, sparkling, flashing materials often evokes Heaven, but the glory of Heaven is not necessarily cut off from the world of the living. The idea that Heaven and earth, spirit and matter, interpenetrate charges humans with the responsibility of bringing bits of Heaven to earth if they can. As the artist Bessie Harvey told Judith McWillie in 1987, "The things of God are for here and now." Perhaps this has contributed to the "spiritual reconnaissance," "spiritual poise," "soul equanimity," and "grace of heart" that led the white southern writer Archibald Rutledge to say in the 1930s that he felt inferior to "plantation Negroes" in "the most important thing in life: in matters pertaining to the human spirit, both here and hereafter."[9] In Rutledge's account, Sam Manigo, a tugboat engineer on the Santee River in South Carolina, brought extraordinary flash into being through transformation of his workplace. As Rutledge reported:

> Of all the awful abodes known to me, the engine room on a tiny tugboat on a Southern river is just about the worst. . . . The odors from the little kitchen, from the smokestack, from the engine—these made a combination that rendered reaching shore like an escape. Often did I cross the Santee . . . and always did the sights and smells make me sick. But on a day memorable to me . . . I saw we had a new Negro engineer. He sat in the doorway of the engine room reading the Bible. . . . To have to live in the hole in which he was immured seemed to me the height of torment. But he looked serene. Here was a situation worth investigating.
>
> . . . I immediately noticed that the characteristic odors . . . were no longer there. And the engine! It gleamed and shone. . . . Instead of grime and filth and stench I found beauty and order. And there sat the master of the

transformation, quietly reading the Word.

At first I thought that the engine must be a new one. But Sam Manigo, the engineer, told me that it was the old one. I asked him how in the world he had managed to clean up the old room and the old engine. His words I shall never forget—. . . [He] said, "It is just this way: I got a glory." He meant that making that engine the best on the river was his glory in life; and, having a glory, he had everything. . . . He did one thing better than anyone else in that whole region; and I take it that anyone who does anything better than anybody else finds his glory in that.[10]

Like the artful yards of master gardeners and the handmade objects of master artists and craftspeople, Sam Manigo's engine room was authoritatively professional and practical as well as beautiful. "Got a glory" is more than a remark about an urge to scrub neglected equipment and make it aesthetically satisfying. It is a meticulously chosen indigenous term masking as innocently transparent English. The presence of glory is a cosmological high point, the high noon of strength: a state that combines maximal blessing and intimate personal affirmation and power.[11] In this spirit, the nineteenth-century black seaman George Henry called his first awareness of the wider world in young manhood "just getting in my glory."[12]

Here, as in Manigo's terms, "glory" refers to a special kind of purposefulness whose tangible results not only reflect well on a person's success but actually flash out the possibility of a better world like a beacon. Self-satisfaction is tempered by the watchfulness of a close and discerning community, as suggested by a sign on the side of a church bus that we were fortunate to see in Hattiesburg, Mississippi, in 1988: "Shine, but Don't Show Off."

Rutledge gives another example that sheds light on the same type of transformation of matter from dull to bright in the cause of personal renewal. A man named Morris, he wrote, taught "me that one can bury sorrow in a glory." After Morris's wife left him for another man he directed his anguish into polishing silver and cutlery. "Neither before or since have I ever seen anywhere silver that glistened so, or knives as glittering and keen." Sylvia Cannon (see chap. 5) would probably have agreed with him that the "only sure way out of suffering that I know is to find a glory, and to give to it the strength that we might otherwise spend in despair."[13] This is the precise dynamic that she employed with the sign she made for her yard, "This is a house of the Lord. Don't go pass. This is a house of the Lord. . . ." Nor would the sharpness of the knives have been lost on her.

Conversion

Morton Marks has argued that African American performances of gospel music recapitulate the conversion experiences of the singers.[14] The same may well be true in other expressive forms. For Christians, conversion and acceptance into church membership are events of consummate importance, although the process varies regionally and denominationally. Albert J. Raboteau sees conversion as "literally a turning," a central characteristic of black religion that "represented not just a change

in behavior but *metanoia,* a change of heart, a transformation in consciousness."[15] In the words of Ed McCrorey, "I never went to church in the time of slavery. . . . I now belong to the Big Zion Methodist Church in Chester, S.C. What I feel like when I jine? I felt turnt all 'round, new all over. It was like I never had been, never was, but always is to be 'til I see Him who clean my heart. Now you is teched on sumpin dat I better be quiet about."[16] In the words of healer George Briggs of Union County, South Carolina: "[F]rom [the] bundle of [the] heart [the] tongue speaketh."[17]

Material signs signal that seekers of conversion are set apart and that they desire to change. Raboteau notes that it was the custom of people enslaved on a Virginia plantation to shave their heads "when they became anxious about their souls" and that this is also customary for initiates into Yoruba- and Dahomean-related religions.[18] During the Civil War, Thomas Wentworth Higginson observed material markers of religious conversion in connection with the familiar phrases "de valley" and "de lonesome valley" in spirituals that he recorded:

> Way down in de valley,
> Who will rise and go with me?
> You've heard thern talk of Jesus
> Who set poor sinners free.

"De valley" and "de lonesome valley" were familiar words in religious experience. To descend into that region implied the same process with the "anx-ious-seat" of the camp meeting. When a young girl was supposed to enter it, she bound a handkerchief by a peculiar knot over her head, and made it a point of honor not to change a single garment till the day of her baptism, so that she

was sure of being in physical readiness for the cleansing rite, whatever her spiritual mood might be. More than once, in noticing a damsel thus mystically kerchiefed, I have asked . . . its meaning, and have received the unfailing answer,— framed with their usual indifference to the genders of pronouns,—"He in de lonesome valley, sa."[19]

Perhaps more important than the specific cues involved here—the (material) handkerchief, the (gestural) knot, the (physical and metaphorical) anxious-seat, and the (metaphoric and sung) phrase "lonesome valley"—is the precision this passage reveals in knitting together seemingly disparate media, materials, and rituals into a coherent network of associations. Yards that include small "wildernesses" sometimes include white seats and other chairs beside tall trees, as in the yard of Mary Tillman Smith of Hazlehurst, Mississippi, or, as in Mrs. Hamler's yard, within a dense little thicket. This is appropriate since, in the old-time religion, seekers who hoped to "come through" were directed to pray at tall trees, in thickets, and in the graveyard.

Raboteau's discussion of the conversion experience in James Baldwin's novel *Go Tell It on the Mountain* pays careful attention to the arrangement of objects that the young hero, John Grimes, sees on the family mantelpiece: "photographs, greeting cards, flowered mottoes, two silver candlesticks that held no candles, and a green metal serpent poised to strike."[20] The greeting cards stand for "the seasons, the passage of years, and the photographs, the history of John Grimes's people," with the threatening

serpent in its midst. Together, these material signs represent the "spiritual, psychological, and emotional distance" that Grimes must travel on this day of his rebirth.[21] Baldwin's detailed description of the mantel and Raboteau's interpretation of it vividly show the integral relationship of constellated objects, great and small, indoors and out, to the intertwined cultural and religious history of African Americans.

Some yards elaborate similar themes of overcoming danger and sin through conversion. Mary Tillman Smith surrounded her yard with paintings of Jesus and inscribed messages about the meanings of religious experience in her life. Dilmus Hall of Athens, Georgia, created a concrete tableau in his yard, entitled *The Devil and the Drunk Man,* and used it as an occasion to recite parables to passersby, such as this one recorded in 1984 (see portfolio IV and plate 12).

Light unto the Tomb

When . . . [whites] say, "The Lord gave, and

the Lord hath taken away," [they] are usually

thinking of the person who has lived and died;

but a Negro would mean the life, the vital spark.

—Archibald Rutledge, 1938

Along with images from the Bible and conversion, the grave is a wellspring of flash. Shortly after the Civil War, a northern traveler recorded a song sung by the black workers in a Richmond, Virginia, tobacco factory that contained this phrase: "Bright sparkles in de church-yard give light unto de tomb."[22] The traveler remarked that these

words had "the incoherence of ignorance," yet they communicated the "intense yearning" of which the song was born. However, although "yearning" may accurately have described the feelings that the song expressed, its words were more coherent than the recorder supposed.[23]

African American graveyards must have looked just this way in the moonlight and glow of pitch pine torches during nighttime funerals.[24] Some enslaved people preferred to bury their dead at night, but some planters also required it because they were unwilling to sacrifice valuable daylight hours of labor in the fields.[25] Not only did the moon, stars, and torches sparkle through the trees surrounding old-time burial places, but the churchyards and graveyards themselves sparkled day and night. From at least the mid-nineteenth century through the 1960s, many rural African American grave mounds contained glittering shards of broken glass, inverted bottles, bits of tin, mirror, and shell, and, to light the way to the other world as brightly as possible, oil lamps and globes, some broken, some left intact (see portfolio II, figs. 35, 36). Although geographical and local variations await mapping, evidence of bottles and broken and shiny items on graves exists in virtually every place where an appreciable black population lived. In 1898 Susan Showers remarked on graves "decorated with bits of broken glass and china and old bottles, a survival, I fancy, of an old heathen custom brought from Africa, for I have heard the missionaries from Africa allude to it."[26] In a well-known passage, Ernest Ingersoll described African American grave decoration in the late nineteenth century near Columbia, South Carolina:

When a negro dies, some article or utensil, or more than one, is thrown upon his grave; moreover it is broken . . . nearly every grave has bordering or thrown upon it a few bleached seashells . . . Mingled with these is a most curious collection of broken crockery and glassware. On the large graves are laid broken pitchers, soap dishes, lamp chimneys, tureens, coffee cups, sirup jugs, all sorts of ornamental vases, . . . teapots, . . . plaster images, . . . glass lamps and tumblers in great number. . . . Chief of all of these, however, are large water pitchers; very few graves lack them. . . . The negroes themselves hardly know how to account for this custom. They say it is an "old fashion."[27]

Within the last twenty years, resemblances between African American grave decoration and African practices have been discussed in some detail, but awareness of these resemblances is hardly new. For example, another observer in Columbia, South Carolina, contemporary with Ingersoll, compared broken china on black American graves with E. J. Glave's description of the grave of a Congo chief: "The natives mark the final resting-places of their friends by ornamenting their graves with crockery, empty bottles, old cooking-pots, etc., all of which articles are rendered useless by being cracked, or perforated with holes."[28] Today the motif of breakage also appears in commercially produced items like "broken wheels" made of Styrofoam that sometimes accompany sprays of real or artificial flowers at the funeral and on the grave.[29]

An African American missionary, Alexander Priestly Camphor, who was born on a farm in Alabama, described passing the grave of a powerful chief in Liberia early in the twentieth century:

On the route to the mountain, about midway, is the grave of Nawvlee, one of the old and powerful kings of the Gibi people. It is marked by a huge granite rock and occupies a plot of ground enclosed by bamboo palings. Within the enclosure are placed articles of various kinds, such as broken pots, plates, pipes, bowls, jugs, beads, coral, bits of glass, chinaware, toy statuary and an old nickel-plated clock. On the center of the grave stands a large demi-john of palm wine. . . . While other and unmarked graves are scattered about the towns and half-towns, this one lies in a secluded spot away from the roadside, in the forest, apart and alone, bearing abundant evidence that he who lies there is still revered by a grateful people.[30]

A procession encircled the grave to communicate "that they may be rejuvenated by new hope and contact with his disembodied spirit," also offering a white chicken and a dish of white rice. The chicken pecking the rice was a sign that the offering was accepted.[31]

In New Orleans graveyards, blacks and whites alike arranged abundant materials. According to *Gumbo Ya-Ya,* a compilation of Louisiana folklore: "[I]n Louisiana graveyards the decorating is unrestrained. Ground plots are covered with many-colored shells or bright bits of broken glass. . . . Conch shells, painted pastel shades, perhaps gilded, silvered, even painted a doleful black, a not ineffective touch, as do china dogs, pig banks . . . and vases of every conceivable kind, size, shape and color."[32]

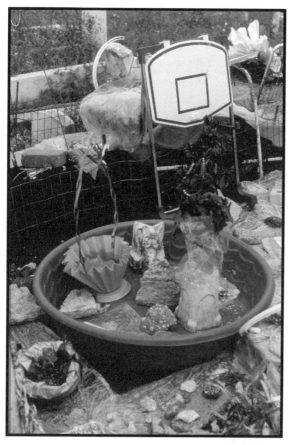

Fig. 6.3
Detail of a grave in central New Orleans, 1988.
Photograph by Judith McWillie.

More recently, a burial plot in New Orleans's Potters Field was enclosed with a white wire fence and covered with shining objects that included a wading pool that would catch rain water (fig. 6.3). Usually, the bright colors on graves come from flowers and the shine and flash from the metallic foil paper that florists use to cover flower pots. As Thompson has pointed out, and as our fieldwork confirms, this foil is usually reversed so that the silver side replaces the green side facing outward.[33] This not only makes the surface of the foil brighter but also brings it into the orbit of references to water, the Jordan River over which the Christian soul crosses to Heaven, and in earlier times the passage over, under, and across the water of the Atlantic ocean, the Niger River, the Bantu Kalunga water, and a host of local sacred springs, streams, and lakes.

In regions of the United States where it is customary to cover graves with concrete slabs, some like those in figure 6.4 (graves from Elloree, South Carolina, James Hampton's birthplace) have been painted silver and inscribed with rippling waves. A

Fig. 6.4
Metallic paint and inscriptions on graves. Elloree, South Carolina, 1988. Photograph by Judith McWillie.

grave near Santee, South Carolina, was molded into the form of an inverted boat. In *Let Us Now Praise Famous Men,* James Agee mentioned seeing these kinds of grave mounds, which the rain eventually washed down to flatness.[34]

Ancestral Presence

The Jordan River is a two-way conduit. The believer "gets over" as his or her soul gains a seat at God's table—like the silver table and chairs that Reverend Kornegay made for his yard (fig. 6.5). Guidance also comes over or down from the "other side" to the seeker, aided by prayer places like those in some yards: the separate, wilder areas that are located across some dividing line such as the driveway and that contain bright, flashing materials alluding to past generations who have passed through the threshold of the graveyard to Heaven.

Such places indicate that although it is important to show respect at the time of the funeral, acknowledgment of those who have passed on as members of the community should, ideally, continue. As the memory of the personality of the deceased fades over the generations into the more generalized status of ancestor, the potential for power can intensify to that accorded to a group.

Among the Yoruba, Dahomeans, and followers of related religions in the Americas, ancestor status does not come at death automatically. Rather, over time, the qualities of especially worthy individuals gradually merge into a larger configuration of powers. Karen McCarthy Brown has eloquently described the way that African (mainly Dahomean) beliefs about ancestors

Fig. 6.5

God's table in the yard of the Reverend George Kornegay. Brent, Alabama, 1992. Photograph by Judith McWillie.

flowered inside, and transformed, aspects of Catholicism into Haitian Vodou:

> The movement from French to Creole, from Catholicism to Vodou, from the soft sing-song clapping of European Christian liturgy to the energetic contrapuntal clapping that accompanies African rhythms also marks a change in imagery. Images of transcendence are replaced by images of family. The awe-inspiring distance between a Catholic heaven and earth transmutes to an image of a bloodline continuous throughout time, one running along

the spine of Danbala [the snake-rainbow deity] and extending further back in time than memory can reach. The image of a single savior figure, at once human and divine, gives way to a family continually present in the form of the ancestors and the spirits.[35]

Brown also mentions that in Vodou in Haiti and Brooklyn, water-mirrors "can be seen as a route even more direct than divination to the wisdom of those who have gone before."[36]

In the yards where we have documented commemorations of ancestors and homage to the family dead, the image of the family has not so much displaced as joined the image of Jesus as savior, with the Holy Spirit sometimes flexibly transforming into the more generalized "spirit" that communicates messages from God. Ancestors and spirit guides and guardians partake of this spirit to a greater degree than humans, but humans "get in the spirit" through worship, prayer, and the grace of God.

Underpinning commemorative sites are notions of transformation and rebirth in which Christian and West and Central African concepts of the other world and the eternal life of the soul mutually reinforce each other. But some African American yards also diverge from European and Euro-American Christian iconography, especially with respect to inversion, breakage, conduits like metal pipes, and twisted wood. Although there is nothing inherently "unchristian" about these materials, as we mentioned in chapter 2, they are more likely to cause talk than, say, a statue of Jesus or Mary, and their history is surely transatlantic. For example, among the Kongo-Angola peoples, the ancestors inhabit a world of the dead that

inverts that of the living. Noon in our world is midnight for the dead, and the dark skin of the living becomes white on "the other side."[37] From their worlds under the waters, among the tangled roots of the wilderness, the ancestors stand behind the activities of the living, backing up their descendants against adversaries and jealously demanding respect.

In the United States, ancestors go by a number of names in everyday speech: "the old folks," "slavery-time people," "people back then," "my people," "the people," "old-time folks." Hints of ancestral disturbance and backing for the living occur often in African American folklore, even as enforcement for "good manners." For example, Newbell Niles Puckett pointed out that the injunction to children not to "sass" old people "may at one time have had a real meaning, since the old folks were 'almost ghosts,' and hence worthy of good treatment lest their spirits avenge the disrespect and actually cause bad luck to the offender."[38]

It is hard to say whether any of the yard makers we have come to know subscribe to this view, because the same reasons that make it unwise to offend the ancestors also make it unwise to talk about the trouble they can cause. However, our sense is that the makers of yards who refer to ancestors explicitly do so to honor them without reservation as unsung heroes.

Not only is it important to honor the dead but also, at one's own death, to be buried on ancestral ground.[39] The slave trade brutally foreclosed this possibility for the African captives shipped to the New World. Ancestral connections had to be reestablished on alien terrain. The burial-like areas in some African American yards contribute to this process. While the contents of these areas

of the yard contain the same silvery water-like materials, mirrors, and broken vessels that occur in some African and U.S. graveyards, the yard is more spacious and free from the lawnmowers and intruders that disturb objects on actual graves. The yard is also part of the home ground of a family. Indeed, the representation of the bloodline sometimes appears on a grave or a memorial in a yard in the form of a red ribbon, a red fluid, or a red wheel. Bennie Lusane made a "loveseat" with a vial of "blood" attached to the back. (The notable preacher and author, Dr. Wyatt Tee Walker, also used this phrase in the title of a chart, "Black Sacred Music: Diagram of a 'Blood Line,'" thereby memorializing the ancestry and familial connections within a tradition that extends from the cries and moans of early "Slave Utterances" to "Contemporary Gospel and Freedom Songs.")[40]

Florence Gibson of Savannah, Georgia, paired two identical sets of the biblical lion-and-the-lamb couple by her front door (see plate 6), asserting her home as a zone of peace and fulfillment. The theme of a vision of Heaven ran through her yard as she

Fig. 6.7
Objects in the "North Pole" section of Florence Gibson's yard. Savannah, Georgia, 2003. Photograph by Judith McWillie.

Fig. 6.6
Florence Gibson. Savannah, Georgia, 2002.
Video still by Judith McWillie.

dressed it with sparkling silver. She attached a mirror and silver-painted objects to the outside of the house and suspended them from clotheslines. She placed a set of aquariums in graduated sizes along a silver-painted base and subdivided the yard into two sections, selecting objects accordingly (plate 7). The south side of the house she called the summer side. Its colors were varied and bright, and its liveliness more than metaphoric because here Mrs. Gibson grew flowers, raised (live) rabbits, and arranged colorful pairs of animals (statues) like the ones from Noah's Ark. She called the north side yard "The North Pole" (fig. 6.7). Here, heavenly silver dominated, joining the theme of Heaven to

Fig. 6.8

This small whitewashed marker was in the center of the
grave enclosure of Mother Ella Riley in Holley Hill,
South Carolina. It was surrounded by fencing and pipe
fittings that had the personal effects of the deceased
(hats, eyeglasses, clothes) wired to them.
Grave assemblage composed by Asberry Davis, early 1990s.
Photograph by Judith McWillie, 1994.

red rose for a penny. Thus, the phrase called to mind a whole era and the people who lived then.[41]

References to the ancestors in both African American burial landscapes and yards often include allusions to the sun. In Holly Hill, South Carolina, the grave enclosure of Mother Ella Riley, created by Asberry Davis, was filled with her belongings attached to chicken wire and pipe fittings (see portfolio II, fig. 14). A small white headstone was placed in the center of the enclosure with a white-painted wheel attached (fig. 6.8). The circle in the center of the marker suggests a rising or setting sun, a motif that recurs as a marker of thresholds to the other world, especially the Gate of Heaven.

Both Gyp Packnett of southwestern Mississippi and the Reverend George Kornegay of Brent, Alabama, set aside areas in their yards to commemorate their ancestors and marked the entry to these areas with archways and glistening wheels/ suns made from hubcaps, in the case of Mr. Packnett, and bicycle wheels, in the case of Reverend Kornegay (fig. 6.9). Now in his mid-eighties, Reverend Kornegay began working on his yard show in earnest in the 1970s after he retired from pastoring several churches. His relatives' houses and mobile homes surround his property, and he was building a new home for his daughter on the edge of his front yard when we interviewed him in 1991 and 1993. His yard/showplace thus served as a kind of visible center for the family. He began the yard project with a pointed slab and a quotation from the scripture: "On this rock I will build my church." Near the rock a vessel-laden table (fig. 6.5) includes a telephone off the hook, poised to transmit the word of God.

that of Christmas, the wintertime event when Jesus came to earth.

Behind the house she set aside a small enclosure that she labeled "PENNY ROSE MEMORIAL GARDEN" in silver stick-on capital letters on a red sign board. She buried beloved animals there when they died and explained that she chose the name because she remembered a time long ago when she was able to buy a beautiful long-stemmed

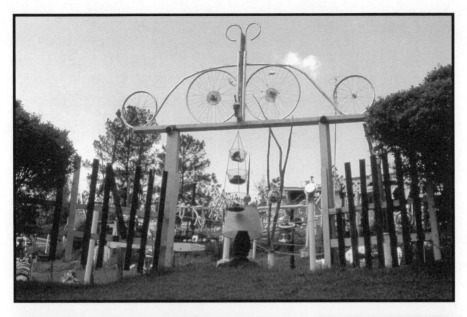

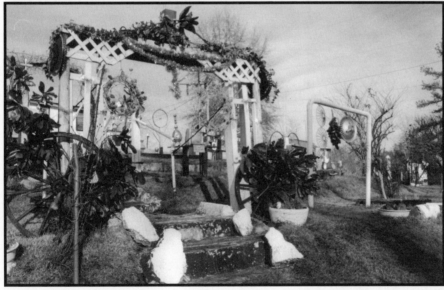

Top left: Fig. 6.9
Archway leading to area of yard set aside to honor ancestors. Rev. George Kornegay's residence, Brent, Alabama, 1992. Photograph by Judith McWillie.

Left: Fig. 6.10
Entrance to "Mount Calvary" with Christmas decorations at Rev. George Kornegay's residence. Brent, Alabama, 1993. Photograph by Grey Gundaker.

Reverend Kornegay calls the gate in figure 6.10 "Mt. Calvary." It represents one of the seven holy mountains into which he divided the site, and it contains two crosses, four red wheels, and two wreaths of barbed wire that read as crowns of thorns. The painted red magnolia leaves are part of the arrangement all year long, but ivy and gold tinsel are Christmas decorations added seasonally. The stairs that pass through the gateway lead up to Reverend Kornegay's hand-built house. Therefore, visitors must move through red and white emblems of Jesus' crucifixion and resurrection as they climb upward.

Just to the right of the Mt. Calvary gate, and thus to the right hand of God, Reverend Kornegay created an area he named Potters

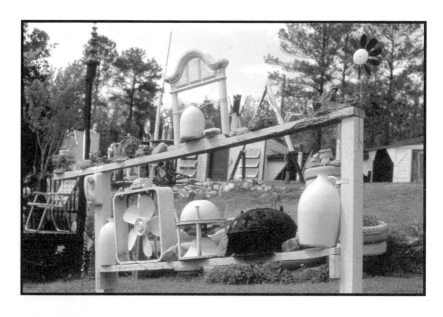

Right: Fig. 6.11
Potters Field, a graveyard commemorating the unnamed dead, at Rev. George Kornegay's residence. Brent, Alabama, 1992. Photograph by Judith McWillie.

Below: Fig. 6.12
A rebus for the phrase "the Acts of the Apostles" at Rev. George Kornegay's residence. Brent, Alabama, 1993. Photograph by Judith McWillie.

Field, a graveyard commemorating the unnamed dead (fig. 6.11). Most of the ensembles in this area are painted mourning colors of silver or white, and many of the objects are the same as those found on traditional African American burial mounds: lengths of pipe, overturned and perforated pots, stones, shiny hubcaps, and shells. Throughout Potters Field, material signs honor the memory of slavery-time dead. An arch over a white jug caps a structure that includes a wide array of commemorative elements: a wooden triangle/trinity with a telephone in its center, a silver chain, stones that Reverend Kornegay described as dating from the creation of the world, and an over-turned black pot, an object that was both part of enslaved peoples' daily world of labor and part of their religious observances: an overturned pot was said to contain the sound of secret worship so that the slaveholders could not overhear.

Elsewhere in Reverend Kornegay's yard, a decorative silvery cluster of axes forms a rebus for the phrase "the Acts of the Apostles" (fig. 6.12). The phonological similarities

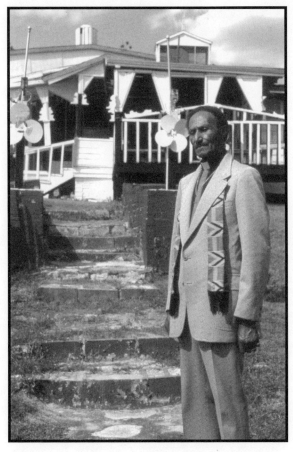

Fig. 6.13
The Reverend George Kornegay. Brent, Alabama, 1992.
Photograph by Judith McWillie.

Read through the lens of Kongo cosmology, which complements rather than contradicts Christian interpretations, the image of the wheel as a map of the soul's course links the taking away of sin with the turn of the wheel of the earth, and by extension the soul's movement below the horizon into the spirit world, like the sinking of the setting sun. This complementarity is built in to this version of the familiar spiritual "Roll, Jordan, Roll":

> I want to go to hebben when I die,
> Roll, Jurdan, Roll!
> If ye' can't cross Jurdan, ye' can't
> go roun'
> Roll, Jurdan, Roll!

The association of rolling movement with the taking away of sin or negativity of any kind also echoes Joshua 5:9: "And the Lord said unto Joshua, this day have I rolled away the reproach of Egypt from off you. Wherefore the name of the place is called Gilgal [A Rolling] unto this day" (see plate 4).

Gyp Packnett's yard contains three kinds of commemorative areas. The driveway and periphery of the property are lined with objects that honor Mr. Packnett's father, a farmer, including his wagon wheel, and plow. A skull with flashing eyes made from silver balls recalls a familial responsibility that Mr. Packnett assumed from his father and grandfather: that of butchering steers and hogs. These objects cue recollection and respect, but they are not funereal; thus they contrast with the area around the carport. Here Mr. Packnett composed two ensembles that specifically commemorate the life of his late wife. He used mirrors, a seat, shoes, and toys alongside sprays of artificial flowers and a cross made especially for display on a grave. The third area in the yard surrounds

ask/axe/acts invite word and eye play. Also, the qualities of one medium—the steel of the axe head—point toward the acts/axe of the apostles who were prototypical "Christian soldiers." Wheels provide the material counterparts to countless biblical references to prayer, progress, and exoneration in spirituals and songs. The final verse of "Mary Wore Three Links of Chain" repeats three times the phrase "Jonah made a wheel, and he made it on the ground," followed by "The wheel turned over and the earth turned around. All my sins were taken away, taken away."

what Mr. Packnett calls his "family tree," a large cedar. This tree is "tied" in chains and laden with heavy weights that, according to Mr. Packnett, are reminders of the burden of slavery. His ancestors "took the weight and came on through though they were burdened down." The tree not only honors the ancestors but portrays and invokes them by making them a home in the family compound. On fence posts that enclose the tree Mr. Packnett mounted spirals of steel. An airborne chair attached to the fence calls to mind the words of a profound spiritual: "I'm going to fly, I'm going to fly, I'm going to fly to my Lord and SIT DOWN."[42] Heaven is not only the home of God and the ancestors but also a place of release for the physically exhausted.

These themes continue through the arrangement of chairs Mr. Packnett made on the other side of the tree, facing the street where he portrayed the transcendent outcome of his ancestors' earthly trials, stacking chairs on tires to show the places reserved for them and for himself and his late wife around the throne of God. Entering this part of the yard means passing through a gate surmounted by a wheel under an arch made from the head of an iron bed. The wheel represents the face of the resurrection, the rising sun. Mr. Packnett identified this gate as the entrance to the burial ground as well the other world, for to reach Heaven one must pass through the grave.

Creating such a place for the ancestors recruits their backing for the living, extending the idea of a spiritual and ethical safety zone into a more overt political statement. Gravelike areas display family roots on the property and show that the occupant has a right, even an obligation, to stand his or her ground and have a say in community life. Objects such as sewing machines, tools, and pots associated with the skills of the deceased, also collapse time and space. They imply that the spirit world is not distant but, rather, that it is another dimension of the here-and-now located just on the other side of the water, just under its surface, through the threshold, and that the deceased's skills are part of a legacy that touches the living. Further, some arrangements make room for ancestors, not just as memories but as presences that range in palpability for the yard's maker from a vague sense of nearness to intense visionary encounters. Thus, according to his sister-in-law Carrie Robuck, Bennie Lusane named special rocks in his yard after biblical prophets and deceased relatives, and at night he would walk around the yard calling their names and talking with them. When asked about this, he smiled, nodded, and said, "They talks to me through my memory."

Facing toward Glory

Another aspect of burial that relates to yards has to do with spatial orientation. It, in turn, creates connections between the movement of sparkling heavenly bodies, especially the sun, and the directions of the wind and four corners of the world. Throughout the country, bodies were, and are, typically interred facing East, like those of many European Americans, but African Americans in the Sea Islands added to this convention a strong injunction against burial "crossways of the world," which was reversed for victims of unnatural death, who were buried on a north-south axis.[43]

As the injunction against burial "crossways of the world" implies, there are also

resonances between the brightness of glass, mirrors on graves, the movement of the sun, the grave as crossroads between worlds, and the posture of the body of the dead in the grave.[44] This posture makes the body the axis of the four cardinal points in space and orients the movement of the soul to them (as does the figure/crossmark made of small stones that Bennie Lusane positioned front and center of his yard). In this way the body in the grave reiterates the emphasis on the four corners of the yard and the association of mastery and liberation with movement in all directions. For example, Henry George Spaulding recorded this spiritual in the years before the Civil War:

> I'd a like to die as Jesus die
> An' he die with a freely good will
> He lay in the grave
> An' he stretchy out his arms,
> Oh Lord, remember me.[45]

Higginson recorded similar phrasing in this spiritual:

> I walk in de moonlight, I walk in
> de starlight,
> To lay dis body down.
> I'll walk in de graveyard, I'll walk
> through de graveyard,
> To lay dis body down.
> I'll lie in de grave and stretch out
> my arms;
> Lay dis body down.[46]

A powerful prayer that the novelist and planter's daughter Julia Peterkin included in a camp-meeting scene in her novel *Green Thursday* maps the cosmological four cardinal points by means of body posture. The phrase "face like looking glass" suggests mirror-like stillness on a face that has been frozen by death into a mask. Other phrases

orient the body to the twin faces of the other world, the rising and setting sun:

> O Gawd,
> I know de time ain' long
> When my room gwine be lak a
> public hall
> My face gwine be lak a lookin'-glass. . . .
> Dese ol' feet'll be tu'n todes sunrise-side,
> An dis head'll be tu'n toes de wes'. . . .
> De life ob a man is same lak e pat' ob
> de sun.
> Een 'e mawnin 'e rise up bright een
> de east . . .
> But de time haffer come we'en
> 'e strengt' gwine fail.
> 'E ceasted f'om climbin' higher.
> 'E sta't fo' drap todes de wes'.[47]

Often, the head of the deceased lies at the west in order, it is said, to face Gabriel's horn when it blows the call to Resurrection.[48] However, other burials inter the head to the east, aligned with the star that appeared in the east at the Savior's birth.[49] An account of the death of an elderly woman included her last wish: "She made him promise to bury her wid her head to de risin' sun and her feet to de wes,' so dat when she rise she can walk straight into de glory ob de Lawd."[50] Sylvia Cannon remembered a funeral song from her youth that contained the lines: "Star in the East en star in de west, I wish a star was in my breast. Mother is home, sweet home"[51] The artist David Butler pulled together this venerable network of associations linking the soul, water, stars, and ancestral protection in the screens and whirligigs cut from sheet metal with which he buffered his house in Louisiana, explicitly connecting his central motif, the "starfish" with the soul.[52]

Similar phrasing about the body as a crossroads and the idea of the facial

brightness and stillness of the dead also figure in blues lyrics, like this recurring, ironic stanza sung by Robert "Guitar" Welch:

> Graveyard ain't nothin, Lord, but a great
> big lonesome place,
> You can lay flat on your back, little
> woman, an' let the sun shine in
> your face.[53]

A variant that extends to the ideal east-west orientation of the house and yard is the famous phrase: "The sun's gonna shine in my back door someday."[54]

All these images and phrases cycle through yard work in the principle of Mastery of All Directions, a premise echoed in African and African American dance as "up, down, all around," the lower and the deeper moves counterpoised with jumps to touch the sky.[55] To truly own a space one must be thoroughly knowledgeable about its every dimension. Hyatt quotes a spiritual healer's recollection of his grandfather, Bill Jones, saying, "I can keep every bit of the ground I stand on" because "I have traveled the four corners of the world." He also quotes another's instruction that those who wish to travel must ask God to give them a "directional star" in their minds.[56] Kongo scholar Fu Kiau Kia Bunseki told Robert Farris Thompson that for members of the Lemba Society, standing on the cruciform cosmogram, "meant that a person was fully capable of governing people, that he knew the nature of the world, that he had mastered the meaning of life and death."[57]

This principle extends from built-in crossroads, grave-like thresholds to other realities, juxtapositions of "cultivated" and "wild" space, emphasis on the four corners of the yard, and signs of height and depth like trees to the more compact signs in yards

such as whirligigs, wheels, umbrellas, and lighthouses. The circling beams of lighthouses mediate between water and land.[58] They also flash guidance to help seekers avoid rocks and ditches on their paths. Ultimately, they imply the all-seeing-flashing eye that encompasses everything. But even the ubiquitous horseshoes hung over the doors of black and white homes had to have the open end pointing up or "the luck will fall out."[59] (Tin foil covering a horseshoe made it more effective.[60]) The shine of reflective surfaces, like the glistening purity of white stones and flowers in the yard of Jackie Jones, also bears witness to omni-directional mastery through personal and spiritual cultivation. A yard that is polished throughout testifies to significant accomplishments within the larger context of the person's blessings. As James Lucas implied during an interview in the 1930s, silver paint is a preservative, but one that aided the survival of more than the mere material to which it was applied: "I paid $800 dollars for my house but if I'd'a thought I'd'a got one wid more land. I wanted to put an iron fence around hit an' gild hit wid silver paint. Den when I'se gone hit woulda been dar."[61] This durability was also the rationale for using a silver dollar as a proxy for the petitioner in conjure: the silver circle is not only complete; it also *endures,* whatever happens to the other materials used in the ritual.[62]

Although Puckett and many others have written that a silver dime was a highly regarded protective device, at least one of his informants, Frank Dickerson, said that "only a silver ball would do the work."[63] Certainly, silver balls continue to appear in yards, not just in the form of gazing balls—a common garden decoration for all ethnic groups—but also in balls elevated on poles. For example,

in a Virginia yard a silver ball overlooks the entrance to the backyard like a sentry. This yard was also surrounded by silver hubcaps raised on red columns and filled with white conch shells. Another Virginia yard contained a scarecrow holding an enormous ball of sparkling aluminum foil at least eighteen inches in diameter. This is like a giant version of the tinfoil core of Charlie Leland's luck ball, which, according to Puckett, "represent[s] the brightness of the little spirit who was going to be in the ball."[64]

One of the ways to see that this mastery was as important in the past as it is today is to look at the actions of the ultimate masters, God and Jesus. Thus, the words of spirituals transcribed in the nineteenth century describe King Jesus riding up and down the cross on a horse, a sign of elevated status:

> Jesus rides a milk-white hoss,
> No man can hindah!
> He rides him up an' down de cross,
> No man can hindah![65]

The Reverend Charles C. Jones recounted, in Gullah cadence, the vision of the elderly Daddy Jupiter who saw "de blessed Jesus, wid de print en de nail een eh han an eh foot, an wid de star on eh head."[66] Jesus in his divine personas as "the light of the world" and "the lamp unto my feet," along with the Holy Spirit, reveal the most fully resolved potentials of existence. When artists such as Carroll Kenny, Reverend Kornegay, Bennie Lusane, and Mary Tillman Smith create paintings and sculptures of Jesus for their yards, they employ bold, abstract shapes, brightness, and shine. Quite consistently the "body" is a wheel, square, or other directional sign, while the face is a light and sometimes literally a light bulb. These features hold the promise of another

world through polished, implacable countenances that are immune to negativity and transitory affliction. Again, there are parallels with African and African American performance. As Thompson has written: "To dance or perform athletic or jurisprudential wonders with a cold face is to enact the force of reason. The human condition is momentarily led to points of calm, there to find sources of renewed illumination."[67]

More simply said in the spirituals, but just as eloquently, Jesus endured the crucifixion with implacable calm: "He never said a mumblin' word."

Glorify My Son, That My Son May Also Glorify Thee

The words "Glorify My Son, That My Son May Also Glorify Thee, Amen," painted in red enamel on a diamond-shaped mirror and mounted on the inside of the front door, address everyone who enters or leaves the Seventh Church of Christ in Freeport, New York (fig. 6.15). The lifework of Elder Samuel

Fig. 6.14
Delores Smith. Freeport, New York, 2002.
Photograph by Grey Gundaker.

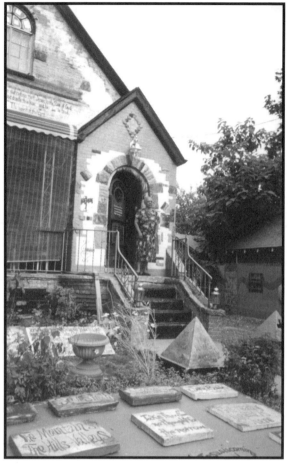

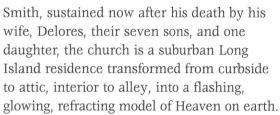

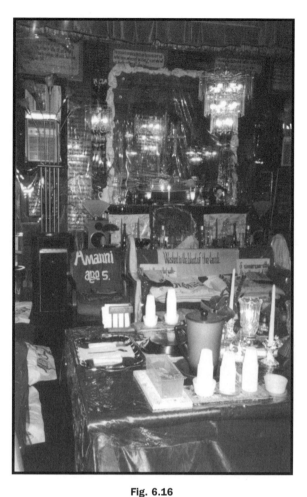

Fig. 6.15
The Seventh Church of Christ, created by Samuel Smith and sustained by Delores Smith. Freeport, New York, 2002. Photograph by Grey Gundaker.

Fig. 6.16
"The Lord's Table" in the Seventh Church of Christ, created by Samuel Smith and sustained by Delores Smith. Freeport, New York, 2002. Photograph by Grey Gundaker.

Smith, sustained now after his death by his wife, Delores, their seven sons, and one daughter, the church is a suburban Long Island residence transformed from curbside to attic, interior to alley, into a flashing, glowing, refracting model of Heaven on earth.

Passing through a yard paved in stones inscribed with biblical texts ("I am Black," Song of Sol. 1:5), prayers, and testimony, visitors and members proceed between paired golden pyramids ("A Prince Shall Come Forth from Egypt"), mount golden stairs, and

enter a small foyer painted blue, red, and royal purple. Beyond this threshold, one end of the main room is set aside for reading and contemplation of those who have passed before, with special seats and a table for the Book of God's Remembrance. In the middle of the room, the Lord's Table, covered in red satin and golden ribbons, is set for a daily meal with sparkling crystal, brass candlesticks, and a pitcher of pure water (fig. 6.16).

Beyond, the altar dizzyingly disconnects from earthly bonds through the flicker and

refraction of crystal chandeliers, candles, a wall of diamond-shaped mirror tiles inscribed in red with Bible passages, and unrolled scrolls suspended like banners from the ceiling throughout the room (fig. 6.17). Because all the walls and pews have satin draperies with clear plastic sheeting layered over them, there is no space in the room without sparkle and no way to leave without sensing the love that went into bringing Glory into being.

Fig. 6.17
Sanctuary entrance to the Seventh Church of Christ, created by Samuel Smith and sustained by Delores Smith. Freeport, New York, 2002. Photograph by Grey Gundaker.

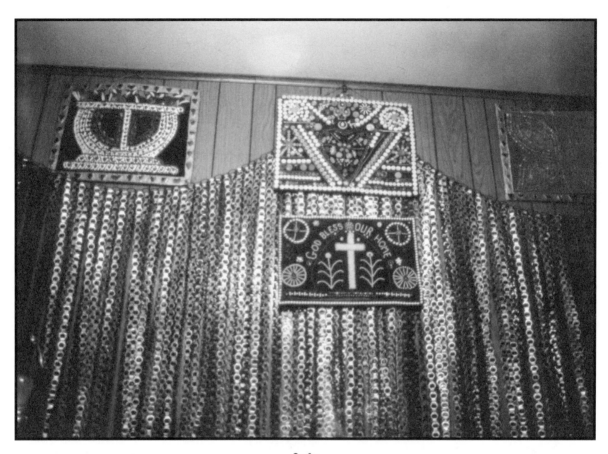

Coda
..........
Interior of Sylvanus Hudson's house. Augusta, Georgia, 1987.
Photograph by Judith McWillie.

Notes

Portfolio I

1. The accounts of the yards of Estelle Hamler, Sam Hogue, and Olivia Humphrey in this section are derived from interviews conducted by Gundaker from 1987 through 1997.

2. Anne Thomas, personal communication to Gundaker, Oct. 1989.

Chapter 1

Parts of the section on the Bowens family in this chapter first appeared in Judith McWillie, "Total Relay: Conversations with Robert Farris Thompson," *The Arts Journal* (Winston Salem, N.C.), vol.15, no. 10, (summer 1990): 4–7; and in Judith McWillie, "Art, Healing, and Power in the Afro Atlantic South," in *Keep Your Head to the Sky: Interpreting African American Home Ground,* ed. Grey Gundaker (Charlottesville: Univ. of Virginia Press, 1998), 69–70. Reprinted with permission of the University of Virginia Press.

Epigraph: Bessie Jones, *For the Ancestors: Autobiographical Memories,* ed. John Stewart (Urbana: Univ. of Illinois Press, 1983), 84.

1. These terms derive from our own conversations with practitioners and recur too frequently to attribute to specific individuals. "Something I enjoy doing" is most common.

2. For example, Richard Westmacott has used the first two of these terms; see his "Pattern and Practice in Traditional African-American Gardens in Rural Georgia," *Landscape Journal* 10, no. 2 (1991): 87–104; and *African-American Gardens and Yards in the Rural South* (Knoxville: Univ. of Tennessee Press, 1992). On yard shows, see Robert Farris Thompson, *Face of the Gods: Art and Altars of Africa and the African Americas* (New York: Museum for African Art, 1993), 76–95. On "environments," see D. F. Ward, ed., *Personal Places: Perspectives on Informal Art Environments* (Bowling Green, Ohio: Bowling Green State Univ.

Press, 1984); John Beardsley, *Gardens of Revelation: Environments by Visionary Artists* (New York: Abbeville Press, 1995); and Roger Manley, Mark Sloan, and Jonathan Williams, *Self-Made Worlds: Visionary Folk Art Environments* (New York: Aperture, 1997). On "dressed yards," see Grey Gundaker, "Tradition and Innovation in African American Yards," *African Arts* 26, no. 2 (1993): 58–71, 94–96. For previous research on African American yards, see Lizetta LeFalle-Collins, *Home and Yard: Black Folk Life Expressions in Los Angeles* (Los Angeles: California Afro- American Museum, 1987); Robert Farris Thompson and Joseph Cornet, *The Four Moments of the Sun: Kongo Art from Two Worlds* (Washington, D.C.: National Gallery of Art, 1981); and various writings by Robert Farris Thompson, notably *Flash of the Spirit: African and Afro-American Art and Philosophy* (New York: Random House, 1983); "The Circle and the Branch: Renascent Kongo-American Art," in *Another Face of the Diamond,* ed. Judith McWillie and Inverna Lockpez (New York: INTAR Latin American Gallery, 1988), 23–56; and "The Song That Names the Land: The Visionary Presence of African American Art," in *Black Art Ancestral Legacy: The African Impulse in African-American Art,* ed. Robert V. Roselle, Alvia Wardlaw, and Maureen A. McKenna (Dallas: Dallas Museum of Art, 1989), 97–141. Also important are Grey Gundaker, "African American History, Cosmology, and the Moral Universe of Edward Houston's Yard," *Journal of Garden History* 14, no. 3 (1994): 179– 205; and Grey Gundaker, ed., *Keep Your Head to the Sky: Interpreting African American Home Ground* (Charlottesville: Univ. of Virginia Press, 1998). In addition, see the following writings by Judith McWillie: "An African Legacy in the Yard Shows of the Georgia Piedmont" (Department of Art, Univ. of Georgia, n.d., photocopy); and "Art, Healing, and Power in African American Yards," in *Head to the Sky,* ed. Gundaker, 65–92. Works that focus on African American gardening traditions

include Westmacott, *Gardens and Yards;* and Elise Eugenia Lemaistre, "African Americans and the Land in Piedmont Georgia from 1850 to the Present, with Prototypes for Reconstruction and Interpretation" (M.A. thesis, Univ. of Georgia, 1988).

3. For example, see Elinor Lander Horwitz, *Contemporary American Folk Artists* (Philadelphia: J. B. Lippincott, 1975); Walker Art Center, *Naives and Visionaries* (New York: E. P. Dutton, 1974); Jan Wampler, *All Their Own: People and the Places They Build* (Cambridge, Mass.: Schenkman, 1977); and Jane Livingston and John Beardsley, *Black Folk Art in America, 1930–1980* (Jackson: Univ. Press of Mississippi, 1982).

4. For example, see Paul S. Briedenbach and Doran H. Ross, "The Holy Place: Twelve Apostles Healing Gardens," *African Arts* 2, no. 4 (July 1978).

5. To list only a few widely distant parallels: Newbell Niles Puckett, *Folk Beliefs of the Southern Negro* (Chapel Hill: Univ. of North Carolina Press, 1926), 432, 541; Grey Gundaker, *Signs of Diaspora/Diaspora of Signs: Literacies, Creolization, and Vernacular Practice in African America* (New York: Oxford Univ. Press, 1998), 116–19, 223; Mechal Sobel, *Trablin' On: The Slave Journey to an Afro-Baptist Faith* (1979; reprint, Princeton, N.J.: Princeton Univ. Press, 1988), 109; Victor Turner, *Revelation and Divination in Ndembu Ritual* (Ithaca, N.Y.: Cornell Univ. Press, 1975), 178–205; Sylvia Ardyn Boone, *Radiance from the Waters* (New Haven, Conn.: Yale Univ. Press, 1986), 18–21; Susan Mullin Vogel, *Baule: African Art, Western Eyes* (New Haven, Conn.: Yale Univ. Press, 1997), 78–79.

6. For example, see Harry Middleton Hyatt, *Hoodoo, Conjuration, Witchcraft, Rootwork: Beliefs Accepted by Many Negroes and White Persons, These Being Orally Recorded among Blacks and Whites,* Memoirs of the Alma Egan Hyatt Foundation (Hannibal, Mo.: Western Publishing, 1970), 1744. For much greater detail in relation to balance and movement, see Robert Farris Thompson, *African Art in Motion* (Los Angeles: Univ. of California Press, 1974), 5–26; also, Fu-Kiau Kia Bunseki, personal communication to Gundaker, Haifa, Israel, Apr. 1990.

7. See Gwendolyn Midlo Hall, *Africans in Colonial Louisiana* (Baton Rouge: Louisiana State Univ. Press, 1992), 38, 163; and Puckett, *Folk Beliefs,* 16, 186, 218, 225–26.

8. There are obvious parallels between geometric designs and arrangements in certain African American yards and those that Ron Eglash has described in his *African Fractals: Modern Computing and Indigenous Design* (New Brunswick, N. J.: Rutgers Univ. Press, 1999); see esp. pp. 20–38, 55, 162–78. However, this subject awaits systematic study.

9. J. H. K. Nketia, *Funeral Dirges of the Akan People* (Achimota, Ghana, and Exeter, U.K.: J. Townsend, 1955), 35.

10. Johnson Smith, personal communication to Gundaker, May 1992.

11. Thompson, *Face of the Gods,* 78–80.

12. John Thornton, *Africa and Africans in the Making of the Atlantic World, 1400–1680* (Cambridge: Cambridge Univ. Press, 1992).

13. See Michael A. Gomez, *Exchanging Our Country Marks: The Transformation of African Identities in the Colonial and Antebellum South* (Chapel Hill: Univ. of North Carolina Press, 1998), 17–37, and map 6.1, for a lucid analysis of slave trade statistics. Table 2.7 in this source estimates that 26.1 percent of captives came from West Central Africa.

14. Thompson, *Face of the Gods,* 79.

15. Nkisi have been confused with sculptures and figures but instead comprise a complex of materials and actions that includes rituals and medicines as well. See Wyatt MacGaffey, *Art and Healing of the Bakongo Commented by Themselves: Minkisi from the Laman Collection* (Stockholm: Folkens Museum, 1991).

16. Charles Piot, *Remotely Global: Village Modernity in West Africa* (Chicago: Univ. of Chicago Press, 1999), 143.

17. Important resources that illustrate the enormity of information available include John F. Szwed and Roger D. Abrahams, *Afro-American Folk Culture: An Annotated Bibliography of Materials from North, Central, and South America and the West Indies* (Philadelphia: Institute for the

Study of Human Issues, 1978); and George P. Rawick, ed., *The American Slave: A Composite Autobiography,* 41 vols. (Westport, Conn.: Greenwood, 1972–79).

18. See Vincent L. Wimbush, ed., *African Americans and the Bible: Sacred Texts and Social Textures* (New York: Continuum, 2000).

19. Haldane Macfall, *The Wooings of Jezebel Pettifer* (London: Simpkin, Marshall, Hamilton, Kent & Co., 1898), 136.

20. Nan Stewart, in *American Slave,* ed. Rawick, vol. 16, Ohio Narratives, p. 89.

21. John Jasper, quoted in William E. Hatcher, *John Jasper, the Unmatched Negro Philosopher and Preacher* (New York: Fleming H. Revell, 1908), 178–79.

22. Marvin White, personal communication with McWillie, July 5, 2002.

23. Compare with the dolphin skull as *simbi* in Robert Slenes, "The Great Porpoise-Skull Strike," and the existence of the *simbi* or *cymbi* spirit near this area in Ras Michael Brown, "Walk in the Feenda: West Central Africans and the South Carolina–Georgia Low Country," both in *Central Africa and Cultural Transformation in the American Diaspora,* ed. Linda M. Heywood (Cambridge: Cambridge Univ. Press, 2001), 183–208, 289–317.

24. Eddie Bowens, interview with McWillie, Nov. 1987.

25. Ibid.

26. Ibid.

27. Bessie Harvey, interview with McWillie, June 1987.

28. Washington Harris, conversation with McWillie, Dec. 1989.

29. Charles A. Brown, *Memphis Press-Scimitar,* July 31, 1961.

30. Ibid.

31. *Memphis Commercial Appeal,* May 15, 1965.

32. William Thomas, *Memphis Commercial Appeal,* July 14, 1984.

33. Steven Russell, *Memphis Flyer,* Oct. 26, 1989.

34. Ibid.

35. Steve Mays, personal Web site, http://www.smays.com/basement/voodoo.htm.

Mays compiled the newspaper accounts quoted in this chapter and posted them on this site.

36. Washington Harris, conversation with McWillie, Dec. 1989.

37. Washington Harris, conversation with McWillie, March 1987.

38. Marvin White to McWillie, Jan. 24, 1988.

39. Marvin White, Letters to the Editor, *Memphis Commercial Appeal,* Sept. 6, 2003.

40. When queried about the phrase "silliness of God," Pastor White explained: "Regarding the question of 'silliness of God,' if one views a preacher in the act of preaching the Word of God in a setting that is disconnected from the church, it would seem silly to one who could not make that connection. Look at it this way, if you or I observed someone in a shopping mall, for example, waving their arms, prancing back and forth, jumping up and down, shouting, crying and speaking in tongues without the benefit of knowing that they were held captive in the Holy Spirit, that person would appear silly. But God has used the silly act of preaching to communicate His most serious instructions to mankind. So it is with the visual works of the spirit, taken out of context they appear silly but if received prayerfully, they communicate a most serious message. Moreover, the silly things of God are still Holy and are far more serious than any sincerity of mankind of God that communicates visually rather than audibly. Both are avenues for the Holy Spirit." Marvin White, e-mail message to McWillie, Feb. 23, 2004.

41. Pastor White is referring to sketches of structures on the temple grounds, which he provided to the authors in February 2004. See plates 17, 18, and 19.

42. Pastor White gave this statement, dated December 31, 2003, in typescript to McWillie and J. Martin Regan Jr. Permission to print it was granted on Jan. 12, 2004.

43. Bessie Harvey, interview with McWillie, June 1987.

Portfolio II

1. We follow Thompson's use of "lexicon" in his "Circle and Branch," 24.

2. For more detailed discussion of the elements listed here and others, see Thompson, "Song," and Gundaker, "Tradition and Innovation." "Old way" and "old time" are widespread usages; for example, see quotations from Eddie Bowens in chapter 1 and La Verne Spurlock in chapter 2.

3. Kimbwandènde Kia Bunseki Fu-Kiau, *Self-Healing Power and Therapy: Old Teachings from Africa* (New York: Vantage Press, 1991), 8, and esp. 65–72, regarding the *"musoni* sun of perfection." See also McWillie, "Another Face of the Diamond," *Clarion* 12, no. 4 (1987): 42–52; and Thompson, *Flash of the Spirit,* 124.

4. Thompson, "Song"; LaVerne Spurlock, personal communication to Gundaker, Aug. 13, 2002.

5. Thompson, "Circle and Branch," 29–37; Grey Gundaker, "What Goes Around Comes Around: Temporal Cycles in African American Yardwork," in *Recycled, Re-Seen: Folk Art from the Global Scrap Heap* (New York: Harry N. Abrams, 1996), 72–81.

6. Thompson, *Four Moments,* 193–95.

7. Ibid., 24, 31.

8. Ibid., 184.

9. Judith McWillie, "Art, Healing, and Power," in *Keep Your Head to the Sky,* ed. Gundaker, 84.

10. Thompson, *Flash of the Spirit,* 132–42.

11. Ibid., 181, 198.

Chapter 2

Epigraphs: Wyatt MacGaffey, *Religion and Society in Central Africa: The BaKongo of Lower Zaire* (Chicago: Univ. of Chicago Press, 1986), 15; Thompson, *Face of the Gods,* 79–80.

1. Thompson, *Face of the Gods,* 79–80.

2. We encountered this sign in Tennessee and Georgia. See also Harry Middleton Hyatt, *Folklore from Adams County, Illinois* (New York: Alma Egan Hyatt Foundation, 1935), 569.

3. Ibid., 67.

4. Marietta Minnigerode Andrews, *Memoirs of a Poor Relation: Being a Story of a Post-War Southern Girl and Her Battle with Destiny* (New York: E. P. Dutton, 1927), 222–23.

5. For terminology, see Paul Groth, "Lot, Yard, and Garden: American Distinctions," *Landscape* 30, no. 3 (1990): 29–35. African Americans generally follow the widespread American usage of "yard" to refer to the domestic landscape around a dwelling, in contrast to British usage in which the yard is a paved area containing trash cans and perhaps parked automobiles.

6. See Fu-Kiau, *Self-Healing.* Here the author outlines, through the contributions of Kongo and related Bantu peoples, an implicit foundation of African American yard work. See also John M. Janzen, *The Quest for Therapy in Lower Zaire* (Berkeley: Univ. of California Press, 1978), 162; and A. Fu-Kiau Kia Bunseki-Lumanisa, *Le MuKongo et le Monde qui L'Entourant,* trans. C. Zamenga-Betukezanga (Kinshasa: Centre d'Education et de Recherch Scientifiques en Langues Africaines, 1969).

7. On social uses of proverbs, see Sw. Anand Prahlad, *African American Proverbs in Context* (Jackson: Univ. Press of Mississippi, 1996). There are also parallels with material signs in the verbal-visual interplay in avant-garde African American poetry; see Aldon Lynn Nielsen, "The Calligraphy of Black Chant," in *Black Chant: Languages of African-American Postmodernism* (Cambridge: Cambridge Univ. Press, 1997), 3–37. African graphic and material systems of communication may well have contributed resources to African American uses of objects to pun on words. See Clémentine Faïk-Nzuji, *Symboles Graphique en Afrique Noire* (Paris: Éditions Kathala pour CIL-TADE, Louvain, 1992); and David Dalby, *L'Afrique et la Lettre/Africa and the Written Word* (Lagos: Centre Culturel Français; Paris: Fête de la Lettre, 1986). Especially important are object codings of proverbs. See Thompson, *Four Moments,* 116–18; and Joseph Cornet, *Pictographies Woyo* (Milan: Quaderni Poro 2, PORO, Associazione degli Amici dell' Arte Extra-europea, 1980).

8. Philip Peek describes the diviner as a "translator of esoteric codes" in "African Divination Systems: Non-Normal Modes of Cognition," in *African Divination Systems,* ed. Philip M. Peek (Bloomington: Indiana Univ. Press, 1991), 200.

9. See, for example, Thompson, *Flash of the Spirit,* 138–39.

10. Mary Belle Dempsey, in *American Slave,* ed. Rawick, vol. 16, Ohio Narratives, p. 33.

11. MacGaffey uses the concepts of metaphor and metonymy to explain the reasoning involved in Kongo *nkisi.* As he notes, these concepts "make it possible to link symbolism to the social structure it presupposes" (*Religion and Society,* 13).

12. Henry John Drewal and John Pemberton III, with Roland Abiodun, *Yoruba: Nine Centuries of African Art and Thought,* ed. Allen Wardell (New York: Center for African Art; Harry N. Abrams Publishers, 1989), 62.

13. Ibid., 63.

14. Essie Collins Matthews, *Aunt Phebe, Uncle Tom and Others: Character Studies among the Old Slaves of the South, Fifty Years After* (Columbus, Ohio: Champlin Press, 1915).

15. Julia Peterkin, *Green Thursday* (New York: Knopf, 1924), 17.

16. Henry Bibb, "Conjuration and Witchcraft," in *Afro-American Religious History: A Documentary Witness,* ed. Milton C. Sernett (Durham, N.C.: Duke Univ. Press, 1985) 77–78.

17. See, for example, Albert J. Raboteau, *Slave Religion: The "Invisible Institution" in the Antebellum South* (New York: Oxford Univ. Press, 1978), 74–75; David H. Brown, "Conjure/Doctors: An Explanation of a Black Discourse in America, Antebellum to 1940," *Folklore Forum* 23, no. 1–2 (1990): 3–46; and Yvonne Patricia Chireau, "Conjuring: An Analysis of African American Folk Beliefs and Practices" (Ph.D. diss., Princeton Univ., 1994).

18. Samuel Sutton, in *American Slave,* ed. Rawick, vol. 16, Ohio Narratives, p. 95.

19. See, among others, Edward D. C. Campbell Jr. and Kym S. Rice, eds., *Before Freedom Came: African-American Life in the Antebellum South* (Richmond, Va.: Museum of the Confederacy; Charlottesville: Univ. of Virginia Press, 1991); Leland Ferguson, *Uncommon Ground: Archaeology and Early African America* (Washington, D.C.: Smithsonian Institution Press, 1991); Theresa A. Singleton, ed., *"I, Too, Am America": Archaeological Studies of African American Life* (Charlottesville: Univ. of Virginia Press, 1999); Mark Leone et al, *Archaeological Excavations at the Charles Carroll House in Annapolis, Maryland* (College Park: Univ. of Maryland, 1992); Thompson, *Face of the Gods,* 57–58; Kenneth L. Brown and Doreen C. Cooper, "African Retentions and Symbolism," *Levi Jordan Plantation,*

http:www.webarchaeology.com/html/african.htm;

and Mark P. Leone and Gladys-Marie Fry, "Conjuring in the Big House Kitchen: An Interpretation of African American Belief Systems Based on the Uses of Archaeology and Folklore Sources," *Journal of American Folklore* 112 (1999): 372–404.

20. Alice Eley Jones, "Sacred Places and Holy Ground: West African Spiritualism at Stagville Plantation," in *Head to the Sky,* ed. Gundaker, 97.

21. Thompson, *Flash of the Spirit,* 45.

22. See Keith Otterbein, "Setting of Fields: A Form of Bahamian Obeah," *Philadelphia Anthropological Society Bulletin* 13 (1959): 3–7.

23. See Carolyn Morrow Long, *Spiritual Merchants: Religion, Magic, and Commerce* (Knoxville: Univ. of Tennessee Press, 2001).

24. Bennie Lusane, interview with McWillie and Gundaker, Apr. 1990.

25. Stewart Culin, "Reports Concerning Voodooism," *Journal of American Folklore* 2 (1889): 233.

26. Harold Matthews, *River-Bottom Boy* (New York: Thomas Y. Crowell, 1942), 39.

27. See Hyatt, *Hoodoo,* 1312.

28. R. E. Dennett, *At the Back of the Black Man's Mind, or Notes on the Kingly Office in West Africa* (London: Macmillan, 1909), 11.

29. Hyatt, *Hoodoo,* 1891.

30. Ibid., 1866.

31. Ibid., 1875.

32. Ibid., 1884.

33. Ibid., 1931–32.

34. Ibid., 1959–60.

35. Ibid., 1969–70.

36. Ibid., 2013–14.

37. Ibid., 1988.

38. Ibid., 2009.

39. Ibid., 1923.

40. Ibid., 2031

41. Joseph Murphy, *Santería: An African Religion in America* (Boston: Beacon Press, 1988), 41.

42. Puckett, *Folk Beliefs,* 315.

43. Hundreds of references to these substances and their uses are contained in Hyatt, *Hoodoo.*

44. George Briggs, in *American Slave,* ed. Rawick, vol. 2, pt. 1, South Carolina Narratives, p. 89.

45. See Dan Rose, "Active Agents," in *The Consumption of Mass,* ed. Nick Lee and Rolland Munro (Oxford: Blackwell, 2001), 44–59.

46. LaVerne Spurlock, conversation with Gundaker and Mei-Mei Sanford, Freeport, N.Y., Aug. 12, 2002.

47. Mary Alicia Owen, *Voodoo Tales as Told Among the Negroes of the Southwest* (New York: Putnam, 1893), 8. See also Puckett, *Folk Beliefs,* 219–20.

48. Johnson Smith, personal communication to Gundaker, Nov. 1990.

49. Dan Rose, "Detachment: Continuities of Sensibility Among Afro-American Populations of the Circum-Atlantic Fringe," in *Discovering Afro-America,* ed. Roger D. Abrahams and John F. Szwed (Leiden, The Netherlands: Brill, 1975), 68–82; Amos Tutuola, *The Palm-Wine Drinkard and His Dead Tapster in the Dead's Town* (New York: Grove Press, 1953), 16–22.

50. Eliza Hartley, in *American Slave,* ed. Rawick, vol. 2, pt. 2, South Carolina Narratives, p. 254. Italics ours.

51. Millie Barber, in *American Slave,* ed. Rawick, vol. 2, pt. 1, South Carolina Narratives, p. 38.

52. Puckett, *Folk Beliefs,* 115.

53. James Battle Avirett, *The Old Plantation: How We Lived in Great House and Cabin Before the War* (New York: F. Tennyson Neely, 1901), 34.

54. Zora Neale Hurston, *Dust Tracks on a Road* (Philadelphia: Lippincott, 1942), 145.

55. Kenneth Little, *The Mende of Sierra Leone,* rev. ed. (London: Routledge & Kegan Paul, 1967), 235.

56. This name is a pseudonym. Interview with Gundaker, June 1998.

57. See Donald J. Cosentino, *Sacred Arts of Haitian Vodou* (Los Angeles: Fowler Museum of Cultural History, 1995), 399–415, esp. illus. 16.20.

58. Charles E. Thomas, *Jelly Roll: A Black Neighborhood in a Southern Mill Town* (Little Rock, Ark.: Rose Publishing Company, 1986), 43.

59. Hyatt, *Hoodoo,* 301.

60. Fu Kiau's discussion of *kinenga* or balance is insightful and relevant here; see *Self-Healing,* 66–70.

61. See Puckett, *Folk Beliefs,* 456; Hyatt, *Hoodoo,* 1297; and Loudell F. Snow, *Walkin' Over Medicine* (Detroit: Wayne State Univ. Press, 1998), 1–18, 39–65.

62. Anna Riva, *The Modern Herbal Spell Book* (Tohica Lake, Calif.: International Imports, 1974), 14.

63. Anonymous informant, interview with Gundaker, Chattanooga, Tenn., Apr. 21, 1990.

64. MacGaffey, *Religion and Society,* 136–37.

Portfolio III

Parts of the biography of Eddie Williamson previously appeared in Judith McWillie, "(Inter) Cultural (Inter) Connections: Eddie Williamson, Tyree Guyton, and the Cosmogonic Crossroads," in *Public Art Review,* Summer–Fall 1992, 14–15. This article was subsequently reprinted in *Cities, Cultures, Conversations: Readings for Writers,* ed. Richard Marback, Patrick Bruch, and Jill Eicher

(Needham Heights, Mass.: Allyn and Bacon, 1998), 214–19. Parts of the biography of Lonnie Holley—and the 1991 interview with him—previously appeared in ©*Artforum,* Apr. 1992, "Lonnie Holley's Moves," by Judith McWillie.

1. Robin DeMoniz, "Discards Become His Art: Oakman's 'Sanford' Fills Yard; Wife Draws the Line," *Birmingham News,* Dec. 25, 1990. This feature lists Mr. Lathern's first name as "West" rather than "Wess." While some of his coworkers also used the former as a nickname, the Latherns' son, Johnny, now residing in Englewood, California, corrected the record in an interview with Judith McWillie in 2003.

2. DeMoniz, "Discards Become His Art."

3. Wess Lathern, interview with Judith McWillie, 1991.

4. See fig. 2.4. Also, Thompson, *Four Moments,* 178–81; Thompson, *Face of the Gods,* 83–88.

5. Eddie Williamson, interview with Judith McWillie, videotape, 1986.

6. Lonnie Holly, interviews with Judith McWillie, videotape, Mar. 19, 1987, and Dec. 13 and 30, 1991.

Chapter 3

Epigraphs: Lydia Wood Baldwin, *A Yankee School-Teacher in Virginia: A Tale of the Old Dominion in a Transition State* (New York: Funk & Wagnalls, 1884), 108. Hal Bennett's observation that black farmers considered dead white people to be especially good fertilizer is from *A Wilderness of Vines* (New York: Doubleday, 1966), 126.

1. Thompson, *Four Moments,* 181; compare Teddy Aarni, *The Kalunga Concept in Ovambo Religion from 1870 Onwards,* Acta Universitatis Stockholmiensis, no. 22 (Stockholm: Almquist & Wicksell, 1982), 28, 102–6.

2. James Weldon Johnson and J. Rosamond Johnson, eds., *The Books of American Negro Spirituals* (1925–26; reprint, New York: Da Capo, 1977), vol. 1: 145–47, quoted in Anthony B. Pinn, *Why Lord? Suffering and Evil in Black Theology* (New York: Continuum, 1995), 27.

3. Mary Wooldridge, in *American Slave,* ed. Rawick, vol. 16, Kentucky Narratives, p. 110.

4. Hamner Cobb, "Superstitions of the Black Belt," *The Alabama Review* 11, no. 44 (1958): 50.

5. Baldwin, *Yankee School-Teacher,* 47–48. See also Westmacott, *Gardens and Yards,* 78–79.

6. Archibald Rutledge, *It Will Be Daybreak Soon* (New York: Fleming Revell, 1938), 10–12.

7. Ibid., 12–13.

8. Eula Hendrick McClaney, *God, I Listened,* ed. Mark Taylor and Anthony Sweeting (Los Angeles: Dr. La-Doris McClaney, 1989), 24.

9. Baldwin, *Yankee School-Teacher,* 11–12.

10. See Jones, "Sacred Places."

11. Amelia Wallace Vernon, *African Americans at Mars Bluff, South Carolina* (Baton Rouge: Louisiana State Univ. Press, 1993); Theodore Rosengarten, "The Secret of the Marshes: An Agricultural Mystery in a Southern Town Leads to New Understanding of the African-American Experience," *New York Times Book Review,* May 8, 1994, 5.

12. Rutledge, *Daybreak,* 65–66.

13. Westmacott, *Gardens and Yards.*

14. J. Herman Blake, "'Doctor Can't Do Me No Good': Social Concomitants of Health Care Attitudes and Practices Among Elderly Blacks in an Isolated Rural Population," in *Black Folk Medicine: The Therapeutic Signs of Faith and Trust,* ed. Wilbur H. Watson (New Brunswick, N.J.: Transaction Publishers, 1984), 35–36.

15. Gundaker, "Cosmology."

16. Jim Auchmutey, "Sandman's Blues, Part 3: Family in the Fire," *Atlanta Journal-Constitution,* Mar. 16, 1999.

17. Ibid.

18. Julia Peterkin, *Roll, Jordan, Roll* (New York: Robert O. Ballou, 1933), 208–9.

19. James Street Jr., ed., *James Street's South* (Garden City, N.Y.: Doubleday, 1955), 50.

20. For example, female Peace Corps volunteers in Barbados were warned not to walk in cemeteries because of the threat of rape. Elizabeth Barnum, personal communication to Gundaker, July 1988.

21. Mrs. M. E. Abrams, in *American Slave,* ed. Rawick, vol. 2, pt. 1, South Carolina Narratives, pp. 1–2.

22. Millie Bates, in *American Slave,* ed. Rawick, vol. 2, pt. 1, South Carolina Narratives, pp. 46–47.

23. Richard Fardon, *Between God, the Dead and the Wild: Chamba Interpretations of Religion and the Wild* (Washington, D.C.: Smithsonian Institution Press, 1990), 79–185. See also Janzen, *Quest for Therapy,* 162; and Bunseki-Lumanisa, *Le MuKongo.*

24. Robert Farris Thompson, "An Aesthetic of the Cool," *African Arts* 7, no. 1 (Autumn 1973): 40–43, 64–67, 84–91.

25. Robert Farris Thompson, "An Introduction to Transatlantic Black Art History," in *Discovering Afro-America,* 63.

26. Theophus H. Smith, *Conjuring Culture: Biblical Formations of Black America* (New York: Oxford Univ. Press, 1994), 142–43.

27. Ibid., 17, 81, 101–2.

28. M. C. Jedrej, "Cosmology and Symbolism on the Central Guinea Coast," *Anthropos* 81 (1986): 497–515.

29. Lonnie Holley, quoted by Anne Rochell, "Waiting for Takeoff," *Atlanta Journal-Constitution,* Oct. 24, 1997.

30. Piot, *Remotely Global,* 144.

31. Thomas, *Jelly Roll,* 43.

32. Thomas W. Talley, *The Negro Traditions,* ed. Charles K. Wolfe and Laura C. Jarmon (Knoxville: Univ. of Tennessee Press, 1993), 30.

33. Historian Margaret Washington Creel has pointed out the parallels here with initiation into the Poro and Sande societies of the Mende and other groups in Sierra Leone and Liberia. See her *"A Peculiar People": Slave Religion and Culture among the Gullahs* (New York: New York Univ. Press, 1988).

34. Samuel Miller Lawton, "The Religious Life of South Carolina Coastal and Sea Island Negroes" (Ph.D. diss., George Peabody College for Teachers, 1939), 145.

35. Sylvia Cannon, in *American Slave,* ed. Rawick, vol. 2, pt. 1, South Carolina Narratives, p. 184.

36. Henrietta Matson, *The Mississippi Schoolmaster* (Boston: Congregational Sunday-School & Publishing Co., 1893), 2.

37. Jones, *For the Ancestors,* 110.

Portfolio IV

Parts of the Dilmus Hall narrative and biography first appeared in Judith McWillie, "Art, Healing, and Power in the Afro Atlantic South," in *Keep Your Head to the Sky: Interpreting African American Home Ground,* ed. Grey Gundaker (Univ. of Virginia Press, 1998). Reprinted with permission of the University of Virginia Press.

1. University of Southern Mississippi News, Sept. 17, 1998.

2. Robert Watson, interviews with Judith McWillie, March 1991.

3. Dilmus Hall was interviewed by McWillie on June 3 and 25, July 10, Aug. 24, 1984, and Mar. 13, 1985. These comments and others in this section are taken from those conversations.

Chapter 4

Epigraphs: Lura Beam, *He Called Them by the Lighting: A Teacher's Odyssey in the Negro South* (Indianapolis: Bobbs-Merrill, 1967), 230; line from spiritual quoted in John Lovell Jr., *Black Song: The Forge and the Flame* (New York: Macmillan, 1972), 342.

1. Julian R. Meade, *I Live in Virginia* (New York: Longman's, 1935).

2. Eldred K. Means, *Black Fortune* (1931; reprint, Freeport, N.Y.: Books for Libraries, 1972), 112.

3. Minnie Clare Boyd, "Alabama in the Fifties" (Ph.D. diss., Columbia Univ., 1931), 98.

4. Vernon, *Mars Bluff,* 168.

5. Ibid., 170.

6. See, for example, the comments of Willis Williams in *American Slave,* ed. Rawick, vol. 17, Florida Narratives, p. 353.

7. Thompson, "Song"; also, Bruce Jackson's summary of counting charms in his introduction

to Susan Showers, "A Weddin' and a Buryin' in the Black Belt," in *The Negro and His Folklore in Nineteenth-Century Periodicals,* ed. Bruce Jackson (Austin: Univ. of Texas Press, 1967), 293. In addition, see Robert W. Pelton, *The Complete Book of Voodoo* (New York: Berkeley, 1972), 16–17; Michel Laguerre, *The Voodoo Heritage* (Beverly Hills, Calif.: Sage Publications, 1980), 54–55; Peterkin, *Green Thursday,* 66.

8. Northcote W. Thomas, *Anthropological Report on Sierra Leone,* pt. 1, *Law and Customs of the Timne and Other Tribes* (London: Harrison & Sons, 1916), 53.

9. Susan Legêne, "From Brooms to Obeah and Back: Fetish Conversion and Border Crossings in Nineteenth-Century Suriname," in *Border Fetishisms: Material Objects in Unstable Spaces,* ed. Patricia Spyer (New York and London: Routledge, 1998), 43.

10. Zora Neale Hurston, "Hoodoo in America," *Journal of American Folklore* 44 (1931): 317–417.

11. Henry Fielding, "Memoirs of Low Country Funeral Director," in *The Last Miles of the Way: African American Home Going Traditions in South Carolina,* ed. Elaine Nichols (Columbia: South Carolina State Museum, 1989), 58.

12. Roger D. Abrahams, *The Man-of-Words in the West Indies: Performance and the Emergence of Creole Culture* (Baltimore: Johns Hopkins Univ. Press, 1983).

13. See Ywone Edwards-Ingram, "Trash Revisited," in *Head to the Sky,* ed. Gundaker, 245–71.

14. *Dan to Beersheba, or Northern and Southern Friends* (London: Chapman & Hall, 1864), 102–3.

15. Ruby Gilmore, interview with Gundaker, Aug. 1997.

16. See Thompson, *Flash of the Spirit,* 221–22.

17. John Milton Mackie, *From Cape Cod to Dixie and the Tropics* (New York: Putnam, 1864), 341.

18. Interviewer's comments in narrative of Joseph Leonides Star, in *American Slave,* ed. Rawick, vol. 16, pt. 7, Tennessee Narratives, p. 72.

19. Ibid.

20. Marie Campbell, *Folks Do Get Born* (New York: Rinehart, 1946), 82.

21. Beam, *Lighting,* 12.

22. Zora Neale Hurston, "The Gilded Six Bits," *Story* 14, no. 3 (1933): 60–70.

23. See Suzanne Seriff, "Folk Art from the Global Scrap Heap: The Place of Irony in the Politics of Poverty," and Allen F. Roberts, "The Ironies of System D," both in *Recycled Re-Seen: Folk Art from the Global Scrap Heap,* ed. Charlene Cerny and Suzanne Seriff (New York: Harry N. Abrams, in Association with Museum of International Folk Art, Santa Fe, 1996), 8–29, 82–101.

24. Henry P. Orr, "Decorative Plants around Historic Alabama Homes," *Alabama Review* 2, no. 1 (1958): 9.

25. Richard Harding Davis, *The Congo and The Coasts of Africa* (New York: Charles Scribners Sons, 1907), 57.

26. A variety of dwarf ironwood called the bayahonda bush is mentioned in Pelton, *Complete Book of Voodoo,* 28.

27. John V. Watkins, *Gardens of the Antilles* (Gainesville: Univ. of Florida Press, 1952), 62.

28. Ibid., 64–65.

29. Westmacott, *Gardens and Yards,* plate 10.

30. See Anthony Huxley, ed., *The New Royal Horticultural Society Dictionary of Gardening,* vol. 2 (London: Macmillan, 1992), 20.

31. See Huxley, *New Royal* 1: 402.

32. Westmacott, *Gardens and Yards.*

33. David Hilary Brown, "The Garden in the Machine: Afro-Cuban Sacred Art and Performance in Urban New York and New Jersey" (Ph.D. diss., Yale Univ., 1989), 373.

34. Effie Graham, *The "Passin'-On" Party* (Chicago: A. C. McClurg, 1912).

35. Marie Taylor, interview with Gundaker, Dec. 1989.

36. Quoted in Orr, "Decorative Plants,"12–13.

37. Joyce Johnson, personal communication with Gundaker, Apr. 1989.

38. Hurston, "Hoodoo"; Louisa Teish, *Jambalaya: The Natural Woman's Book of Person*

Charms and Practical Rituals (San Francisco: Harper & Row, 1985).

39. See Thompson, *Flash of the Spirit* ; Owen, *Voodoo Tales.*

40. See Beverly McGraw's photographs and Thompson's discussion in *Face of the Spirit,* 85, 93; also, Thompson, "Song," 129–30.

41. Gaston Mulira, "The Case of Voodoo in New Orleans," in *Africanisms in American Culture,* ed. Joseph E. Holloway (Bloomington: Indiana Univ. Press, 1990), 34–68.

42. Robert G. Noreen, "Ghetto Worship: A Study of the Names of Chicago Storefront Churches," *Names* 13 (1965): 26.

43. William A. Owens, *On Borrowed Land* (Indianapolis: Bobbs-Merrill, 1950), 21.

44. This ad ran in January 1988.

45. Hyatt, *Hoodoo,* 3622.

46. Ronald G. Killion and Charles T. Walker, *A Treasury of Georgia Folklore* (Atlanta: Cherokee Publishing Co., 1972), 75.

47. Thompson, "Song," 104, 130, 134.

48. Puckett, *Folk Beliefs,* 232–33, 314, 391.

49. Georgia Writers' Project, *Drums and Shadows: Survival Studies among Georgia Negroes* (1940; reprint, Athens: Univ. of Georgia Press, 1986).

50. Elliot Lieb and Reneé Romano, "The Reign of the Leopard: Ngbe Ritual," African Arts 18, no. 1 (1984): 54.

51. Dennett, At the Back, 84.

52. Hyatt, Hoodoo, 193–94.

53. Labelle Prussin, quoted by Fred T. Smith, "Compound Entryway Decoration: Male Space and Female Creativity," *African Arts* 24, no. 3 (May 1986): 52.

54. Thompson, *Four Moments,* 179.

55. Puckett, *Folk Beliefs,* 106.

56. Robert Farris Thompson, conversation with Gundaker, Apr. 1990.

57. Lyle Saxon, Robert Tallant, and Edward Dreyer, *Gumbo Ya-Ya: A Collection of Louisiana Folktales* (Boston: Houghton Mifflin, 1945), 249.

58. Ishmael Reed, *The Terrible Twos* (1982; reprint, New York: Atheneum, 1988), 126.

59. Thompson, *Face of the Gods,* 70–76.

60. See Gundaker, "Cosmology."

61. Hyatt, *Adams County,* 500.

62. Dennett, *At the Back,* 126–35; Little, *Mende of Sierra Leone,* 219–20.

63. Teish, *Jambalaya,* 68. On the tree of the ancestors, see also Eric de Rosny, *Healers in the Night* (Maryknoll, N.Y.: Orbis Press, 1985), 75.

64. Gyp Packnett, interview with Gundaker, Apr. 1990.

65. Donald Grey, *Black Echo* (New York: Pegasus, 1932), 103. Also compare with Jim Wafer's description of trees with white strips for the Orisha Tempo in Brazil in *The Taste of Blood: Spirit Possession in Brazilian Candomblé* (Philadelphia: Univ. of Pennsylvania Press, 1991).

66. James Bullock, personal communication to Gundaker, Apr. 1993.

67. Wyatt MacGaffey, "The Black Loincloth and the Son of Nzambi Mpungu," in *Forms of Folklore in Africa: Narrative, Poetic, Gnomic, Dramatic,* ed. Bernth Lindfors (Austin: Univ. of Texas Press, 1977), 149–50.

68. See Cosentino, *Sacred Arts.*

69. Serge Larose, "The Meaning of Africa in Haitian Vodu (Voodoo)," in *Symbols and Sentiments: Cross-Cultural Studies in Symbolism,* ed. I. M Lewis (London: Academic Press, 1977), 110.

70. Ibid., 111.

71. *The Sisters of Orleans: A Tale of Race and Social Conflict* (New York: Putnam, 1871), 324–25.

72. Samuel Galliard Stoney, *Plantations of the Carolina Low Country,* ed. Albert Simons and Samuel Lapham (Charleston, S.C.: Carolina Art Association, 1938), 83.

73. Watkins, *Gardens of the Antilles,* 38.

74. Pelton, *Voodoo,* 17, 113.

75. Barbara J. Heath, *Hidden Lives: The Archaeology of Slave Life at Thomas Jefferson's Poplar Forest* (Charlottesville: Univ. of Virginia Press, 1999).

76. Ron Bodin, *Voodoo: Past and Present* (Lafayette: Center for Louisiana Studies, Univ. of Southwestern Louisiana, 1990), 17; Joe Gray,

Negro Slavery in Louisiana (1963; reprint, New York: Negro Universities Press, 1969), 34–40.

77. See discussion and photo in Thompson, *Flash of the Spirit,* 86.

78. Pascal James Imperato, *African Folk Medicine: Practices and Beliefs of the Bambara and Other Peoples* (Baltimore: York Press, 1977), 32.

79. J. H. Nketia, *Drumming in Akan Communities of Ghana,* (London: Thomas Nelson for Univ. of Ghana, Accra, 1963), 5–6.

80. Ralph Griffin, interview with Judith McWillie, spring 1987. See also Judith McWillie, *Even the Deep Things of God: A Quality of Mind in Afro-Atlantic Traditional Art* (Pittsburgh: Pittsburgh Center for the Arts, 1989), 11.

81. Thompson, *Four Moments,* 176–77.

82. See John Mason Brewer, *Dog Ghosts and Other Texas Negro Folk Tales* (Austin: Univ. of Texas Press, 1958), 7, 15–17; and Lawton, "Religious Life." Regarding a Georgia "prayer ground" in the form of "a old twisted thick rooted muscadine bush," see Andrew Moss, in *American Slave,* ed. Rawick, vol. 16., pt. 7, Tennessee Narratives, p. 49. Also compare with Little, *Mende of Sierra Leone,* 219–20.

83. Thompson, *Four Moments,* 154–55.

84. Baldwin, *Yankee School-Teacher,* 84.

85. Thompson, *Face of the Gods.* Johnson Smith identified this posture to Gundaker, May 1992, as a "Mason's" sign.

86. Lonnie Holly, interview with McWillie, Apr. 1989.

87. Interviewer's comments in narrative of Martin Richardson, in *American Slave,* ed. Rawick, vol. 17, Florida Narratives, p. 340.

89. For more on Furcron's yard and hand-built house, see Westmacott, *Gardens and Yards,* 91-94, 149.

89. Johnson Smith, interviews with Gundaker, Nov. 1991 and June 1992.

90. Johnson Smith, interview with Gundaker, June 15, 1991.

91. Watkins, *Gardens of the Antilles,* 61–62.

92. Killion and Walker, *Georgia Folklore,* 89.

93. Hyatt, *Adams County,* 500.

94. Ruby Gilmore, interview with Gundaker, Feb. 1991.

95. Frances Gray Patton, *A Piece of Luck and Other Stories,* (London: Vicot Gollanz, 1955), 230.

96. William Mahoney, *Black Jacob* (New York: Macmillan, 1969).

97. Puckett, in *Folk Beliefs* (291), states that "a frizzly chicken is a veritable hoodoo watchdog." On "senseh," see Mary Robinson and M. J. Walhouse, "Obeah Worship in East and West Indies," *Folk-Lore* 4 (1893): 211.

98. John Szwed, personal communication to Gundaker, Nov. 1, 1994.

99. Thompson, *Face of the Gods,* 75–91.

100. Crystal Montague, personal communication to Gundaker, Feb. 14, 1996.

101. Dennett, *At the Back,* 85–88.

102. MacGaffey, *Religion and Society,* 94–95. See also Thompson's discussion of guardian grave statuary, *Four Moments,* 97–98.

103. Albert Raboteau and Ann Taves, personal communication with Gundaker, Oct. 10, 1997.

104. Rev. Charles C. Jones, *Tenth Annual Report of the Association for the Religious Instruction of the Negroes in Liberty County, Georgia* (Savannah: Office of P. G. Thomas, 1845), 9.

105. Jason Berry, *The Spirit of Black Hawk: A Mystery of Africans and Indians* (Jackson: Univ. Press of Mississippi, 1995), 8, 15.

106. Sister Shirley Dailey to McWillie and Gundaker, Hattiesburg, Miss., Mar. 1987.

107. See Thompson, *African Art in Motion,* 98-101, 117–225.

108. Gus Feaster, in *American Slave,* ed. Rawick, vol. 2, pt. 2, South Carolina Narratives, p. 52.

109. William Owens, quoted in Jackson, *Negro and His Folklore,* 146–47.

110. Squire Irvin, in *American Slave,* ed. Rawick, supp., ser. 1, vol. 8, pt. 3, Mississippi Narratives, p. 1086. For the pumpkin as the conjurer's familiar, see Norman E. Whitten, "Contemporary Patterns of Malign Occultism among Negroes in North Carolina," *Journal of American Folklore* 75 (1962): 311–25.

111. See Gundaker, "Halloween."

112. Sojourner Truth, quoted in *Black Women in White America: A Documentary History,* ed. Gerda Lerner (New York: Pantheon, 1972), 567–68.

113. Martha Emmons, *Deep Like the Rivers: Stories of My Negro Friends* (Austin: Encino Press, 1969), 10.

114. See esp. Sobel, *Trablin' On;* Lawton, "Religious Life," 25; and Hyatt, *Hoodoo,* 1295–1309. See also Julius Lester, *The Knee-High Man and Other Tales* (New York: Dial, 1972); and Ruth Bass, "The Little Man," in *Mother Wit from the Laughing Barrel,* ed. Alan Dundes (Englewood Cliffs, N.J.: Prentice-Hall, 1973), 388–96.

115. See Lawton, "Religious Life." Also, Sobel, *Trablin' On.*

116. Abass Rassoull, *The Theology of Time by the Honorable Elijah Muhammad* (Hampton, Va.: U.B. & U.S. Communications Systems, 1992), 2, 32.

117. Hawkins Bolden, interview with Judith McWillie, 1986. On four eyes and special sight, see summary in Gundaker, *Signs of Diaspora,* 67–71.

118. Emmons, *Rivers,* 45.

Portfolio V

1. Elizabeth and Bennie Lusane, interviews with Judith McWillie, July 19, 1991, and Sept. 1999.

2. John F. Szwed, "Vibrational Affinities," in *Migrations,* ed. McWillie and Lockpez, 59–67.

3. According to Graham Lock, Braxton "gives each of his compositions a pictorial or diagrammatic title instead of using words." In correspondence with McWillie (March 28, 2004), Lock writes, "John F. Szwed has also written about Mr Braxton's titles as sharing similarities with yard art. It's in an essay called 'The Local and the Express: Anthony Braxton's Title Drawings' which JFS wrote for a festschrift I put together in honour of Mr Braxton's 50th birthday. The book is called 'Mixtery' and was published by Stride Publications in the UK in 1995. It also

includes another essay on the title drawings— by a Belgian writer, Hugo DeCraen, who compares them (and other aspects of Mr Braxton's work) with the work of Kandinsky and his circle in late 19th/early 20th century Europe." Lock asked Braxton if there was a link between yard work and his drawings. Braxton replied that he had no conscious memory of this but that the two "possibly come from the same source"; see Lock, *Forces in Motion: Anthony Braxton and the Meta-reality of Creative Music* (London: Quartet Books, 1988), 366–69.

4. Szwed, "Vibrational Affinities," 66.

5. Annie Sturghill, interview with McWillie, Aug. 30, 1988.

6. Cololy Hester, "Annie Bell Sturghill Makes Lawn Art Out of That Which Others Throw Away," *Athens (Ga.) Banner Herald,* undated clipping in McWillie's possession.

Chapter 5

1. See Nell Irvin Painter, *Exodusters: Black Migration to Kansas after Reconstruction* (1976; reprint, New York: W. W. Norton, 1976), 3–68; Jacqueline Jones, *Labor of Love, Labor of Sorrow: Black Women, Work, and the Family, from Slavery to the Present* (1985; reprint, New York: Vintage, 1988), 44–151; Dorothy Sterling, ed., *The Trouble They Seen: The Story of Reconstruction in the Words of African Americans* (1976; reprint, New York: Da Capo, 1994).

2. L. H. Hammond, *In Black and White: An Interpretation of Southern Life* (New York: Fleming H. Revel Co., 1914), 55.

3. Illinois Writers' Project, *Cavalcade of the American Negro* (Chicago: Diamond Jubilee Exposition Authority, 1940), 61–62.

4. Ibid., 63.

5. Quoted in Hortense Powdermaker, *After Freedom: A Cultural Study in the Deep South* (New York: Viking, 1939), 79.

6. Mechel Sobel, *The World They Made Together: Black and White Values in Eighteenth-Century Virginia* (Princeton, N.J.: Princeton Univ. Press, 1987).

7. On double voicing and cultural politics, see Henry Louis Gates Jr., *The Signifying Monkey: A Theory of Afro-American Literary Criticism* (New York: Oxford Univ. Press, 1988).

8. Rev. I. E. Lowery, *Life on the Old Plantation in Ante-Bellum Days* (Columbia, S.C.: The State Company, 1911), 41.

9. Ibid., 33–34.

10. Ibid., 35.

11. In *Exodusters* (113), Painter speaks of the reluctance of blacks in Tennessee to move away from their parents' graves; people enslaved in Gulf states had often already been forced to do so by slave traders and planter migration.

12. Thompson, "Song That Named the Land"; Frederick Law Olmsted, *A Journey Through Texas* (New York: Dix & Edwards, 1857), 35.

13. Jones, "Sacred Places," 96.

14. Graham, *"Passin'-On" Party,* frontispiece.

15. Federal Writers' Project interviewer, *American Slave,* ed. Rawick, vol. 16, Tennessee Narratives, p. 55.

16. Prince Johnson, in *American Slave,* ed. Rawick, supp., ser. 1, vol. 8, pt. 3, Mississippi Narratives, pp. 1178–79.

17. Hammond, *In Black and White,* 173–75.

18. Built in a rented garage, *The Throne* is now in the collection of the Smithsonian Institution's National Museum of American Art in Washington, D.C. See Lynda Roscoe Hartigan, *The Throne of the Third Heaven of the Nations Millennium General Assembly* (Montgomery, Ala.: Montgomery Museum of Fine Arts), 1977.

19. Zora Neale Hurston, "Gilded Six-Bits," 30–40.

20. Minnie Hite Moody, *Death Is a Little Man* (New York: Julian Messner, 1936), 4.

21. Mrs. Sarah A. Dorsey, *Panola: A Tale of Louisiana* (Philadelphia: T. B. Peterson, 1877), 29–30.

22. Kofi Opoku, personal communication to Gundaker, Apr. 1998.

23. *American Slave,* ed. Rawick, vol. 17, Florida Narratives, p. 4.

24. Lovell, *Black Song,* 244–73.

25. "Christian's Automobile" can be heard on the recording *The Dixie Hummingbirds, Looking Back: A Retrospective,* 3X Platinum Records, 1998. The composer and date of this song are listed as Archie J. Lion, 1957, by the Chicago Public Library Sheet Music Collection, catalog no. 508139. However, Jerry Zoltan, author of a recent book on the Dixie Hummingbirds, states that the song was actually written by Ira Tucker, one of the group's members, who credited it to a relative named Jessie Archie (Jerry Zolten, personal correspondence with Judith McWillie, March 31, 2004).

26. Extrus Cropper, interview with Gundaker, Jan. 1988.

27. Orland Kay Armstrong, *Old Massa's People: The Old Slaves Tell Their Story* (Indianapolis: Bobbs-Merrill, 1931), 257.

28. Quoted in Graham, *Passin'-On.*

29. Interviewer's comments in narrative of Sylvia Gannon, in *American Slave,* ed. Rawick, vol. 2, pt. 1, South Carolina Narratives, p. 187.

30. Sylvia Gannon, in *American Slave,* ed. Rawick, vol. 2, pt. 1, South Carolina Narratives, pp. 181–82.

31. On indirection from a linguist's perspective, see Marcyliena Morgan, "The Africanness of Counterlanguage among Afro-Americans," *Africanisms in Afro-American Language Varieties,* ed. Salikoko Mufwene (Athens: Univ. of Georgia Press, 1993), 423–35.

32. Quoted in Sterling R. Brown, *A Son's Return: Selected Essays of Sterling R. Brown,* ed. Mark A. Sanders (Boston: Northeastern Univ. Press, 1996), 218–19.

33. Zora Neale Hurston, "The Characteristics of Negro Expression," in *Sweat,* ed. Cheryl Wall, (New Brunswick, N.J.: Rutgers Univ. Press, 1997), 55–71.

34. Thomas, *Jelly Roll,* 35.

35. Lawton, "Religious Life," 123.

Portfolio VI

Portions of this chapter were previously published in Judith McWillie, "Writing in an

Unknown Tongue," in *Cultural Perspectives on the American South,* vol 5, *Religion* (New York: Gordon and Breach, 1991), 103–19. Reprinted with permission of the publisher.

1. J. B. Murray, interview with McWillie, Apr. 1986.

2. Mary G. Padgelek. *In the Hand of the Holy Spirit: The Visionary Art of J. B. Murray* (Macon, Ga.: Mercer Univ. Press, 2000), 6, 7.

3. René Bravman, *African Islam* (Washington, D.C.: Smithsonian Institution Press, 1983), 22.

4. Lynda Roscoe Hartigan, "Going Urban: American Folk Art and the Great Migration," *American Art* 14, no. 2 (summer 2000): 26–51.

5. Robert Hughes, "Overdressing for the Occasion," *Time,* Apr. 5, 1976, 42.

6. Lynda Roscoe Hartigan, *The Throne of the Third Heaven.*

7. Hartigan, "Going Urban."

8. As of this writing, *The Throne* is installed in the Abby Aldrich Rockefeller Folk Art Museum, Williamsburg, Virginia, in partnership with the Smithsonian American Art Museum.

9. Hartigan, "Going Urban."

10. Ibid.

11. Ibid.

12. Ibid.

13. Hartigan, *Throne of the Third Heaven.*

14. Greg Bottoms, "The Throne of St. James," in *Crossing Boundaries,* production of Radio New Zealand for the International Documentary Exchange series.; published on World Wide Web at
http://www.soundprint.org/radio/display_show/ID/1177/name/Throne+of+St.+James (accessed June 5, 2003).

15. Hartigan, *Throne of the Third Heaven.*

16. Hartigan, *Throne of the Third Heaven.*

17. Stephen Jay Gould, "Boundaries," in *Time's Arrow and Time's Cycle: Myth and Metaphor in the Discovery of Geological Time* (Cambridge, Mass.: Harvard Univ. Press, 1987), 182.

18. For a theological discussion of the Seven Dispensations, see "Dispensational Premillen-

nialism" subsection in Lonnie Kent York, "History of Millennialism,"
http://www.geocities.com/Heartland/9170/YORK1.HTM
(accessed June 7, 2003).

19. Dennis Jay Stallings, "The Secret Writing," *The Secret Writing of James Hampton, African American Sculptor, Outsider Artist, Visionary,*
http://www.geocities.com/ctesibos/hampton/writing.html
(accessed Nov. 21, 2002).

20. Douglas Ward, "The 'Third Heaven,'" *Christian Resource Institute,*
http://www.cresourcei.org/thirdheaven.html
(accessed Oct. 20, 2002).

21. Ibid.

22. Quoted in Hartigan, *Throne of the Third Heaven.*

23. York, "Dispensational Premillennialism."

24. Ibid.

25. Ibid.

26. See Gould, "Boundaries," 184. Here Gould compares *The Throne* to Thomas Burnet's *Sacred Theory of the Earth.* "The two structures," he writes, "are identical in concept: they display the same conflict and resolution between time's arrow of history and time's cycle of immanence."

27. Ibid., 187.

28. Hartigan, *Throne of the Third Heaven.*

29. Otelia Whitehead, interview with Hartigan and McWillie, Feb. 27, 1986.

30. Ibid.

31. When *The Throne* made its transition from the garage behind Seventh Street into the context of art museums, installations of it were heavily influenced by aesthetic tastes and issues of preservation. In Hampton's original installation (fig. VI.7), panels with diamond shaped emblems superimposed on crosses were prominent across the front. During the national tour of *The Throne* in 1976–77, the Walker Art Center in Minneapolis left the panels intact. However, because they had been damaged by water in the garage, curators at the Smithsonian American

Art Museum made a decision not to exhibit them (fig. VI.13). Variations on the configuration of elements continue. However, the Walker Art Center's version is probably closest to Hampton's, and it is the version that was first exhibited.

Chapter 6

Epigraphs: Hagar Brown, in *American Slave,* ed. Rawick, vol. 2, pt. 1, South Carolina Narratives, p. 114; Bennie Lusane, interview with Gray Gundaker, May 1988. The epigraph at the beginning of the subsection entitled "Light unto the Tomb" is from Rutledge, *Daybreak,* 12–13.

1. Puckett, *Folk Beliefs,* 288, 477; Hyatt, *Hoodoo,* 214; Norman Whitten, "Contemporary Patterns," 314.

2. See Gundaker, *Signs of Diaspora,* 63–94, 219 n.19. The authors thank Ramona Austin, director of the Hampton University Museum, for sharing with Gundaker (Jan. 24, 2003) the information from her fieldwork that the Kongo chiefs with whom she spoke kept before them silver balls as badges of office.

3. Thompson, *Flash of the Spirit.* Although bright and flashing materials recur in arts discussed throughout the book, one of the most notable instances, and perhaps the one that inspired the title, is the tinfoil core of Charlie Leland's luck ball, which, according to Puckett, "represent[s] the brightness of the little spirit who was going to be in the ball" (*Folk Beliefs,* 231).

4. See esp. Thompson, in Thompson and Cornet, *Four Moments;* and Thornton, *Africa and Africans.*

5. Avalene McConico, in *American Slave,* ed. Rawick, vol. 10, pt. 5, Arkansas Narratives, p. 11.

6. Joanna Thompson Isom, in *American Slave,* ed. Rawick, supp., ser. 1, vol. 8, pt. 3, Mississippi Narratives, p. 1099.

7. Ibid., 1100.

8. Ibid., 1101.

9. Rutledge, *Daybreak,* 9, 13. Apparently, however, feeling inferior about his soul was not sufficient cause for Rutledge to moderate his white supremacist views.

10. Ibid., 28–30.

11. Thompson, *Flash of the Spirit,* chap. 2; Thompson, *Face of the Gods;* Thompson and Cornet, *Four Moments;* Wyatt MacGaffey, "The Eyes of Understanding," in *Astonishment and Power,* ed. Wyatt MacGaffey and Michael D. Harris (Washington, D.C.: Smithsonian Institution Press, 1993).

12. George Henry, *Life of George Henry together with a Brief History of the Colored People in America* ([Providence, R.I.]: Published by George Henry, 1894), 12.

13. Rutledge, *Daybreak,* 31.

14. Morton Marks, "Uncovering Ritual Structures in Afro-American Music," in *Religious Movements in Contemporary America,* ed. Irving I. Zaretsky and Mark P. Leone (Princeton: Princeton Univ. Press, 1974), 60–134.

15. Albert J. Raboteau, *A Fire in the Bones: Reflections on African American Religious History* (Boston: Beacon Press 1995), 152.

16. Ed McCrorey, in *American Slave,* ed. Rawick, vol. 3, pt. 3, South Carolina Narratives, p. 118.

17. George Briggs, in *American Slave,* ed. Rawick, vol. 2, pt. 1, South Carolina Narratives, p. 83.

18. Raboteau, *Fire in the Bones,* 154.

19. Thomas Wentworth Higginson, *Army Life in a Black Regiment* (1870; reprint, Boston: Beacon Press, 1962), 205. See also Mary Allen Grissom, *The Negro Sings a New Heaven* (1930; reprint, New York: Dover, 1969), 2–3.

20. James Baldwin, quoted in Raboteau, *Fire in the Bones,* 158.

21. Ibid., 159.

22. Edward King, *The Great South,* ed. W. Magruder Drake and Robert R. Jones (1875; reprint, Baton Rouge: Louisiana State Univ. Press, 1972), 609.

23. Scholars of African American music have often pointed out that the outside observers who wrote down the words of songs failed to grasp their meaning—for example, Wyatt Tee Walker, *"Somebody's Calling My Name": Black Sacred Music and Social Change* (Valley Forge, Pa.: Judson Press, 1979).

24. See Mom Ryer Emmanuel, in *American Slave*, ed. Rawick, vol. 2. pt. 2, South Carolina Narratives, pp. 15–16.

25. Harry Oster, *Living Country Blues* (Detroit: Folklore Associates, 1969), 181, 210.

26. Susan Showers, quoted in Jackson, *Negro and His Folklore*, 298.

27. Ernest Ingersoll, "Decoration of Negro Graves," *Journal of American Folklore* 5 (1892): 68–69.

28. E. J. Glave, "Fetishism in Congo Land," *Century Magazine* 41 (1891): 827. See also John Michael Vlach, *By the Work of their Hands: Studies in Afro-American Folklife* (Ann Arbor, Mich.: UMI Press, 1991), 44.

29. Cynthia Connor, "Archaeological Analysis of African-American Mortuary Behavior," in *The Last Miles of the Way: African-American Homegoing Traditions, 1890– Present,* ed. Elaine Nichols (Columbia: South Carolina State Museum, 1989), 51–55; Oster, *Living Country Blues,* 181, 210.

30. Alexander Priestly Camphor, *Missionary Story Sketches: Folk-lore from Africa* (1909; reprint, Freeport, NY: Books for Libraries, 1971), 46–47.

31. Ibid., 51.

32. Saxon, Dreyer, and Tallant, *Gumbo Ya-Ya,* 317.

33. Thompson, in Thompson and Cornet, *Four Moments of the Sun,* 199, quoting an unpublished paper by Jeremiah Bentley, 1977.

34. James Agee and Walker Evans, *Let Us Now Praise Famous Men* (Boston: Houghton Mifflin, 1941), 10.

35. Karen McCarthy Brown, *Mama Lola* (Berkeley: Univ. of California Press, 1991), 284.

36. Ibid.

37. The association of white with the dead is of course much more widespread; for example, Bamana offerings "are white because this is the primary color associated with the dead and the spirits" (Sarah Brett-Smith, *The Making of Bamana Sculpture: Creativity and Gender* [Cambridge: Cambridge Univ. Press, 1994], 133–34).

38. Puckett, *Folk Beliefs,* 397.

39. Sterling Stuckey, *Going through the Storm: The Influence of African American Art in History* (New York: Oxford Univ. Press, 1994), 77.

40. Walker, *Somebody's Calling,* 146.

41. Florence Gibson, interview with Gundaker and McWillie, Apr. 2, 1999.

42. Killion and Waller, *Georgia Folklore,* 250.

43. Hennig Cohen, "Burial of the Drowned Among Gullah Negroes," *Southern Folklore Quarterly* 22 (1958): 93–97.

44. MacGaffey, *Religion and Society,* 124.

45. Henry George Spaulding (1863), quoted in Jackson, *Negro and His Folklore,* 69.

46. Higginson, *Black Regiment,* 55, 209.

47. Julia Peterkin, *Green Thursday,* 71–73.

48. Puckett, *Folk Beliefs,* 94.

49. Portia Smiley, "Folk-Lore from Virginia, South Carolina, Georgia, Alabama, and Florida," *Journal of American Folklore* 32 (1919): 382.

50. L. M. Alexander, *Candy* (New York: Dodd, Mead, 1934), 95.

51. Sylvia Cannon, in *American Slave,* ed. Rawick, vol. 2, pt. 1, South Carolina Narratives, p. 195.

52. Samella Lewis, "David Butler," *International Review of African American Art* 11, no. 1: 31–35.

53. Oster, *Living Country Blues,* 181, 210.

54. The authors thank John Szwed for pointing this out.

55. Thompson, *African Art in Motion,* chap. 1.

56. Hyatt, *Hoodoo,* 360.

57. Thompson, *Flash of the Spirit,* 109.

58. Robert Farris Thompson, lecture at the Southeastern Center for Contemporary Art, Winston-Salem, N.C., May 16, 1990; Hyatt, *Hoodoo,* 360.

59. Flossie Bailey, personal communication to Grey Gundaker, approximately 1960, Chattanooga, Tenn.

60. *The Frank C. Brown Collection of North Carolina Folklore,* ed. Newman Ivey White, vol. 7

(Durham, N.C.: Duke Univ. Press, 1964), 122; Puckett, *Folk Beliefs,* 477; Flossie Bailey, personal communication to Gundaker.

61. Hyatt, *Hoodoo,* 1334.

62. Ibid., 2009.

63. Puckett, *Folk Beliefs,* 288. See also Whitten, "Contemporary Patterns," 314.

64. Puckett, *Folk Beliefs,* 232. For the full account of this ball, see also Owen, *Voodos,* 169–71,

65. Mary Virginia Bales, "Some Negro Songs of Texas," in *Follow the Drinkin' Gou'd,* ed. J. Frank Dobie (Austin: Texas Folklore Society, 1928), 84.

66. Charles Colcock Jones, *Negro Myths from the Georgia Coast Told in the Vernacular* (Boston: Houghton Mifflin, 1888), 102.

67. Thompson, "Transatlantic Black Art History," 67.

Selected Bibliography

Aarni, Teddy. *The Kalunga Concept in Ovambo Religion from 1870 Onwards.* Acta Universitatis Stockholmiensis, no. 22. Stockholm: Almquist & Wicksell, 1982.

Abrahams, Roger D. *The Man-of-Words in the West Indies: Performance and the Emergence of Creole Culture.* Baltimore: Johns Hopkins Univ. Press, 1983.

Agee, James, and Walker Evans. *Let Us Now Praise Famous Men.* Boston: Houghton Mifflin, 1941.

Alexander, L. M. *Candy.* New York: Dodd, Mead, 1934.

Andrews, Marietta Minnigerode. *Memoirs of a Poor Relation: Being a Story of a Post-War Southern Girl and Her Battle with Destiny.* New York: E. P. Dutton, 1927.

Armstrong, Orland Kay. *Old Massa's People: The Old Slaves Tell Their Story.* Indianapolis: Bobbs-Merrill, 1931.

Avirett, James Battle, *The Old Plantation: How We Lived in Great House and Cabin Before the War.* New York: F. Tennyson Neely, 1901.

Baldwin, Lydia Wood. *A Yankee School-Teacher in Virginia: A Tale of the Old Dominion in a Transition State.* New York: Funk & Wagnalls, 1884.

Bales, Mary Virginia. "Some Negro Songs of Texas." In *Follow the Drinkin' Gou'd,* edited by J. Frank Dobie. Austin: Texas Folklore Society, 1928.

Bass, Ruth. "The Little Man." In *Mother Wit from the Laughing Barrel: Readings in the Interpretation of Afro-American Folklore,* edited by Alan Dundes. Englewood Cliffs, N.J.: Prentice-Hall, 1973.

Beam, Lura. *He Called Them by the Lighting: A Teacher's Odyssey in the Negro South.* Indianapolis: Bobbs-Merrill, 1967.

Beardsley, John. *Gardens of Revelation: Environments by Visionary Artists.* New York: Abbeville Press, 1995.

Bennett, Hal. *A Wilderness of Vines.* New York: Doubleday, 1974.

Blake, J. Herman, "'Doctor Can't Do Me No Good': Social Concomitants of Health Care Attitudes and Practices Among Elderly Blacks in an Isolated Rural Population." In *Black Folk Medicine: The Therapeutic Signs of Faith and Trust,* edited by Wilbur H. Watson. New Brunswick, N.J.: Transaction Publishers, 1984.

Berry, Jason. *The Spirit of Black Hawk: A Mystery of Africans and Indians.* Jackson: Univ. Press of Mississippi, 1995.

Bibb, Henry. "Conjuration and Witchcraft." In *Afro-American Religious History: A Documentary Witness,* edited by Milton C. Sernett. Durham, N.C.: Duke Univ. Press, 1985.

Bodin, Ron. *Voodoo: Past and Present.* Lafayette: Center for Louisiana Studies, Univ. of Southwestern Louisiana, 1990.

Boyd, Minnie Clare. "Alabama in the Fifties." Ph.D. diss., Columbia Univ., 1931.

Boone, Sylvia Ardyn. *Radiance from the Waters: Ideals of Feminine Beauty in Mende Art.* New Haven, Conn.: Yale Univ. Press, 1986.

Breidenbach, Paul S., and Doran H. Ross. "The Holy Place: Twelve Apostles Healing Gardens." *African Arts* 2, no. 4 (July 1978).

Brett-Smith, Sarah. *The Making of Bamana Sculpture: Creativity and Gender.* Cambridge: Cambridge Univ. Press, 1994.

Brewer, John Mason. *Dog Ghosts, and Other Texas Negro Folk Tales.* Austin: Univ. of Texas Press, 1958.

Brown, David H. "Conjure/Doctors: An Explanation of a Black Discourse in America, Antebellum to 1940." *Folklore Forum* 23, no. 1–2 (1990): 3–46.

Brown, David Hilary. "The Garden in the Machine: Afro-Cuban Sacred Art and Performance in Urban New York and New Jersey." Ph.D. diss., Yale Univ., 1989.

Brown, Frank C. *The Frank C. Brown Collection of North Carolina Folklore.* Edited by Newman Ivey White. 7 vols. Durham, N.C.: Duke Univ. Press, 1964.

Brown, Karen McCarthy. *Mama Lola: A Vodou Priestess in Brooklyn.* Berkeley: Univ. of California Press, 1991.

Brown, Kenneth L., and Doreen C. Cooper. "African Retentions and Symbolism." *Levi Jordan Plantation.*

http:www.webarchaeology.com/ Html/african.htm.

Brown, Ras Michael. "'Walk in the Feenda': West Central Africans and the Forest in the South Carolina–Georgia Low Country," In *Central Africa and Cultural Transformation in the American Diaspora,* edited by Linda M. Heywood. Cambridge: Cambridge Univ. Press, 2001.

Brown, Sterling R. *A Son's Return: Selected Essays of Sterling R. Brown.* Edited by Mark A. Sanders. Boston: Northeastern Univ. Press, 1996.

Bunseki, Fu-Kiau Kimbwandènde Kia. *Self-Healing Power and Therapy: Old Teachings from Africa.* New York: Vantage Press, 1991.

Bunseki-Lumanisa, Fu-Kiau Kia. *Le MuKongo et le Monde qui L'Entourant.* Trans. C. Zamenga-Betukezanga. Kinshasa: Centre d'Education et de Recherche Scientifiques en Langues Africaines, 1969.

Campbell, Edward D. C., Jr., and Kym S. Rice, eds. *Before Freedom Came: African-American Life in the Antebellum South.* Richmond: Museum of the Confederacy; Charlottesville: Univ. of Virginia Press, 1991.

Campbell, Marie. *Folks Do Get Born.* New York: Rinehart, 1946.

Camphor, Alexander Priestly. *Missionary Story Sketches: Folk-lore from Africa.* 1909. Reprint, Freeport, N.Y.: Books for Libraries, 1971.

Chireau, Yvonne Patricia. "Conjuring: An Analysis of African American Folk Beliefs and Practices." Ph.D. diss., Princeton Univ., 1994.

Cobb, Hamner. "Superstitions of the Black Belt." *Alabama Review* 11, no. 44 (1958): 50.

Cohen, Hennig. "Burial of the Drowned Among Gullah Negroes." *Southern Folklore Quarterly* 22 (1958): 93–97.

Connor, Cynthia. "Archaeological Analysis of African-American Mortuary Behavior." In *The Last Miles of the Way: African-American Homegoing Traditions, 1890–Present,* edited by Elaine Nichols. Columbia: South Carolina State Museum, 1989.

Cornet, Joseph. *Pictographies Woyo.* Milan: Quaderni Poro 2, PORO, Associazione degli Amici dell'Arte Extraeuropea, 1980.

Cosentino, Donald J., ed. *Sacred Arts of Haitian Vodou.* Los Angeles: Fowler Museum of Cultural History, 1995.

Creel, Margaret Washington. *"A Peculiar People": Slave Religion and Community-Culture among the Gullahs.* New York: New York Univ. Press, 1988.

Culin, Stewart. "Reports Concerning Voodooism." *Journal of American Folklore* 2 (1889): 233.

Dalby, David. *L'Afrique et la Lettre/Africa and the Written Word.* Lagos: Centre Culturel Français; Paris: Fête de la Lettre, 1986.

Dan to Beersheba, or Northern and Southern Friends. London: Chapman & Hall, 1864.

Davis, Richard Harding. *The Congo and Coasts of Africa.* New York: Charles Scribners Sons, 1907.

Dennett, R. E. *At the Back of the Black Man's Mind, or, Notes on the Kingly Office in West Africa.* London: Macmillan, 1909.

Dorsey, Sarah A. *Panola: A Tale of Louisiana.* Philadelphia: T. B. Peterson, 1877.

Drewal, Henry John, and John Pemberton III, with Roland Abiodun. *Yoruba: Nine Centuries of African Art and Thought.* Edited by Allen Wardell. New York: Center for African Art; Harry N. Abrams Publishers, 1989.

Edwards-Ingram, Ywone. "Trash Revisited." In *Keep Your Head to the Sky: Interpreting African American Home Ground,* edited by Grey Gundaker. Charlottesville: Univ. of Virginia Press, 1998.

Eglash, Ron. *African Fractals: Modern Computing and Indigenous Design.* New Brunswick, N.J.: Rutgers Univ. Press, 1999.

Emmons, Martha. *Deep Like the Rivers: Stories of My Negro Friends.* Austin: Encino Press, 1969.

Faïk-Nzuji, Clémentine. *Symboles Graphique en Afrique Noire.* Paris: Éditions Kathala pour CILTADE, Louvain, 1992.

Fardon, Richard. *Between God, the Dead and the Wild: Chamba Interpretations of Religion and Ritual.* Washington, D.C.: Smithsonian Institution Press, 1990.

Ferguson, Leland. *Uncommon Ground: Archaeology and Early African America, 1650–1800.* Washington, D.C.: Smithsonian Institution Press, 1991.

Fielding, Henry. "Memoirs of Low Country Funeral Director." In *The Last Miles of the Way: African American Homegoing Traditions, 1890–Present,* edited by Elaine Nichols. Columbia: South Carolina State Museum, 1989.

Gates, Henry Louis, Jr. *The Signifying Monkey: A Theory of Afro-American Literary Criticism.* New York: Oxford Univ. Press, 1988.

Georgia Writers' Project. *Drums and Shadows: Survival Studies among the Georgia Coastal Negroes.* 1940. Reprint, Athens: Univ. of Georgia Press, 1986.

Glave, E. J. "Fetishism in Congo Land." *Century Magazine* 41 (1891): 825–37.

Gomez, Michael A. *Exchanging Our Country Marks: The Transformation of African Identities in the Colonial and Antebellum South.* Chapel Hill: Univ. of North Carolina Press, 1998.

Gould, Stephen Jay. "Boundareis." In *Time's Arrow and Time's Cycle: Myth and Metaphor in the Discovery of Geological Time.* Cambridge, Mass.: Harvard Univ. Press, 1987.

Graham, Effie. *The "Passin'-On" Party.* Chicago: A. C. McClurg, 1912.

Gray, Joe. *Negro Slavery in Louisiana.* 1963. Reprint, New York: Negro Universities Press, 1969.

Grey, Donald. *Black Echo.* New York: Pegasus, 1932.

Grissom, Mary Allen. *The Negro Sings a New Heaven.* 1930. Reprint, New York: Dover, 1969.

Groth, Paul. "Lot, Yard, and Garden: American Distinctions." *Landscape* 30, no. 3 (1990): 29–35.

Gundaker, Grey. "Tradition and Innovation in African American Yards." *African Arts* 26, no. 2 (1993): 58–71, 94–96.

———. "African American History, Cosmology, and the Moral Universe of Edward Houston's Yard." *Journal of Garden History* 14, no. 3 (1994): 179–205.

———. *Signs of Diaspora/Diaspora of Signs: Literacies, Creolization, and Vernacular Practice in African America.* New York: Oxford Univ. Press, 1998.

———, ed. *Keep Your Head to the Sky: Interpreting African American Home Ground.* Charlottesville: Univ. of Virginia Press, 1998.

Hall, Gwendolyn Midlo. *Africans in Colonial Louisiana: The Development of African Creole Culture in the Eighteenth Century.* Baton Rouge: Louisiana State Univ. Press, 1992.

Hammond, L. H. *In Black and White: An Interpretation of Southern Life.* New York: Fleming H. Revel Co., 1914.

Hartigan, Lynda Roscoe. *The Throne of the Third Heaven of the Nations Millenium General Assembly.* Montgomery, Ala.: Montgomery Museum of Fine Arts, 1977.

———. "Going Urban: American Folk Art and the Great Migration," *American Art* 14, no. 2 (summer 2000): 26–51.

Heath, Barbara J. *Hidden Lives: The Archaeology of Slave Life at Thomas Jefferson's Poplar Forest.* Charlottesville: Univ. of Virginia Press, 1999.

Henry, George. *Life of George Henry together with a Brief History of the Colored People in America.* [Providence, R.I.]: Published by George Henry, 1894.

Higginson, Thomas Wentworth. *Army Life in a Black Regiment.* 1870. Reprint, Boston: Beacon Press, 1962.

Horwitz, Elinor Lander. *Contemporary American Folk Artists.* Philadelphia: J. B. Lippincott, 1975.

Hurston, Zora Neale. "Hoodoo in America." *Journal of American Folklore* 44 (1931): 317–417.

———. "The Gilded Six Bits." *Story* 14, no. 3 (1933): 60–70.

———. *Dust Tracks on a Road.* Philadelphia: Lippincott, 1942.

——. "The Characteristics of Negro Expression." In *Sweat,* edited by Cheryl Wall. New Brunswick, N.J.: Rutgers Univ. Press, 1997.

Huxley, Anthony, ed. *The New Royal Horticultural Society Dictionary of Gardening.* Vol. 2. London: Macmillan, 1992.

Hyatt, Harry Middleton. *Folklore from Adams County, Illinois.* New York: Alma Egan Hyatt Foundation, 1935.

——. *Hoodoo, Conjuration, Witchcraft, Rootwork: Beliefs Accepted by Many Negroes and White Persons, These Being Orally Recorded among Blacks and Whites.* Memoirs of the Alma Egan Hyatt Foundation. Hannibal, Mo.: Western Publishing, 1970.

Imperato, Pascal James. *African Folk Medicine: Practices and Beliefs of the Bambara and Other Peoples.* Baltimore: York Press, 1977.

Illinois Writers' Project. *Cavalcade of the American Negro.* Chicago: Diamond Jubilee Exposition Authority, 1940.

Jackson, Bruce, ed. *The Negro and His Folklore in Nineteenth-Century Periodicals.* Austin: Univ. of Texas Press, 1967.

Janzen, John M. *The Quest for Therapy in Lower Zaire.* Berkeley: Univ. of California Press, 1978.

Jedrej, M. C. "Cosmology and Symbolism on the Central Guinea Coast." *Anthropos* 81 (1986): 497–515.

Johnson, James Weldon, and J. Rosamond Johnson, eds. *The Books of American Negro Spirituals.* 2 vols. 1925–26. Reprint, New York: Da Capo Press, 1977.

Jones, Alice Eley. "Sacred Places and Holy Ground: West African Spiritualism at Stagville Plantation." In *Keep Your Head to the Sky: Interpreting African American Home Ground,* edited by Grey Gundaker. Charlottesville: Univ. of Virginia Press, 1998.

Jones, Bessie. *For the Ancestors: Autobiographical Memories.* Collected and edited by John Stewart. Urbana: Univ. of Illinois Press, 1983.

Jones, Rev. Charles C. *Tenth Annual Report of the Association for the Religious Instruction of the Negroes in Liberty County, Georgia.* Savannah: Office of P. G. Thomas, 1845.

——. *Negro Myths from the Georgia Coast Told in the Vernacular.* Boston: Houghton Mifflin, 1888.

Jones, Jacqueline. *Labor of Love, Labor of Sorrow: Black Women, Work, and the Family, from Slavery to the Present.* 1985. Reprint, New York: Vintage, 1988.

Killion, Ronald G., and Charles T. Walker. *A Treasury of Georgia Folk-lore.* Atlanta: Cherokee Publishing Co., 1972.

King, Edward. *The Great South.* Edited by W. Magruder Drake and Robert R. Jones. 1875. Reprint, Baton Rouge: Louisiana State Univ. Press, 1972.

Laguerre, Michel. *The Voodoo Heritage.* Beverly Hills, Calif.: Sage Publications, 1980.

Larose, Serge. "The Meaning of Africa in Haitian Vodu (Voodoo)." In *Symbols and Sentiments: Cross-Cultural Studies in Symbolism,* edited by I. M Lewis. London: Academic Press, 1977.

Lawton, Samuel Miller. "The Religious Life of South Carolina Coastal and Sea Island Negroes." Ph.D. diss., George Peabody College for Teachers, Nashville, 1939.

LeFalle-Collins, Lizetta. *Home and Yard: Black Folk Life Expressions in Los Angeles.* Los Angeles: California Afro-American Museum, 1987.

Legêne, Susan. "From Brooms to Obeah and Back: Fetish Conversion and Border Crossings in Nineteenth-Century Suriname." In *Border Fetishisms: Material Objects in Unstable Spaces,* edited by Patricia Spyer. New York: Routledge, 1998.

Lemaistre, Elise Eugenia. "African Americans and the Land in Piedmont Georgia from 1850 to the Present, with Prototypes for Reconstruction and Interpretation." M.A. thesis, Univ. of Georgia, 1988.

Leone, Mark et al. *Archaeological Excavations at the Charles Carrol House in Annapolis, Maryland.* College Park: Univ. of Maryland, 1992.

Lerner, Gerda, ed. *Black Women in White America: A Documentary History.* New York: Pantheon, 1972.

Lester, Julius. *The Knee-High Man and Other Tales.* New York: Dial Press, 1972.

Lewis, Samella. "David Butler." *International Review of African American Art* 11, no. 1 (1994): 31–35.

Lieb, Elliot, and Reneé Romano. "The Reign of the Leopard: Ngbe Ritual." *African Arts* 18, no. 1 (1984).

Little, Kenneth. *The Mende of Sierra Leone*. Rev. ed. London: Routledge and Kegan Paul, 1967.

Livingston, Jane, and John Beardsley. *Black Folk Art in America, 1930–1980*. Jackson: Univ. Press of Mississippi, 1982.

Long, Carolyn Morrow. *Spiritual Merchants: Religion, Magic, and Commerce*. Knoxville: Univ. of Tennessee Press, 2001.

Lovell, John, Jr. *Black Song: The Forge and the Flame*. New York: Macmillan, 1972.

Lowery, Rev. I. E. *Life on the Old Plantation in Ante-Bellum Days*. Columbia, S.C.: The State Company, 1911.

Macfall, Haldane. *The Wooings of Jezebel Pettifer*. London: Simpkin, Marshall, Hamilton, Kent & Co., 1898.

MacGaffey, Wyatt. "The Black Loincloth and the Son of Nzambi Mpungu." In *Forms of Folklore in Africa: Narrative, Poetic, Gnomic, Dramatic*, edited by Bernth Lindfors. Austin: Univ. of Texas Press, 1977.

———. *Religion and Society in Central Africa: The BaKongo of Lower Zaire*. Chicago: Univ. of Chicago Press, 1986.

———. *Art and Healing of the Bakongo, Commented by Themselves: Minkisi from the Laman Collection*. Stockholm: Folkens Museum, 1991.

———. "The Eyes of Understanding." In *Astonishment and Power*, edited by Wyatt MacGaffey and Michael D. Harris. Washington, D.C.: Smithsonian Institution Press, 1993.

Mackie, J. Milton. *From Cape Cod to Dixie and the Tropics*. New York: Putnam, 1864.

Manley, Roger, and Mark Sloan. *Self-Made Worlds: Visionary Folk Art Environments*. New York: Aperture, 1997.

Mahoney, William. *Black Jacob*. New York: Macmillan, 1969.

Marks, Morton. "Uncovering Ritual Structures in Afro-American Music." In *Religious Movements in Contemporary America*, edited by Irving I. Zaretsky and Mark P. Leone. Princeton: Princeton Univ. Press, 1974.

Matson, Henrietta. *The Mississippi Schoolmaster*. Boston: Congregational Sunday-School & Publishing Co., 1893.

Matthews, Essie Collins. *Aunt Phebe, Uncle Tom and Others: Character Studies among the Old Slaves of the South, Fifty Years After*. Columbus, Ohio: Champlin Press, 1915.

Matthews, Harold. *River-Bottom Boy*. New York: Thomas Y. Crowell, 1942.

McClaney, Eula Hendrick. *God, I Listened*. Edited by Mark Taylor and Anthony Sweeting. Los Angeles: Dr. La-Doris McClaney, 1989.

McWillie, Judith. "An African Legacy in the Yard Shows of the Georgia Piedmont." Department of Art, Univ. of Georgia, n.d. Photocopy.

———. "Another Face of the Diamond." *Clarion* 12, no. 4 (1987): 42–53.

———. *Even the Deep Things of God: A Quality of Mind in Afro-Atlantic Traditional Art*. Pittsburgh: Pittsburgh Center for the Arts, 1989.

———. "Writing in an Unknown Tongue." In *Cultural Perspectives on the American South*, edited by Charles Reagan Wilson. New York: Gordon & Breach, 1991.

———. "The Migrations of Meaning." In *The Migrations of Meaning*, edited by Judith McWillie and Inverna Lockpez. New York: INTAR Latin American Gallery, 1992.

———. "Art, Healing, and Power in African American Yards." In *Keep Your Head to the Sky: Interpreting African American Home Ground*, edited by Grey Gundaker. Charlottesville: Univ. of Virginia Press, 1998.

Meade, Julian R. *I Live in Virginia*. New York: Longman's, 1935.

Means, Eldred K. *Black Fortune*. 1931. Reprint, Freeport, N.Y.: Books for Libraries, 1972.

Moody, Minnie Hite. *Death Is a Little Man*. New York: Julian Messner, 1936.

Morgan, Marcyliena. "The Africanness of Counterlanguage among Afro-Americans." In *Africanisms in Afro-American Language Varieties,* edited by Salikoko Mufwene. Athens: Univ. of Georgia Press, 1993.

Mulira, Gaston. "The Case of Voodoo in New Orleans." In *Africanisms in American Culture,* edited by Joseph E. Holloway. Bloomington: Indiana Univ. Press, 1990.

Murphy, Joseph. *Santería: An African Religion in America.* Boston: Beacon Press, 1988.

Nielsen, Aldon Lynn. "The Calligraphy of Black Chant." In *Black Chant: Languages of African-American Postmodernism.* Cambridge: Cambridge Univ. Press, 1997.

Nketia, J. H. Kwabena. *Funeral Dirges of the Akan People.* Achimota, Ghana, and Exeter, U.K.: J. Townsend, 1955.

———. *Drumming in Akan Communities of Ghana.* London: Thomas Nelson for Univ. of Ghana, Accra, 1963.

Noreen, Robert G. "Ghetto Worship: A Study of the Names of Chicago Storefront Churches." *Names* 13 (1965): 19–38.

Olmsted, Frederick Law. *A Journey through Texas.* New York: Dix & Edwards, 1857.

Orr, Henry P. "Decorative Plants around Historic Alabama Homes." *Alabama Review* 2, no. 1(1958): 5–29.

Oster, Harry. *Living Country Blues.* Detroit: Folklore Associates, 1969.

Otterbein, Keith. "Setting of Fields: A Form of Bahamian Obeah." *Philadelphia Anthropological Society Bulletin* 13 (1959): 3–7.

Owen, Mary Alicia. *Voodoo Tales as Told Among the Negroes of the Southwest.* New York: Putnam, 1893.

Padgelek, Mary G. *In the Hand of the Holy Spirit: The Visionary Art of J. B. Murray.* Macon, Ga.: Mercer Univ. Press, 2000.

Painter, Nell Irvin. *Exodusters: Black Migration to Kansas after Reconstruction.* 1976. Reprint, New York: W. W. Norton, 1988.

Patton, Frances Gray. *A Piece of Luck and Other Stories.* London: Victor Gollanz, 1955.

Peek, Philip M. "African Divination Systems: Non-Normal Modes of Cognition." In *African Divination Systems: Ways of Knowing,* edited by Philip M. Peek. Bloomington: Indiana Univ. Press, 1991.

Pelton, Robert W. *The Complete Book of Voodoo.* New York: Berkeley, 1972.

Peterkin, Julia. *Green Thursday.* New York: Knopf, 1924

———. *Roll, Jordan, Roll.* New York: Robert O. Ballou, 1933.

Pinn, Anthony B. *Why Lord? Suffering and Evil in Black Theology.* New York: Continuum, 1995.

Piot, Charles. *Remotely Global: Village Modernity in West Africa.* Chicago: Univ. of Chicago Press, 1999.

Powdermaker, Hortense. *After Freedom: A Cultural Study in the Deep South.* New York: Viking, 1939.

Prahlad, Sw. Anand. *African-American Proverbs in Context.* Jackson: Univ. Press of Mississippi, 1996.

Puckett, Newbell Niles. *Folk Beliefs of the Southern Negro.* Chapel Hill: Univ. of North Carolina Press, 1926.

Raboteau, Albert J. *Slave Religion: The "Invisible Institution" in the Antebellum South.* New York: Oxford Univ. Press, 1978.

———. *A Fire in the Bones: Reflections on African-American Religious History.* Boston: Beacon Press, 1995.

Rassoull, Abass. *The Theology of Time, by the Honorable Elijah Muhammad.* Hampton, Va.: U.B. & U.S. Communications Systems, 1992.

Rawick, George P., ed. *The American Slave: A Composite Autobiography.* 41 vols. Westport, Conn.: Greenwood, 1972–79.

Reed, Ishmael. *The Terrible Twos.* 1982. Reprint, New York: Atheneum, 1988.

Riva, Anna. *The Modern Herbal Spell Book.* Tohica Lake, Calif.: International Imports, 1974.

Roberts, Allen F. "The Ironies of System D." In *Recycled Re-Seen: Folk Art from the Global Scrap Heap.* Ed. Charlene Cerny and Suzanne Seriff. New York: Harry N. Abrams, in Association

with Museum of International Folk Art, Santa Fe, 1996.

Robinson, Mary, and M. J. Walhouse. "Obeah Worship in East and West Indies." *Folk-Lore* 4 (1893): 207–18.

Rose, Dan. "Detachment: Continuities of Sensibility Among Afro-American Populations of the Circum-Atlantic Fringe." In *Discovering Afro-America,* edited by Roger D. Abrahams and John F. Szwed. Leiden, The Netherlands: Brill, 1975.

———. "Active Agents." In *The Consumption of Mass,* edited by Nick Lee and Rolland Munro. Oxford: Blackwell, 2001.

Rosengarten, Theodore. "The Secret of the Marshes: An Agricultural Mystery in a Southern Town Leads to New Understanding of the African-American Experience." *The New York Times Book Review,* May 8, 1994, 5.

Rosny, Eric de. *Healers in the Night.* Maryknoll, N.Y.: Orbis Books, 1985.

Rutledge, Archibald. *It Will Be Daybreak Soon.* New York: Fleming Revell, 1938.

Saxon, Lyle, Robert Tallant, and Edward Dreyer. *Gumbo Ya-Ya: A Collection of Louisiana Folktales.* Boston: Houghton Mifflin, 1945.

Seriff, Suzanne. "Folk Art from the Global Scrap Heap: The Place of Irony in the Politics of Poverty." In *Recycled Re-Seen: Folk Art from the Global Scrap Heap,* edited by Charlene Cerny and Suzanne Seriff. New York: Harry N. Abrams, in association with Museum of International Folk Art, Santa Fe, 1996.

Showers, Susan. "A Weddin' and a Buryin' in the Black Belt." In *The Negro and His Folklore in Nineteenth-Century Periodicals,* edited by Bruce Jackson. Austin: Univ. of Texas Press, 1967.

Singleton, Theresa A., ed. *"I, Too, Am America": Archaeological Studies of African-American Life.* Charlottesville: Univ. of Virginia Press, 1999.

The Sisters of Orleans: A Tale of Race and Social Conflict. New York: Putnam, 1871.

Slenes, Robert. "The Great Porpoise-Skull Strike." In *Central Africans and Cultural Transformation in the American Diaspora,* edited by Linda M. Heywood. Cambridge: Cambridge Univ. Press, 2002.

Smith, Fred T. "Compound Entryway Decoration: Male Space and Female Creativity." *African Arts* 24, no. 3 (May 1986).

Smiley, Portia. "Folk-Lore from Virginia, South Carolina, Georgia, Alabama, and Florida." *Journal of American Folklore* 32 (1919): 257–383.

Smith, Theophus H. *Conjuring Culture: Biblical Formations of Black America.* New York: Oxford Univ. Press, 1994.

Snow, Loudell F. *Walkin' Over Medicine.* 1993. Reprint, Detroit: Wayne State Univ. Press, 1998.

Sobel, Mechal. *Trablin' On: The Slave Journey to an Afro-Baptist Faith.* 1979. Reprint, Princeton, N.J.: Princeton Univ. Press, 1988.

———. *The World They Made Together: Black and White Values in Eighteenth-Century Virginia.* Princeton, N.J.: Princeton Univ. Press, 1987.

Sterling, Dorothy, ed. *The Trouble They Seen: The Story of Reconstruction in the Words of African Americans.* 1976. Reprint, New York: Da Capo, 1994.

Stoney, Samuel Galliard. *Plantations of the Carolina Low Country.* Edited by Albert Simons and Samuel Lapham. Charleston, S.C.: Carolina Art Association, 1938.

Street, James, Jr., ed. *James Street's South.* Garden City, N.Y.: Doubleday, 1955.

Stuckey, Sterling. *Going through the Storm: The Influence of African American Art in History.* New York: Oxford Univ. Press, 1994.

Szwed, John F. "Vibrational Affinities." In *Migrations of Meaning,* edited by Judith McWillie and Inverna Lockpez. New York: INTAR Latin American Gallery, 1992.

Szwed, John F., and Roger D. Abrahams. *Afro-American Folk Culture: An Annotated Bibliography of Materials from North, Central, and South America and the West Indies.* Philadelphia: Institute for the Study of Human Issues, 1978.

Talley, Thomas W. *The Negro Traditions.* Edited by Charles K. Wolfe and Laura C. Jarmon. Knoxville: Univ. of Tennessee Press, 1993.

Teish, Louisa. *Jambalaya: The Natural Woman's Book of Personal Charms and Practical Rituals.* San Francisco: Harper & Row, 1985.

Thomas, Charles E. *Jelly Roll: A Black Neighborhood in a Southern Mill Tow.* Little Rock, Ark.: Rose Publishing Company, 1986.

Thomas, Northcote W. *Anthropological Report on Sierra Leone.* Part I. *Law and Customs of the Timne and Other Tribes.* London: Harrison & Sons, 1916.

Thompson, Robert Farris. "An Aesthetic of the Cool." *African Arts* 7, no. 1 (Autumn 1973): 40–43, 64–67, 84–91.

———. *African Art in Motion: Icon and Act in the Collection of Katherine Coryton White.* Los Angeles: Univ. of California Press, 1974.

———. "An Introduction to Transatlantic Black Art History." In *Discovering Afro-America,* edited by Roger D. Abrahams and John F. Szwed. Leiden, The Netherlands: Brill, 1975.

———. *Flash of the Spirit: African and Afro-American Art and Philosophy.* New York: Random House, 1983.

———. "The Circle and the Branch: Renascent Kongo-American Art." In *Another Face of the Diamond,* edited by Judith McWillie and Inverna Lockpez. New York: INTAR Latin American Gallery, 1988.

———. "The Song That Named the Land: The Visionary Presence of African American Art." In *Black Art Ancestral Legacy: The African Impulse in African-American Art,* edited by Robert V. Roselle, Alvia Wardlaw, and Maureen A. McKenna. Dallas: Dallas Museum of Art, 1989.

———. *Face of the Gods: Art and Altars of Africa and the African Americas.* New York: Museum for African Art, 1993.

Thompson, Robert Farris, and Joseph Cornet. *The Four Moments of the Sun: Kongo Art in Two Worlds.* Washington, D.C.: National Gallery of Art, 1981.

Thornton, John. *Africa and Africans in the Making of the Atlantic World, 1400–1680.* Cambridge: Cambridge Univ. Press, 1992.

Turner, Victor. *Revelation and Divination in Ndembu Ritual.* Ithaca, N.Y.: Cornell Univ. Press, 1975.

Tutuola, Amos. *The Palm-Wine Drinkard and His Dead Tapster in the Dead's Town.* New York: Grove Press, 1953.

Vernon, Amelia Wallace. *African Americans at Mars Bluff, South Carolina.* Baton Rouge: Louisiana State Univ. Press, 1993.

Vlach, John Michael. *By the Work of Their Hands: Studies in Afro-American Folklife.* Ann Arbor, Mich.: UMI Research Press, 1991.

Vogel, Susan Mullin. *Baule: African Art, Western Eyes.* New Haven, Conn.: Yale Univ. Press, 1997.

Wafer, Jim. *The Taste of Blood: Spirit Possession in Brazilian Candomblé.* Philadelphia: Univ. of Pennsylvania Press, 1991.

Walker Art Center. *Naives and Visionaries.* New York: E. P. Dutton, 1974.

Walker, Wyatt Tee. *"Somebody's Calling My Name": Black Sacred Music and Social Change.* Valley Forge, Pa.: Judson Press, 1979.

Wampler, Jan. *All Their Own: People and the Places They Build.* Cambridge, Mass.: Schenkman, 1977.

Ward, Daniel Franklin, ed. *Personal Places: Perspectives on Informal Art Environments.* Bowling Green: Bowling Green State Univ. Popular Press, 1984.

Watkins, John V. *Gardens of the Antilles.* Gainesville: Univ. of Florida Press, 1952.

Westmacott, Richard. "Pattern and Practice in Traditional African-American Gardens in Rural Georgia." *Landscape Journal* 10, no. 2 (1991): 87–104.

———. *African-American Gardens and Yards in the Rural South.* Knoxville: Univ. of Tennessee Press, 1992.

Whitten, Norman E. "Contemporary Patterns of Malign Occultism among Negroes in North Carolina." *Journal of American Folklore* 75 (1962): 311–25.

Wimbush, Vincent L., ed. *African Americans and the Bible: Sacred Texts and Social Textures.* New York: Continuum, 2000.

Index